Jacques-Louis David,

REVOLUTIONARY ARTIST

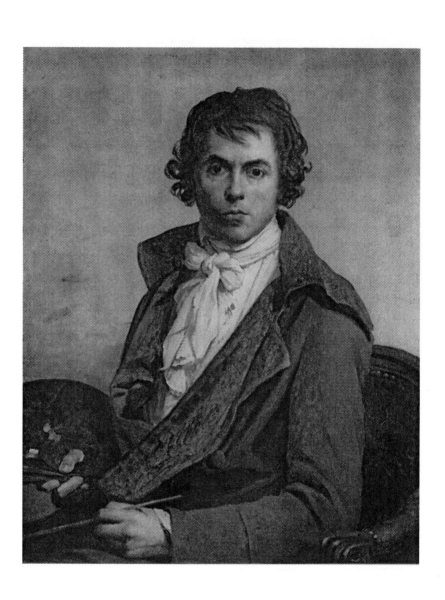

Jacques-Louis David,

REVOLUTIONARY ARTIST

ART, POLITICS, AND

THE FRENCH REVOLUTION

by Warren Roberts

THE UNIVERSITY OF

NORTH CAROLINA PRESS

CHAPEL HILL & LONDON

The paper in this book meets the guidelines for permanence
and durability of the Committee on Production Guidelines
for Book Longevity of the Council on Library Resources.

93 92 5 4 3 2

Library of Congress Cataloging-in-Publication Data

Roberts, Warren E.
 Jacques-Louis David, revolutionary artist : art, politics,
 and the French Revolution / by Warren Roberts.
 p. cm.
 Bibliography: p.
 Includes index.
 ISBN 0-8078-1845-3 (alk. paper)
 ISBN 0-8078-4350-4 (pbk.: alk. paper)
 1. David, Jacques Louis, 1748–1825—Criticism and
 interpretation. 2. David, Jacques Louis, 1748–1825—
 Political and social views. 3. France—History—
 Revolution, 1789–1799—Art and the revolution. I. Title.
 N6853.D315R63 1989
 759.4—dc19 88-37320
 CIP

Quotations from *Jacques-Louis David* by Anita Brookner,
copyright © Anita Brookner 1980, reprinted by permission
of the publisher, Thames and Hudson.

Quotations from *The Mind of Napoleon* edited by Christopher
Herold, copyright © 1955, 1961 Columbia University Press,
used by permission.

Design by April Leidig-Higgins

THIS BOOK WAS DIGITALLY MANUFACTURED.

To Anne

Contents

Preface ix

Introduction: David and the Revolutionary Age 1

1 David before the Revolution 9

2 David and the Two French Revolutions 39

3 David after the Fall of Robespierre 93

4 David and Napoleon 129

5 David in Exile 187

Conclusion: David, History, and History Painting 209

Notes 219

Bibliography 239

Index 249

Preface

THIS IS NOT the first book on David written by a historian. David Dowd wrote an important monograph, *Pageant-master of the Republic, Jacques-Louis David and the French Revolution,* as well as a number of articles on David several decades ago. His interest was in David's political activities, and thanks to his extensive archival research we know much about the artist's membership on revolutionary committees, his organization of revolutionary festivals, and his long and bitter struggle against the Academy. Dowd did not pay particular attention to David's art; he was interested in David's artistic career and his use of art as propaganda. David's paintings were not among the "texts," the historical evidence, that he examined, at least not with the attention he gave to archival materials. Dowd's objective was to make a limited contribution to David studies, and his book benefits from the goals he set for himself, even if some of his conclusions have been proven wrong.

Philippe Bordes, an art historian, has corrected some of Dowd's findings about David's politicization in his *Le Serment du Jeu de Paume de Jacques-Louis David.* Through a combination of scrupulous attention to documentary evidence and impeccable historical thinking, Bordes has traced David's political development step by step. Moreover, he studied David's art with the same rigor and sensitivity to detail that he gave to the written evidence. His brilliant treatment of David's *Tennis Court Oath* combines formalistic with historical analysis. Bordes traces the evolution of the *Tennis Court Oath,* ties it to David's political development, explains the reasons for its having been abandoned, and studies it as a work of art. Bordes's book is a tour de force and indispensable, and the assembled documents and illustrations add to its importance. It is a work that ideally combines historical and art historical research, and one only wishes that it covered more than a brief period of David's career. The same may be said of Robert Herbert's superb monograph, *David, Voltaire,* Brutus *and the French Revolution: An Essay in Art and Politics.* Also written by an art historian and also focusing on one of David's

key works, it too is a masterly work of reconstruction that combines historical and art historical analysis.

There are several other books on David that I should like to mention. Antoine Schnapper's *David* is based on thorough scholarship and is filled with valuable information. It is a rather quiet book, even a bit self-effacing, but it is solid, dependable, and its conclusions are sound and reliable. Unlike Dowd's, Bordes's, and Herbert's books, it covers David's entire lifetime. The same is true of Anita Brookner's *David*. No more insightful work on David has been written, and none has been written with such style. Brookner does what no one else has done in a full-length study: she has tried to capture David the person, to take his emotional and psychological measure, and to tie the person to his art. It is an ambitious and dazzling book, all the richer because of the chances it takes. One need not agree with it in every particular to recognize its central position in David scholarship. Besides these books on David, there is Louis Hautecoeur's useful biography, *Louis David,* and the stimulating work of Thomas Crow, which has given fresh life to David studies. There are also articles by specialists too numerous to mention individually. Among those who have studied David are historians and art historians of various approaches and persuasions, from Marxist to conventional scholars, whose particular questions come out of their particular interests. Given the range and variety of David scholarship one may well wonder whether there is room for another book. What is it about this book that might set it apart from the work of others, or might add something to what has already been said?

My work on David is the first to examine his entire life and work historically. My interest in art and politics defines the questions I ask and determines the contents of each chapter: this is the only book on David written from such a perspective. In each of the five chapters I have chosen a theme, and politics is of central importance in each case. The opening chapter, "David before the Revolution," looks at the interplay between David's development as an artist within the hierarchical world of the ancien régime and mounting tensions within that same world. The final chapter, "David in Exile," is about David the *ci-devant* Jacobin who lived and continued to paint in Brussels after having been banished from France.

I have not written a biography, but I have been keenly interested in David the person. Only Brookner, among those who have written full-length studies, has gotten close to the inner David. Others, such as Bordes and Schnapper, have discussed the life and work of the artist and let the readers draw their own conclusions about David the person. Dowd defended David

against the various charges to which he has always been vulnerable. I have tried neither to accuse nor defend, but to understand and explain an artist whose entire career was filled with controversy. My understanding of David the person is tied to my interpretation of his art. How I build my case is a reflection of my historical approach. David's art is seen as a personal record that draws from the artist's inner life and it is seen as historically conditioned.

Research for this book was facilitated by a semester sabbatical given by the University at Albany and by a Summer Research Fellowship awarded by that same institution. I must also express indebtedness to the United University Professions for a Summer Travel Grant that helped make possible a trip to France in 1987. There I was able to see the splendid collections of David drawings in the Louvre and in the Musée des Beaux-Arts in Lille. Arlette Sérullaz, of the Cabinet des dessins in the Louvre, gave me some of her time even as she was pressed by her many obligations. The information she gave me was very valuable. So too was that of Miriam Stewart of the Drawing Study Room at the Fogg Museum in Cambridge, Massachusetts. Not only did she give me access to the wonderful David drawings in the Fogg collection but she let me use curator emeritus Agnes Mongan's catalogue, which one hopes will soon be published. Finally, I should like to thank Micheline Toureille of the Sterling and Francine Clark Art Institute Library, in Williamstown, Massachusetts. Throughout the time I worked on the manuscript my requests to Micheline Toureille for photocopies were promptly accommodated, greatly facilitating my work.

Critical comments on early drafts of the first several chapters by Robert Herbert and Lynn Hunt were very helpful. That scholars of their stature were willing to read chapters by someone they had never met speaks eloquently of their dedication. The probing comments of James Harkins are all one could hope for from such a tough and fine historian. I should also like to thank my colleague, G. J. Barker-Benfield for reading several of my chapters. He is the kind of colleague who makes an academic department more than a collection of individuals. Another helpful reader was Judith Holtan. That I now thank three graduate students for their contributions, David Wisner, Robert Schumann, and Elizabeth Buss, does not mean that they are late in the order of my gratitude. They have been my most attentive and critical readers, in the best sense of the word. Not only did they read through the entire manuscript and make intelligent criticisms but their own work on David gave me direction. I regard all three as David scholars of real originality. My gratitude to Simon Schama is so great as to be difficult to express. Suffice it to say that his probing reading of the manuscript and well-

informed suggestions contributed materially to the final form of this book. If Simon Schama helped make the book possible, so too did Iris Tillman Hill, as capable and helpful an editor as I ever hope to meet. Finally, I must thank John Webb, Dean of the College of Social and Behavioral Sciences, and Jeanne Gullahorn, Vice-President for Research and Graduate Studies, at the University at Albany, for their timely and important assistance, which facilitated publication of this book.

Jacques-Louis David,

REVOLUTIONARY ARTIST

Introduction

DAVID AND THE REVOLUTIONARY AGE

achieved the capacity to support the huge public indebtedness was insupportable. In 1787 a crisis was at hand, and events were set in motion that led to the French Revolution. Thus, the most important of the eighteenth-century democratic revolutions, the American, played a direct role in bringing about the French Revolution.

A brief look at David's life will show how closely it was bound up with these larger changes. His father was a tradesman and his mother was from a family of architects. After the death of his father when David was nine, relatives on his mother's side of the family were responsible for his upbringing. With their assistance he received an elite education at the Collège de Beauvais and the Collège des Quatre Nations. Beyond the advantage of such an education David had access to the world of liberal thought through his godfather, the writer Michel-Jean Sedaine, whose lodgings in the Louvre he shared in 1769. By this time he was an art student, working under Joseph-Marie Vien. Two years later, in 1771, he submitted his first academic competition piece, and in 1775, having finally been declared a winner, he went to Rome for a period of study that lasted until 1780.

Every stage of David's life up to this point coincides with events that had some larger significance and were part of an unfolding pattern of historical change. The year of his birth, 1748, was the year that Montesquieu published one of the great works of the Enlightenment, the *Spirit of the Laws*. When David was a student at the Collège de Beauvais and the Collège des Quatre Nations, France was in the middle of the Seven Years' War (1756–63), fought against England and her continental allies. One result of that war was the American Revolution, which began after England tried to impose taxes on her American colonies to help repay the huge war debt. It was during the period between the end of the Seven Years' War and the outbreak of the American Revolution that David completed the first stage of his apprenticeship as an artist.

When he traveled to Italy in 1775 as a Prix de Rome winner he went with his mentor Joseph-Marie Vien, who had just become head of the Rome school. A new director of the French Academy had been appointed in the previous year, the comte d'Angiviller, a friend of Turgot, Louis XVI's reforming minister. Previous directors had tried to strengthen the Academy by favoring history painting, just as they had encouraged didactic, moralistic art. These efforts were undertaken even more rigorously under d'Angiviller, whose policies were an integral part of the reform movement within the government of Louis XVI. While Turgot fell in 1776, other ministers and dedicated officials continued to work for progressive change. The Academy

was one of the agencies of government within which reform initiatives were successful. Out of d'Angiviller's efforts, and those of Vien, David's mentor, came a generation of artists who celebrated civic virtue and patriotism, ideals promoted by the Academy.

After returning to Paris in 1780 David achieved stunning successes in the Salons of 1781, 1783, 1785, and 1789, which catapulted him to a position of leadership in the group of artists whose talents the leaders of the Academy had nurtured. He returned to Rome in 1784 to work on the *Oath of the Horatii,* the most brilliant of his paintings up to that time and still one of the two or three works by which he is best known. After exhibiting the *Horatii* in the 1785 Salon he attended gatherings in liberal Parisian intellectual circles whose members were swept into the Revolution in 1789. Among those who visited David in his studio as the revolutionary storm was brewing was Thomas Jefferson, who was favorably impressed by the *Horatii.* The patriotism and sacrifice of the individual to the state that David celebrated in his painting expressed ideals favored by leaders of the Academy but they had also particular meaning for Jefferson. David's painting was more than a realization of an artistic program within an agency of the French government; it belonged to the Age of Democratic Revolution. The artist who painted it drew from the ethical forces that were transforming the Western world. If that artist was born into and came to artistic maturity within the ancien régime, he also partook of the spirit of change that would culminate in the French Revolution.

The painting exhibited by David in the 1789 Salon, *Brutus and the Lictors,* made him appear to be a prophet, as its themes were acted out in Paris of the Revolution. From this time on David was recognized as the artist whose works best captured the ideals of the Revolution. The Revolution proclaimed him its leading artist and he, in turn, put his brush in service of the new regime. He served the Revolution in more than an artistic capacity: he was politically involved as well. Among the major artists of his or any other age his political role is unique. He signed the death order for Louis XVI and Marie Antoinette; he was elected to the National Convention, of which he served one term as president; he was a member of the Jacobin Club and served a term as president; and he held seats on the Committee of General Security and the Committee of Public Instruction. He signed warrants that resulted in the execution of enemies of the Revolution, and as a close ally of Robespierre he orchestrated civic pageants whose purpose was to solidify public support for the Revolution. David was up to his neck in politics and he was lucky not to lose that same neck. He did not attend the meeting of the

Convention on 9 Thermidor that proved fatal to Robespierre and his closest followers. Had he been there he probably would have gone to the scaffold.

Had David been executed—he was forty-five at the time—an active artistic career that was to continue for another three decades would have been cut short. His work up to that time had already established him as one of France's greatest artists, and his position in posterity was already assured, but the loss would have been grievous. It would have been grievous not only because of masterpieces that would not have been painted but also because an important part of the unfolding historical record would not have been made. Through David's art during the Directory, under Napoleon, and during the Restoration we are able to follow his creative direction; moreover, we are allowed unique insights into the interplay between art and politics. David had been in the exact center of the Revolution, he had felt its enormous pressure, and his revolutionary paintings are a record of that fact. With the fall of Robespierre came a period of rapid decompression, and through David's works we can see how he responded to this change. As before, his art is more than a personal statement; again it expresses the deeper, spiritual changes within his world. The same is true of David's work in the Napoleonic period, in which he continued to be France's leading artist. His portraits show us Napoleon the person and his *Coronation of Napoleon and Joséphine* and *Distribution of the Eagles* record two carefully staged public events. These two immense state paintings are more than a record of Napoleonic ceremonies, however; they also reveal some of David's own reactions to the imperial court, in which he had a front-row seat. Napoleon had been David's hero, but years of service as his First Painter left David disenchanted. By the end of Napoleon's reign the burdens of his ambitious policies took a toll on France and on David, too. His *Leonidas at Thermopylae,* completed in the year of Napoleon's defeat, can be regarded as an allegory of that event.

When Napoleon returned to France and to power during the Hundred Days he again named David his First Painter. David accepted the position and signed the *acte additionnel* that bound him irrevocably to a regime that was soon put to the test. After the Battle of Waterloo, David was driven from France by a Bourbon government that was far less forgiving than at the time of the first Restoration. Still France's greatest artist and still very active as a painter, he spent the last ten years of his life in Brussels, in exile. Once again, his paintings from this period are a record of the age. His portraits depict former revolutionaries who joined him in exile and his mythological paintings, scenes of love, are the work of an artist who was separated from *la patrie*

and no longer able to paint the patriotic subjects that had been the foundation of his greatness and into which, through a career that lasted over a half-century, he had poured so much of his creative energy. Those mythological paintings not only tell us much about David's internal life as a former Jacobin exiled to Brussels, they also reveal something of the spiritual climate of the age. But this was something David's art had always done, from the time of his heroic paintings in the 1780s all the way down to his final work, *Mars Disarmed by Venus*, a parody of his great patriotic works. Thus, David's work is an incomparable record of the revolutionary age, from its very beginnings all the way down to its bitter sequel during the Bourbon Restoration.

David

BEFORE THE REVOLUTION

You should go to Vien, a good painter and a good teacher; he is a bit cold, but come to see me from time to time and when you bring me your works I will correct the fault of this master and show you how to put in warmth and even to break an arm and a leg with grace.
—François Boucher to David, Miette de Villars, *Mémoires de David*[1]

I am busy with a new painting, badly as I feel. I am in this poor country like a dog thrown into the water against his will, and who has to reach the bank so he will not lose his life. . . . I am doing a painting purely of my invention. It is Brutus, man and father, who has deprived himself of his children and who, having returned to his hearth, receives the bodies of his two sons who are brought back for burial.
—June 14, 1789, letter written by David to his student, Jean-Baptiste Wicar[2]

*T*HE QUOTATION from Miette de Villars records the advice that Jacques-Louis David received when he was taken to the studio of François Boucher, an aging and unwell but highly successful artist favored by Louis XV himself and by Mme de Pompadour. The visit probably took place late in 1764 or in the early part of 1765, when David was sixteen and determined to become an artist. Although Boucher, a distant relative, was unable to accept David as a student, he does seem to have made an impression on the young man, for in David's first Prix de Rome competition piece, the *Combat of Mars and Minerva,* painted in 1771, the influence of the rococo master is evident in the nude figure floating on a cloud in the top of the painting. All traces of the rococo have been expunged from the painting David was working on when he wrote the letter from which the second of these quotations is taken. The work he referred to, *Brutus and the Lictors,* was the hit of the 1789 Salon two months later. When David wrote this letter the Estates-General had assembled at Versailles, and when he sent his sensational painting to the Salon in August the Revolution was an established fact.

Between the time of David's visit to Boucher's studio and his completion of the *Brutus* was an interval of twenty-five years. During that period David established himself as France's greatest artist and as the most powerful force in the antirococo reaction. The artist who began his career visiting Boucher repudiated more decisively than anyone else the polite, refined, erotic hedonism of the older master. That style was already in decline when Boucher urged David to study under Vien. The winds of change favored a more serious art, one that would inspire virtue and dedication to the state. The Academy, an agency of the government and the most forceful arbitrator in the artistic life of eighteenth-century France, threw all of its weight behind didactic art, which critics such as Diderot also supported. If the *philosophes* called for moral reform so did officials of the Academy, and art was to be an instrument of change. More than any other painter it was David who gave artistic form to the ideals of those days and he did so as a member of the Academy.

The style that David brought to maturity as a member of the Academy in the years before the Revolution brought him success and fame. Yet all was not well between David and this agency of the government. Though he became France's leading artist, painting subjects that were encouraged by officials of the Academy and in a style favored by those same officials, he was embittered and alienated in the midst of his success. How that happened is the subject of this chapter. Its significance goes beyond David's development as an artist within the Academy but touches on the larger issue of art and

politics. How David became a revolutionary is inextricably bound up with his successes and his struggles within the Academy in the years before France was rocked by political explosions in 1789. But we are getting ahead of ourselves. Let us see how David's career unfolded.

His mother had opposed him when he announced that he wanted to become an artist, but after he prevailed upon an aunt to take up his cause, an uncle took him to see whether Boucher would accept him as a pupil. David had spent three months in the life drawing class in the Academy of Saint Luke, an unofficial body controlled by the guilds, but his family knew that if he was to become an artist the only way to achieve success was to study under an established master. Boucher's recommendation that he study under Vien was eminently practical, for Vien was the acknowledged leader of the neo-classical school favored by the Academy. Moreover, Vien was a highly respected member of that institution. David's decision to study under Vien was influenced by the goal of academic success.

After five years of study under Vien, David submitted his first Prix de Rome competition piece, the *Combat of Mars and Minerva*. He was initially declared the winner, but the prize was awarded to another student when Vien urged the jury to reverse its decision because David had not asked his permission to submit the work.[3] After he failed again to win the prize in the following year David locked himself in his room for two days until friends, worried about his absence, found him there in an apparent attempt to take his own life by starvation.[4] After competing unsuccessfully for the Prix de Rome three times David finally won the prize in 1774. Vien, appointed head of the Rome school, accompanied him to Italy in 1775. Some time after arriving he is reported to have said to his student, "I had hopes for you that have not been realized: decidely you are doing yourself no good." David's reply was, "Oh well: If I harm myself I will suffer the consequences."[5] The five years in Rome were difficult for David in many ways. He had become a source of concern for school authorities and the subject of discussion between officials in Rome and d'Angiviller, the director of the Academy. J. B. M. Pierre, the First Painter, wrote Vien that "we are dealing with a man who is open, honest, but at the same time excitable enough to need careful handling."[6]

David's problems in Rome were both personal and artistic. In 1779 he experienced difficulty completing his *académie,* a painting he was required to do according to official procedures. The matter turned into a crisis of sorts, the solution of which came about after David left Rome for a trip to Naples with another student, F. M. Suzanne, and the young archaeologist Antoine

Life, has rekindled the fires of art historical controversy by seeing David's *Oath of the Horatii* as a prerevolutionary painting. This is very different than seeing the work as "fully republican," the older view that Ettlinger successfully repudiated. By employing the historical concept of "prerevolutionary" art, Crow built his case on new foundations. David was no longer a republican waiting for the Revolution to happen but instead was an artist who lived in a world within which revolutionary pressures were developing.[26]

Just how fundamental the cleavage is between Crow and his adversaries is suggested by Anita Brookner's discussion of David's *Death of Socrates*, a work that was completed in 1787, two years before the Revolution. According to Brookner, the *Death of Socrates* "was conceived in a secure eighteenth-century world in which attention to the classics, obedience to the *philosophes*, and the permitted emotions of sentimental fiction were the moulding influences."[27] For Crow the world in which the *Socrates* was created was anything but secure, and while the *philosophes* were an important intellectual force it was not obedience that they inspired. Nor were the permitted emotions those of sentimental fiction. Emotions were not circumscribed by the conventions of eighteenth-century novels but were fanned by political controversy. For Crow the historical ground of the 1780s was far from stable; it was intensely politicized and from it came the voices of radicals who helped define David's world in the years during which he established himself as the greatest painter of his generation. Between the positions taken by Brookner and Crow there is fundamental opposition, and politics is at the heart of the conflict.

The advantage of the "prerevolutionary" construct is that it helps historians identify the elements within a society that contribute to a political explosion before it takes place.[28] Crow's purpose is not to explain the Revolution but he does use the "prerevolutionary" concept in his analysis of David's *Oath of the Horatii*. Central to his case are the radical art critics who churned out criticism when the Academy held its Salons every two years. That criticism threw aside polite formalities and was couched in adversarial, provocative, contentious, and sometimes scurrilous language. The radical critics were part of a new, politicized art public that was hostile to the Academy, and it was this hostility, Crow explains, that was important to David when he exhibited the *Horatii*. When he sent his painting to the Salon he was at loggerheads with officials of the Academy and with other artists. Given the opposition that he encountered within the art establishment it was important to find support elsewhere, and this is where the radical critics come in. They were enthusiastic about the *Horatii* and sang its praise in the

antiofficial press. With the support of the radical critics, Crow argues, David broke away from the official art world within which his talent had been nourished and his previous successes had been achieved.

The radical critics who championed David brought intense political involvement to their journalism. Their world was that of the aristocratic elite; they belonged to groups such as the Kornmann circle and the coterie of the duc d'Orleans, and like others who moved in those fashionable surroundings they threw themselves into the Revolution in 1789.[29] Seen from this perspective, these groups were a seedbed of revolutionaries. Out of the world of the aristocratic elite came radical voices, voices with a democratic ring. And it was this world, Crow maintains, that played a crucial role in redefining David's position as an artist in the years immediately before the Revolution.

For Crow the work that best reveals the division between establishment and radical critics is the *Oath of the Horatii*. What he finds on the part of establishment critics is generalized praise but also an undercurrent of "inarticulate hostility."[30] These critics recognize the brilliance of David's painting, but they object to something within it that bothers them and they object to the enthusiasm of the public reception. The radical critics, by contrast, criticize particular faults in the painting but conclude that those faults are negated by the work's overpowering impact, which moved them as did no other painting in the Salon. Precisely those elements of the *Horatii* that set it apart from the works of other artists disturbed one set of critics but brought forth a positive and favorable response from others.

And what was it about the *Horatii* that was responsible for the divided response? For Crow one of the answers to that question lay in the style in which the painting was done. He sees the work as disjointed, strained, stiff, awkward, and without the grace, the bravura brushwork, and the exquisite painterly qualities favored by the Academy and elite critics. "The handling is plain, undemonstrative, neither polished nor broad."[31] David employs a direct language, a "language of truth," a language that describes real things as does the language of Jean-Louis Carra, a radical pamphleteer. Just as there was a dialectic between establishment and antiestablishment critics, and between style and antistyle in the war of words, so was there a similar dichotomy in art. David, Crow maintains, came down on the side of antistyle, and this is one of the reasons for his dramatic, overwhelming impact on the radical critics who praised David. He addressed them in a language they understood.

Crow's stylistic analysis of the *Horatii* does not agree in all respects with that of other David scholars. Anita Brookner, for instance, finds the painting

"well-mannered," and Hugh Honour sees the style as "rigorously puri-
fied."[32] While Crow emphasizes David's renunciation of "conventional
academic practice," others stress the similarity between his stylistic develop-
ment and the larger pattern of stylistic change within the Academy. Crow
argues that the caesura, the compositional rift running through the *Horatii*,
contributes to the "dissonant, unnuanced, and disjointed" quality of the
painting, and as such it is an expression of David's rejection of the stylistic
canons favored by the Academy.[33] Hugh Honour argues that the "dissocia-
tion or isolation of parts," from which so much of the painting's "bru-
talism" derives, is consistent with and even has its origins in accepted
academic practice and was a compositional approach David learned from his
teacher André Bardon.[34] Similarly, Norman Bryson sees the "broken com-
position" of the *Horatii* as a feature that it shares with works by other artists
of David's generation.[35]

Given the circumstances under which David painted the *Horatii* and
exhibited it in the Salon, does it seem convincing, as Crow maintains, that
he was appealing to a popular Salon audience? Such an interpretation is
supported by the difficulties David had with academic authorities while
doing the work. He had defied official rules and provoked an important
official, who warned him that he would anger his colleagues. David was
controversial and he knew it. He might well have tried to broaden the base of
his support under these circumstances, and as we have seen he was already
aware of both the "important people" and the "crowd" in 1781, when he
exhibited the *Belisarius*. At that time he seems to have been more interested
in the "important people," who wanted to "see the author." When it was
time to send the *Horatii* to the Salon he could well have hoped to appeal to a
popular Salon constituency. Fearing establishment opposition, a new base
of support could have been essential. Still, if that was the case, how much
does such a strategy tell us about the painting itself? Was it David's intention
while working on it to create a new style, a "language of truth," that would
appeal to a popular constituency? In considering this question it should be
remembered that not all critics agree with Crow about David's style. In fact,
other art historians have emphasized the continuity between David's stylistic
development and the larger line of development encouraged by the Acad-
emy. Let us turn, then, to the *Horatii* to see how David brought the painting
to completion in Rome in 1784, after having begun work on the project in
1781.

If one follows David's progress as he worked his way through a series of
preparatory sketches that culminated in the *Oath of the Horatii*, it is possible

to arrive at some different conclusions than those of Thomas Crow. The dissonances, distortions, awkwardness, and strained geometry of the *Horatii* can be seen not as the result of David's striving to create a language that would enable him to speak clearly and directly to the "crowd" or to radical critics but as an infusion into his art of his own feelings.[36] One of the keys to the *Horatii* is its intensely private quality—despite its public appeal.

The story of the Horatii was one of antique heroism. It took place during the monarchy, when Rome fought with neighboring Alba over the theft of cattle. The people resisted going to war, and both states chose men to resolve the difference. The Romans chose three Horatii sons and the Albans three Curiatii sons. The struggle between the Horatii and Curiatii was complicated by ties between the two families. One of the Horatii was married to a Curiatii, and one of the Curiatii was betrothed to a Horatii daughter. As it turned out, the eldest of the Horatii sons, Horatius, killed all three of his rivals after his two brothers had been slain. When he returned victoriously to Rome his sister, Camilla, who was betrothed to one of the dead Curiatii, expressed anger over the death of her lover. Furious with his sister, Horatius ran her through with his sword.

David's first preparatory study for the *Horatii* was a 1781 drawing that showed Horatius pointing at the dead body of Camilla after he slew her. In 1782 David did another *Horatii* sketch, this time showing the sequel of the event portrayed in the earlier study. Now the father defends the action of his son in a speech to the people. According to Alexandre Péron, just before David made the drawing he attended a performance of Corneille's *Horace*, a scene of which (in the last act) had made a powerful impression on him, and helped revive his interest in a painting of the Horatii. Péron explains that David did his drawing after the play and in the same evening discussed it with friends at a literary gathering, at which his former protector, the writer Sedaine, was present. When David showed the drawing to the guests, Sedaine said, "The action you have chosen is practically nil. It's all words, a marvellous appeal involving many tricks of oratory which attracted Corneille and led him to compose a sort of appendix to his tragedy. Moreover, would our French habits take kindly to the ferocious authority of a father who pushes stoicism to the limit of excusing his son for the murder of his daughter? . . . We are not mature enough for a subject of this sort."[37] After hearing Sedaine's opinion, David excused himself, thought about it, and returned having made up his mind about the subject of his painting: "The moment which must have preceded the battle, when the elder Horatius, gathering his sons together in their family home, makes them swear to

conquer or to die."[38] The subject David chose had no literary or historical basis; it was completely his own invention. Why did the idea occur to him? What chemistry was responsible for the idea?

In Péron's account of the conversation between David and Sedaine the writer tells the artist that the scene he had witnessed in Corneille's *Horace* was "all words" and wrong for David's purposes. This account is significant because it describes David discussing a drawing that had been inspired by Corneille's play. Earlier in the play, before the scene in the last act that gave him the idea for his drawing, David had seen on the stage fierce, resolute, even barbarous Romans whose dedication to Rome transcended personal feelings and family loyalties. In Corneille's drama Horatius saw the coming battle as a noble trial to "test our valor"; he proclaimed that "such strength of will is ours alone"; and he said that "the solid manliness of which I have boasted permits no weakness in its firmness."[39] The heroic pride, the complete mastery of self, the inflexible resolve of Corneille's Horatius represented a moral outlook that resonated with something in David's own interior life. Such resolution and mastery were what David strove for. And when Horatius said that his manhood permitted no weakness he struck a vibrant chord in David, for these words reached deeply into his experience, into his own psychic conflicts.

It would not be farfetched to say that David experienced conflicting emotional tendencies, or even that his personality was beset by deep internal divisions. Early biographers described him as quarrelsome, and he had a fierce desire to excel, an intense pride, and a character—as his student Delécluze put it—that was difficult to tame.[40] This would appear to have been a family trait. David's father was killed in a duel, and David fought one as a young man, in which he received a gash in his cheek that left him with a permanent facial disfigurement and speech impediment. If a combative side was present in David from the beginning, so too was a softer and more lenient side. Anita Brookner has written that as a young artist he "remained secretly faithful to [the style] of Boucher."[41] He was to break from that style later, but this was the starting point, the original given. David's identification with Boucher suggests more than stylistic preference; it implies a favorable emotional response, perhaps an inner affinity between Boucher's art and something in David's own makeup. David's more pacific side came through in a solicitude for his students, and in particular his concern for female students, of which he was an early champion. His artistic affinity for the female manifested itself in his portraits. Already in his 1769 portrait *Mme Buron,* David revealed a "sensitivity to female influence" (in Brookner's

words) that would enter into his many portraits of women throughout his artistic life.[42]

How David portrayed men and women and worked out relationships between male and female figures in his paintings was not unrelated to his own internal life. He had separated male and female figures in his three competition pieces, which he had done as a student, but now, in the *Oath of the Horatii*, the division is sharper and more decisive. The separation is not only physical but also moral; it is as if the contradictory tendencies in David, the male and female principles we may call them, had crystallized in different groups of figures.[43] Of these groups, the men are clearly dominant. Not only do they occupy more space on the canvas but they are physically larger than the diminutive, almost underscaled women. The men are set off by brilliant reds, while the women are dressed in cooler whites, browns, and blues.

The three brothers hold out their well-muscled arms as they take their oath "to conquer or to die." Horatius grasps a lance with his left hand, and he and his brothers are about to receive the swords that catch light, glisten, and, so to speak, are the spiritual center of the painting. Four preparatory sketches show how the swords came to have such importance.[44] The first of these drawings (in the Ecole des Beaux-Arts, Paris) shows the father bending at the waist, his arms lowered as he holds the swords which point toward himself (see fig. 2). In contrast to the well-defined women on the right the Horatii men are done sketchily, as if David were groping for the right pictorial solution. In a drawing in the Louvre the three sons are drawn more firmly, but the father is again done tentatively, and the swords are only hinted at (fig. 3). In this version David seems to have considered dispensing with the swords, having the sons swear the oath by reaching toward or grasping the fist of their father. A third drawing (in the Musée des Beaux-Arts in Lille, fig. 4) announces in most essentials the finished version. The father now stands upright, both arms are raised, and as in the painting he holds the swords in his left hand. The father looks gravely at the upheld swords and the sons reach out to take them as they swear their oath. And yet, the swords lack the menacing quality they were to have in the finished version. A drawing in the Louvre shows how David took the final step in his rendering of the swords (fig. 5). Here a single, massive, curved blade runs almost the entire length of the page. Unlike the swords of the Musée des Beaux-Arts drawing, which are historically accurate thin-bladed Roman swords, this one is an anomalous Saracen sword, chosen by David because of what it added to the oath-taking ceremony. The sketch in which this sword

appeared was one of the last preparatory drawings and to its right the nurse and two children are seen, arranged as they would be in the painting. Below the grieving woman and frightened children is the head of a warrior who, interestingly, is bearded like the father and wears a helmet like the sons, as if he embodied the attributes of both—as if he were the epitome of male resolution. He is shown facing the sword. The nurse and children above him face in the other direction, away from the sword. The sword has thus assumed the menacing quality that it was to have in the painting, and it defines the sharply contrasted realm of feeling that separates the male and female figures. In working his way to the finished version David became progressively more direct in the arrangement of figures; there is a steady increase in the tension; and the "epigrammatic edge" that is finally achieved owes much to the pictorial treatment of the swords.[45]

In the finished painting the men inhabit an altogether different moral world than the women, and in none of the figures is the contrast more striking than between Horatius and Camilla, who frame the painting at opposite ends. The virile, athletic brother who reaches proudly for the sword with tense and muscled arm is the polar opposite of the swooning sister whose arm hangs limply at her side. Compositionally, Horatius and Camilla define the outer side of the spaces occupied by the male and female figures. In the case of the male figures that space is a triangle within a square and in that of the female figures it is an oval. Horatius is the principle source of the energy that flows into the space occupied by the male figures, while Camilla sets in motion the very different feelings that are present within the space, made up of flowing arabesques, occupied by the female figures. As Camilla's head leans against that of Sabina, the nurse at the other side of the oval bends to touch the standing child. Grief and sorrow are found at one end of the compositional unit and shelter and solicitude at the other, different but related parts of a coherent sphere of feeling. The moral realm of the males is no less unified. The father who leans back and looks up at the swords is no longer able to use them as can his sons, whose straight and virile limbs are juxtaposed against the bent limbs of the father. Yet between the sons and father there is absolute unanimity of mind and principle.

If the male figures occupy more of the pictorial space than the female figures and dominate the scene, they do not monopolize it. In their own way the female figures are no less important than their male counterparts. *Andromache Mourning Hector*, done two years before the *Horatii*, points toward David's 1785 masterpiece. A preparatory study for *Andromache* shows the grieving mother holding a squalling infant, but in the painting a boy

looks toward and gently touches the chest of his mother. Peace and composure, calm and solicitude, descend on the work as a result of this change, and with it a deepening of the pathos. And this quality of feeling, the pathos that rises from female grief, is what would reappear in the *Horatii*. This was to be one of the hallmarks of David's art, not only in the paintings that are the source of his fame but also and in many ways even more revealingly in his drawings, preparatory studies that show him over and over creating groups of male figures and then groups of female figures, proud and virile warriors and patriots on the one hand and solicitous and caring females on the other. David's art is evidence of his attraction to the courageous, heroic, and violent, yet it also reveals a different side, one that was tender and fragile. It was his ability to dramatize both so effectively that sets the *Horatii* apart from the outwardly similar works of other artists.

Both the male and female figures of the *Horatii* drew from various sources. This is most evident in the figure of Horatius that is copied—copied "very blatantly" as Brookner puts it—from Nicolas Poussin's *Rape of the Sabines* and also from that same artist's *Death of Germanicus*.[46] Also derivative are the nurse and the grief-stricken Camilla, whose sources are the two female figures in Poussin's *Testament of Eudamidas*. David himself said of the *Horatii* that it depended more on Poussin than Corneille. This remark indicates how conscious David was of both the literary and artistic sources that were so manifestly important to his masterpiece.

The *Horatii* can be connected to the neo-Poussinist revival, but it also has ties to currents of change within the Enlightenment.[47] Rousseau had turned against the gilded world of the salons in the 1750s, and in his two novels, *La Nouvelle Héloïse* and *Emile,* he denounced the effete society of *la cour et la ville.*[48] What he called for was plain manners, not the insincere politeness of artificially refined people; what he admired was not the liberal spirit of ancient Athens but the severity, rigor, and discipline of Sparta. Diderot was to echo these ideas in his *drames* and in writings that praised Stoic virtue as an antidote to the debility of contemporary French society and culture.[49]

As an art critic Diderot railed against the languid, amorous, rococo art of Boucher and the *petits-maîtres,* artists who excelled in erotic insinuation. The hallmark of that school of painting was playfulness, fancy, and hedonism; what Diderot favored was the exact opposite, virtue within the spheres of both private and public life. In Salon after Salon he denounced the works of the rococo masters and lavished praise on artists who dedicated their brushes to morality. The problem was that no artist was able to capture on canvas the

ethical values that Diderot hoped to find. As chance had it, the artist who
was able to achieve the severe ideals that Diderot imagined in his mind's eye
did not do so in time for him to appreciate the fullness of his achievement.
David was in Rome painting the *Horatii* in 1784, the year of Diderot's death.
Diderot had seen the *Belisarius* when it was shown in the 1781 Salon, and he
had been impressed: "I see it every day and always think I am seeing it for
the first time."[50] It was the *Horatii* that made concrete the ideal that Diderot
hoped, in vain, to see during the many years of his Salon criticism.[51] It may
be said of the *Horatii* that it not only gave expression to Diderot's ideal but
was the culmination of the antirococo reaction whose beginnings reached
back to the 1750s.

David was slow to come to his mature style. Although he was to become
the artist that Diderot was calling for, others anticipated his breakthrough
more than he did himself in his early paintings. Such a work as Jacques-
Antoine Beaufort's *Oath of Brutus* of 1771 is much closer to the *Horatii* than
David's own paintings done in the 1770s, and as we have seen it was one of
David's sources. When shown in the 1771 Salon, Beaufort's *Oath of Brutus* was
a decided success. One critic commented on the "manly and Roman fig-
ures" and was impressed by their passion and anger, while another saw in the
outraged Collatinus a man who was "the friend of his country, and a citizen
of Rome."[52] Against a chorus of approval was a dissenting voice, that of
Diderot, who found a lack of involvement in the work, a failure of imagina-
tion.[53] Diderot wrote that Beaufort had not "become" Collatinus, seen
Lucretia stabbed, and in the heat of anger sworn to take vengeance for the
death of his wife. Diderot also wrote that for an artist to capture the full fury
of Brutus, who was to defeat Tarquin and found the Roman Republic, he
must become that Roman and see Tarquin on his throne. Because Beaufort
lacked the necessary capacity for involving himself in the scene he portrayed,
the work was but another academic exercise, a prize-winning work by an able
painter. Diderot's judgment has been that of posterity, for this work, so
much admired when first shown, has long hung obscurely in a provincial
museum, its actual identity unknown until its recent discovery.

What explains the success of David's *Horatii* is his involvement in the scene
he portrayed, but his involvement was not the type that Diderot prescribed.
As we have observed, David invented the scene he painted. Crucial to the
crystallization of his ideas was Corneille's *Horace,* in which the play's hero
resolved that his "stalwart manhood" permitted no room for "weakness in
its firmness." The call for a noble trial of the hero's manliness struck a
resonant chord in David; in portraying Horatius's "strength of will" he

expressed one of the deepest urges within his own being.[54] So too did his depiction of the mourning females issue from a reservoir of personal feeling. The keys to David's involvement in the *Horatii*, and to the painting's tensions—its electricity—are his own inner tensions, the rifts and divisions within his own personality.

That the *Horatii* had such appeal to the radical critics in the 1785 Salon was not just because David sought their support and employed a "language of truth" calculated to win their approval. David's style, his language, was his own and it was highly personal. Caution should be exercised in trying to tie it to the language of contemporary radical critics. If there was a directness in both his language and theirs, those qualities came from distinctly different sources. David was a thoroughly academic artist who used a vocabulary that grew out of his training. His way of applying paint to canvas was anything but rough. He achieved a highly polished surface that was quite free of bravura, painterly, rococo brushwork. The surface was impeccable: the work of a superb technician whose creations impressed even academic officials who begrudged his success.[55]

All of this is very different from the language of the radical critics, whose rough and sometimes scurrilous verbal outpourings expressed social and political anger. Their heated invectives poured from their pens in a language that has few similarities with the disciplined, polished language of David. And yet, as Crow says, the radical critics responded immediately and powerfully to the *Oath of the Horatii*, and did so in ways that separate their reactions from the begrudging praise of academic officials and establishment critics. They were responding to tensions in the *Horatii* which passed from a conflicted emotional life into the painting.

The *Oath of the Horatii* did appeal to radical critics and David may have sought their support, although there is no evidence to suggest that he did so because he shared their political views. Indeed, there is no evidence that he had any particular political ideas at this time, or that he was interested in politics. Having been introduced to *philosophes* by his godfather Sedaine, and having access to an upper-class liberal milieu, it would be reasonable to assume that his thought reflected the progressive values of the time. Moreover, the heads of the Academy not only shared in those values but strove to promote them through art. Even though Turgot fell from office in 1776, his friend d'Angiviller continued to promote liberal ideas through art. The academic program calling for moralistic art was clearly progressive, and as an artist David was an instrument of that program. This is not to suggest that David had particular political views or to imply that there were ideological

ties between him and the radical critics. Nor does Crow make any such claims. David's protest, he maintains, is that of an artist who rebelled against the Academy.

Conflict between David and the academic hierarchy intensified in the years directly after the 1785 Salon. After the stunning success of the *Horatii* he made an unsuccessful bid to be appointed head of the Rome school, a post that became vacant in 1786. He wrote Drouais, still studying in Rome, that he wanted the position. His student replied that Peyron, whom he had heard was always in the company of d'Angiviller, would be his rival. Drouais believed that in spite of Peyron's efforts to curry favor, the director would not dare give Peyron the post. "It seems that we have the same antipathy for [Peyron] and his merit."[56] Drouais urged David to do everything in his power to become head of the Rome school, which would be good for all students and would mean that he and David would have the pleasure of spending several years in Rome together. Drouais saw intrigue everywhere, and separated people into two categories, those who like himself respected David and those who were jealous of him. He told David that since his detractors could not compete with him on equal terms they would rely on baseness and plots to achieve their goals.

As it turned out, d'Angiviller chose neither David nor Peyron for the Rome post. (The position went to F.-G. Ménageot, whose *Cléopatre* had been completely eclipsed in the 1785 Salon by David's *Horatii*.) In a letter to Bièvre, d'Angiviller expressed his admiration for David as an artist, but explained that he was too young for the position and had not yet reached a sufficiently high place in the academic hierarchy. At the same time, he said that he might well support David in the future, perhaps in six or twelve years, when the post would again be vacant. D'Angiviller may have had good reasons for denying David the post, but his explanation could hardly have been the complete one. Among the reasons for his decision must have been David's previous difficulties with officials of the Academy and his disregard for the regulations that artists were expected to observe, as well as a personality that had shown itself to be complicated and unpredictable. Writing to d'Angiviller in 1785, Cochin had said of David that "the serpent of envy hissed secretly in his heart," and he added that he could not "count on his judgment."[57] These are opinions that would have struck d'Angiviller as not altogether wrong. Both he and Cochin recognized David's genius, but as a person and academician they found him difficult. David was understandably bitter about the rejection.

In the years that followed this rejection David strengthened his ties with

liberal circles in Paris.[58] He met at the house of Mme Pourrat, wife of a rich banker, who loathed priests and was to be an enthusiastic supporter of the Fête de la Féderation in July 1790. David painted her two daughters between 1786 and 1788. His 1788 portrait of Antoine Lavoisier, the famous chemist and reformer, is further evidence of his ties to liberal circles on the eve of the Revolution. Important also is David's connection through his friends to American and English politicians, intellectuals, and artists.[59] In 1786 he received a visit from the American painter John Trumbull, a protégé of Thomas Jefferson, who was staying in Paris at the time. Both Trumbull and Jefferson were enthusiastic about David's paintings, especially the *Oath of the Horatii*. Among Jefferson's friends in Paris was the Italian patriot Filippo Mazzei, who published a four-volume work in 1788 praising America and the recognition it gave to natural rights, which he maintained that men in all countries should enjoy. Mazzei met often with David, discussing with him an ambitious artistic project of Stanislas-Augustus, the king of Poland, who wanted to commission a series of portraits of illustrious Frenchmen.[60] David met another Italian through his liberal friends, Vittorio Alfieri, who wrote a play in 1788, the *Bruto primo,* which portrayed the stern patriotism of Brutus precisely when David was working on his *Brutus and the Lictors*.[61]

The group to which David was attached most closely in the years before the Revolution was the *société Trudaine,* which met at a magnificent *hôtel* in the place Royale owned by the Trudaine brothers, Charles-Louis Trudaine de Montigny and Charles-Michel Trudaine de Sablière, sons of an intendant of finances who had been a friend of Turgot and was close to the Physiocrats. At the Trudaine gatherings David met with a cultivated, enlightened, liberal elite that included writers and intellectuals. He discussed his artistic projects with the members of this circle and was influenced by their opinions.

It was probably in 1787 that David met André Chénier in the *société Trudaine*.[62] The twenty-five-year-old poet had just returned to Paris from a trip he had taken to Italy with the Trudaine brothers, fellow students in earlier years at the Collège de Navarre. At this elite school Chénier, the son of a government contractor, had socialized with and was befriended by the sons of millionaires. In his early twenties he had tried to enter the navy but not been able to because of his birth. He joined the army instead, but did not get the expected commission and left the service. Already noted for his independent judgment, he was stung by the experience and became outspoken in his criticism of privilege. This attitude was to give form and color to the essays and poetry he wrote as a member of the Trudaine circle in 1787, when he became a close friend of David.

In works begun or written in 1786–87, "Liberty," "The Republic of Letters," "Hymn to Justice," and "Essay on the Causes and Effects of the Perfection and Decadence of the Letters and the Arts," Chénier developed his ideas on art and society in ways that were heavy with political implication. He maintained that the arts could not be healthy in an unhealthy society, and that they could not flourish in an aristocracy, in which favoritism was unavoidably present.[63] Literary associations, academies, and the protection of princes were harmful to letters and the arts;[64] only in the more open and free climate of a democracy or republic would artistic talent take full wing.[65] Under the rule of privilege and aristocratic patronage the artist had to please those he was obliged to serve and was not free to express himself and develop his talent. Only if the artist was free, only if he had artistic liberty, would he achieve his own creative potential and only then would his work benefit society. Even as Chénier criticized privilege he respected the rule of law.[66] As a political thinker he admired the British constitution, and as the advocate of a more free and open society he praised the American Revolution.

It can well be imagined how strongly Chénier's ideas would have appealed to David. The poet said that academies and the protection of princes were harmful to the arts; the artist had been a victim of academic intrigue when he exhibited his *Horatii,* and while working on the painting he decided not to follow the conditions of the royal commission: "having turned [the] composition in all ways" he saw that if he did it in the specified size "it would lose its energy." In breaking the rules he painted a picture not for the king, but for himself. Flushed with success after showing the *Horatii* David made a bid in the following year to become director of the Rome school, but his campaign ran into opposition within the Academy. Once again, he would have believed, he was the victim of academic intrigue and discrimination. Now, in 1787, as a member of the Trudaine circle, he heard from Chénier that academies damaged the arts, and that the entire system of princely and aristocratic patronage thwarted artistic liberty.[67] Chénier's pronouncement that "no one is judge of the arts but the artist himself" would have spoken directly to David and given theoretic form to the position he had reached as an artist, trying to get a painting right.[68] Beyond validating the role David had defined for himself as an artist ("Never again will anyone make me do anything detrimental to my own glory"), beyond entering a plea for artistic liberty, Chénier argued that the arts could not flourish in an unhealthy society. As a student of Montesquieu and Rousseau, Chénier worked out an idea of artistic liberty that was grounded in theoretic constructs and had at

its core a radical social critique: only in the open and free climate of democracy would the artist be free to develop his talent fully and only within such a society would the arts remain healthy.[69] These ideas would have appealed to David and given political form to the protest he had recently made as an artist. Chénier can be said to have raised David's political awareness—to have contributed to his politicization.

In the year that David's friendship with Chénier developed and in which he became a member of the Trudaine circle, 1787, he was working on the *Death of Socrates* (fig. 6). For this painting David bypassed the usual route of a royal commission in favor of a private commission: his patron was the younger of the Trudaine brothers, and it was in his circle that David worked out some of the details of the painting. Members of the circle were interested in a pantomime drama on the death of Socrates that Diderot had thought about writing and commented on in his *Traité de la poësie dramatique* (1758), but never completed. They discussed with David a passage from the proposed drama in the *Traité* that portrayed Socrates surrounded by his students, sitting on a bed and preparing to drink hemlock. In Diderot's passage Socrates held the cup in one hand and turned his eyes to heaven, but Chénier argued that the Stoic point of the episode would be more effective if "Socrates, entirely absorbed in the great thoughts he is expressing, should stretch out his hand for the cup; but should not seize it until he has finished speaking."[70] Chénier's advice concerning the gesture of Socrates is completely consistent with his artistic and political views. The Socrates who reaches for the cup of hemlock respects the rule of law but at the same time is exercising his rights as a free person. He was the victim of intolerance but would demonstrate his moral supremacy by ending his life as the citizen of a state that would no longer accept his independent views.[71]

Chénier left France at the end of 1787, frustrated over conditions there.[72] Social anger broke through repeatedly in his writings and was directed at many abuses, from the corvée, crushing taxes, and inequality of wealth to privilege and the influence of the court.[73] At the time of his departure there had already been collisions between reform-minded ministers of the king and opposition groups. France was beset by a grave fiscal crisis, the remedy of which required a restructuring of the system of taxation. The privileged would have to pay more than they had in the past, and to that end an Assembly of Notables was summoned in February 1787.[74] The members of that body would accept proposed taxes but wanted to see account books, which created an impasse. C.-A. Calonne's successor, E. C. Loménie de Brienne, tried to achieve fiscal change through the parlements, which only

shifted the ground of the dispute and led to an escalation of the conflict, which ran through 1788 and into 1789, up to the meeting of the Estates-General. It was during this period that strategies were devised and a pamphlet warfare began that contributed to the stunning events that rocked France after the assembled delegates met at Versailles.[75]

It was against this background that David painted *Brutus and the Lictors* (fig. 7). In 1787 he proposed two subjects that he was prepared to paint for the Salon of 1789. The two subjects were "Coriolanus restrained by his family from seeking revenge" or "Regulus returning from Rome to Carthage." D'Angiviller chose the Coriolanus subject, which meant that David was officially commissioned by the government to do a work that was to be shown in the Salon of 1789. There are no known drawings for a Coriolanus painting, and there is no evidence that David ever began work on the project. He did execute two drawings of the Regulus subject, but already in 1787 he began sketches for the work he exhibited in the Salon of 1789, *Brutus and the Lictors,* and for two years he was involved in that undertaking. At no point did he notify d'Angiviller of his decision to strike off on his own, and only when the work was nearing completion did news of its subject begin to leak out. David's decision can only be called a deliberate act of defiance. He did this in the very year in which he became a member of the Trudaine circle, where he heard André Chénier expound on the importance of artistic liberty. He had already struck a blow for that cause in the *Horatii* when he refused to conform to the stipulated conditions of the official commission and now, in the *Brutus,* he struck another blow for the same cause. That he chose Brutus as the subject of a painting in what was at once an act of defiance and a proclamation of liberty was not accidental. To understand why this was so it is necessary to know what Brutus, a figure of Roman history, meant to David and his contemporaries.

Robert Herbert has written that "it cannot be an accident that the maturing of Enlightenment thought on the eve of the Revolution was accompanied by a 'Brutus syndrome.'"[76] Having driven Tarquin from his throne, Brutus learned of the involvement of his sons in a royalist conspiracy, and as a magistrate the duty fell upon him to sign their death warrant and witness their execution. It was the aftermath of this event that David portrayed in his painting. Plutarch found in Brutus's action a deed that was "open alike to the highest commendation and the strongest censure"; that he "sternly watched his children suffer" could be explained by the "greatness of his virtue" or it could be regarded as "brutish."[77] About this Roman's virtue there is something fierce, extreme, and severe, and from the

time of the Renaissance on his name tended to be put forward whenever reformers challenged those in power.

In a letter to Melchior Grimm written in 1781 Diderot said, "The book that I love and that kings and their courtiers detest is the book which causes Brutuses to be born."[78] Diderot's friendship with Grimm was strained at the time, and he felt Grimm had become too much of a courtier. The letter may never have been sent, and if it was it would be hard to imagine a continuation of the friendship, so filled was it with molten rage. Diderot's political thought had taken a radical turn whereas his friend had gone in the opposite direction, a divergence that fed Diderot's anger and brought to his mind Brutus, the enemy of kings and courtiers. In another letter to Grimm, also written in 1781, Diderot commented on the contemporary political scene: "May there fall upon the heads of these infamous men and on the old imbecile [the minister J. F. P. Maurepas] whom they serve, the ignominy and the execrations which fell of old upon the heads of the Athenians who made Socrates drink the hemlock."[79] This passage shows how Diderot could identify with a scene from antiquity as his anger was stirred by contemporary issues. That mechanism is at the center of what Herbert calls the Brutus syndrome.

As with the *Horatii* David invented the scene he chose to portray in the *Brutus*. There is no historical basis for the subject of the painting; there is no account describing the lictors bringing the dead bodies of the sons into Brutus's house. As a critic wrote in 1791, the event could not have taken place because "the Romans never buried their dead inside their cities."[80] That the scene David chose for the *Brutus* issued from his own mind and imagination suggests the possibility, as with the earlier *Horatii*, of personal involvement. And it is to the *Horatii* that this work is most directly connected. Unlike the *Socrates*, which is considerably smaller at 130 by 196 centimeters, *Brutus* is nearly the same size as the *Horatii* (325 by 425 centimeters, compared with 330 by 425 centimeters). Both works portray scenes from the early history of Rome, both scenes were invented by David, both were done in defiance of official rules, and both segregate male and female figures. The *Socrates* partakes of the philosophical atmosphere and shared ideas of the *société Trudaine,* but the *Horatii* and *Brutus* are highly personal, reflecting David's own tensions and conflicts.

David's life was troubled in 1787–89, when he painted the *Brutus*. He was bitter over not getting the post in Rome, he was grief-stricken over the death of Drouais, who died in 1788 at the age of twenty-four, and he himself experienced an apparently long illness.[81] At the same time he had what must

have been heady discussions with Chénier on art and society and the importance of artistic liberty. The poet maintained that academies were harmful to the arts; that under the rule of privilege and aristocratic patronage the artist had to please those in power and was not free to develop his own talent; and that artistic talent could best take flight in the open and free climate of a democracy or republic. These ideas could only have had direct appeal to David, and must have fed his spirit of defiance. He would not paint the subject that he had proposed and d'Angiviller had accepted: he would portray Brutus instead, not Brutus swearing to defeat Tarquin and create the Republic but Brutus brooding over the deed he had both ordered and witnessed.

David's Brutus is a different kind of hero than the *Horatii* men, whose proud, upright figures catch light and whose outstretched arms suggest the brave deeds they are about to perform. Brutus, by contrast, is covered by shadow. In preparatory sketches the figure of Brutus underwent a series of changes, from a slumping, inert figure to one whose upper body is upright and whose head looks sternly outward. Initially Brutus slumped into and sat squarely in his chair (fig. 8), but in the painting he sits on the edge of the chair, pushes away the cushion with the pressure of his body, and holds his upper body upright and erect. In one drawing his left arm hangs limply at Brutus's side (fig. 9), in another it is in his lap, then the fist is clenched and in his lap (fig. 10), and finally in the painting itself his hand holds the death order. In what may be the most decisive change of all from the early sketches his feet no longer rest flatly on the floor but are arched upward from toes that grip the pedestal and send forward pressure that extends throughout the body and limbs of the grim Roman and even give force to his resolute but anguished face. While the rest of Brutus is in shadow his toes and feet, a focus of attention, catch light.

The toes of Brutus are clenched and gnarled, as if hewn from wood, and indeed they resemble the wooden base of the table which also catches rays of light that filter across the room. The same rays that pass over the base of the table also fall on the toes of Brutus's wife, who supports a collapsing daughter with one arm and reaches toward the dead body of her son with the other. Lying on the litter, that body also receives light from the corridor through which it passes. As the body is carried in feet first it is the toes that are contrasted with the outstretched hand of the mother. In passing over the body of the dead son the light shines on all four of the women and on the two chairs and table, the symbolically empty chair and the table with the sewing basket and the pair of scissors. This is the domestic world to which

the sons would never again return and from which Brutus has been separated. That he is covered by shadow underlines the fact of his separation. What further emphasizes the distance between Brutus and the women is the contrast between the geometrical order of his figure, which is organized into parallel units, and the flowing arabesques of the female figures.

As with the *Horatii* there is a separation of male and female figures, one designed according to a principle of rectilinear and the other curvilinear forms. As before, male will, resolution, and violence are contrasted with female grief, suffering, and support, the latter indicated literally by the hand of the mother that holds the daughter. The sewing basket on the table, with yarn, cloth, and scissors, materials of mending that which needs fixing, that which has been torn, underscores the role played by the women. While the mother and one daughter look at the dead son on the litter, Brutus stares directly ahead, just as his position on the chair puts him on a different axis than that of the dead son and four women, all of whom are on the same plane. From that plane he is removed by a full 90 degrees.

That David covered Brutus with darkness could have been a gamble, a calculated effort to impress audiences with his originality. There could have been another, more personal reason, bound up with his own involvement in the scene that he has portrayed.[82] When David was working on the *Brutus,* he wrote a letter to his student Wicar which is quoted at the beginning of this chapter. Several points are significant: David said that he was wretched because he was in France (he envied Wicar, who was in Italy: "Oh Florence! Florence! How far you are from Paris! You are there, so profit by it"), and he was under such pressure, such stress, that he could barely keep going.[83] Having to swim to the opposite bank like a dog thrown into the water, to use David's image, required all of his resources, all of his energy, all of his will. Given these strains, it is not difficult to imagine that David identified with the resolute hero of his painting. The shadows that fall on the grim Roman can be said to represent the troubles that beset the artist, a sense of frustration and anger to which he referred while working on the *Brutus.*

Like the *Horatii,* the *Brutus* was a receptacle for many of David's own tensions and conflicts, but in the later work a marked change took place: he portrayed a hero who grimly contemplates the terrible event that has just occurred; unlike the heroes of the *Horatii,* whose proud figures catch light, this Roman sits in darkness. These differences are consistent with changes in David's life in the four years that separate the two paintings. It is pride that comes through in the *Horatii,* but in the *Brutus* the dominant mood is one of resolution; this is a more troubled world, and it is one that reflects David's

own experience, his many quarrels with highly placed figures in the Academy, the unsuccessful effort to land the coveted post in Rome, the intrigues when he showed his paintings in the Salons, the death of Drouais, which left him without an important emotional support, and the departure of his friend André Chénier for England.[84]

Unlike the *Horatii*, the setting of *Brutus* is the Roman Republic, for which the intrepid and fierce hero made such sacrifices. Does this mean that David was a republican while painting it? The answer to that question is no, he was not a republican. Yet David had heard Chénier maintain that only in a democracy or republic could artistic liberty be fully achieved. Chénier had also said that the arts could not flourish in an unhealthy society, particularly in aristocracy, and he became so disgusted with conditions in France that he accepted a position in England and set sail from Calais to Dover in December 1787. This action does not mean that Chénier was an enemy of monarchy, but it does reveal his frustration and anger as events were beginning to unfold in France that would lead to revolution a year and a half later. David would have shared this frustration and anger and this is what entered into the *Brutus*, a painting that may be regarded as "prerevolutionary" in the sense that it was a manifestation of the ideas that had found expression in the Trudaine circle and in the added sense that it expressed the personal anger in David that helped make him a revolutionary.

David's painting prefigured much that was central to the revolutionary experience. The Brutus who made such extraordinary sacrifices did so because of unswerving loyalty to his state. There was about him something of the ideological extremist, and in this respect what he did, what David shows him to have done, anticipates much that was to happen in France within the next several years. Moreover, David's Brutus anticipates his own role as a revolutionary, signing death warrants out of a sense of virtue and to save the state from its enemies. The moral universe of the *Brutus* is Manichean, and so too would be the actual political world, that of the Revolution, in which David would become one of the actors.

For Thomas Crow the *Brutus* "would never have come to be had not David found an oppositional public to sustain his conceptual and technical audacity."[85] In this interpretation one of the keys to the painting is a popular constituency that gave David crucial support in his struggle with the Academy and more generally with the art establishment. Crow has mustered such compelling evidence and built his case so carefully, more so in his book than in his 1978 article, that his conclusions cannot be denied. His argument is brilliant and rests upon exhaustive and rigorous scholarship. Moreover, by

using the "prerevolutionary" concept he is alert to the changes within French society and culture that anticipated the political explosion of 1789. In the radical critics Crow has identified alienated, politicized writers who dealt verbal blows against the ancien régime in its final months and years—and who were ardent champions of the art of David.

It has been argued here that David also found support from his own friends, the members of his own social world, one that was highly political. François Furet, in one of the more probing recent studies of the Revolution, *Penser la Révolution française,* sheds light on the social world to which David belonged.[86] One of the key concepts of Furet's book is revolutionary consciousness, a crystallization of which he maintains took place in 1789 when the battles over elections to the Estates-General were being waged. But he argues that the elements of revolutionary consciousness were present within the society and culture of France before the moment of crystallization, during the decades of the 1770s and 1780s. He chose to examine the germs of revolutionary consciousness in the 1770s and 1780s in the neglected and much abused work of a Catholic historian of the early twentieth century, Augustin Cochin, whose study of *sociétés de pensée* traced the formation of a new type of political sociability.[87] Into these *sociétés*—philosophical societies, Masonic lodges, literary circles, academies, and patriotic and cultural clubs—flowed the ideas of the Enlightenment, and from them came public opinion, an imaginary substitute for the power that was legally embodied within the monarchical state.

This was the world in which David lived in the years before the Revolution. It was here that David, a highly successful but also difficult and contentious artist, heard arguments about art and society and artistic liberty which gave conceptual form to his struggles within the Academy. The insights he gleaned from conversations with Chénier in the cultivated gatherings of the *société Trudaine* emboldened him and made him even more difficult and contentious; what had been the defiance of an artist who objected to academic rules became something more, a struggle for artistic liberty. In the process, David became more angry and more frustrated—even physically ill. Into *Brutus and the Lictors,* a work that went to the Salon after the political explosions of July 1789, passed the anger, the frustration, and the politicized attitudes that David had acquired in the period just before the Revolution. David inhabited a world in which revolutionary consciousness was in the making, and this painting captures, as does no other painting, the stresses and strains of that world.

2 *David*

AND THE TWO FRENCH REVOLUTIONS

It is on the subject of Mademoiselle your daughter [that I write]. You know that I have had girl [students] staying with me and that the elder of the two sisters is very advanced [in her art]. The idea has occurred to me that Mademoiselle your daughter could stay with them [the two female students already working with him]. . . . I propose to you that your daughter stay with these girls [in the] faubourg Saint-Martin, hôtel des arts, with very honest daughters whose parents are deputies, the father of the municipality of Paris and the uncle of the National Assembly.
—December 3, 1789, letter from David to Mme Huin[1]

The virtuous artists of whom I have spoken are Fragonard and [J.-F.] Taillasson, the one from Marseilles, the other from Bordeaux. The first is well known by his talents, but what one might not know is that his manners and morals are those of a respectable family. I have spoken to you before of his paintings, comparing them to the simple and patriarchal morals of our forefathers. The second [artist], a bachelor of forty-six, a student as I was of M. Vien, never thought of money and is poor, reduced to living in a small corner of the Louvre; it is there, in this garret, that he does his paintings.
—October 24, 1792, letter from David to J. M. Roland[2]

I demand that you assassinate me. I also am a virtuous man . . . liberty will triumph.
—April 3, 1793, from Thomé de Gamond, *Vie de David*[3]

And you, infamous oppressors of the earth; you who give your speech to one who created liberty, pretending to have from him the right to govern the world, where are your heroes? . . . Compare our young Republicans to these vile courtiers raised in the milieu of the court, in the cauldron of sensual pleasures, these effeminate Sybarites whose corrupted soul does not merit the idea of virtue and whose weak arms are only charged with the lewd wages of their adulterous love.
—July 11, 1794, from David's report to the Convention[4]

*D*AVID had to defend himself to d'Angiviller in 1787 for the arrangements he had made for three female students. These women, he wrote, were really students of Mme Vigée-Lebrun, and were "absolutely separated from the atelier of my students," with whom they could have no communication. The morals of the women students were "irreproachable" and the reputation of their parents was "established in the most honorable manner." While he agreed with d'Angiviller that nothing "contrary to decency" could be allowed in the Louvre, in the matter of these students there was no impropriety whatsoever. He well knew that honor was "dear to a sex of which it is the principal ornament, and I have been scrupulously dutiful in telling you the truth."[5]

Two years later, in December 1789—in the first of the preceding quotations—David again explains arrangements he had made for female students, this time to the mother of a student. That so many explanations and justifications were needed indicates the obstacles faced by female artists, and that David went to such efforts suggests a special concern on his part. As in the earlier remarks to d'Angiviller he assured the young artist's mother that there would be no trace of impropriety: her daughter would stay in a home with "very honest daughters" whose fathers were deputies.

Three years later, in October 1792—in the second of the above quotations—David again helped other artists, only now the circumstances are strikingly different. Here he comes to the assistance of two older artists, aged sixty-two and forty-six, and addresses J. M. Roland, one of the most powerful figures in the revolutionary government. The artists whose causes he espouses have been forgotten, he says, but they still have one friend and it is he who appeals to a "virtuous minister" for help in their hour of need. One of the artists, Fragonard, had given David support when he was a student, but styles had changed, the superb canvases of the rococo master were no longer popular, and it was David, now the leading revolutionary artist, who remembered the past favor. Just eight days earlier David had appealed to Roland on behalf of Mme Julliard, the seventy-six-year-old widow of an artist who was left with only 229 livres and was about to be expelled from her lodging in the Gobelins. In the following year, 1793, David visited the children of Louis XVI and Marie Antoinette, the dauphin and his sister Marie Thérèse Charlotte, in what he called a "sad commission." He was appalled at the "abominable tissue of lies" he heard from the mouth of the dauphin, who had been corrupted by his jailors. David was genuinely moved by the sight of the "unhappy child," and he was touched by the concern of the sister toward her brother.[6]

We encounter a different David in the final two quotations. In that of April 3, 1793, he responds to charges made in the Convention against Marat: "I demand that you assassinate me. I also am a virtuous man." If David was virtuous in the support he gave to artists, artist's widows, and those who were threatened by or victims of the Revolution, his virtue bore a different stamp in this intense moment when he sprang to the defense of the self-styled "friend of the people." There is something unbalanced and hysterical about this David, something of the extremist, and it is this David that we encounter again in the last quotation. This passage is taken from a long, rambling report of July 11, 1794, which David made to the National Convention about a festival he was organizing for two youthful martyrs of the Revolution, Joseph Bara and Agricol Viala. The counterrevolutionaries responsible for the death of Bara and Viala were "oppressors of the earth," and on their side of the moral fence were "vile courtiers raised in the milieu of the court," "effeminate Sybarites whose corrupted soul does not merit the idea of virtue."[7] In David's overheated rhetoric, in his intemperate and tendentious moralizing, virtue was the exclusive monopoly of one party, his party, and those of the other party were vicious and corrupt. "Democracy takes counsel only from nature," he wrote, while "despotism attenuates and corrupts public opinion. . . . It proscribes without care all of the virtues and to assure its empire is preceded by terror and envelopes itself with fanaticism and wears the hat of ignorance. Everywhere squinting and perfidious treason follows it, and death and devastation. . . . It meditates its crime in darkness and forges the chains of its unfortunate victims, from whom it sucks blood. Ingenious in tormenting [its victims], it builds Bastilles; in its moments of leisure it invents torments and feasts its eyes on the scene of cadavers immolated by its fury."[8] He calls upon a vengeful god to spare only "women, children and the homeless aged; spare only the house of the humble and poor, and let the entire world repeat with us: Peace to the *chaumières*! Death to all tyrants!"[9]

In these quotations we encounter two Davids, just as we did in the previous chapter. Here we have a David who is by turns solicitous and accusatory; there we found a person who was both lenient and combative. The argument in this chapter is that the David of the Revolution, now sympathetic, now hostile, can only be understood if these two elements of his experience are linked. And so we return to the earlier David, the successful and acclaimed but also difficult and contentious artist of pre-revolutionary France. Michael Levey, like Anita Brookner, finds deep emotional divisions within David. For Levey what is central to David's "divided

nature" was tension between reason and passion. If the tension created great art, it is an art that Levey finds distasteful because of its violence and the Nietzschean morality in which it was grounded. He writes that "action, bloodshed, the old French bugbear of *la gloire*, all these were rising to the surface again as concepts well before the Revolution." The "urge towards the blacker, baser side of human nature" that is present in Diderot's writings Levey also finds in the art of David. The result is the violence of the *Horatii* and even more that of the *Brutus*, whose "decapitated corpse," Levey writes, "is slowly entering—for ever—the picture."[10]

For the Salon of 1789 David intended to show two other recently completed works beside *Brutus and the Lictors*, both privately commissioned. One was the superb portrait *M. and Mme Lavoisier* (fig. 11) and the other was *Paris and Helen* (fig. 12). These works belong to a different realm of feeling than the *Brutus*. The *Lavoisier* portrait shows the celebrated chemist, an acquaintance of the Trudaine brothers, seated at a table and surrounded by scientific instruments. His wife stands at his side and leans on his shoulder, but she does not look at him. Rather, she looks straight ahead, as if her gaze were directed at some person who was witness to the marital scene. Could that person have been David? Could this have been an intentional part of the painting's content, not just a conventional pose? What suggests the possibility of such a reading of the work is the drawing album, neatly tied shut, on the chair behind Mme Lavoisier. She had been an artist, a pupil of David, but gave up her studies when she married so she could illustrate her husband's experiments. While the album is shut and behind her, Lavoisier is seen in the midst of his scientific apparatus and with a pen in hand he is writing: she has joined him in his world. The expression on her face is wistful, suggesting a sense of loss over giving up her artistic studies, and she wears this expression in the presence of her former teacher, known for his support of female artists. It would not be fanciful, given that fact, to see an element of sympathy in the painting, compassion on the part of the artist toward the former student. This element of the painting would be a subtext, however. What is most apparent is the sympathy between husband and wife as she bends to lean on his shoulder and he turns away from his work to look at her.

As different in subject as *Paris and Helen* is from the *Lavoisier* portrait it is strikingly similar compositionally. In both paintings the standing female figure leans on the shoulder of the seated male, and in both the male's head is turned in the same direction. A sense of intimacy pervades both works, but *Paris and Helen* is more erotic; here David has portrayed not husband and

wife but two lovers. Paris is nude, and Helen's sumptuous body is made all
the more provocative by the clothing, done in the Hellenistic style, which
clings to her breast and emphasizes her curves. Behind the lovers is a bed and
behind it are bas relief figures in amorous embrace. As if these details were
not sufficient to invest the painting with erotic content the four spouts of
water in the fountain in the foreground offer the most obvious of sexual
metaphors.[11] To the left of the lovers is a column surmounted by a statue of
Aphrodite, on which Paris's quiver of arrows is hung.[12]

The contrast between the *Lavoisier* portrait and *Paris and Helen* on the one
hand and the terrifying *Brutus and the Lictors* on the other could hardly be
more striking. In compositional terms the husband and wife and mythologi-
cal lovers of the former two paintings occupy the center of the pictorial
space, and the figures are linked by a complex series of lines whose intercon-
nections bind them together. In *Brutus* the male and female figures occupy
different parts of the pictorial space and they are ethically separate: the male
world is one of Stoicism, stern patriotism, and grim and bloody deeds, while
the female world is one of grief and sorrow.

How David approached these three works was clearly influenced by the
circumstances under which they were commissioned. In the *Lavoisier* por-
trait he painted a husband and wife, but in a way that suggests empathy for
the wife, a former student. At the same time he invested the work with an
intimacy and tenderness fully appropriate to the subject. If there is both a
text and subtext in the *Lavoisier* portrait the same may be true of *Paris and
Helen*. The comte d'Artois, who commissioned the work, was a notorious
rake and womanizer, much as was the Paris of David's painting. David did the
work when he was hostile to the court, which has led to speculation that the
painting can be seen as an ironic statement about the patron.[13] If this is so—
if this is the subtext—what is most obvious about the main text is the warmth
between the lovers, which David captured superbly.

The patriotism and self-sacrifice, the performance of tragic deeds for the
public good, lent timeliness to the *Brutus* and made it the hit of the 1789
Salon. By contrast, the reception of *Paris and Helen* was not favorable: it was
deemed "not very impressive," the attitudes of the figures were "cold and
unanimated," it was Corneille reduced to the rank of Philippe Quinault, a
lesser seventeenth-century dramatist, and so forth.[14] Suffering from the
inevitable comparisons with the *Brutus*, *Paris and Helen* has never been one
of David's more popular paintings, and it has always been something of a
puzzle. Yet, *Paris and Helen* belongs very much to a stylistic current that
passes through David's art from the beginning to the end of his career, what

he was later to call the Grecian as opposed to the Roman style.[15] Paintings done in the Grecian style emphasized the refined and exquisite, and often portrayed love scenes. These qualities, along with delicacy of feeling and compassion, come through also in the *Lavoisier* portrait, a work that reveals the sympathetic side of David. Whereas the *Brutus* was a receptacle for David's frustrations and anger, the other paintings, the *Lavoisier* portrait and *Paris and Helen*, done at the same time, are repositories for different emotions.

If there were two Davids there were also two revolutions. The Revolution of 1789 gave birth to a new nation, one that was no longer to be hierarchical and stratified but unified.[16] In the months of July and August popular movements swept away the ancien régime. This was done with minimal violence and it was given the sanction of law on the night of August 4. As the definitive decree announced, "The National Assembly destroys the feudal regime *entirely*."[17] Everything old and antiquated was to be abolished; gone was the rule of privilege that lavished immense favor on the few at the expense of the many. The document that best sums up the sense of renewal that accompanied the stirring events of 1789 is the Declaration of the Rights of Man and Citizen, which the National Assembly began to discuss on August 12 and was provisionally adopted on August 26: "Men are born and remain free and equal in rights"; "The aim of all political association is to preserve the natural and imprescriptable rights of man"; "The principle of all sovereignty rests essentially in the Nation."[18]

The Revolution of 1792 was strikingly different. After months of mounting pressure an angry crowd stormed the Tuileries on August 10 and butchered the Swiss guards. The king and queen, who had fled to the Manège, were subsequently imprisoned in the Temple. These events, the result of political fear and anger, unleashed a wave of violence in September that convulsed Paris, France, and all of Europe. Out of these tremors came a political struggle within the Convention that led to the destruction of those who opposed the ultimate victors, the Jacobins. It was the Jacobins who presided over the Reign of Terror, the official policy by which the Revolution was to be cleansed of its enemies. During the trial of Louis XVI, Louis Antoine Saint-Just forged a new vocabulary and rhetorical style, the terse "style guillotine," as Albert Camus has described it.[19] The execution of the king was not only a political event of the most far-reaching consequences but one that went against the spirit of generosity on which the Revolution had prided itself in less troubled times. Saint-Just's rhetoric cut through the legal knots interfering with the king's execution and it argued for the necessity of that deed. The people, who put the king on trial, were

innocent by definition. What logically followed from this premise was the conclusion that the people's enemies were guilty. As Saint-Just said to the Convention, "Defenders of the king, what do you want for him? If he is innocent, *le peuple* is guilty."[20]

Saint-Just's case against Louis XVI reveals a dualism between the people and its enemies, between good and evil, which would become more pronounced as the Revolution entered its most radical stage. During the king's trial rhetoric intensified as the enemy, Louis XVI in this case, became the object of virtuous scorn. It was Camille Desmoulins who said, "You know very well that there is only one man whom the true Republican cannot regard as a man [but] a two-legged cannibal, and that enemy beast is a king."[21] And as Robespierre proclaimed, "Have not all nations until now been granted the right to strike tyrants down, and has not the admiration of the centuries put such courageous acts on the level of the most sublime characteristics of virtue?"[22] Many believed that the execution of Louis XVI would bring peace to a divided nation, but in fact the opposite happened. Divisions and conflict went deeper than ever, and those who spoke for the people became ever more vigilant in their efforts to crush the enemies of the Revolution. Already in 1792 Robespierre had said that "the nation [was] divided into two parties, the royalists and the defenders of the people's cause," but with each successive purification the line between the people and its enemies became sharper.[23] If the people were the epitome of virtue, virtue was increasingly equated with terror.

Conceptually fundamental to the Revolution of 1789 was the nation. The key symbolic political event was the transformation of the Estates-General into a National Assembly, achieved when the king accepted the demands of the Tennis Court Oath. Delegates no longer sat as members of estates that divided them into legally separate orders, but as members of the nation. Out of this event came the ideals of unity and harmony; all of the people should become a whole. In October 1789 women marched on Versailles and, buttressed by forces of the National Guard, they brought Louis XVI and Marie Antoinette to Paris so they would be amongst the people. A contemporary said of the patriotic deed that it was "associated with dawning Liberty . . . Liberty is going to create . . . a new society and new models."[24]

Among the models for a new society was one that redefined the position of women. The century of the Enlightenment had been an age of incipient feminism, and with the sudden changes of the French Revolution, ideas passed from the phase of gestation to full articulation.[25] Advocates of women's rights, both from France and foreign countries, appealed to the

Assembly and then to the Convention to include women in the great changes of the Revolution. The subservience of women was decried and the legal disabilities to which they had been subject, it was said, should be removed. Since the Revolution had declared the rights of man it was logical for feminists to decree the rights of women, and Olympe de Gouges did so in 1791, a year before Mary Wollstonecraft published the *Vindication of the Rights of Women*. Among those supporting the cause of women were male publicists and public figures, such as the marquis de Condorcet. Moreover, women became actively involved in the leading political clubs and even founded some of their own. Consistent with this type of involvement was women's attendance at meetings of the Assembly and the Convention.

From the beginning there was opposition to the claims advanced by advocates of women's rights and to their involvement in public events. How the lines could be drawn is suggested by the role women wanted to play in public festivals. Could they swear the civic oath in the Fêtes de la Fédération in 1790? In some towns women were allowed to participate in the symbolic expression of national unity but in others they were barred. The same problem arose in the festivals of 1791 and with the same results. It was after the upheavals of August and September 1792 that the position of women in the Revolution underwent a marked change. Opposition to their involvement increased in 1793, and the Jacobin Club in Paris was one of the centers of male reaction.

Jacobin ideas of virtue were Spartan and male. In Saint-Just's ideal state, children were given over to the state. Boys and girls were segregated and at age five boys went to "schools in the country," where they were subjected to strict discipline, slept on mats, and ate abstemiously. They were to be "trained for laconism." After age ten, several subsequent stages of development were carefully worked out, with emphasis on military training and specialized education in farming and manufacturing. In contrast to the detailed educational program for boys was a brief, two-sentence discussion of girls. "Girls are raised in the home," and "on holidays a virgin over the age of ten may not appear in public without her mother, father, or tutor."[26] Louis Michel Lepelletier de Saint-Fargeau, another Jacobin, advocated a similar program. Virtue for the Jacobins was intensely public, and it was to be developed by the state. The result would be a male citizenry whose training and discipline prepared it for the public functions it exercised exclusively. Within such a program as this the position of women was passive; in the strictest sense of the word they were not to be heard.

The political role of women was discussed in meetings of the Jacobin

Club, and by the fall of 1793 a full-scale campaign was mounted that culmi-
nated in the abolition by the Convention of all women's clubs. In October
J. B. André Amar raised three questions in a meeting of the Committee of
General Security: "(1) Must assemblages of women meeting in popular
societies be permitted? (2) Can women exercise political rights and take an
active part in government affairs? and (3) Can they deliberate in political or
popular gatherings?"[27] The Committee of General Security said no to each
of these questions. The final blow against women came in 1795 when they
were barred from attending meetings of the Convention.

It has been argued that "the most important reason for the almost total
failure of Revolutionary feminism was its narrow base."[28] This is undoubt-
edly correct, but it does not explain the dynamics of change. Why did the
feminist cause enjoy a period of modest, partial success from 1789 to 1792,
and why was 1793 a year of sharp reaction? To answer that question it is useful
to go back to October 1789, when women marched on Versailles after
opponents of the Revolution had abused the revolutionary tricolor. Those
women identified with the Revolution and shared in the enthusiasm for the
"dawning liberty" of the new age. Out of the great changes in France would
come "a new society and new models," and within these configurations the
position of women was not to be the same. Central to such hopes and
aspirations was belief in a France that would be more unified and coherent
because of the inclusion of women. This was a hope, a dream, a vision that
should be seen within the context of a particular historical moment; it was
born of the events of 1789 and partook of the emotional climate of that time.

The revolutionary feminist movement that grew out of this vision was
unable to survive the pressures and conflicts after the events of August and
September 1792. With those events came a new phase of the Revolution and
new models. If liberty inspired unity in the earlier model of the 1789
Revolution, virtue could only be achieved through terror in the polarized
France that emerged from the Revolution of 1792. If optimism was at the
center of the earlier model, fear was at the core of the later model. One model
was unified and provided space for women whereas the other was divided
and excluded women.

What impact did the two French revolutions have on David? He was still
working on his *Brutus* when Paris was rent by the explosive events of July
1789. When he sent *Brutus* to the Salon in August it was another sensational
success, all the more so because of political conditions when it was shown.
The themes associated with David's painting, a corrupt court, sexual scan-
dal, the tyrannical power of kings, emasculation of the Senate, and aristo-
cratic plots against the government, were reenacted in Paris (with the

Estates-General taking the place of the Senate) in the months just before the work was finished and put on exhibit. Brutus was to occupy a central position in the pantheon of revolutionary heroes, and David, the artist who portrayed him so superbly on canvas, contributed to the force of his appeal. If David's painting helped the French to find contemporary meaning in Brutus, so did the importance of that Roman to the Revolution make David appear as something of a prophet. Not only did his last great prerevolutionary painting portray a figure that the Revolution would idealize, but the moral issues it presented seemed pertinent to France of 1789. David experienced sensational successes in earlier Salons, but *Brutus* had a deeper impact than previous paintings.

Even before David sent his *Brutus* to the Salon it created controversy. The events of July were responsible for the departure of d'Angiviller for Spain at the end of the month, and during his absence Charles-Etienne-Gabriel Cuvillier of the Royal Fine Arts office wrote a letter to Vien, now president of the Academy, expressing uneasiness about the showing of David's *Brutus*. News of Cuvillier's letter leaked out, and within two days charges of suppression were leveled against those who would have prevented David from exhibiting his latest painting. In the days that followed charges and countercharges were hurled back and forth in the press.

It was in this climate that a pamphlet appeared, the *Voeu des Artistes*, published in September 1789, by younger artists who set forth a series of demands. These artists called for the posthumous admission of Drouais to the Academy (David's student who had died in Rome in 1788 at the age of twenty-four). This was also one of David's most deeply felt wishes. The pamphlet went beyond a plea for Drouais's admission to the Academy; it also contained criticism of the academic teaching program and the power of professors over students. Officials of the Academy took a firm line against the *Voeu* in a rebuttal published in the *Journal de Paris* on September 17. Some concessions were made to the dissident students, but there was no yielding on the question of a posthumous exhibit for Drouais. David himself now took up the cudgel in a meeting of the Academy on October 3, in which he demanded that Drouais be given a posthumous exhibit. Pierre had ruled against the request on the grounds that because Drouais had not been *agréé* he was not entitled to have his works shown, and exhibiting them, even posthumously, would directly defy the rules of the Academy. In the stormy meeting of October 3, Vien, with whom David had gone out of his way to remain on favorable terms, took the same position as Pierre, which resulted in a violent argument between David and his opponents.

In December David, heading a group of some twenty academicians, led an

all-out attack on the Academy, demanding that its statutes be revised and that *commissaires* be elected who would draw up a new constitution according to procedures that would make members of all three classes eligible for office. Clearly the intent was to democraticize the Academy, a goal that partook of the spirit of change at this stage of the Revolution. A committee was formed on March 6 to reform the Academy's statutes, but David was not on it, nor were the lowly *agréés,* whose cause he championed. David now pursued different tactics in his continuing struggle with the Academy. On July 20, 1790, he led a deputation that appeared before the Constituent Assembly and delivered a speech that was well received by Lepelletier, who gave instructions for it to be printed. In this address, the *Mémoire sur l'Académie royale de peinture,* David claimed that the Academy was incompatible with the new spirit of reason and the Constitution, and he called for the formation of a new body, a Commune of the Arts. From this time on David would deliver repeated blows against the organization that had played such a crucial role in his development as an artist. His campaign against the Academy met with marked success. The Assembly instructed the Academy to revise its statutes in August 1790, and when new regulations were drawn up they followed David's pedagogic principles, although they did not make the *agréés* eligible for office. David formed a new organization on September 27, the Commune of the Arts, which embodied his democratic principles. At this stage—September of 1790—David had been instrumental in the reform of the Academy and he stood at the head of a rival body of artists. His final victory would come in August 1793 when he presided over the dissolution of the Academy. By that time his own position had changed profoundly; so too had conditions within France.

What is important to understanding the impact of the first French Revolution on David is his struggle with the Academy in the thirteen-month period between August 1789 and September 1790. It was then that David's earlier conflict with the Academy entered a new stage. Previously he had been the angry outsider who identified closely with his own students. Now, thanks to the Revolution, he led dissident artists in a political struggle against the Academy. He appealed to the Assembly in that struggle and secured its support. The Academy was made to overhaul its statutes. In the often bitter exchanges of words and in the campaign waged in the public press he was the leader of artists who called for democratic reform. Moreover, he was the champion of the lowly *agréés.* Even though David's position was controversial it was a position that gave him greater stature.

While he was occupied by his struggle with the Academy David received a

commission from the city of Nantes in December 1789 to paint the patriotic mayor, C. C. Danyel de Kervegan. He went to that city in March 1790 and remained there until the end of April, receiving constant attention and acclaim during the period of his visit. He was officially received on March 26, 1790, and when it was his turn to make a statement he said, "My art has never offered me such opportunities for success, and never have I had the happiness of combining motives to glorify myself. I am making it my duty to answer the noble and patriotic invitations and the recognition that will consecrate the history of the most happy and the most astonishing revolution."[29]

Like all of his liberal friends David welcomed a revolution that offered hope of a better future for the nation, but now his stock as an artist also climbed sharply. He was feted as never before, and it was the trip to Nantes, where he had an unprecedented opportunity to glorify himself through his art by putting it in the service of a "most happy and most astonishing revolution," that contributed to the idea to paint the *Tennis Court Oath* (fig. 13). Here or in Paris after his return is where he first conceived of painting one of the most important events of the French Revolution, the celebrated oath of June 20, 1789, taken by deputies of the Estates-General in a royal tennis court at the Palace of Versailles. The probable catalyst for that artistic project was a work that David was to have done for Nantes but never executed, an allegorical painting that would have commemorated the role of Nantes in the events that preceded the Revolution. This was a genre of art for which David's talent was not well suited, and the project never went beyond a few sketches.[30] In the same notebook he used for those sketches he began his first studies for the *Tennis Court Oath*: rather than commemorate recent events through the time-honored medium of allegory he would become a painter of contemporary history.

Once David began making sketches for the new project in his Versailles Sketchbook, he never returned to the allegorical work. After the remaining sheets were covered with drawings, he jotted down ideas that he would incorporate into the finished work: "remember to show the deputies moved to tears and holding their hands to their eyes"; "remember the dust that the movement of the action must have raised"; "some [delegates are] serious and frowning, some laughing as if filled with delight, some respectful, some looking fiercely patriotic"; "Mirabeau, great energy, strength, vehemence, [Emmanuel] Sieyès, depth, [Antoine] Barnave, calm."[31] After filling up the sheets of the Versailles Sketchbook David made additional sketches in another sketchbook, the Louvre Sketchbook, besides doing other studies on

individual sheets of paper. All of this work preceded the final study that David completed in May 1791 and showed in his studio at the end of that month before he put it on display in the Salon.

Because David was not at the historic event of June 20, he traveled to Versailles while he was doing the preparatory sketches and made a drawing of the tennis court. When that sketch (fol. 33 in the Versailles Sketchbook, fig. 14) is compared with the final study of 1791 it is evident that David used artistic license in lowering the walls and ceiling to give greater prominence to the figures swearing the oath. This is but one of several liberties he took in designing the *Tennis Court Oath*. An engraving "executed on the spot by Flouest" shows the delegates as they presumably stood on the floor of the tennis court (fig. 15). Jean Bailly stands on a table in the center of the room with delegates separated into two groups on opposite sides of the table. Observers at the rear look down at the scene from a gallery that runs along the length of the tennis court. In David's design the delegates stand not along the length but across the width of the building and the observers are seen in galleries on both sides. Bailly's table has been brought forward and the delegates are no longer broken into two groups but are a completely unified mass. All of these changes heighten the drama of the event and underline the theme of unity which clearly was at the heart of David's conception. In another artistic decision that contributed to the sense of historic importance David wished to impart to the oath taking, the delegates have been brought to the front of the pictorial space, thereby making them individually identifiable.

In depicting the oath that would result in a National Assembly—in the creation of a new France—the unity of all who participated in the event was the key to its historical significance, and unity is what gives the design its form and structure. Thus, just below Bailly, the central figure, are dom Gerle (who was not there), abbé Grégoire, and Rabaut Saint-Etienne (fig. 16), representatives of the secular clergy, the regular clergy, and Protestantism, whose fraternal embrace (and compositional symmetry) symbolize the creation of a new society, free of former divisions. This gesture is repeated by A.-A.-M. Thibault and Jean François Reubell (fig. 17), two figures on the left, who also clasp one another fraternally. Only Martin Dauch (fig. 18), the one deputy who did not take the oath, seated on the far right, does not share in the unity: he does not hold his arms outward but clutches them to his chest, and his drawn legs are diagonal to the legs of the standing delegates, a visual dissonance in keeping with his role in the event.

Above the morally and politically unified delegates in galleries on both

sides of the tennis court, people are crowded together looking down at the historic moment being enacted below them. Among the spectators are soldiers who raise their swords, as if they joined in the oath taking, reinforcing the theme of unity but at the same time giving a hint of menace to the scene: were the king to order the military to expel the delegates from the tennis court they occupied in defiance of royal directives, the delegates would be defenseless. Also, soldiers with muskets can be seen under the canopy on the left of the tennis court. The menacing forces confronting the delegates are expressed by the armed soldiers, but other, more powerful forces also assure victory. An allegorical gust of wind driven by an electric storm blows the curtains into the room and turns an umbrella inside out. Behind the curtains a bolt of lightning flashes through the sky against the backdrop of the royal chapel, a symbol of monarchical power and the divine right of kings. The curtain that is blown into the room breaks in upon the ordered geometrical space of the royal tennis court that is the seat of a new nation.

David did not limit himself to work on the *Tennis Court Oath* from the time of the first sketches in Nantes in March 1790 to completion of the final study in May 1791. This was one of the busiest and most productive periods of his artistic life. Besides the enormous amount of work that went into the *Tennis Court Oath* and the unfinished work for the city of Nantes, he is known to have painted five portraits in 1790. These portraits have not received the attention they deserve, although connoisseurs have long recognized them for the superb paintings they assuredly are. The very fact that these works are portraits has diminished their importance in studies that emphasize David's idea paintings and trace his development as a political artist. Yet the portraits are important not only for their artistic worth but also because of the light they shed on David's political involvements.

The five portraits David painted in 1790 are *Mme d'Orvilliers, Mme de Sorcy-Thélusson, Mme Hoquart de Turtot* (lost), *Mme Lecolteux* (lost), and *M. Sériziat.* Of all his portraits none exhibit greater technical mastery and none convey a fuller sense of calm and repose than do the portraits of *Mme d'Orvilliers* (fig. 19) and *Mme de Sorcy-Thélusson* (fig. 20). The subjects of these two portraits, the former Rillet sisters, are different in appearance, and as psychological portrayals quite different persons emerge from the canvases. At the same time there are obvious compositional similarities. In these works David has developed a new type of portrait in which the figure is cut off above the knee and the subject is seen against a neutral background. That background and the play of light on the seated figure brings out the living

presence of the subject. What comes through in these paintings is the composure of the two women, who are completely at ease in their surroundings. Within the world they inhabit there is not a suggestion of trouble.

The other extant 1790 portrait is David's painting of his brother-in-law, *M. Sériziat* (fig. 21). This oval painting is considerably smaller than the portraits of the two sisters (which are 131 by 98 centimeters; this one is 55 by 46 centimeters). Its brushwork is sketchy in contrast to the polished technique of the *Mme d'Orvilliers* and *Mme de Sorcy-Thélusson* portraits. Despite differences in size, shape, and technique, it shares a sense of privacy with the other two works. The Sériziat of this painting, a friend as well as a relative of David, is fine of feature, agreeable in his smile, and obviously a man of taste. There is even something exquisite about him, and nothing of the heroic, strident male. This intimate painting shares the same climate of feeling as the other portraits done in the same year.

As a portrait painter David responded in various ways to his sitters. Toward some he is neutral, almost indifferent, rendering a likeness of the person on canvas, nothing more and nothing less. Some sitters appear to be peering at him, as if he were the object of their attention—or their scrutiny. In other portraits it is David who scrutinizes his subjects and with his brush captures a psychological portrayal. In the three extant portraits of 1790, what comes through in each work is the person's composure. These sitters reveal not the least trace of tension or conflict; each is at peace within a world that is inwardly calm; and David himself seems to have been comfortable in the presence of his sitters.

In almost all obvious ways the 1790 portraits stand apart from the *Tennis Court Oath*: among the polarities between these works are private-public, domestic-political, intimate-heroic, and predominantly female (four of the five portraits are of women) and predominantly male (only a few female spectators stand on the upper left balcony of the *Tennis Court Oath*). Yet all of these works issue from a common wellspring, the positive circumstances in David's own life which resulted from the artistic successes and public acclaim that he enjoyed after the Salon of 1789.

David's newly gained recognition was bound up with the Revolution. The great political changes in France gave timeliness to his art, and made him appear as something of a prophet of the new age. He immediately became the leader of dissident students, a position that could only have added to his own sense of stature. Moreover, he received commissions from Nantes to paint its patriotic mayor and to portray the city's role in the events leading up to the Revolution. Given these changes it is small wonder that David, while

in Nantes, praised the "most happy and most astonishing revolution." It was an event that ushered in a new era for France, and it profoundly altered his own position as an artist. Out of the optimism of his altered circumstances came the positive and harmonizing impulses that found their way into all of his works in 1790, both the heroic, political, public *Oath of the Horatii* and the private, domestic portraits.

David's *Self-Portrait* (fig. 22) of 1791 shows a furrowed brow and a troubled expression; with disheveled hair and a "haunted intensity of . . . gaze" (Schnapper's phrase) he does not appear to be at peace with his world.[32] That world was more disturbed than it had been in the previous year. As George Rudé has commented, 1790 was "a period of remarkable social calm," but that was no longer true in 1791.[33] The revolutionary festivals that were held on July 14 in 1790 and 1791 are an index of the mounting pressures within France. Some 12,000 workers prepared the 1790 Fête de la Fédération, in which 400,000 men, women, and children participated. This was a day of parades, oath taking, and singing on the champ de Mars, and in the evening there was dancing on the site of the Bastille, a symbol of the fallen order. Bells were rung not only in Paris but in towns everywhere, and people from all of France flocked to the capital for the patriotic celebration. In Mona Ozouf's words, this, the first of the great revolutionary festivals, "was presented as an end. The speeches delivered on the occasion made this abundantly clear: the festival 'completes the edifice of our liberty.' It puts 'the final seal on the most memorable of revolutions.' "[34]

The sense of completion that marked the 1790 festival was decidedly not present in the following year. Less than a month before people gathered to celebrate the 1791 Fête de la Fédération Louis XVI had tried to escape from France. On the night of June 20 the king, the queen, and their entourage slipped out of the Tuileries and out of Paris, but just before making their way across the frontier they were captured at Varennes. The tortuous ride back to Paris ended on June 25. The Assembly had to decide what to do with a king who not only tried to escape from the nation, but left behind a letter disavowing the measures he had approved during his "captivity." While the king's royal functions were provisionally suspended on June 26, the Assembly needed a monarch in order to put into effect the constitution that it had been working on and which was nearing completion. It was against this background, on July 14, the day of the Fête de la Fédération, that the Cordeliers Club presented a petition to the Assembly calling for a plebiscite on the troubled question of the king. The Assembly refused to accept the petition, and on the next day another petition was presented to the Assem-

bly, and again the document was carried out of the Manège, the Assembly's
meeting place. The following day, July 16, yet another petition was read
aloud from the altar in the champ de Mars, the center of the July 14 festival. It
was now demanded that "the National Assembly shall accept in the name of
the nation Louis XVI's abdication on June 21. . . ." Still another petition
was prepared on the following day, July 17, and some 6,000 signatures were
collected, from ordinary Frenchmen and Frenchwomen as well as from
important and influential leaders. The Assembly was angered and the
municipality feared trouble. Bailly, the mayor of Paris, imposed martial law,
and after disturbances were reported he ordered the red flag of authority—it
was not yet the flag of revolt—to be raised. That evening, at about half past
seven, when most of the crowd was leaving the champ de Mars, there were
cries of "Down with the red flag!" Some stones were thrown and perhaps
there were a few pistol shots. The guards fired over the crowd and when it
did not disperse they fired into its midst. Twelve were killed and thirty or
forty were wounded. Thus ended the festivities for the second of France's
two Fêtes de la Fédération. This was the last time this type of festival was
held; from now on festivals reflected the antagonistic conditions within a
France that was no longer calm.

The David who painted the 1791 *Self-Portrait* lived in the world within
which these changes were taking place. Just as his contemporaries were being
pulled in different directions so was he. The artist's troubled expression is
consistent with the tensions and conflicts that broke open the previous
period of national calm. Two other portraits, both from 1791-92, shed
additional light on David's position as pressures were mounting within
France that would culminate in the political upheaval of August and Sep-
tember 1792. Both of these portraits are of women and both are unfinished.
The Mme Pastoret of the first of these portraits (fig. 23) may have been
David's pupil before she married; her husband was to become first president
of the Legislative Assembly. Both the husband and wife came from upper-
class families and both belonged to the progressive, educated liberal stratum
that championed the ideals of the 1789 Revolution. In David's portrait of
Mme Pastoret one finds a woman who does not put on airs but shows herself
in all of her natural—and maternal—simplicity. At her side is a cradle with an
infant born in 1791. The cradle and unadorned wooden chair on which she
sits are plain, as is her flowing white dress. The décolletage suggests that she
is a mother who nurses her child and she is occupied with her sewing,
another sign of naturalness and domesticity. And yet, for all of the simplicity
of Mme Pastoret's attire and the openness of her manner there are signs of

strain. "Her expression," writes Brookner, "has the blankness of the desperately self-absorbed, and both her femininity and the dangers of her life are projected in the eerily vibrant lilac aura which sets off her roughly-dressed brown hair with particular emphasis."[35]

The second portrait, *Mme Trudaine* (fig. 24), is of a woman who belonged to the same social class as Mme Pastoret. She was the wife of Charles-Louis Trudaine de Montigny, one of the two Trudaine brothers who presided over the circle that David had belonged to in the years just before the Revolution, and in which he had met André Chénier. In David's portrait of Mme Trudaine we find a woman who, like Mme Pastoret, is at one with the world of revolutionary society. Her black dress is the color of the Third Estate and it is plain and simple, as is everything about the painting, including the wooden chair she sits on. The other colors of the painting are the blue of Mme Trudaine's sash and her white fichu and the red background. These are the colors of the revolutionary cockade. Like Mme Pastoret there is something impassive about Mme Trudaine, and something enigmatic; we sense troubled qualities that are difficult to pin down. She stares blankly ahead, but her brooding expression suggests tensions of some sort.

As a group the two portraits of 1791–92 are strikingly different from the earlier portraits of 1790, *Mme d'Orvilliers* and *Mme de Sorcy-Thélusson*. The difference goes beyond the fact that the earlier portraits are finished while the later ones are not. There is an opulence in the 1790 portraits, apparent in the fine clothing and fine furnishings but also in the radiance of the women David has portrayed; the later portraits are spare, even austere. Moreover, tensions in the *Mme Pastoret* and *Mme Trudaine* portraits are demonstrably absent form the earlier paintings.

What is known about the two women David painted in 1791–92 provides possible insights to the uneasy atmosphere of the portraits. Mme Pastoret's husband was an important political figure in the opening stage of the Revolution. He was an admirer of David and as a member of the Legislative Assembly he praised him as an artist, and he praised his service to the Revolution. This was in September 1791. Like other political moderates he was opposed to the outbreak of violence in August 1792 and fled France after the storming of the Tuileries. Mme Pastoret was imprisoned during the Terror. That the painting was not completed lends it an ominous note, given the political conditions when it was left in that state.

The husband of Mme Trudaine, Trudaine de Montigny, was enthusiastic about the Revolution of 1789 and quickly rose to a position of political importance. Like Pastoret, he was a member of the Assembly, and also like

Pastoret he was a moderate who opposed the second Revolution of 1792. He did not flee France, however, and suffered the consequences: he went to the guillotine during the Terror, along with his brother and his longtime friend and former schoolmate André Chénier, and along with his wife, the woman David painted. That the portrait of Mme Trudaine was not completed suggests that it too was left in that condition because of the political convulsions that shook France in 1792.

In both *Mme Pastoret* and *Mme Trudaine* David portrayed wives of important figures in the Revolution. The world of both portraits is that of the politically moderate revolutionary class, those who came to power during the Revolution of 1789. Both paintings reveal the strains of the times and they suggest David's own tensions. The way he portrayed Mme Pastoret and Mme Trudaine not only reflects what David saw in them but also hints at his own feelings. These were people David knew. Between them and him, one suspects, a silent dialogue is taking place, one that concerns shared responses to the upheavals of 1792.

The convulsions of 1792 were responsible for the abandonment of a work that had occupied David since the spring of 1790—the *Tennis Court Oath*. When France was shaken by the second Revolution, he stopped work on a painting that would have been his most ambitious undertaking—it was to have been quite large, 400 by 660 centimeters (35 by 26 feet)—and in which he had made an enormous artistic and emotional investment. When he gave up his project in September 1792, some of the heroes of the June 20, 1789, event were no longer the heroes of the Revolution but now were its enemies. Bailly, the central figure in David's *Tennis Court Oath,* became mayor of Paris in July 1789, but had to resign after he ordered troops to fire on a crowd in July 1791. He went to the guillotine in November 1793. Mirabeau, whom David particularly admired, died in April 1791, by which time Robespierre already suspected him of having political ties with the king, proof of which was later discovered. Once a hero of the Revolution, his ashes had been placed in the Pantheon, but they were removed from that shrine in 1793. Sieyès, another prominent figure in the events of 1789 and a prominent figure in David's design, was also discredited. So too were Barnave and E. L. A. Dubois-Crancé. In the canvas that David began to paint but had to abandon, he sketched a number of nude figures and painted a total of four faces. Three of them, Mirabeau, Barnave, and Dubois-Crancé had completely fallen from favor. Given their centrality in the design, continued work on the project was no longer feasible.

Yet another artistic project fell victim to the year 1792. This was *Louis XVI*

Showing the Constitution to His Son, which never went beyond a series of sketches begun in March. The work that David abandoned, probably in April, had been controversial from the beginning. The radical press criticized David for accepting the commission for the *Louis XVI* painting, which came from the king himself.[36] David's purpose was to use the painting to show that the king derived his power not from divine right but from the Constitution. Above the first of his sketches (fig. 25) he wrote, to himself, "put a table in good position; place the scepter and crown on it and make it known that he can reign only by observing religiously the duties it imposes on him." Louis was to have been shown educating the dauphin politically, explaining to him that royal authority was not divinely ordained but was based on the Constitution, a copy of which lay on the table next to the crown. The king showed the Constitution to the dauphin at the same time that he pointed to the crown he would inherit.

Among those participating in the debate on the *Louis XVI* project in the press was André Chénier, who had returned to France in 1790 after his stay in England. As a political moderate Chénier was committed to the principles of 1789. He favored constitutional monarchy and was understandably sympathetic to David's *Louis XVI* project, which commemorated that ideal. That David began work on a painting commissioned by the king suggests that he was not unsympathetic at the time to constitutional monarchy and to the principles of political moderation. It was while he was doing his preparatory studies that a change of political attitude seems to have taken place. This, at any rate, is what the preparatory studies themselves appear to indicate.

In three of the first four drawings (figs. 25, 26, 27) Louis XVI is seen showing his son the Constitution which is placed on a table next to the crown he will inherit. In the final three preparatory studies (figs. 28, 29, 30) the king is no longer seen with the dauphin. In two (figs. 28, 30) a figure that might or might not still be the king is seen with allegorical figures, the French People and the Genius of Liberty and Victory. One holds a Phrygian cap, a revolutionary symbol, on a pike. The other drawing (fig. 29) shows only the king, who points at a crown. The Constitution is not present in this study, nor is it shown in the other two drawings. Clearly David's ideas have changed, and the original theme of constitutional monarchy that is expressed so directly in the first four drawings does not occupy the same position in the last three. After exploring different approaches to the *Louis XVI* painting David abandoned the project. He did so while making preparations for the Châteauvieux Festival that was held on April 15. That event,

the first of the revolutionary pageants that David was to orchestrate, was the occasion of a breach in his friendship with André Chénier.

One way to trace the political transformation of the artist who had identified with the Revolution of 1789 to the radical Jacobin of the Terror is by examining his friendship with André Chénier, with whom he had exchanged ideas on artistic liberty as a member of the Trudaine circle in 1787. As we have seen, Chénier became disgusted with conditions in France and left for England at the end of that year. He remained in England from December 1787 to the time of his return to France in 1790, except for one brief visit to France in the spring of 1789. When Chénier returned to France, David had just begun work on the *Tennis Court Oath*. Chénier was to develop a keen interest in the painting and wrote an ode, *Le Jeu de Paume*, for it in February or March 1791. Before looking at that poem and at Chénier's relationship with David it will be useful to trace Chénier's movements after he returned to France in 1790. The poet joined his old friends of the Trudaine circle in the newly founded Society of 1789 as soon as he arrived back in Paris.[37] More of a debating society than a political club, the Society of 1789 was made up of moderates committed to the toleration of free thought. It described itself as "neither a sect nor a party, but a company of friends of men and, so to speak, agents of true social commerce."[38] Condorcet, its first important spokesman, said it was "consecrated to the defense of the principles of a free constitution and to the perfection of social art."[39]

Chénier became a leading voice of the Society of 1789 in articles he wrote for its official publication, the *Journal of the Society of 1789*. He began his first essay, "Advice to the French People on Their True Enemies," written in August 1790, by calling the Revolution "a just and legitimate insurrection," and in the word "insurrection" one of the keys to Chénier's political thought can be found.[40] He was a moderate who favored the uprising against previous authority but he was also an admirer of the British constitution and he respected the rule of law. He sought and called for the formation of a new government based upon a constitution and he opposed further uprisings and the intervention of the people in the remaking of France. Much that was bad, he felt, had been destroyed, and those charged with carrying out reforms should make haste in their work, which he hoped the people, in the heat of their emotions, would not obstruct. Tranquillity was essential for the peaceful establishment of a new regime. Accordingly, he was bothered by demagogic writers who stirred up the people, popular journalists such as Marat, Desmoulins, and Jacques Hébert. Another source of

concern for Chénier was lack of discipline in the army, a problem high-lighted by the recent revolt of the Swiss regiment of Châteauvieux.

The Châteauvieux incident was controversial because the soldiers who mutinied did seem to have legitimate grievances against their officers. The soldiers were popular in the town of Nancy where the revolt took place, and in 1789 their commander had refused to give orders to fire on the people at the storming of the Bastille. Nonetheless, M. J. P., marquis de La Fayette, a general concerned with discipline in the army, was determined to make an example of the regiment, which sent eight soldiers to Paris to plead its case. La Fayette had them arrested and sent his cousin, General Bouillé, to Nancy to investigate the problem. This led to another insurrection and a bloody battle that finally resulted in the defeat of the Swiss soldiers. Some twenty were hanged and forty-one sent to the galleys. Discipline in the army had been a serious problem, and the Assembly applauded the severe measures taken against the Châteauvieux regiment. Others felt differently, and popular journalists, including Marat, denounced the action as counterrevolution-ary. Articles continued to praise the soldiers and speeches were made on their behalf in the Jacobin Club. The tide of opinion began to shift in favor of the Swiss, not only because writers and orators took up their cause but because the Revolution itself was changing direction, and with that shift events of the past were seen in a different light. A subscription was begun in November 1791 to raise funds so the galley convicts could be freed, and in December the Assembly granted the soldiers an amnesty—and made plans for a public festival to be held in honor of the "martyrs of liberty and the fatherland." David was chosen to organize the festival in March 1792 and it was held on April 15 of that year.

David's role in the Châteauvieux Festival brought about a rupture of his friendship with Chénier. The poet had been enthusiastic about David's *Tennis Court Oath* when he returned to France in 1790 (probably June), and dedicated his *Jeu de Paume* to the artist. Written in two parts, the first half of the poem praises the fall of the Bastille, from whose debris emerged the proud beacon of liberty.

> L'enfer de la Bastille, à vous les vents jeté,
> Vole, débris infâme, et cendre inanimée;
> Et de ces grands tombeaux, la belle Liberté,
> Altière, etincelante, armée.[41]

As a political moderate what Chénier wanted was national unity:

O France! sois heureuse entre toutes les mères.
Ne pleure plus des fils ingrats,
Qui jadis s'indignaient d'être applés nos frères;
Tous revenus des lointaines chimères,
La famille est toute en tes bras.[42]

In the second half of the poem Chénier turns from the events he has just glorified, the fall of the Bastille and the Tennis Court Oath, and sends a warning to the people of France on the dangers facing the nation. The Revolution had lost sight of its original purpose as extremists both of the left and right created rancor and dangerous divisions within the nation. "Hangmen orators" had incited the people to commit bloody deeds and freedom had been placed in jeopardy.[43] Chénier warns the people not to believe that everything was permitted them, and he cautions them against demagogues who would lead them astray. He expresses the opinion that fanaticism is the worst enemy of justice and maintains that in such a time of crisis as that facing France moderation and good sense are essential.

Chénier's plight was that of the liberal caught up in the logic and force of a revolution that moved inexorably from moderate to more extreme stages. He was worried about a mounting sectarianism in political clubs, and in response to that concern, in March 1791, he wrote his "Réflexions sur l'esprit de parti." At this very time bitter debates were taking place in the Jacobin Club which would result in the secession of moderates several months later; the "spirit of party" that Chénier feared and deplored was becoming a fact of life in a France that was increasingly divided: mounting pressures would lead to the explosions of August and September 1792. Thus, when Chénier wrote his *Jeu de Paume* his ambivalent vision was reflected in the two parts of the poem. The first part rejoiced in the defeat of tyranny and the victory of liberty, achieved through the fall of the Bastille and the Oath of the Tennis Court. The second half of the poem was dominated by an accurate reading of current political conditions in France, which Chénier feared could lead to future violence.

When he wrote the poem he had every reason to see David as part of the first vision, and he dedicated it to his friend and praised him as an artist: "David, king of the *savant* brush."[44] Both Chénier and David opposed despotism, an obstacle to the liberty they held dearly. With the Tennis Court Oath liberty had been established, and this was what David intended to celebrate in his heroic artistic project. Besides commemorating an event to which Chénier attached the greatest historical importance, David designed

the work in a way that must have met with his friend's approval, and for which Chénier made specific suggestions.[45] The pictorial means by which David portrayed the creation of a new nation emphasized the unanimity of the delegates, and the delegates to whom David gave the greatest compositional importance were moderates whose views Chénier shared.

In the *Jeu de Paume* Chénier identified the very conditions and forces in France by which David would be swept up: the factional strife, the political rhetoric, and the intervention of the people. In his earlier "Advice to the French People on Their True Enemies" he had even discussed the incident of Châteauvieux, an event that was to be the occasion of their falling out. As plans were going forward for the festival for the Châteauvieux regiment, Chénier launched a journalistic attack against it in the *Journal de Paris*. He denounced the Swiss who were to be feted as "insubordinate and rebellious . . . murderers . . . public enemies."[46] He expressed displeasure with those responsible for staging the event: David, his own brother M.-J. Chénier, and the composer F. J. Gossec. The line "O vous, enfants d'Eudoxe et d'Hipparque et d'Euclide" alluded to these three men.[47] As director of the Châteauvieux Festival, David was a leading figure in an event that stood for everything Chénier opposed. Thus, the festival placed impossible strains on their friendship. When David organized another festival, that of August 10, 1793, Chénier poured out his anger:

> Arts digne de nos yeux! pompe et magnificence
> 　Digne de notre liberté,
> Digne des vils tyrans qui dévastent la France,
> Du stupide D(avid) qu'autrefois j'ai chanté.[48]

Another friendship, if that is the way to describe the relationship, sheds further light on David in the period between the Revolution of 1789 and that of 1792. Jean Paul Marat was not a friend of David's in the same way that André Chénier was, but Marat was a supporter of David—it was he who nominated David to the National Convention on September 6, 1792—and as we have seen David sprang to Marat's defense in a meeting of that same body in April of the following year.[49] Like David, Marat was an enemy of academies, against which he wrote a scathing attack before the Revolution, and which he reprinted in his journal *L'Ami du Peuple* in 1791. That David admired Marat at the time is suggested by his portrayal of him in the final design of the *Tennis Court Oath,* completed in May 1791, over a year before Marat nominated David to the Convention. The place of Marat (who was not actually there) in the design is significant: he was not one of the delegates

and is not shown on the floor of the tennis court but stands on the balcony on the right-hand side of the room (fig. 31). He faces away from the tumultuous scene below and can be seen writing "friend of the people" on a tablet. Standing in front of him is a soldier who raises his sword in his right hand.

It is tempting to see in David's depiction of Marat a statement about the man. After journalistic attacks on the Commune of Paris in October 1789, Marat had gone underground, because he was sought by the police. After fleeing to England he returned to Paris in April 1790, when he began denouncing Bailly and Mirabeau, two of the central figures in David's design for the painting. From then to the time of his assassination in April 1793 Marat would denounce the traitors he saw everywhere, he would uncover conspiracies, and he would call for the heads of the Revolution's enemies.[50] This is the Marat that David shows facing away from the oath taking that takes place below him—he is virtually the only figure in the design who does so—and this is the Marat who stands behind a soldier with raised sword. Just as the soldier brandishes his sword with his right hand so does Marat hold his pen in his right hand, which is at the exact level as that of the soldier.

David's admiration of Marat was in striking contrast to the repugnance André Chénier felt toward him. Of all the revolutionary leaders that Chénier despised none stood higher on his list than Marat.[51] In his very first political tract, the *Advice to the People of France,* he warned against writers who made themselves public enemies by preaching revolt and denouncing leaders such as Bailly, La Fayette, and Sieyès who were most devoted to the national welfare. No one attacked the moderates-more venomously than Marat and no one tried to stir up the people more than the radical journalist. Marat was genuinely devoted to the people even though he had little faith in their intelligence; they were an abstraction in his mind, but at the same time he perceived in them a force that could be goaded and stirred and activated, a force that could be called upon to crush the enemies of the Revolution. Society was divided into two hostile groups: first, the people, "without whom [it] could not exist a single day . . . [and] upon whom weigh all the burdens of the state [but] none of its advantages," and second, the rich and powerful, who oppressed the people, "in the midst of luxury, pomp and pleasure."[52] If the people were an abstraction for Marat, so too were men of property and wealth. He lived in a world of categories, of antagonistic groups between which there could be no resolution of differences. "Expect nothing from rich and opulent men, from men brought up in luxury and pleasures, from greedy men who love only gold." But the people were "not

educated" and nothing was "so difficult as to educate them"; to "form them [into] a free people" was "an impossible task."[53] Given the impossibility of the rich aiding the poor or the people becoming free of their own accord, the political future was bleak. The French were unable to achieve liberty, for they were "so vain, so foolish, so imbecile, that it is almost impossible to save them."[54] Because the French did not love equality they were incapable of democracy; only through tyranny, he came to conclude, could a reign of virtue be imposed.

In his extremism, his reduction of society to abstract categories, and his dualism, Marat was poles apart from André Chénier. Chénier came to the question of liberty through his experience as an artist, and in considering its meaning and implications the sensibilities of the poet came into play. As a young poet he had considered humanity's position in the universe, first in isolation and then in society, and to his verse he brought an exquisite Hellenism, a combination of grace and clarity that was part of an eighteenth-century elite education. Both his poetic qualities of mind and his education influenced his approach to politics; critical as he was of the ancien régime and enthusiastic about the Revolution of 1789 he felt that once the old order had been toppled what was most important was establishing stability. It was not just that he feared forces that the Revolution had unleashed, anarchic forces as he regarded them, but that he felt a need for reconciliation between rival groups. The revolutionaries he admired most, Mirabeau, Bailly, La Fayette, were prepared to mediate between rival groups in the hope of establishing a durable basis of government. The Revolution had rent society, torn its fabric, and the task of leaders was to mend it. A willingness to compromise was essential to Chénier, and made him a loyal and outspoken supporter of political moderates.

Thus, Marat and Chénier, the leading journalistic voices of the revolutionary left and the revolutionary right, were polemicists who not only wrote on behalf of different principles but brought to their writing different qualities and habits of mind. There were profound differences of temperament as well as political convictions and political objectives. Both were revolutionaries, but Chénier was loyal to the Revolution of 1789 while Marat welcomed the upheavals of the second French Revolution, that of 1792. It was the latter of whom David was to become a devoted follower, on whose behalf he demanded that he be assassinated, and of whom he painted one of his very greatest works.

The question, then, is why did David move away from Chénier and attach himself with all of his intense feeling to Marat? The answer lay within

David's own psyche, within the troubled and conflicted inner life that we have already observed. As Louis Hautecoeur remarked, David "was very susceptible to influences," and he "became the prisoner of his own attitudes."[55] Or, as David himself said, when defending himself against accusers after the execution of Robespierre, his heart was "vulnerable."[56] It had been vulnerable not only to the unswerving, unbending, incorruptible Robespierre but to the fanatical and violent Marat.

The seeds of David's fascination for Marat and Robespierre were present in the David who moved in the polite surroundings of the *société Trudaine* in the years before the Revolution and was a close friend of André Chénier. Neither David nor Chénier could have been aware of the differences that would result in the later rupture, but those differences can be traced in the *Oath of the Horatii* and *Brutus and the Lictors*. Within the moral universe of these paintings there is no room for compromise. This is a realm of unswerving dedication to principle, which must be served at any cost. Moreover, it is a world stained with blood, the result of violent deeds done in the name of virtue. The Manichean structure of this universe, its extremism and bloodiness, was alien to Chénier, for whom moderation, limit, and restraint were of the greatest importance. Steeped in the thought of the Enlightenment, he was keenly aware of conflicts between reason and imagination, the rights of the individual and the demands of society, and he recognized the importance of mediating between these opposites. Within such an analytical system, it was necessary to make critical distinctions, to reconcile competing claims, and to appreciate ambiguity and the demands of the contingent. In all of these respects Chénier's mental world differed from that of David.

Were it not for the Revolution the differences between David and Chénier would not have been revealed, at least not with such decisiveness. Initially, both approved of the events of 1789, and for a time both saw the Tennis Court Oath as an emblem of a new order, a France that had burst the fetters of tyranny. That Chénier not only wrote a poem on the Tennis Court Oath, but collaborated with David by making suggestions for his painting indicates how close they were, personally, artistically, and politically in 1791.

David became a member of the Jacobin Club at the end of 1790, but that did not mean that he was veering to the left politically. He first showed interest in the Jacobins in July 1790 when he sought their support in his struggle with the Academy.[57] In that same month the Jacobins agreed to organize a subscription for the *Tennis Court Oath* so that prints could be sold to patriotic Frenchmen. When David joined the Jacobin Club it still included moderates; it was not until the spring and summer of 1791 that

moderates pulled out. Moreover, David's interest in the club when he joined and during the first year of membership was artistic, not political. In all of 1791 he attended only three meetings, in each of which artistic matters were discussed. David was not a follower of Robespierre at this time nor did the Jacobin leader have an interest in the artist. It was only in the spring of 1792, after the Châteauvieux Festival, that ties would be formed between the two men, by which time David's Jacobinization can be said to have begun. Pressures were mounting which would culminate in the second French Revolution in August of 1792.

The historian François Furet has brilliantly analyzed the revolutionary forces that led to the explosions of 1792 and the period of Jacobin domination and Terror that followed.[58] He explains that a new mode of historical action issued from the opening events of the Revolution. With the summoning of the Estates-General it was the people to whom appeals would be made and in the decisive month of July it was the direct intervention of the people that was responsible for the collapse of the ancien régime. Using a linguistic analogy Furet explains that a new political discourse began in which power was in the word, and it was through the word, now made public, that the nefarious enemies of the people were exposed. In the discourse between opposing groups a "maximalist language" came to be employed, rhetoric that became ever more inflammatory as the struggle between the friends of the people and their enemies escalated. The negative counterpart of the Revolution was "the Plot," a belief in conspiracy that was as pervasive and ubiquitous as the reality of the Revolution itself. Once power passed to the people the Plot became a necessity; it was present within the very logic of the Revolution and it was an indefinitely expandable figment. What developed out of the myth of the Plot, and the real plots that did exist, was a Manichean universe and the belief that evil must be overcome. The friends of the people, the servants of virtue, must crush the forces of evil—the enemies of the Revolution. Marat was at one with the Manichean Revolution of Furet's analysis from the beginning, but not David. The radical journalist denounced traitors and conspiracies in the opening months of the Revolution and was so violent in his attacks that he had to go underground and flee France. David, by contrast, welcomed the 1789 Revolution, which brought him greater fame and recognition than he had ever known.

The Revolution of 1792 brought out a different David. This was the David who identified completely with Robespierre and was a willing and active member of the Jacobin dictatorship. As a member of the Committee of General Security he expressed his hatred for nobles and priests and was ever

vigilant to ferret out the criminal enemies of the Revolution. Even David
Dowd, who has tried to defend David from charges of vindictiveness, con-
cedes that "occasionally, he indulged his excitable temperament in violent
exclamations and melodramatic scenes which gained for him the name of
'ferocious terrorist.'" Dowd may well be correct in saying that David
demonstrated ideological consistency as a revolutionary, but Stanley Mellon
is also correct and closer to the real David when he describes him as a radical
revolutionary who always, with every purge, moved further to the left.[59]
Like Robespierre, David was caught up by forces that drove the Revolution
to ever greater severities in efforts to crush its enemies.

The Jacobin leadership carried out its policies under pressures it was never
able to control. It was intervention by the people of Paris, *sans-culottes* from
revolutionary *sections,* that gave the Jacobins, a minority party, power in June
1793. Robespierre and his allies claimed to be the voice of the people, but at
the same time they lived under constant pressure from the people. Robes-
pierre did not want a recurrence of the September Massacres, butchery
resulting from a breakdown of order. He had to depart from his own
economic principles in September 1793 when he imposed the Great Law of
the Maximum; he had no choice but to impose price limits because of food
scarcity and hunger. He was subject to both the logic and reality of fear, to
the pressures resulting from military reversals beyond the frontiers of France
and to counterrevolution within its borders. When these pressures mounted
the threat of popular intervention was greatest, and in those moments
Robespierre resorted to repression. He had to grapple with those on his left,
Jacques Roux, Hébert, and the *sans-culottes* of militant *sections,* and on his
right Danton and political moderates. First he crushed one and then the
other. How he did so is revealing.

Robespierre denounced both Roux and Hébert as traitors. He even
accused Roux, who was arrested and imprisoned in September 1793, of being
an Austrian spy. Hébert, like Robespierre a Montagnard, was a leader of the
sans-culottes after the crushing of Roux and the *enragés.* He was arrested and
executed on March 24, 1794. Having eliminated leaders of the *sans-culottes* on
the left, Robespierre had little choice but to wipe out Danton and the
moderates. Danton was executed on April 5, 1794. Every purge had to be
carried out legally, by vote, and Robespierre enlisted the needed support
with some difficulty. Some who voted for the execution of Hébert did so
reluctantly; they then exerted pressure to apply similar measures to those on
the right. When these final purges were carried out the Revolution was
secure, both internally and externally. France's armies were victorious

beyond the frontiers and the forces of counterrevolution were all but defeated. Danton and Desmoulins had called for a relaxation of the Terror. A committee was established to begin a policy of conciliation. Yet Desmoulins pushed so hard for an end of repression that others became suspicious and called for ever greater zeal and vigilance. The Committee for Conciliation was disbanded and charges were made against the moderates, who were accused, found guilty, and executed.

The Terror continued and with the passage of new laws it accelerated. Popular democracy was stifled and political action by the *sections* curtailed. Even as the Jacobin leadership carried out a policy of systematic Terror in the name of the people it was more isolated from the people. Saint-Just claimed that the Revolution had "frozen up," and that its every principle had been weakened. This made regeneration all the more essential and set the stage for the Great Terror, for which the Laws of 22 Prairial were a prelude. Now the Terror was accompanied by fear among the people of Paris and within the political leadership that carried it out. It was not without reason that the guillotine was moved from the place de la Révolution in the center of Paris to the place Antoine and finally to the more distant barrière du Trône. Nor was it accidental that on July 14, 1794, revolutionary celebrations were curtailed. The Terror, by now, had almost run its course, and the Jacobin leadership was about to break apart from pressures it had never been able to regulate.

Robespierre was never free to chart his own course. Righteous, puritanical, and incorruptible, he presided over the Terror, whose goal was creation of a new order. He wanted the rule of law and stability but carried out a policy of violence and repression. Reluctant as he was to carry out such extreme measures, politically he had little choice, and so it was he who pushed the Terror into its final stage. He was among its final victims.

David was a member of the Jacobin leadership. Like Robespierre he was swept forward by events beyond his control. Fiercely committed to the Revolution, he too would resort to extreme measures for its sake. If Robespierre could be stern and unbending, so could he. And unforgiving. When he was interrogating Mme Elisabeth, the pious and reactionary younger sister of Louis XVI, she asked David for some of his snuff. According to a witness, who wrote down the remark, David said, "You are not meant to place your hand on my *tabac*." On another occasion the artist Carl Vernet pleaded with David to intervene on behalf of his sister, Mme Chalgrin, who had been arrested for possessing furniture that belonged to the Revolution. Vernet said that David not only refused to help his sister but denounced her as an aristocrat and said she was guilty. She went to the guillotine.

As Robespierre's ally, David was responsible for artistic projects that furthered the revolutionary cause. One such project was his plan, announced on November 7, 1793, to build a giant Hercules on the Pont-Neuf, where the statue of Henry IV had formerly stood. The forty-six-foot-high *Colosse* was to be an allegorical representation of the People. Although the project was never brought to completion it is revealing for what it says about both David and the Revolution at the time of its proposal.

To appreciate the significance of Hercules as a political image in France during the Terror it should be seen against the background of earlier revolutionary images. With the taking of the Bastille civic imagery was used to represent the ideals of a new era. As Maurice Agulhon has written, "There was total liberty that tolerated no rules and carried [a] variety [of images] to the point of confusion."[60] Still, in the plethora of images that appeared in 1789 were patterns that can only be understood within the larger structure of change. Unity was central to the goals of the first French Revolution, and female symbols gained currency at that time. The nation was a motherland, and female figures were used to symbolize that entity.

Between 1789 and 1792 the most popular female symbol was the allegorical figure of Liberty, often identified by the Phrygian cap that she either wore or carried on the end of a pike. Among the many versions of Liberty that appeared, two essential types can be discerned. One was young, short, and active, wearing a short dress that revealed her legs at least below the knee and sometimes with one breast bared. This Liberty was "rather a tomboy."[61] The other type was calm, sometimes seated, fully draped in the classical style, and with or without the Phrygian cap. The liberties that she stands for, Agulhon says, "are always of the sedate type."[62] The crystallization of popular imagery into these two generic types is a useful index of the tensions within the Revolution in the period 1789–92. The active allegorical type is inherently dynamic and represents belief that further struggle is needed before the Revolution will be complete. By contrast, the sedate allegorical type projects a different vision of the Revolution, one of finality and completion.

The second Revolution of August and September 1792 brought an end to the monarchy and created a need for a new type of symbol, one representing the Republic. At this point the unofficial female allegory became official, and it was decreed that "the State Seal should be changed and should bear the image of France in the guise of a woman dressed in the style of Antiquity, standing upright, her right hand holding a pike surmounted by a Phrygian cap or cap of Liberty, her left hand resting upon a sheaf of fasces."[63] This

standing figure was militant, with pike in hand ready to do battle in the continuing struggle against the enemies of the Revolution. In the period that was to follow, those enemies were to become greater than ever, not only in the armies of hostile foreign powers but through the forces of counter-revolution inside France.

Within this polarized France a new image appeared, that of Hercules, symbol of the People. The popularity of the female allegorical figure began to wane as the Revolution swerved to the left, most notably after the Jacobins crushed their Girondin rivals. As Lynn Hunt has written, in October 1793 Jacobin leaders issued a new seal and new coins in an effort "to recast the Republic in a more radical mold."[64] The seal bore the inscription "Le peuple seul est souverain." In the following month, November 1793, the Convention voted to make a giant statue, Hercules, the official emblem of the Republic. That an allegorical male figure should achieve prominence after the changes wrought by the second French Revolution is not surprising. This happened in a France dominated by the Jacobins, whose ideas of virtue were intensely masculine. For the Jacobins, crushing the enemies of the Revolution was the essence of virtue. The people were good by definition; their enemies were evil by definition. It logically followed that the people had to destroy their enemies. This required constant vigilance and extreme measures; there could be no respite, no mercy, in the struggle against the enemies of the Revolution. The figure of Hercules, whose club dealt blows to those who must be crushed, became a potent allegorical figure.

The figure of Hercules first appeared publicly in the festival of August 10, 1793, which David organized. Held in five stages, the Fête de la Réunion began at the site of the Bastille, proceeded to the boulevard Poissonière, and then went to the place de la Révolution, where the "imposter attributes of royalty" were burned in front of a female statue of Liberty. The fourth stage was at the place des Invalides, where, "at the summit of a mountain" a colossal figure of Hercules representing the French People had been placed.[65] One of the giant's vigorous arms held the fasces of the departments, to which a figure, half-man and half-beast also clung. The giant reached upward with a mighty club in his other hand, preparing to deliver final blows to the Hydra figure at his feet, the symbol of a defeated federalism. In the fifth and final stage the procession moved to the champ de Mars, where the festival ended with a mock battle representing the bombardment of Lille. In this morality play, as Lynn Hunt has described it, "the placement of Hercules [the giant statue of stage four] relative to Liberty [the

allegorical statue of stage three] is particularly relevant."[66] The position of the figure of Liberty in the earlier stage of the procession meant that the figure of Hercules was supreme. The delegates were actors at the third stage, consigning the symbols of monarchy to flames, but in the following stage the assembled group stood passively below the towering giant and contemplated his destruction of the People's enemies.

It was after this festival that David proposed to the Convention that it erect a Hercules statue on the Pont-Neuf. David was not a sculptor, and he would not have made the huge statue, but the conception was entirely his. He proposed it to the Convention three days before the Festival of Liberty celebrated the victory of philosophy over fanaticism. On that occasion the Convention met in Notre Dame, now the Temple of Reason. Statues of the kings of France and religious statues had been torn from the building, and in the purified interior a civic festival was held. David intended to embed the mutilated sculptures from Notre Dame in the base of the giant Hercules. As he said in his speech to the Convention on November 7, the debris from the smashed religious statues and the statues of kings, the "effigies of superstition," would "serve as the pedestal of this emblem of the people."[67] "Unable to usurp God's place in the churches," David explained, "the kings took possession of their portals . . . accustomed to laying their hands on everything, they had the presumption of competing with God himself for the incense which men offered Him. You have overthrown these insolent usurpers; laughed to scorn, they now litter the soil which is stained with their crimes."[68] Contained within the Hercules pedestal, the "dismembered fragments of the royal statues [will] form a lasting monument of the king's downfall and the people's glory."[69] To underline the militancy of his conception David intended for the giant bronze Hercules to be made from enemy cannons captured by the victorious armies of France.

The importance of Hercules in the August 10 Fête de la Réunion is an expression of the profound changes within the Revolution. What should be borne in mind is that David himself was responsible for planning the festival, and it was his July 11 report to the Convention that spelled out in minute detail the stages of the day-long event that culminated in the gathering before the giant statue of Hercules and the mock battle that ended the event in the evening. David was responsible for giving prominence to the giant Hercules over the allegorical figure of Liberty, thereby identifying with and giving visual expression and symbolic form to the ideals that were now at the center of the Revolution.

David had not participated artistically in the first revolutionary festival,

the Fête de la Fédération of 1790, held on the first anniversary of the fall of the Bastille.[70] He does seem to have played some role in 1791 in the apotheosis of Voltaire, which took place three days before the second Fête de la Fédération, but it is not clear what that role was. From this time on David would be the driving force behind all but one of the revolutionary festivals. The next celebration was the Fête des Suisses de Châteauvieux, held on April 15, 1792, which was responsible for the falling out between David and Chénier. David did not take part in the Fête de la Loi, held on June 3, 1792, whose purpose was to encourage respect for the law. There were no more counter-festivals of this type, and from now to the end of Jacobin rule in July 1794 all festivals were intended to solidify support for the Revolution.

The great year of festivals was 1793. One was held in conjunction with the funeral of Lepelletier de Saint-Fargeau on January 24; the next was on April 28 for the funeral of M. Lazowski, a Pole who was a member of the Commune and, who some believed, had been poisoned. Then came the much larger festival on July 16 for the funeral of Marat; after that was the Fête de la Réunion of August 10, which we have already mentioned. Finally, a festival celebrating the capture of Toulon was held on December 30. In 1794 only one festival was held, the Fête de l'Etre Suprême, on June 8. Another one was being prepared at the time of Robespierre's fall from power on the ninth of Thermidor. That was to have been the festival in honor of Bara and Viala; it is from David's official report to the Convention for this event that the last of the quotations was taken at the beginning of this chapter. This was the David who asked the "world [to] repeat with us: Peace to the *chaumiers*! Death to the tyrants!"

As David poured time and energy into revolutionary festivals, he obviously had much less time to devote to his art. Moreover, from the time of his election to the Convention in October 1792 he was an active political figure who increasingly spent his time in committee meetings carrying out the bureaucratic functions of his various offices. Dowd has written that David "introduced bills, made speeches, conducted debates, served on various commissions and legislative committees, led deputations to explain governmental policies to the people, and in general played [his] part in promoting the vital legislative and administrative activities of the Convention."[71] He served a term as president of the Convention, and a term as president of the Jacobin Club. As a member of the Committee of General Security he was one of twelve (later fourteen) men who headed a national security organization entrusted with devising measures that would safeguard the country against counterrevolution. Much of his time was spent in

administrating the projects of the Committee of General Instruction, of which he was also a member. This committee strove to universalize literacy and to end "prejudice" and "fanaticism," which meant transforming subjects loyal to church and monarchy into citizens committed to the Revolution. As the artistic leader of the Revolution David's work on this committee was highly demanding. Besides organizing festivals that would inculcate revolutionary principles in the citizenry, David was entrusted with the design of new clothing, "adapting it to republican manners and to the character of the Revolution."[72]

David spoke on about one hundred occasions on the floor of the Convention and read more than twenty-five major speeches or reports, including those on the festivals he organized. In addition to the major offices he held he was appointed to more than twenty special commissions. As Dowd has shown, he took his official responsibilities seriously. Of the 315 meetings of the Committee of General Security he attended at least 131, and of the 4,737 decrees promulgated by that body he signed no less than 406. Many of these decrees, of course, were for the arrest of political suspects. As a highly placed official David was in the thick of the Revolution and the Terror. His signature, Dowd tells us, "appears on almost as many decrees as Robespierre's."[73]

David's personal life underwent an important change during this period. His marriage finally came to an end, after an earlier period of separation. A marital crisis occurred in 1789, and in 1790 David authorized his wife to enter a convent, a euphemism for separation. Divorce was not legally permissible until the legislation of September 20, 1792. David did not initiate the divorce: it was his wife who decided to end the marriage after her husband signed the death warrant for Louis XVI in January 1793. Although she was a patriot and politically active, she did not view favorably the direction the Revolution had taken.[74] She divorced her regicide husband as the Revolution was entering its radical stage, a stage that saw an end of the active role and political influence of women.

As a Jacobin, David was a dedicated member of the revolutionary club that played the key role in the movement against women. In the fiercely masculine and virtue-obsessed world of the Jacobins there was no place for women and no place for the moderation associated with their sex. As the Revolution swung to the left, measures were initiated which could succeed only if they were applied courageously, relentlessly, and severely. David was at one with the Revolution as it entered its most violent stages. Morally righteous and dedicated to the revolutionary cause, he acted according to his

conscience, even when it meant signing arrest orders for such friends as Quatremère de Quincy, his traveling companion to Naples in 1779 when both were students in Italy. In a sense Dowd is correct in describing David as completely "impartial toward those who were arrested as suspects," and austerely disinterested in the exercise of his public responsibilities.[75] For Dowd, David "showed a commendable impartiality" as a committed and dedicated revolutionary, neither enriching himself nor satisfying private grudges.[76] Yet, to take the full measure of David the revolutionary it is necessary to see him not just as the impartial committee person dutifully signing warrants for those suspected of political crimes but as a person of intense feeling who in a moment of agitation called rhetorically for his own assassination on the floor of the Convention.[77] This was the David who, according to a contemporary, shouted at Danton as he went to the guillotine on April 5, 1794, "Le voilà, le scélérat, c'est ce scélérat-la qui est le grand juge."[78] David was present not only at the execution of Danton, his former friend and supporter, but also that of Camille Desmoulins. And according to a written account attached to David's drawing of Marie Antoinette (in the Louvre) he watched the condemned queen as she was conveyed from the Conciergerie to the place de la Révolution for her execution in October 1793 (fig. 32). Having signed the former queen's death warrant, he now sketched her with her hands tied behind her back, capturing with rapid strokes of his pen her downcast eyes and proud, resolute mouth and chin. Defiant as she was, she was dressed as any other victim of the Revolution, and it was that tension that David caught in his superb sketch. The bonnet on the head of Marie Antoinette and the unkempt hair symbolize the fall of a social and political order. Objective and dispassionate as the sketch may appear,[79] it was, in fact, a vehicle for David's own feelings: it is as if he were again sitting in judgment of the former queen and the world to which she had once belonged.[80]

As J. M. Thompson has written, at the time of Marie Antoinette's trial, "the monarchy was still being persecuted with a vindictiveness which can only be explained by fear."[81] Three weeks after the execution of Marie Antoinette, David proposed to the Convention that the statue of Hercules be built. In March 1794 he was at work on another project that included a figure of Hercules: two curtain designs for a special program at the Opera that alluded to the festivals that he himself had previously organized. The production, performed on April 5, 1794, was entitled *The Meeting of the Tenth of August,* or *The Inauguration of the French Republic.* The play by Gabriel Bouquier and P. L. Moline was described as a "*sans-culottide* play in

five acts, in verse interspersed with orations, songs, dances and military displays."[82] David's two designs for the curtain for this production, both bearing the title *The Triumph of the French People*, depict a giant Hercules holding his club, seated on a chariot. Standing in front of him are allegorical figures of Liberty and Justice and ahead of the chariot are sword-wielding citizens who slay the enemies of the Revolution. In the first, incomplete drawing (fig. 33) two hugely muscled nude warriors plunge their swords into a falling and fleeing crowd of people, at the bottom of which is a king from whose head a crown falls. In the finished version of *The Triumph of the French People* (fig. 34) the crowd has disappeared and the warrior-citizens slay only the king and one other fallen figure. In both drawings the wheels of the chariot ride over and crush trappings of the Old Order; in both the chariot is followed by the heroes and heroines of liberty; and in both the crown falls from the king's head. In the earlier sketch Cornelia, mother of the Roman Gracchi, can be identified as well as Brutus and William Tell and his son. Added to the heroes of the finished sketch are Pierre Bayle and Beauvais de Préau, who had been strangled by order of the British in Montpellier on March 27, 1794, a few days before David made the sketch. In David's rendition the recent martyr of liberty appears to be strangling himself with his own neckcloth.

Compositionally, the design is an unequal triangle, whose shorter arm on the right is formed by the palms held by the heroes (this arm of the triangle is more pronounced in the earlier sketch) while the longer arm on the left is defined by the allegorical figures below Hercules, the oxen drawing the chariot, and the warriors who slay the fallen tyrants. If the work is read from right to left the palms form a line rising toward Hercules with his club and from that apex the long arm of the triangle leads downward to the sword-wielding citizens who slay the tyrants. One of the warriors prepares to drive home the sword with his cocked right arm and the other holds a sword above his head, about to bring it down on the enemies. There is indeed something intemperate in this depiction of violence.[83]

David's three major paintings in 1793–94 depicted martyrs of the Revolution and all were done in conjunction with festivals that he organized. The first painting was of Lepelletier de Saint-Fargeau (see figs. 35, 36), who, like David, was a member of the Convention and a regicide. Lepelletier was murdered by a former royal guard on January 20, 1793, after voting for Louis XVI's death. After Lepelletier's assassination, discussion in the Convention centered on plans for an elaborate funeral, the planning of which was entrusted to David. It was Marie-Joseph Chénier who proposed that David

arrange the funeral and that the composer Gossec provide the music. Thus, the three men responsible for the Châteauvieux Festival of April 15, 1792, collaborated again in a funeral festival held on January 24, 1793. The service itself took place on the floor of the Convention and then the body of the dead deputy was taken to the place Vendôme where it was set on the pedestal of a statue of Louis XIV, which like all royal statues had been pulled down in 1792. The body of Lepelletier was put on a couch with the torso uncovered, so that the wounds could be seen by all. A crown was placed on the head of the political martyr and incense issued from large containers. Clearly the intention was to use the funeral ceremony as an occasion to galvanize support for the Revolution: the conscious objective was to encourage the people to identify with Lepelletier, a victim of counterrevolution. In an "Address to the French People," published in most newspapers, the Convention proclaimed, "Citizens, it is not one man alone who has been struck, it is not Michel Lepelletier who has been basely assassinated, it is you; it is not against the life of a deputy that the blow has been dealt but against the life of the nation, against public liberty, against popular sovereignty."[84]

David's initial role in the funeral festival did not include plans for him to paint the revolutionary martyr. On January 25 he proposed "a marble monument to show posterity how Lepelletier looked as you saw him yesterday, when he was being carried to the Pantheon."[85] Then David himself decided to do a painting, which he described in a speech to the Convention on March 29:

> I shall have done my duty if one day I cause an aging patriarch, surrounded by his large family, to say, "Children, come and see the first of your representatives to die for your freedom. See how peaceful his face is—when you die for your country, you die with a clear conscience. Do you see the sword hanging over his head by just a hair? Well, children, that shows how much courage Michel Lepelletier and his noble companions needed to rout the evil tyrant who had oppressed us for so long, for, had they set a foot wrong, the hair would have broken and they would all have been killed. Do you see that deep wound? You are crying, children, and turning your heads away! Just look at the crown; it's the crown of immortality. The nation can confer it on any of its children; be worthy of it."[86]

It is clear from David's description of the painting that he was already at work on it and he showed it in the Salon of 1793, which opened on August 10.[87]

The history of the painting is a strange one. The work was returned to

David in 1795, and he kept it until the time of his death, shortly after which his family sold it to Lepelletier's daughter, who had become an ardent royalist. She not only destroyed the painting, but also bought up copies of P. A. Tardini's engraving of the work as well as the plates. Only one mutilated engraving remains (fig. 35), the only remnant, along with a drawing of the work by Anatole Devosges (fig. 36), of what must have been one of David's masterpieces. From the mutilated print and the drawing it is possible at least to see how David designed his *Lepelletier de Saint-Fargeau*. As he indicated in his speech to the Convention on March 29, a sword hangs "by a thread" over the body of Lepelletier. The sword pierces a piece of paper, a ballot that reads "I vote the death of the tyrant." Blood drips from the sword and the white sheets on which the martyr lies would have been streaked with blood. Both the drawing and engraving show the open wound on Lepelletier's side, but it is the engraving that captures most graphically the torn flesh, from which blood flows onto the sheets. Below the wound is the clenched, powerful fist of Lepelletier, which contrasts with the expression of calm on the dead martyr's face. In depicting Lepelletier David transformed a man known for his extraordinary ugliness into one whose unfortunate features, as Brookner says, have been "turned into a sort of beauty."[88] David's altering of Lepelletier's facial features is consistent with another transformation: drawing from traditional religious imagery (and his own figure of Hector in the *Andromache* painting), particularly from Michelangelo's *Pietà*, David has created a figure worthy of veneration, a type of secular saint to whom the people were encouraged to give their devotion.

David's second martyr painting, *Marat Assassinated* (fig. 37), is his only finished surviving revolutionary painting, and it is arguably his greatest work. He was president of the Jacobin Club when news of Marat's death reached there soon after his assassination on the evening of July 13, 1793. He personally congratulated and embraced the neighbor who was responsible for Charlotte Corday's arrest. In the Convention on the next day Guiraud, spokesman for the Social Contract *section*, requested that the female assassin receive torture that would be worse than death, an appeal that has a grimly ironic edge when seen against the background of Charlotte Corday's life before she came to Paris. The daughter of a Norman aristocrat and tied through her family line to the great Corneille, Charlotte Corday welcomed the Revolution in 1789, and like many educated women can be said to have been politicized by it. Her father was also enthusiastic about the Revolution of 1789, but by 1791 events had moved faster than he could accept, and he and Charlotte fell into bitter quarreling. Still loyal to the Revolution and unable

to discuss it with her father, she left home in June 1791 to take up residence with a spinster aunt in Caen. It was there that she continued to follow the course of the Revolution. In one of her few extant letters, written in March 1792, she commented on her brother who, like her father, opposed the Revolution and with some other "knights-errant" had set off to tilt at "a few windmills."[89] In other words, he had joined the ranks of the counterrevolution. She did not believe that her brother and the other aristocrats would have any success, for the nation was "very well armed" and the "idea of Liberty" inspired its soldiers "with something very like courage."

Events soon dampened Corday's enthusiasm for the Revolution, but not for the ideals that she associated with it and still wished to see fulfilled. In May 1792 she wrote a letter describing an incident in a nearby village, Verson, which had been visited by members of the National Guard. Several priests had refused to swear the oath of loyalty called for in the Civil Constitution of the Clergy and continued to celebrate the Mass. When soldiers arrived, the priests, forewarned of their arrival, had fled, so they sacked the chapel and took some fifty people prisoner and forced them to walk, bound by ropes, to Caen. Most of the prisoners were women. Moreover, the soldiers cut off the hair of a curé's sister and a canon's mother and branded several other women. Charlotte Corday wrote of the incident: "You ask me what happened at Verson. Every imaginable abomination. About fifty people were beaten and their hair cut off. It seems that it was largely women they had a grudge against. Three of them died a few days later. The rest are still ill . . . among the women were the Abbé Adam's mother and the curé's sister." Having described the outrages she said, "That's enough about them," and added that all of her friends were leaving. "We are now almost entirely alone." Beset by feelings of loneliness she said that her death (she was twenty-four) would pass without notice. Still, she dreamed of a better life: "When the present offers nothing and there is no future, one must take refuge in the past and look there for the ideal life which does not exist in reality." She did not give up her political idealism or her commitment to the Revolution. When a friend chided her for living so much in the past, she replied she wished she had in fact lived then: "In Sparta and Athens there were many courageous women." She would show her courage when she went to Paris on July 11, 1793, with the specific plan of killing Marat, whom she believed embodied all that had gone wrong in the Revolution, particularly since the storming of the Tuileries on August 10, 1792, and the September Massacres that followed.[90] Appalled by the direction the Revolution had taken, she hoped to put it back on course by eliminating the person she

identified most closely with the misdirection. She would save the Revolution by assassinating Marat on the floor of the Convention, where she expected to be killed on the spot. Upon arriving in Paris she learned of Marat's illness, one symptom of which was a skin disease that obliged him to remain at home so he could soak in a tub. Before going to his house in the rue des Cordeliers she bought a butcher knife at a shop in the Palais-Royal and presented herself at Marat's door with a note containing news, she said, of Girondin plots in Normandy. Marat's common-law wife refused her admittance, so she returned in the evening, again asking to see Marat. This time Marat heard her and shouted for her to be let in so he could hear her story.

Charlotte Corday had taken good measure of Marat, for if anything could be expected to stir his interest it was news of fresh plots. When she was in his presence Marat asked for information about the rebel Girondins that she had spoken of and after writing down their names, he said that "they would all soon be guillotined in Paris."[91] At that point Charlotte Corday drew her knife from her dress and plunged it into Marat's right side, next to his collarbone. The violent deed that was intended to end revolutionary violence had the scarcely surprising effect of unleashing further violence. As J. M. Thompson has written, "Charlotte's deed was the prelude, not to a Girondin peace, but to a Jacobin vendetta."[92] And it may also have contributed to the mounting feeling against women in the Jacobin Club which reached a peak a few months later when demands were made for the closing down of women's political clubs and for their exclusion from meetings of the Convention. By that time the Terror was in full swing and women were no longer to play a direct role in revolutionary politics. It was men who presided over the Terror and were responsible for the politics of violence. These facts underscore the irony in the appeal made by Guiraud on the floor of the Convention on July 14 not only for Charlotte Corday's death but for torture worse than death.

In his speech to the Convention, Guiraud said, "Where are you, David? You have transmitted to posterity the picture of Lepelletier dying for his country, and here is another painting for you to do." David replied, "Yes, I will do it."[93] The circumstances of the *Marat Assassinated* commission are different than those of *Lepelletier de Saint-Fargeau*: it was not David who proposed the work but a fellow member of the Convention. Still, in a sense David may be said to be responsible for the idea of his second martyr painting because it was his first that prompted Guiraud to call upon David to confer the same honor on Marat. And David saw the second work as a

companion to the first. The two paintings were almost identical in size and the two martyrs faced each other when the pictures were hung together in the Convention on the wall behind the speaker, where they were seen by all members of France's governing body.

David had visited Marat the day before his death. He recalled, "The day before the death of Marat the Jacobin Club sent me and [N.-S.] Maure to see how he was. I found him in a striking position. He had beside him a wood block with paper and ink on it, and his hand, hanging over the bath-tub, wrote down his latest thoughts for the people's safety . . . I thought it might be interesting to show him in the position I found him, writing for the people's happiness."[94] Already in these remarks, made before he began the painting, David can be seen transforming Marat's death from a grim and sordid deed to one that expressed his own fervid idealism. The reality was that an assassin inveigled her way into Marat's room by bringing news of alleged Girondin plots, a stratagem that she correctly calculated would stir his interest. In his room she gave news of the fabricated plot, which led to Marat's reply that the traitors would be assassinated. He said this without any evidence, without any trial, with nothing but the word of a person he had never seen. It was precisely such disregard of ordinary legal procedures, such unswerving determination to destroy all who were suspected enemies of the Revolution that was the essence of Marat the political person, and it was to rid France of such a person that Charlotte Corday journeyed from Normandy to his house in the rue des Cordeliers.

For David, however, Marat had been writing down his "latest thoughts for the people's safety" when he saw him in his bath the day before his assassination; he had been writing "for the people's happiness," and that was how he was to portray him in his painting. Before beginning the painting David did a pen drawing of Marat's head (fig. 38), probably between July 14 and July 16. The transformation of Marat from the fierce and physically ugly person that he was into a figure of veneration and adoration, the secular savior of the finished painting, has already taken place in this drawing. David had sketched Marat before, in his study of the *Tennis Court Oath* (fig. 31). The Marat of that sketch bears little resemblance to the idealized drawing and the painting of 1793 done after his death. In the *Tennis Court Oath* sketch Marat's long nose and chin jut out as he looks with stern eye at the words he inscribed on his tablet of paper, and to underline the militancy of the journalistic message his hand is held at the same level as and is opposite the hand of the soldier that brandishes a sword. This was the real Marat. The Marat of the drawing, *Head of the Dead Marat*, and of the painting, *Marat*

Assassinated, came out of David's imagination, out of the feelings and emotions that were responsible for the creative chemistry and the artistic transformation.

In some external respects David portrayed Marat just as he had seen him the day before his death, with one hand out of the bathtub so he could write. Also, he included the wooden box in his painting that he had seen with paper and ink on it. While his written description of the visit did not include such details as the turban on Marat's head or the sheet in the tub, it would be safe to assume that David showed them much as he had seen them. The Chardinesque attention to physical detail, the remarkable realism of the painting, most explicit in the marred surface of the wooden box, is thus combined with an utter disregard of the actual features of Marat. Adding to the realism of the work was the gaping wound in Marat's chest. Blood flows onto the sheet he lies on and smears of blood are on the leaf of paper he holds with his left hand and also on the sheets beneath his arm. The water in the bath is blood red, and the knife that Charlotte Corday had plunged into his body lies on the floor with traces of blood on the handle and a heavy coat of blood on the lower part of the blade. The color red is all the more striking because it is seen against the pallid skin of Marat. The brilliant red of the painting is made arresting not only by the light field provided by the sheet but also by the green cloth over the tub and the dark green-brown stippling of the background. Violence and death are at the center, the spiritual center, of this painting.

When Charlotte Corday was arrested, a letter that she had written earlier in the day but did not show to Marat was found tucked into her dress. In a slightly amended form it was read at a meeting of the Convention, and it was this letter that David showed in the dead hand of Marat, smeared by his own blood. The original version of the letter ended with the sentence, "I am wretched; that alone gives me a right to your protection."[95] In the version David heard in the meeting of the Convention it was altered to, "I need only make you see how wretched I am to have a right to your esteem."[96] In the painting David added changes of his own to heighten the effect he strove for, and it now reads, "It is enough for me to be truly wretched to have a right to your kindness."[97] Through David's verbal amendment the duplicity of Charlotte Corday has been heightened; she is seen to have appealed to the "kindness" of the man that she has killed with her knife.

The use of religious imagery in *Marat Assassinated* is obvious and often commented upon; it is realized through forms that suggest a descent from the cross. The secular savior, the revolutionary saint, has been cut down by

an assassin who appealed to his humane instincts, to his adoration of the people. To underline that point Marat is seen holding his pen in the moment of death, with which, as David said, he had been "writing for the people's happiness." What further drives home the point of Marat's "kindness" is the *assignat* on the wooden box, with a covering note by Marat that reads, "Give this *assignat* to your mother."[98] In taking such liberties as these—showing a letter in Marat's hand that had been altered and having him give a promissory note to someone's mother—David invested the painting with symbolic meaning.

When David presented the finished painting to the Convention on November 15, 1793, he gave a speech that recalls his earlier comments in March on the *Lepelletier* painting. He said of the *Marat Assassinated*:

> Hurry, all of you! Mothers, widows, orphans, oppressed soldiers, all whom he defended at the risk of his life, approach and contemplate your friend; he who was so vigilant is no more; his pen, the terror of traitors, his pen has slipped from his hand! Grieve! Our tireless friend is dead. He died giving you his last crust of bread; he died without even the means to pay for his funeral. Posterity, you will avenge him; you will tell our descendants how he could have possessed riches if he had not preferred virtue to fortune. . . . To you, my colleagues, I offer my homage with my brush; as you observe the livid and bloody features of Marat, you will remember his virtue, which you must never cease to emulate.[99]

David's remarks on his *Marat* and *Lepelletier* seem oddly inept when they are compared to the paintings themselves. One work was an undisputed masterpiece—the masterpiece of the French Revolution—and the other a work that, judging from an extant print and a drawing, carried the full stamp of David's genius. The paintings are incisive and terse, direct and forceful of utterance, and profoundly moving in their conviction and poetic truth. Yet when David speaks of these works his language is that of an eighteenth-century sentimental play, cloying in its appeal to the poor and defenseless and false in specific claims. Carried away by the flood of his feelings David said that Marat died giving his last crust of bread to the poor. It was true that Marat had not grown rich from his writings and that unlike others such as Danton he had not sought or accepted bribes, but he had not died giving up his last crust of bread. He was killed just after vowing to have Girondins executed on the basis of remarks made by a woman he had never previously seen. The very torrent of emotion that swelled into inflated and bombastic prose when

David put his thoughts into words had an utterly different result when they acted upon his creative chemistry and when he translated his feelings into visual images with his brush. In both the *Lepelletier* and *Marat* there is a striking contrast, almost a bottomless gulf, between the verbal descriptions and the paintings themselves.

Still, the verbal descriptions of the *Lepelletier* and *Marat* paintings do achieve, however tendentiously, something that was of central importance to both works. In the case of the former painting, David has an aged patriarch address children, telling them to observe Lepelletier's deep wound and not to turn their heads away as they cry. The children are urged to look at and be worthy of the martyr's crown of immortality. If inspiring patriotism is David's intention, as indicated by his description of the *Lepelletier*, it is through appeal to the feelings, to emotion, that he would realize his goal. The result is a work of deep pathos—and one that inspires pity. The same is true of the *Marat*. In the description for this painting David asks "Mothers, widows, orphans, oppressed soldiers" to observe the "bloody features" of Marat. Once again David appeals to feelings of sorrow and sympathy; once again he would inspire pity. In both of these paintings David shows victims of the Revolution and he emphasizes the violence of their death through gaping holes in flesh and blood that drips and gushes; in the case of the *Marat* blood turns water in the tub red and coats the blade and smears the handle of the knife, the instrument of death. David portrays violence so graphically, not only for the reason that he gives in his written accounts, to inspire patriotic virtue, but to inspire pity. Pity is the key that would open the door of loyalty to the Revolution; and that pity emerges from a deep reservoir of feeling within David himself.

The last of David's martyr paintings, *Joseph Bara* (fig. 39), is very different from its predecessors. Bara, a thirteen-year-old who was too young to join the army, nonetheless attached himself to a unit that was fighting counter-revolutionaries in the Vendée. He was killed by enemies after refusing to give them two horses they demanded. As James Leith has shown, from the political point of view there were definite advantages in celebrating a young hero such as Bara, or another youthful martyr, Agricol Viala, who was also to be honored in the revolutionary festival that David was to have staged.[100] Youthful heroes had no political past and consequently were free of controversy. This was in striking contrast to Lepelletier and Marat, one a regicide and the other famous—or notorious—for the violence of his ideas and his rhetoric. Both were assassinated for the very reason that they were so controversial. With Bara and Viala this was not the case.

General J.-B. Desmarres, who led Republican troops against a counter-revolutionary force in the Vendée, gave the following account of Bara's life and death: "The entire army saw with astonishment a youth of thirteen confront every danger, always charging at the head of the cavalry. One even saw him with his small arm throw to the ground and capture two brigands who had dared to attack him. Yesterday this courageous youth, surrounded by brigands, chose to perish rather than give them the two horses he was leading."[101] Having sent this account to the Convention on December 8, 1793, and having heard that David would do a painting of the young martyr, Desmarres wrote a second letter spelling out the way he thought the painting should be done: "I believe the way [Bara] should be seen is when he received the last blows, that is on foot, holding the horses by the bridle, surrounded by brigands, replying to the person who came forward to make him give up the horses. 'To you, damned [*foutu*] brigand . . . the commander's and my horses! Are you sure? [Eh bien, oui . . .].' These are his words, repeated several times, that cost him his life."[102]

In the period between Desmarres's two letters on Bara, during which plans were being made for a revolutionary festival in his honor, Robespierre had taken an active role in the project. Recognizing the propaganda value of a Pantheon funeral for Bara, which Desmarres had requested, he conceived the idea of transforming the circumstances of his death. Rather than being killed by Chouans (Breton royalists) who merely wanted to steal two horses, Bara was to be "surrounded by brigands who on one side threatened to kill him and on the other ordered him to cry 'Long live the King!' [and] he died shouting 'Long live the Republic!' "[103]

If Robespierre converted the killing of a boy by enemies who stole his horses into a political event heavy with propaganda value, David denied the actual circumstances of the event even more radically in his painting (fig. 39).[104] An anonymous engraving depicts the event much as Desmarres described it, with Chouans stealing two horses and holding the weapons they used to kill Bara. In David's unfinished painting a nude, androgynous youth is seen lying horizontally on the ground, clasping a cockade in his hand. Apart from the cockade and the outline of a flag that barely intrudes into the picture space on the far left nothing about the painting suggests a political content and nothing whatever refers to the actual circumstances of Bara's death. There are no horses, no soldiers, only the curvaceous figure of a boy who does not appear to be a boy. While it has been said that David might have planned to paint clothes onto the figure of Bara, the detailed brushwork on parts of the body suggests that this was not his intention.[105]

Moreover, David's rendering of the nude figure indicates that he wanted to portray an androgynous youth, certainly not a virile young soldier. At first glance one would assume that the nude figure is that of a girl with long tresses flowing from the beautiful head: the lips are red, and the full hips are more feminine than masculine. Departing still further from the actual circumstances of Bara's death and even from the reality of death itself, the body of the sinuous youth is not only without wound marks but the boy is still alive. The head is raised, and the eyes are closed not in death but in rapture, which is also expressed by the lips of the youth. In removing from his painting the grim circumstances of the boy's death David has created a stylized figure, an abstract image whose perfect feminine beauty expressed an ideal more spiritual than physical, more timeless than contemporary and political.

The question is, why did David depart so radically from the historical particulars of Bara's death in his painting of the youthful martyr? It should be borne in mind that he had taken liberties in both of his earlier paintings of revolutionary martyrs, transformations that, as in his *Bara,* were the work of a refining and idealizing creative process. But in *Lepelletier* and *Marat* the transformation was carried out with a logic that always kept sight of politics; indeed, politics was of central and dominating importance. In the painting of *Lepelletier* the sword that pierced the ballot paper with the inscription "I vote the death of the tyrant" speaks directly of politics, as does the letter of Charlotte Corday in the hand of the *Marat.* Everything about these works expresses one essential point, that heroes have been sacrificed to the Revolution. Both victims are political martyrs. And David identified himself with the heroes, with the martyrs, in inscriptions to both. At the top of *Lepelletier* appear the words "To Michel Lepelletier, assassinated for having voted the death of the tyrant, J. L. David, his colleague," and on the wooden box of *Marat* David wrote, "To Marat, David."

The emotional and creative processes responsible for the transformation of Bara from a brave young soldier into an androgynous youth clearly followed a different logic than that of the *Lepelletier* and *Marat* paintings. Politics is no longer central to the logic, at least as evidenced by the few pictorial references to politics in the painting. David was painting a work for the Revolution, in conjunction with a revolutionary festival, and he did put a cockade in Bara's hand and include the outline of a flag at the left of the work, but otherwise political images or symbols are missing. What is most striking about *Joseph Bara* is not its timeliness but its timelessness.

Was David, then, less dedicated and committed to the Revolution when

he worked on *Bara* in the summer of 1794 than he had been when he did *Lepelletier* and *Marat* in 1793, some nine to eighteen months earlier? Was he less of a political person when he organized the festival for Bara and Viala than when he did the earlier festivals for Lepelletier and Marat? The answer to these questions is no, as proven by his remarks to the Convention on July 11, 1794, when he was making final plans for the Bara and Viala festival. As we have seen in the quotation at the beginning of this chapter, David lashed out at the "oppressors of the earth" and the blood-sucking despots who forged chains for their victims. Of all David's political speeches this is the most unbalanced, the most excessive in its flights of overheated rhetoric, and of all his speeches this is the one that expressed his anger, his political anger, most directly. In praising two youthful martyrs he made long and angry denunciations of the enemies of the Revolution. He exhorted aged fathers to rejoice if they were parents of heroes such as Bara and Viala, and he assured mothers whose "chaste fecundity multiplied the resources of the *patrie*" that they were heroines of the Revolution because their sons fought for liberty and gave up their lives to the Nation.[106] The sense of dread that accompanies David's appeal to parents to rejoice in the sacrificial death of their children is, if anything, even more graphic in his rhetorical address to the young heroes he was to celebrate in the festival: "O Bara! O Viala! The blood that you have spread still smokes; it rises toward Heaven and cries for vengeance."[107]

The contrast between the language of David's speech to the Convention, typical of Revolutionary rhetoric at this stage, and his painting of Bara is striking. Into the speech he poured all of his agitated feelings and his intense commitment to the Revolution, as well as his anger toward its enemies. The language is overwrought and his verbal images are grim and bloody. The speech reeks of excess. The painting, however, is pristine, elegant of line and shape, and the sinuous form of the androgynous youth is distant from the world of contemporary politics and violence.

How are the differences between the language of David's speech and that of his painting to be explained? To answer this question it is necessary to think about David's role in the Revolution in 1793 and 1794. The extant evidence is fragmentary and only describes the external facts of his political experience, but the information we have suggests the tremendous and mounting pressures David experienced. As a member of revolutionary committees he signed 406 orders to arrest, search, or detain political suspects. Many of these people went to the guillotine. Among those arrested and sent to the Revolutionary Tribunal by his order were the marquis de Fleury, the duc de Villeroy, the former noble and intendant Antoine-Jean

Terray and his wife Mme du Barry, and Alexandre de Beauharnais, all of whom were executed. He ordered the aged marquise de Crussol to be sent to prison. He also signed arrests for the young and beautiful Bellegarde sisters, whom he was later to befriend, and for Quatremère de Quincy, an old friend. He signed arrest orders for former priests and nuns. And of course he signed the death warrant for Louis XVI and Marie Antoinette. He signed these orders bureaucratically and at the same time out of duty and responsibility. How he felt as he did so is an interesting question to ponder. How did he respond to the death of old friends and acquaintances, such as André Chénier, both Trudaine brothers, and Mme Trudaine? What did the execution of Lavoisier, the subject of one of his finest paintings, mean to him? And the executions of Danton and Camille Desmoulins, which he witnessed? Another consideration should be taken into account; that is, the mounting violence of the Revolution, which included the elimination of those who did not follow the relentless movement to the left or were suspected of disloyalty. The patriot of yesterday could become and in many notorious cases did become today's enemy, and as such that person could go to the guillotine.[108] It is this grim fact, which was central to the Terror, that one must recall in attempting to reconstruct David's political experience. Of course, David's experience cannot really be reconstructed, but it can be imagined. Particularly valuable in this task are David's three martyr paintings.

In *Lepelletier* and *Marat* David transformed sordid political deeds into visions of sacrifice. These works belong to the hagiography of the Revolution, and their political content is consistent with the idealization. Both the political content and the idealization issued from David's mind, from his commitment to the Revolution and from the emotional realm, his intense feelings, which nurtured his political dedication. The unity of feeling and dedication, in a political sense, that is so striking in *Lepelletier* and *Marat* is much less present in *Bara*. With the *Bara*, David's commitment to the Revolution is now expressed in his speech to the Convention, with an extremism and violence that is strangely at odds with the painting. The painting is less the repository of politics and ideology and more a display of feelings that have been separated from their former source. In thinking about all three martyr paintings it is important to keep in mind that the themes of suffering and pity are common to each. It was David himself who had the idea for the first of these paintings, and it was that example that was responsible for the two that were to follow. In this sense David was the source of all three paintings in the sequence. Moreover, these were his only

political paintings in 1793 and in the six months of 1794, before the ninth of Thermidor. Surely there is something significant in his choice of subject, which was heavy with propaganda value but also provided an outlet for his own intense feelings. In 1793 and 1794 David consciously avoided battle scenes and the portrayal of political events such as the storming of the Tuileries or speeches given by revolutionary leaders on the floor of the Convention.[109] Nor did he do portraits of living leaders, such as Robespierre, to whom he was politically devoted. Rather he chose to paint the fallen heroes of the Revolution, subjects that could convey the feelings that arose from the realm of his emotions. When David's feelings passed into his painting of the *Bara* they were far removed from the political dedication so evident in his earlier works. Moreover, those feelings were not represented by the staunch male hero of the first two martyr paintings but by the androgynous figure of the *Bara*. Indeed, for all appearances the form was that of a girl. And it is not just the physical features of the figure that suggest this: the sinuous lines, the flowing arabesques recall forms David had used in his prerevolutionary paintings to portray women, forms that symbolized for him the female character. Stylistically, then, the figure of Bara belongs to an earlier current of David's art, one that found expression in the grouped female figures in the *Oath of the Horatii* and *Brutus and the Lictors*.

It is useful to see *Bara* not only within the earlier current of style but against the crystallized forms of *Lepelletier* and *Marat*. Compositionally both of those works are noteworthy for their use of geometric forms, provided in the first by the sword which dissects the pictorial space and is at the spiritual center of the work and in the second by the sharp edges of the wooden box and the flat cover that lie across the top of the bathtub. The inert figures of the dead martyrs and the curved lines that define them are superbly integrated into the geometry of the two paintings. In *Bara* there are no planes, there is no geometry; the work is exclusively dominated by arabesques. In pictorial terms the female principle has won out over the male principle.

To say this is to connect *Bara* to an argument that has run through much of this and the preceding chapter. We have maintained that in David's emotional life, within his psyche, there was a combative, zealous, and strident side, just as there was a lenient and sympathetic side. The concept of "male and female principles" has been employed to characterize the different components of David's makeup. Superficially it would be easy to say that David the politicized, Jacobinized revolutionary, the regicide and terrorist, was the product of the male component and that his martyr paintings, particularly the first two, were the artistic expression of that fact. Just as the

violence of the prerevolutionary *Horatii* and *Brutus* can be linked to the male component, so can the violence of *Lepelletier* and *Marat,* made graphic by the open wounds and the instruments of death, the sword and the knife, be tied to the same configuration.[110] Yet violence is not what is most central to the paintings. Rather, the violence dramatizes the real purpose of the paintings, which is to inspire loyalty through pity. To put the proposition differently, in creating these images David gave artistic form to icons, which were the repository of his own feelings of loyalty and pity. If the former attribute, loyalty—political loyalty—came from the male component, the latter—pity—issued from the other part of his emotional life, the female principle, as we have called it. Thus in both *Lepelletier* and *Marat* there is a mingling, a convergence, of the two elements of David's psyche. At this stage of the Revolution David was able to pour into his martyr paintings his intense political feelings, his ideology, as well as his feelings of sympathy. In that sense both works are fully integrated psychologically, just as they are unified pictorially through a resolution between the geometric forms and the sinuous lines that define the martyr's dead bodies. In the *Bara* there is no such unity, no such resolution, just the flowing arabesques of the youth. It is as if David's pity had torn its way loose from his still active political commitments. In view of the violent, intemperate language of his speech to the Convention for the Bara and Viala festival, it would seem that the separation between the two impulses was complete. It is as if once that separation was made David's dogmatic and obstreperous tendencies went unchecked in a political speech, whereas the pity passed into the purified form of the beautiful youth. In other words, even as one side of David remained fanatically loyal to the Revolution, another side avoided its grim reality. The pressures under which he had lived for the last year and a half had taken a toll, one suspects a massive toll, and something within David gave out, something collapsed. David's *Bara* is an expression and a record of the collapse, of the burdens that had become too great to bear. In that respect the painting can be seen not only as evidence of David's own experience as a revolutionary but of the Revolution itself. That the work was not completed, and that the festival for Bara and Viala was never held, is significant and symbolic. The logic of fear that drove the Revolution relentlessly forward and consumed ever wider circles of the revolutionary leadership had all but run its course when David made his speech to the Convention on July 11, 1794. The Revolution itself was on the edge of collapse, and days later, on July 28, the end would come with the execution of Robespierre. Not only can David's *Bara* be seen as an expression of David's own responses to the

intolerable pressures of the Revolution but it profoundly reflects the larger history of those troubled times. If David's prerevolutionary paintings breathed the atmosphere of the period immediately before the 1789 upheaval, so does *Bara* partake of the accelerating pressures of a Revolution that was about to fall victim to its own logic. It can be said of David's *Bara* that is was pre-Thermidorean. It is a record of personal and political stresses too great to withstand and as such it anticipates the end of the Revolution.

David

AFTER THE FALL OF ROBESPIERRE

If you drink hemlock I will drink it with you.
—8 Thermidor (July 26, 1794), David to Robespierre[1]

*For three months I have languished under the weight of suspicion all the more
weighty because its source is only in the excess of my love for the patrie and for
liberty, for if the false virtues of Robespierre appealed to my patriotism the error that
I succumbed to was less the effect of particular feelings that attached me to him
than the result of the universal esteem that I saw always surrounded him.*
—November 4, 1794, letter written by David in prison to the Convention[2]

*I am prevented from returning to my atelier, which, alas, I should never have left.
I believed that in accepting the most honorable position, but very difficult to fill,
that of legislator, that a righteous heart would suffice, but I lacked the second
quality, understanding.*
—November 8, 1794, letter written by David in prison to
M. de Mainbourg[3]

*Thus before the ninth of Thermidor I was culpable, without doubt, of marching in
the revolutionary line traced by the dominant opinion of this period, and when
summoned before the three committees which were to review my case showed them
that my misconceptions of the surreptitious views of Robespierre and his accomplices
were largely those of the Convention itself. . . . Since this period, which has opened
my eyes, I have maintained a reserve and circumspection in my conduct to the point
of timidity. Learning from a harrowing experience to mistrust the appearances of
patriotism, freedom, and good faith, I have broken every connection with the men
whose company I kept before my detention.*
—May 1795, from David's reply to charges made against him by
the Museum Section[4]

ROBESPIERRE made a long speech before the Convention on 8 Thermidor, revealing what he described as a vast plot against public liberty headed by a criminal coalition that even included members of the Convention.[5] The conspirators, he said, had accomplices in the Committee of General Security and also included certain members of the Committee of Public Safety. Once again Robespierre's ringing oratory seemed to carry the day, as thunderous applause swelled across the floor of the Convention, striking fear into those present, some of whom were in fact conspiring against him. One of the people mentioned by name in Robespierre's diatribe, Pierre Joseph Cambon, demanded to be heard: "Before being dishonored, I will speak to France! . . . It is time to tell the whole truth: a single man has paralyzed the will of the National Convention; it is the man who has just made the speech; it is Robespierre." Then others, not named by Robespierre but fearing they were on a list he had referred to, defended themselves and denounced the once infallible leader. Robespierre was shaken and refused to give the names of those involved in the conspiracy, even when pressed. Knowing full well that the next day would be crucial, he announced in a meeting of the Jacobins later that night, "We must deliver the Convention from these scoundrels! If we fail, you will see me drink the hemlock with calm."

In a scene reminiscent of his emotional defense of Marat just over a year earlier David rushed forward and embraced Robespierre, saying, "If you drink the hemlock I will drink it with you." That David was not present at the meeting of the Convention on 9 Thermidor probably saved his life. Robespierre went to the guillotine on 10 Thermidor, along with eighteen others, and in the following days more than eighty members of his party met the same fate. David claimed that he missed the meeting of 9 Thermidor because of illness; he was not arrested until 15 Thermidor. Initially he was imprisoned in the Hôtel des Fermes on the rue de Grenelle-Saint-Honoré, and then transferred to the Luxembourg Palace. This period of imprisonment lasted until December 28, 1794, but new charges were drawn up against him later, and he was imprisoned a second time on May 28, 1795, when he was placed in the Quatre Nations. He was released because of illness on August 4, and on October 26 the Convention voted a general amnesty that freed him of all charges.

During his incarceration David had to defend himself against two major sets of charges: he had been a follower of Robespierre and a member of the ruling group; and he had signed arrest warrants that led to imprisonments and executions. Besides these general charges, he had to answer other

accusations, and account for the cost of the festivals he had organized. The task of self-defense was formidable and resulted in statements that David sent to the Committee of General Security, the Committee of Public Safety, and the Convention. During the period of first imprisonment he defended himself on September 15, and November 4, 14, 16, and 17. By far his longest statement was made in May 1795, during the second period of imprisonment. He also wrote letters to students who had intervened on his behalf to the Convention. Taken together, these statements of David's, made in prison, are a remarkable record of an artist who had to explain his conduct to others and who, most certainly, asked himself some searching questions, trying to sort out in his own mind what had happened within his world and what had happened to himself.

Defending himself against charges of being a supporter of Robespierre was made all the more difficult by his impulsive vow to "drink hemlock" with him. In the second of the opening quotations (November 4, 1794), David maintained that he had only made the same mistake as others in following Robespierre, who had appealed to his patriotism and love of liberty. To the extent that he had been wrong it was because of "the excess of my love for *la patrie*." In the next quotation (November 8, 1794) David says he should never have left his atelier, and explains that while he had a "righteous heart" he had lacked understanding. The third passage is an excerpt from his lengthy defense of May 1795. He has now argued his case many times and repeats his former claims: he had indeed been culpable, but only as others had been who also marched "in the revolutionary line traced by the dominant opinion of this period." He had not known of the "surreptitious views" of Robespierre, but since 9 Thermidor his eyes had been opened. He had learned from a devastating experience, and would not again repeat his former errors. From now on caution would be his guide, "to the point of timidity," and he had severed ties "with the men whose company I kept before my detention."

Trying to explain away his ties to Robespierre and the arrest warrants he signed as a member of the Committee of General Security involved David in arguments that, however skilled, were less than forthcoming. For someone as self-righteous, as convinced of his own virtue as David was, disclaiming responsibility for what he had done could not have been easy. It led him into repeated assertions of innocence. "One could never reproach me for any reprehensible deed because my intentions have always been just," he wrote on September 15, 1794, and then quoted a line of *Phèdre*: "The day is no more pure than the depth of my heart."[6] He likened himself to Hippolyte, falsely

accused and the victim of implacable forces, but always certain of his own purity of heart. On November 16, 1794, David wrote that "only a man truly a friend of the arts can fully appreciate the heart and head of an artist. [Such a person] knows better than any other that the artist's exalted imagination draws him forward almost always to a purpose. I knew it myself, I believed I was right, when the abyss opened beneath me and nearly consumed me. How wicked people have abused me. Never believe that I have participated in their infamous plots. No, no, my heart is pure, only my head was wrong."[7] And again, on the very next day, November 17, he made similar protestations of innocence: "I repeat, representatives of the people, and I would proclaim it to my last breath: my conscience is pure and my heart was always free of ambition. I never raised my voice except for the triumph of liberty."[8]

Mingled with his expressions of innocence were claims of victimization. Here the David of old can be recognized, the David who saw the world not in shades of gray but in black and white, the dualistic David whose paintings had revealed a Manichean universe. He said on November 16 that "wicked people have abused me,"[9] and on November 4 he said he had been punished too severely for mistakes that were nothing more than an "illusion." His only crime was failure to understand a colleague who had deceived him. Since he had never had "criminal thoughts" nor had he "drenched his hands in innocent blood" he asked for his liberty so he could return to his home and his art.[10] That he was still detained, he wrote on November 17, injured the principles of justice and equality, and could only be explained as the work of a "secret enemy."[11]

When new charges were made against David in March 1795, artists from the Museum Section took the initiative. Already on March 28 he had defended himself against his accusers, before a formal statement with seventeen specific charges was presented to the Convention on May 2. He refuted those charges in a public reply on May 3, which angered antagonists who continued their efforts to bring him to justice. In the meantime, he was working on a longer and more elaborate answer to the seventeen charges. Then, on 1 Prairial (May 20) there were riots in Paris, one of several uprisings that punctuated the period between the fall of Robespierre and the rise to power of Napoleon. In the atmosphere of fear that followed, David was arrested a second time, on May 29. It was during the ensuing period of imprisonment at the Quatre Nations that he released the long statement of defense he had been working on before his arrest.[12]

In the preliminary observations of his statement, David noted that not

everyone on the revolutionary committees had been arrested. That he had been arrested, he said, could only be explained as the work of those bent upon persecuting him. He declared that the accusations were "completely calumnious" and that his enemies benefited from his absence from Paris during the uprising of 1 Prairial. That absence, as well as his conduct in general, had been useless against the "campaign of hate" that followed him. Then, in his seventeen rebuttals, he answered each of the specific charges, not only denying their validity but presenting himself as an advocate of artistic liberty throughout the Revolution.

It is true that no artist was executed during the Revolution, but this does not mean that David helped all artists. He did go out of his way to support some, but others, such as J.-B. Suvée and Hubert Robert, were imprisoned. Moreover, he denounced Joseph Boze before the Jacobins. Yet, David was able to deny a charge against him by members of the Museum Section that he had drawn up lists of artists to be denounced. A list of artists had, in fact, been found in David's house, but he explained that it was one he had sent to the Ministry of Education with the names of jurors for a competition organized by the Committee of Public Security, of which he was a member. He went on to claim that he had never "signed any note or written any letter having as its object provoking the severity of the revolutionary committee of the Museum Section against the citizens of this Section." Far from arresting or working for the arrest of artists, he said, he helped those who had taken the side of his enemies. Besides denying the charges against him David tried to explain how they could have been made: "In a time of revolution, in which so many deadly passions almost dishonor human nature, people's imagination is seized by an almost irresistible force. That, without doubt, is the secret and I would almost dare to say the mechanism of the persecution directed against me."

In defending himself David alternately projected an image of a stalwart, even heroic patriot and an innocent, fragile artist. Waxing proud, he commented, "What an immense surface I present to the arrows of those snarling about me"; then, shifting gears, he resorted to self-pity: "Ah, how these cruel enemies who pursue me, those who, abusing circumstances, dare to portray me in dark colors . . . say what sacrifice I have refused to make for my country, how I have violated the rights of nature, betrayed the duties of friendship." Still, even in the midst of his misfortunes he found consolation: the plight he suffered was responsible for the recovery of his wife. Out of his misfortunes came marital reconciliation; he had regained the heart of his wife who had been misled by "false appearances." In prison, as before,

David revealed a divided personality, one given by turns to stoic pride and to effusions of self-pity.

How, we can now ask, did David respond artistically to the jarring changes in his own life brought about by 9 Thermidor? In answering this question one point becomes immediately apparent: the conditions of his imprisonment were far from severe. His room in the Hôtel des Fermes had been the studio of the concierge's son, one of David's former students. Pierre Delafontaine, another student, accompanied his master to the place of detention and was sent straightaway to obtain colors, brushes, an easel, canvases, paper, and books. Delafontaine also brought David the mirror that he used for the *Self-Portrait* (fig. 40) made while David was still in the Hôtel des Fermes.

That David should have done a *Self-Portrait* as soon as he was placed in detention—presumably it was the first painting he did—is singularly appropriate. Who is this person, the portrait seems to ask, who has been placed in prison? David referred several times during the period of his detention to his being "in chains," and even signed one of his works that way. In fact, he was visited at the Hôtel des Fermes by his wife and children and already a tearful reconciliation had taken place. He was also visited by students who worked on his behalf until he was finally freed. And he was allowed to paint. In the *Self-Portrait* we see the artist not in tattered clothing in a prison cell but dressed much as he had been in the 1791 *Self-Portrait,* if anything even more smartly with his stylish bow. He is seated on an upholstered chair. The way he sits on the chair, bolt upright, is one of the keys to the painting. The pressure suggested by the upright posture seems to pass into the taut hands that firmly clasp the brush and easel.

The presence of the brush and easel is but one of the differences between this *Self-Portrait* (fig. 40) and the 1791 *Self-Portrait* (fig. 22), in which there are no such instruments. The background had been dark in the earlier painting, but here David is seen against a light setting. Moreover, the brow is less furrowed in the painting done in the Hôtel des Fermes, and the expression is less troubled. David looks younger, if anything, in the later self-portrait, with a warm glow on his cheeks and with hair falling across his forehead rather than pulled back, as in the 1791 painting. The handsome, fit artist in the painting certainly does not look his years—forty-six—and does not look like a prisoner. Indeed, the fact that he grasps his brush and easel seems to emphasize the fact that he was an artist. Here I am, the painting seems to say, practicing my profession. If the facial expression is less troubled than that of the 1791 *Self-Portrait,* it is more earnest, as if to stress his probity. The earlier

work expresses inner tensions and frustrations, the later one reveals a person of candor and forthrightness. There is scarcely a hint of the distended cheek in the 1791 *Self-Portrait*, but the disfigurement is not concealed in the 1794 version. The artist would hide nothing, but would show himself to the world in all of his truth. As Brookner says, the expression is one of "baffled honesty."[13]

The *Self-Portrait*, like his written self-defenses, is a statement of innocence—and at the same time it is utterly different than what he wrote about himself. The verbal protestations of innocence were completely sincere, and they help us to understand the *Self-Portrait*, but they seem bathetic in comparison to the conviction of the painting. If David's self-righteousness led him into self-pity in his written defenses, his belief in his probity found superb expression in the *Self-Portrait*. And one of his comments made during the period of detention suggests a subconscious realization that he could express himself best as an artist. He said on November 16, 1794, a few months after completing the *Self-Portrait*, that "only a man truly a friend of the arts can fully appreciate the head and heart of an artist," implying that an artist is different from others.[14] In its ability to capture conflicting feelings—anxiety and innocence, bewilderment and rectitude, bafflement and honesty—the *Self-Portrait* succeeds precisely where the written defenses fail. The stock phrases of the writing are replaced by the remarkable control of the painting, and the fluctuations between verbal flights of indignation and descents into self-pity are transformed by the magic of David's brush into the ambiguities and tensions of the art.

David's detention was a time of considerable artistic activity, in marked contrast to the preceding period. In the seven months before 9 Thermidor his only painting was the unfinished *Bara*, but during the period between his arrest on 15 Thermidor (August 2) 1794, and his final release on 16 Thermidor (August 3) 1795, he turned out nine paintings. The paintings include the *Self-Portrait*; a *Portrait* of his mother (lost); the portraits *M. Sériziat*, *Mme Sériziat*, *Mlle Tallard*, and *Jeanbon Saint-André*; his only landscape, *View of the Luxembourg Garden*; a half-length *Psyche* (lost); and *The Vestal Garlanded with Flowers*. Also from the year 1795, done after his final release, are two other portraits, *Jacobus Blauw*, and *Casper Meyer*. Besides the paintings from this period, David made two major *Homer* studies and the first sketches of the *Intervention of the Sabine Women*. An excellent drawing in black crayon, *Head of a Young Woman*, bears the inscription "J. L. David faciebat in vinculis." David also occupied himself with plans for completing

the *Tennis Court Oath*. This makes the seventeen-month period between his first arrest and the end of 1795 one of the most fruitful of his entire career.

It is regrettable that David's *Portrait* of his mother, presumably done in November 1794, when he was in the Luxembourg, has been lost. Along with the *Self-Portrait*, done while he was still incarcerated in the Hôtel des Fermes, this work would help illuminate David's artistic response to the abrupt change in his life, and like the *Self-Portrait* it would provide a visual record of his depoliticization. That he directed his gaze at himself and then turned it on his mother suggests a reassessment of himself and his private world. Even without the *Portrait* of his mother the artistic record of David's first period of incarceration is extraordinarily revealing. In the month of November, while he did this work, he wrote his student M. de Mainbourg about another project. "I am bored now because my *Homer* is completely composed. I am dying to get it on canvas because I feel inside myself that it will be a step forward for art. This idea inflames me, but here I am held in irons. I am prevented from returning to my atelier, which, alas, I should never have left."[15] In a letter written four days earlier, on November 4, he said, apparently referring to his *Homer* study, "I have undertaken a picture ambitious of composition and full of difficulties. I am powerless to continue because of the impossibility of getting models, and this consoling art that I have consecrated to the glory of my country has become sterile in the sad place where I am kept captive." He continued, "The illusion of which I have been the victim, the errors that I was led into have been punished too severely by this harsh treatment." Appealing to the Convention, to whom the letter is addressed, and of which he had recently been a member, he wrote, "You cannot refuse to listen to a colleague who knows without doubt that he was deceived, but had no criminal thoughts and whose hands were never drenched in innocent blood. I therefore ask for liberty."[16]

David's two *Homer* drawings were both studies for a work that he never painted. By the time he was released from prison his thoughts had turned elsewhere, to the *Intervention of the Sabine Women*, which was to occupy him until its completion in 1799. The first of the *Homer* studies, *Homer Sleeping* (fig. 41), shows the blind poet resting against a massive column before a courtyard. To his right are two women; one bends to place a loaf of bread next to his harp while the other looks at gifts held in her dress that she will give to the poet. The second study, *Homer Reciting His Verse to the Greeks* (fig. 42), shows the blind poet sitting against the stone column with his harp in his lap and his right arm extended to the crowd of listeners who sit before

him. As in the earlier drawing women behind him bear gifts, although there
are four women rather than two. Behind them and behind the column are
another woman and a child, who observe the giving of gifts. A more
important departure from the first study is the crowd of people gathered
before and listening to Homer. The poet in the second study addresses
fellow Greeks by reciting his verse—bringing his art to the people.

Michael Fried has suggested that there is an obvious resemblance between
the seated Homer of the second study and the blind Belisarius of David's 1780
painting. Fried writes: "One has the impression that for David and his
contemporaries, Belisarius and Homer constituted a single mythic identity,
in which the characteristics and circumstances normally associated with each
other were mingled and interfused." He adds that this was the case in André
Chénier's poem *L'Aveugle,* and suggests that David's *Homer* could "reflect
the influence of Chénier . . . who had died on the guillotine just a few
months before the drawings were made."[17] To say that David might have
recalled Chénier's *L'Aveugle* while working on his *Homer* drawing is to
suggest how personal these studies were. David seems to have identified
with the Homer/Belisarius figure: he too had been blind. In a letter to the
Convention that refers to his *Homer* project he wrote that "you cannot
refuse to listen to a colleague who knows without doubt that he was
deceived."[18] He had been misled—and he had been politically blind. Like
Belisarius he was an innocent victim and like Homer he would share his art
with others—but was unable to because he was in prison. Seen from this
perspective the second of the drawings contains elements of a wish fulfill-
ment; the poet recites to the people who gather around him, just as David
the artist would share his "consoling art" with the people of his country, as
he said in the letter of November 4. Another suggestion of wish fulfillment is
the chariot passing through the courtyard in the *Homer Reciting* drawing.
The courtyard is a stylized rendering of the Luxembourg courtyard where
David was in fact incarcerated. The sharp contrast between the shadows in
the foreground and the light of the courtyard create a strange effect between
the two spatial areas, as does the series of diagonals within the courtyard.
The congestion of the figures in the foreground is in marked contrast to the
openness of the courtyard, and through that openness passes the chariot.
The speeding chariot betokens flight from the oppressive space of the
courtyard, or, more literally, from the Luxembourg, the very building in
which David was imprisoned.

Lending support to the idea that David identified with the seated Homer/
Belisarius figure are the women on the right who bring gifts. David wrote in

the November 8 letter to M. de Mainbourg, "My wife with her four children presented themselves before the concierge who, softened by their tears, brought them to me. She threw herself around my neck in her presence. 'Citizen, she told her, do not believe that you are guarding a bad person. He is the most honest man I know; believe a devoted wife.' She and my four children in tears held me longingly in their arms, my tears flowed abundantly, and we mingled souls in tender and unexpected embrace."[19]

David painted the *View from the Luxembourg* (fig. 43) at the same time he was working on the *Homer* studies, with which it has an obvious similarity. Like the *Homer* drawings, this landscape is seen from a vantage point within the place of David's incarceration, the Luxembourg Palace. In the case of the *Homer* studies David looks from one of the building's wings into the courtyard, and in the landscape painting he looks in the other direction, from a window in the palace into outdoor gardens. During the Revolution, parts of the gardens had been turned into fields so they could be farmed. A fence had been built, and in David's painting men are seen directly below the palace window. The changing colors of the fall landscape are captured in warm, vivid shades of rust and yellow that glow in the sunlight. Every detail has been carefully observed, from the houses on the rue Vaugirard on the right to the rows of trees, the fence, and the men inside the enclosed area. To the left two rows of trees recede into the distance beyond the palace. Running 90 degrees to those trees and the path are a series of planes that help define the receding space. Closest to the palace is the enclosed area, beyond the fence there is another field, not yet harvested, and then there is the row of brilliantly colored trees, above which rises the cloud-lined sky. Altogether, the impression is one of ordered, rectilinear space, but also of openness. Moreover, the colors invest the scene with an atmosphere of warmth. There is an affectionate quality in this landscape achieved by the resplendent colors of the trees and by the brushwork itself, which is freer than anything David had done before. It has been said that the *View from the Luxembourg* looks ahead to Corot and even that it anticipates Monet and the Impressionists. The field beyond the fence, to single out one part of the painting, suggests the use of a new technique. So lightly have touches of paint been applied to canvas, and so fluid is the brushwork that this landscape is leagues away from David's polished neoclassical works, in which individual strokes of the brush are seldom seen.

How are the special qualities of this painting to be explained? Curiously, the *Homer* studies, so different both in subject and medium, provide part of the explanation. In those sketches David used diagonals and a bold use of

light and shadow to create an oppressive interior space, that of the court-yard, from which the chariot, in the more finished of the two works, *Homer Reciting,* is making its exit. The *View from the Luxembourg* can, in a certain sense of the word, be regarded as a pendant to the *Homer* studies: here we see the world beyond that of the Luxembourg courtyard and beyond the palace where David was kept, as he put it, "in irons." Seen from this perspective, the figure walking along the fence achieves particular significance. In front of him are four workers with tools, busy at the task that occupies them, but the solitary walker simply walks, in the outdoors. The openness of this painting is in direct contrast to the claustrophobic space of the two *Homer* drawings; it shows the world beyond the place of David's incarceration and the fears and anxieties inevitably associated with it.

David was ill during the months after his release from prison at the end of December 1794. The charges drawn up against him in March by members of the Museum Section could not have improved his condition, and on April 27 he requested permission to spend two months with his brother-in-law and sister-in-law, Pierre and Emilie Sériziat, at their country house in Saint-Ouen, near Tournan-en-Brie. That such permission was required indicates that although David was a free man, conditions were attached to his free-dom. During the period of his visit the members of the Museum Section continued to press charges against him, and as we have seen he began the work of defending himself before he was arrested again on May 29. Staying at Saint-Ouen he was away from his enemies, and he was with Pierre Sériziat and his wife, of whom he had always been fond. Mme Sériziat would have been pleased by the reconciliation between her sister and David that had taken place in recent months. Under these circumstances, it is hardly surpris-ing that David painted portraits of his brother-in-law and sister-in-law. He did *Mme Sériziat* first and then *M. Sériziat.*

David wrote an answer to the charges against him on May 3, a few days after his arrival at Saint-Ouen, and continued to work on his longer defense in the several weeks before his arrest on May 29. It was during this period that he began the *Mme Sériziat* portrait (fig. 44). David felt relieved to be away from Paris and with friends but still feared continued persecution.

The Mme Sériziat of David's portrait is indoors, leaning on a table; she is shown with her little boy and carrying a bunch of wild flowers. She has been for a walk and her cheeks are reddened, whether from the wind or sun. She wears a white dress gathered by a green sash at the waist that matches the green of her elegant hat. The toussled hair is a reminder of the walk, as are the wild flowers that she recently gathered. The setting is indoors but the

painting evokes the outdoors. The freshly picked flowers suggest not only the world of nature but its renewal, and in that sense they can be seen as a contrast to the autumnal trees in the *View from the Luxembourg* which are about to lose their foliage. The seasons come and go, life ebbs and flows— and it continues. David is touched by the sheer beauty of the wild flowers, whose variety and delicacy are captured exquisitely. He responds to the flowers that suggest renewal and also he responds to Mme Sériziat, the woman and mother who holds them. She is as exquisite and delicate as the flowers in her hand.

The painting expresses renewal and is a lovely portrait of an attractive woman and her child, yet it is not without tensions. The stitching of Mme Sériziat's obviously homemade dress is rough, imperfect, and out of keeping with the elegant hat and matching green sash that she brought to her country estate from Paris, a reminder of the hardships still present in France. The tension suggested by the contrast between the stylish hat and sash and rough finishing of the dress, with pleats that do not flow evenly from the waist, is reinforced by Mme Sériziat's leaning a bit stiffly against the table, by the slight tilt of her head, and by her quizzical expression. Though she smiles, the smile is a bit forced, and there is a touch of melancholy in the eyes. The red-nosed child she holds by the arm turns his head inquiringly, suggesting doubt about something and perhaps uneasiness. With details such as these the atmosphere of the painting is not one of composure.

David was arrested while working on the *Mme Sériziat* portrait, and he probably finished the work while incarcerated in the Quatre Nations. Another portrait was begun during the period of his second detention, a small (18.2 centimeters) pen drawing of Jeanbon Saint-André (fig. 45). Saint-André was arrested in the aftermath of the 1 Prairial uprising, on May 25, four days before David's arrest. A former Protestant minister, he had sat on the Mountain, had voted for the death of Louis XVI, had been president of the Convention, and had been a member of the Committee of Public Safety, the group of twelve that virtually ruled France during the year of the Terror. He was among the few members of the committee who genuinely admired Robespierre, with whom he had little direct contact from September 1793 to July 1794. As a member of the Committee of Public Safety he reorganized the military harbors of Brest and Cherbourg, and at one point he participated in a naval battle with the British, in which he received a slight wound. Besides building up the fleet, Saint-André helped implement policies in the west and south of France that originated in Paris. Here is where he showed his moderation. He favored de-Christianization, but did not want it carried out

violently, and he hoped to maintain toleration of religious belief. Others, more extreme, put him in the paradoxical position of defending Christianity. While Saint-André was away from Brest in December 1793, Dagorne, inspector of the national domain, looted churches, smashed images, and profaned holy vases in the marketplace when peasants were there in large number. To make matters worse, he was guilty of corruption. When Saint-André returned he ordered Dagorne's imprisonment and then resumed the work of building up the fleet. With formidable administrative ability, he enjoyed a large measure of success. Only rarely did he visit Paris during the Terror, and when he arrived there in late June 1794, on the eve of 9 Thermidor, he believed that the government had become too repressive. He returned to the south of France, where he again showed moderation in carrying out his official duties. During the Thermidorean period he does not seem to have been pursued by enemies, as David was, but he was arrested after the 1 Prairial uprising because of the political offices he held during the Revolution. Saint-André and David were on the first proscription list, which also included Robert Lindet, Henri Voulland, Elie Lacoste, L.-T. Lavicomterie, Prieur of Côte-d'Or, J.-N. Dubarran, and Bernard of Saintes. Neither David nor Saint-André was arrested because of links to the 1 Prairial uprising; they were victims of the fear that gripped the government during a period of runaway inflation, economic hardship, political instability, and popular insurrection.

At the bottom of his drawing of Saint-André, on the edge of the frame, David wrote the following inscription: "A gift of friendship. Solace of affection. David made in irons in the third year of the French Republic on Messidor 20 (July 28, 1795)." Saint-André is seen in profile, staring directly, even sternly ahead. His fixed facial features and folded arms indicate determination and a sense of rectitude. He is anything but passive or defensive, and by leaning forward slightly he seems to take a firm stand against his accusers. This man of probity, once a minister and then a dedicated revolutionary, apologizes for nothing. The sense of David's drawing is that here is a man who was active in political life; he denies nothing for he has done no wrong. Still, there is something private and even informal about Saint-André, shown in his top hat, cravat, and the flowing folds of his coat. Moreover, tension arises between Saint-André's hard-edged profile and determined expression and the round frame within which the drawing is encased. The round frame softens and even works against the angular face that is at its center.

To paint a round portrait was exceptional for David. He had done such a

portrait before, in 1790, when he painted his brother-in-law Pierre Sériziat. This is one of David's most intimate and affectionate portraits, made all the more so by the oval frame. In the portrait of Jeanbon Saint-André he retains something of the earlier work's intimacy and private quality, even as he invests the work with the very different feelings that were bound up with the public sphere of life. It was as if this man, this just and fair man, who is seen standing his ground against his accusers, did not deserve to be where he was and defending himself as he had to. To show a fellow prisoner in this way was to show him as a victim of injustice, and for David to say that he did the work while "in irons" was to reveal his own feeling of victimization. In this superb drawing David has projected his own feelings onto the image of a fellow prisoner, who happens to have been his exact age.

At the time of his release on August 3, 1795, David was technically still under arrest. He was escorted by a guard and joined by his former wife, who had pleaded, on the grounds of an apparently serious illness, that he be set free. When he returned to Saint-Ouen for a second stay with the Sériziats he was accompanied by the guard and the woman he would remarry in the following year. David wrote from Saint-Ouen on September 23, "I am not wasting a minute and I am ready to finish the second portrait. My sister-in-law's portrait completed, I am working on one of her husband, who will also never cease to be dear to me. I am leading a life which pleases me very much; I am in the midst of nature, engaged in work related to the countryside and my art."[20] The sense of well-being in these remarks would have been reinforced on the following day, when the Committee of General Security ordered that David be given provisional freedom. The painting that he did under such agreeable circumstances shows his brother-in-law seated on a vine-covered rock, near some plants. Behind Pierre Sériziat is the sky, the fullness of which is unique among David's portraits. The setting is outdoors, very unusual for a David portrait, and Sériziat is shown as a leisured country gentleman. The Pierre Sériziat of David's portrait is refined, impeccable, fastidious, and fashionable in his buttoned vest, cravat, riding jacket, buckskin breeches, fine leather boots, top hat, and kid gloves. His expression suggests ease of manner, as do his crossed legs and the gloves that dangle from one hand and the riding crop casually held in the other. Everything about the portrait underlines the good breeding—the exquisite social qualities—of David's brother-in-law. Everything, that is, except for the cockade on his hat.

When David began the portrait of *M. Sériziat* (fig. 46) it was just over a year since he stopped working on his last revolutionary painting, *Joseph Bara*.

David had shown the youthful martyr holding a cockade. That the same political symbol should appear on the stylish top hat of Pierre Sériziat is odd. This refined gentleman, clearly a man of fashion and of the leisure class, is shown as a private person enjoying the pastimes of his country estate. The leather breeches and boots indicate that riding is one of his pleasures; that his riding crop is frayed suggests that it has been well used—it is not just a prop put in Sériziat's hand for the sake of appearances. How is the cockade, which seems so out of place on the well-cut top hat of this elegant gentleman who enjoys the recreations of his estate, to be explained? In the *Bara* painting the symbolic strip of cloth expresses revolutionary commitment, but in *M. Sériziat* the cockade has been separated from any such ties. Attached as it is to the top hat it is not only out of place but incongruous.

It was suggested at the end of the previous chapter that *Joseph Bara* can be regarded as a pre-Thermidorean painting, in its portrayal of unbearable pressures signaling the end of the Revolution. David's *M. Sériziat* can be regarded as a Thermidorean painting. Of course, it was painted during Thermidor, but it is Thermidorean in other than the literal sense; this portrait captures and expresses a release of tensions and pressures that are the essence of the period. *M. Sériziat* was not only painted *during* the Thermidorean period but also it was *of* that period. It expresses something of David's altered state of mind, particularly after his release from prison, and it conveys some of the deeper, pervasive changes in France after the fall of Robespierre.

As Crane Brinton has written, after 9 Thermidor the French Republic was no longer the Republic of Virtue. "From now on something lofty, inhuman, terrible has gone out of the Revolution. Men have returned to their everyday virtues and vices. Common sense and common foolishness have resumed sway. The Thermidorean reaction has begun."[21] It was a time of decompression, of the release of pressure. The Jacobin dictatorship had been exhausting, and respite was now needed. "The men of 1795," Brinton noted, had been the men of 1794, and what they repudiated was themselves: "By and large, the Thermidoreans had once been Jacobins."[22] What they wanted in 1795 was to be "as nearly as possible all they had not been in 1794."[23] Caricature was one way of rejecting the ideals that they had formerly embraced. Old clichés, slogans, and symbols lingered on, but they were ridiculed or subjected to satire, so prevalent in the frivolous atmosphere of Thermidor. Frivolous *and* fashionable, it should be said. Reacting against the puritanical severity and sansculottism of the Republic of Virtue, Thermidorean clothing became the badge of style and cultivation, while "lusher

pleasures" were enjoyed freely in a period noted for its escapism. "Theaters, cafes, and especially ballrooms did a splendid business."[24] English fashions flourished, and among the favored social types was the country gentleman, the man of ease, so prominent in the portraits of Reynolds, Romney, and Stubbs. David's portrait of *M. Sériziat* belongs very much to the world of Thermidor and to its fashions.

David completed three other portraits in 1795, *Mlle Tallard* (fig. 47), *Jacobus Blauw* (fig. 48), and *Casper Meyer* (fig. 49). The first shows a woman who, according to a description on the back of the painting, was a "pious, charitable person whose struggles and misfortunes are well known."[25] Little is known about her now. Brookner speculates that she may have been a member of the Sériziat household and in charge of the little boy in the portrait of *Mme Sériziat*. What Brookner also suggests is that the mood of *Mlle Tallard* was carried over to *Jacobus Blauw*. In fact, the qualities of feeling—sensitivity, pensiveness, candor—that Brookner finds in both of these portraits are also present in *Mme Sériziat*. Figures in all three paintings are turned in the same direction, and in all three the light shines from the left. There are similarities in the eyes and mouths of Mlle Tallard and Blauw, and in the profiles of Blauw and Mme Sériziat. The shoulders of Mme Sériziat and Blauw slope at much the same angle and both hold an object with one hand and clasp something with the other. Thus, in terms of feeling and composition, there are similarities between the two female portraits and the portrait of *Jacobus Blauw*.

The inscription on the back of *Mlle Tallard* helps explain the fragile qualities that find expression in the painting. In the case of *Mme Sériziat*, enough is known about the woman to explain the chemistry between her and the artist. In the painting David has alluded to the disturbances that have upset the life of his sister-in-law by having her wear a homemade dress, not the type of clothing the daughter of a government contractor and the wife of an important man would be accustomed to wearing. The times were precarious, as David knew only too well; the tensions in the painting refer not only to difficulties within the Sériziat family but to the political world to which they were tied.

Why are there similarities between the two female portraits and the *Jacobus Blauw* portrait, which David must have painted soon after his return to Paris?[26] Blauw was Dutch, a representative of the newly founded Batavian Republic, who had been sent to France after he helped negotiate a treaty with France. "Negotiate" is misleading; it would be more accurate to say that France extorted the treaty from the Dutch.[27] Encouraged by France to

rebel against the Prince of Orange and his supporters, Dutch patriots did so in January 1795. French support was crucial to the success of the revolution, and with the appearance of the French cavalry in Amsterdam the Batavian Republic was proclaimed. The conditions of the treaty make it brutally clear that French policy was dictated by *realpolitik*, not idealism. France required its ally to declare war on England, maintain a French occupying army on its own soil and at its own expense, accept French paper money, cede Flushing and the mouth of the Scheldt to France, and pay an indemnity of 100 million florins. Blauw, a democrat and patriot, went to France as an official of the Batavian Republic after he had signed this treaty, which he resented deeply. Because he believed in the ideals of liberty, equality, and fraternity, he understandably disliked a government, that of the Directory, that took advantage of his country. He was fiercely patriotic and allied to Dutch radical groups, and his political ideas and the eagerness with which he made them known resulted in strained relations with French officials. While he appears pensive in David's portrait, he was, in fact, volatile and given to fits of anger. Those tendencies and his unyielding commitment to an independent Dutch state led to a breakdown in his relations with the Directory in June 1796, when he was asked to leave France. He left in such haste that he was unable to take his portrait from David. The police suspected him of involvement in the uprising led by Gracchus Babeuf in 1796.

The inscription on the back of *Mlle Tallard* could apply to Blauw. He too was a person whose "struggles and misfortunes [were] well known." The Dutch patriot is seen in all of his candor and sincerity, and he is shown as vulnerable, much as the females of the earlier portraits, *Mme Sériziat* and *Mlle Tallard*, had been shown. This was someone with whom David could identify, and with whom he had established a close friendship.[28] Like himself, Blauw had been a victim of those more powerful than himself—those exercising power under the Directory. This person struck a sympathetic chord in a David who never abandoned his patriotic ideals.

Caspar Meyer was also a Dutch patriot who went to France as a representative of the Batavian Republic in 1795. Like Blauw he resented and protested against the treaty between the Dutch state and France. In Paris, however, he maintained easier relations with the Directory. When Blauw was told to leave France, he was replaced by the more accommodating Meyer. Meyer was a more supple diplomat and politician than Blauw, and capable of surviving in the cynical Paris of the Directory. If *Jacobus Blauw* has affinities with two 1795 female portraits, *Mme Sériziat* and *Mlle Tallard,* the *Meyer* portrait resembles a male portrait of the same year, *M. Sériziat.* The men in both paintings are

seated in the same position; both hold objects in their right hands, a riding crop in one case and a pen in the other; and both radiate ease and confidence. Both are finely dressed (Blauw is attired far more simply), and even wear similar clothing, though one is seen outdoors and the other is seated at a desk. Both men project sureness, a sense of having established bearings within their world. There is something a bit jaunty about them, a smartness that is seen in a hand that holds gloves in the one case and a hand that rests casually on the arm of a fine chair in the other. That same elegance is suggested by the curled hair that displays a concern with fashion evident in both men. The Meyer of David's portrait exudes an air of confidence and an ease of manner that he did in fact possess. These qualities served him well during the period of his diplomatic stay in Paris, when David painted his portrait. What is interesting is the contrast between the self-assured image of Meyer and the inwardness of the *Blauw* portrait. The radical and volatile Blauw is portrayed as pensive and reflective, whereas the more accommodating Meyer is depicted with Thermidorean flash and brilliance.

During his work on the Thermidorean portraits, David worked steadily on his ambitious history painting, the *Intervention of the Sabine Women,* which he finally brought to completion in 1799. At 385 by 522 centimeters, it is one of his largest and most ambitious paintings (fig. 50). It is an idea painting, and as such it belongs to that part of his oeuvre that included the earlier *Belisarius, Horatii, Socrates,* and *Brutus.* As a history painting it also has ties with the *Tennis Court Oath,* and in a sense even with his three revolutionary martyr paintings. At the same time, the *Intervention of the Sabine Women* stands apart from all of these earlier pieces. It is the work that reveals most decisively the new direction David's art took after 9 Thermidor. If the portraits represent David's private responses to the postrevolutionary age, the *Intervention of the Sabine Women* can be seen as the public statement of an artist who has forsworn political involvement.

We have already seen that David abandoned the *Homer* project, for which he clearly had high hopes, so he could begin the *Sabine Women.* That he should have scrapped one project in favor of another suggests the urgency he must have felt for the work, or more correctly, the idea that now occupied him. He created many studies, along with the painting itself, based on the idea of reconciliation, of which the *Sabine Women* is an allegorical representation. The painting portrays two warring armies lifting their arms in peace rather than in death and destruction.[29]

Delécluze says that when David was working on the *Sabine Women,* he became defensive about his history paintings of the 1780s and was particu-

larly severe in his judgment of the *Horatii*, which he now called "theatrical" and "grimacing."[30] Addressing his students, again according to Delécluze, David said: "I'm going to do something new; I want to revive in art the rules followed by the Greeks. When I did the *Horatii* and *Brutus*, I was still influenced by Rome. But, gentlemen, without the Greeks the Romans would have been barbarians when it came to art. So you must go back to the source, and that is what I am trying to do just now."[31] His goal was "to create *pure Greekness*; I feast my eyes on ancient statues, and I even mean to copy some of them."[32] Of course, David had copied many an antique statue as a student in Rome, when he had been under the tutelage of Vien and exposed to the doctrines of J. J. Winckelmann. The neoclassical teachings of these mentors were to influence works for which their ideas were most appropriate, such as *Paris and Helen*. But *Paris and Helen* was outside the main thrust of David's art during the 1780s; while it belonged to a current of his art, it was an undercurrent. Now, when David decided to strike off in a new direction, he returned to the ideals to which he had already been exposed while a student in Rome. It is at this critical turning point in his artistic life that the teachings of Winckelmann really sank in.

Winckelmann found in Greek art the ideals that were defined by his own aesthetic theories and his own idealized concept of beauty. Purity, calm, repose, these were the qualities he associated with the finest art and this is what he saw in Greek art. "The most prominent general characteristics of the Greek masterpieces are a noble simplicity and silent greatness in pose as well as in expression."[33] Even as he idealized Greek art Winckelmann was obliged to recognize that it was not always perfect. "Not all Greek statues bear the mark of this wise restraint; their actions and poses are too wildly passionate . . . the quieter the stance of the body, the more it will convey the true character of the soul . . . only in repose and harmony is the soul great and noble."[34] The attainment of these ideals was possible only when the artist achieved maturity. "In all human activity the violent and transitory develops first; repose and profundity appear last. The recognition of these latter qualities requires time; only great masters have them, while their pupils have access only to violent passions."[35] This was not to say, however, that the passions were not to be shown: "As the depths of the sea remain always at rest however the surface may be agitated, so the expression in the figures of the Greeks reveals in the midst of passion a great and steadfast soul."[36] Finally, Winckelmann believed the nude figure to be one of nature's most perfect products, and as such it deserved careful study by artists. "The school of the artist was the gymnasium, where the youths, ordinarily clothed because of modesty, exercised quite naked. It was the gathering place of

philosophers as well as artists. . . . Phidias went there to enrich his art with these magnificent figures."[37]

When David said "I want to create *pure Greekness*," he pursued a goal consistent with the writings and theories of Winckelmann, and the *Sabine Women* is the work that realized his new objectives. In its way it is as seminal a work as the *Horatii* had been. Indeed, these works represent David's two great artistic breakthroughs, one in the Roman style, the other in the Grecian style. The *Horatii* was the culmination of years of artistic development that saw David find his own voice only after many conflicts, within himself and with the Academy. This style was to serve David in the *Brutus* and it was adapted to the *Tennis Court Oath,* whose oath-taking figures came right out of the *Horatii*. Much of the heroic quality of these works is retained in the *Lepelletier* and *Marat* paintings, but not in *Bara,* a work that signals a new direction. This is a work that points toward the *Sabine Women,* not in the sense of embracing a new set of artistic objectives or aesthetic theories but in the sense of having its source in David's emotional fatigue. Something had snapped within David, and he would never be the same person or the same artist; out of his altered condition arose the goal of a more perfect, a more ideal art—a Grecian rather than a Roman art. Whereas the *Horatii* grew out of a long period of tension and conflict and expressed David's growing sense of a personal and artistic mastery, the *Sabine Women* was the result of an opposite procedure. It was the result of burdens too great to sustain, and events that had taken a heavy toll. To embrace the doctrines of Winckelmann under these circumstances was to have a theoretic basis for achieving new objectives.

David depicted the moment when a group of Sabine women, led by Hersilia, intercede in the battle between the Romans and the Sabines. Rather than the oft-depicted rape of the Sabine women, David chose the sequel as his subject. The Romans had forcibly abducted the Sabine women who had since borne their children, and now when the Sabines go to battle to recover them, the women with their children rush forward to intervene between Tatius and Romulus, the leaders of the Sabine and Roman armies. At this exact moment both armies give up the fight, as lances are raised upward from their lowered position, a sign of truce; as soldiers in the ramparts above throw down their arms; as the horseman behind Romulus sheathes his sword; and as Tatius and Romulus look at each other with the knowledge that they will not use their weapons. Tatius lowers his sword with his right hand while Romulus stands frozen and loosens the grip on his lance, a departure from preparatory studies in which the lance is firmly held.

A comparison of the finished painting with two studies, both in the

Louvre, reveals the process of artistic purification followed by David, as if the theories of Winckelmann were sinking in while he worked. In the first of these studies (fig. 51) Romulus's weight is on his right leg, as he prepares to unsheathe the lance. His crouched position and tight, heavily muscled legs evoke force and power, fitting for the deed about to be done. Tatius is endowed with a well-muscled body and athletic legs, too, and, while he has lowered his sword, it is only to a horizontal position, not the vertical position it has in the finished painting. The way he leans back on his right leg expresses a tension that is no longer present in the final version. In this study, a soldier next to Romulus crouches in much the same position as his leader, adding to the sense of menace. The figure of Romulus in the second Louvre drawing (fig. 52) no longer crouches in readiness to hurl his lance but stands more upright, and he holds a round rather than rectangular shield. David had seen an outline drawing from John Flaxman's *Iliad,* and modeled his Romulus after a figure in that work.[38] Flaxman's figure is static, whereas David's figure in this sketch retains some of the vitality of the Romulus in the earlier Louvre study. As in the earlier drawing, the legs of Romulus are well muscled and the powerful hand still grips the lance. It was in the 1799 painting that the final transformation of Romulus took place. The bearded warrior has been replaced by the clean-shaven and younger athlete. Romulus is now nude, his legs are thin and graceful, and delicate fingers relax their hold on the lance. This is a figure that would have met with Winckelmann's approval far more readily than the Romulus of the two Louvre sketches, not only because of the nudity but because of the purity of the form. By removing Romulus's armor and clothing the flowing lines of the body can be seen, elegant rhythms that are underlined by the arabesque of the ribbon that falls from the helmet. Another difference between the Romulus of the 1799 painting and that of the second Louvre sketch is the position of the right leg. It is not a major difference, but it is telling: in the sketch the leg rotates back in a position indicating readiness to hurl the lance, but in the painting the leg is on the same plane as the other leg. The result is that Romulus appears immobile, no longer about to deploy his weapon. Finally, the shield has been lowered slightly, a change consistent with the other alterations; it too contributes to the release of tension that is at the center of the transformation of Romulus from the athletic warrior of the preliminary studies to the static figure of the painting.

Just as the figure of Romulus is transformed from a Roman warrior to an aestheticized Grecian nude, so do the other figures undergo a similar change. The athletic Tatius in the two Louvre sketches is replaced by the devitalized

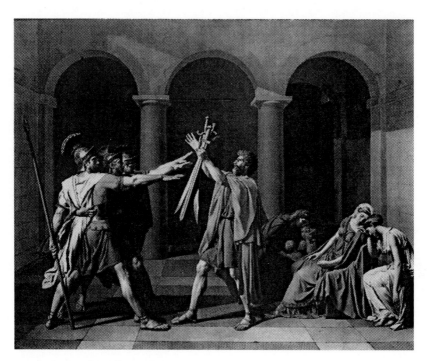

Figure 1. *Oath of the Horatii* (Louvre, Paris)

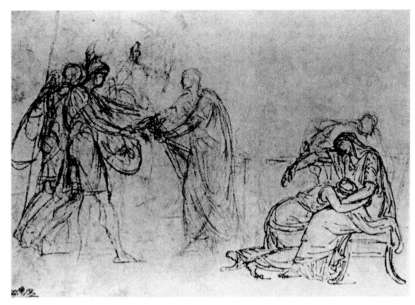

Figure 2. Study for *Oath of the Horatii* (Ecole des Beaux-Arts, Paris)

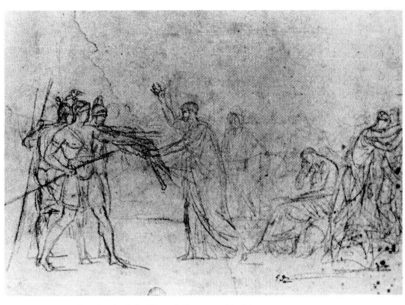

Figure 3. Study for *Oath of the Horatii* (Louvre, Paris)

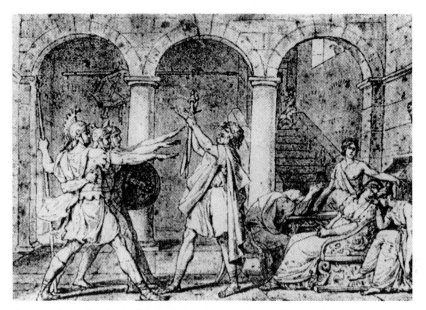

Figure 4. Study for *Oath of the Horatii* (Musée des Beaux-Arts, Lille)

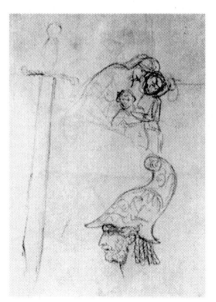

Figure 5. Study for *Oath of the Horatii* (Louvre, Paris)

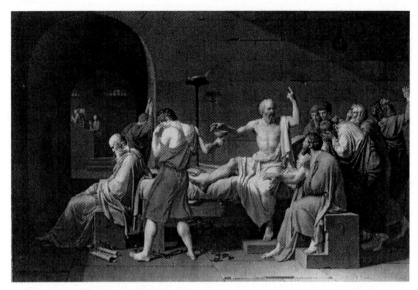

Figure 6. *Death of Socrates* (Metropolitan Museum of Art, New York, Wolfe Fund, 1931. Catharine Lorillard Wolfe Collection. [31.45])

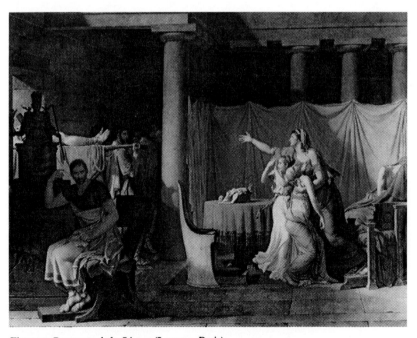

Figure 7. *Brutus and the Lictors* (Louvre, Paris)

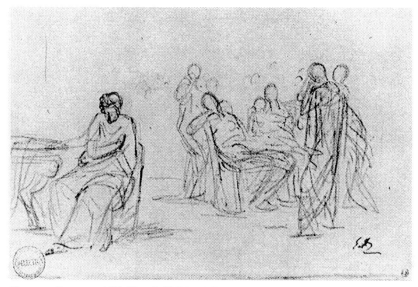

Figure 8. *Brutus and His Household* (Musée Bonnat, Bayonne)

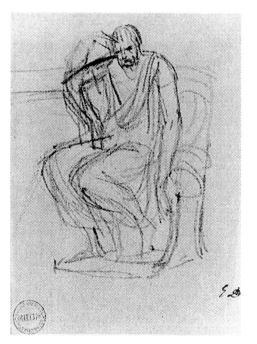

Figure 9. *Dejected Brutus*
(Musée Bonnat, Bayonne)

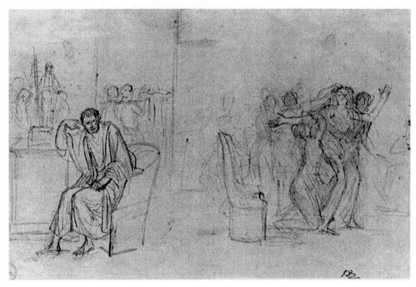

Figure 10. *Compositional Study for Brutus* (Musée Bonnat, Bayonne)

Figure 11. *M. and Mme Lavoisier*
(Metropolitan Museum of Art, New
York, purchase, Mr. and Mrs. Charles
Wrightsman Gift, 1977. [1977.10])

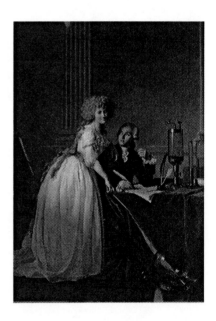

Figure 12. *Paris and Helen* (Louvre, Paris)

Figure 13. *Tennis Court Oath* (Louvre, Paris, on loan to Musée national du château, Versailles)

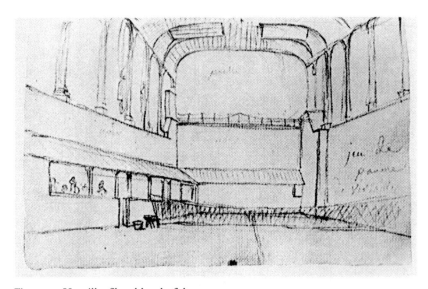

Figure 14. Versailles Sketchbook, fol. 33

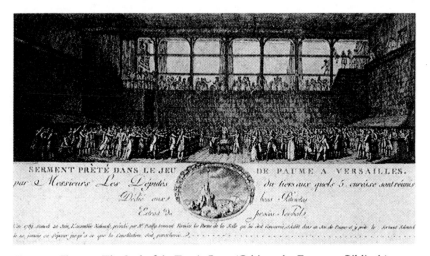

Figure 15. Flouest, *The Oath of the Tennis Court* (Cabinet des Etampes, Bibliothèque nationale, Paris)

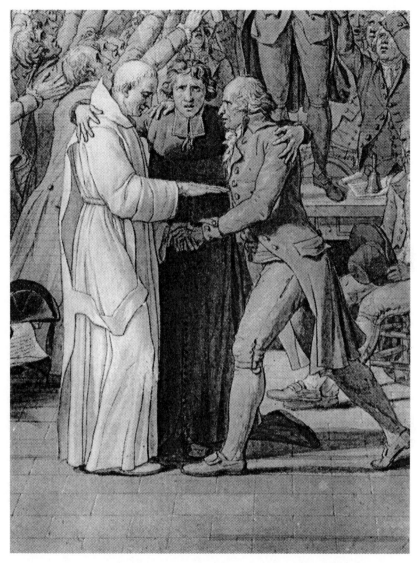

Figure 16. Dom Gerle, Grégoire, and Rabaut Saint-Etienne, detail from *Tennis Court Oath* (Louvre, Paris, on loan to Musée national du château, Versailles)

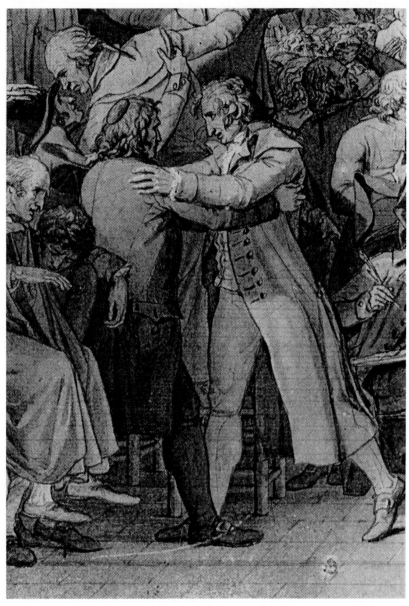

Figure 17. Thibault and Reubell, detail from *Tennis Court Oath* (Louvre, Paris, on loan to Musée national du château, Versailles)

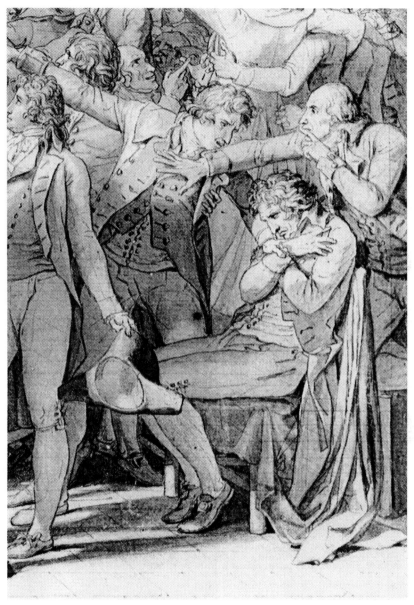

Figure 18. Martin Dauch, detail from *Tennis Court Oath* (Louvre, Paris, on loan to Musée national du château, Versailles)

Figure 19. *Mme d'Orvilliers* (Louvre, Paris)

Figure 20. *Mme de Sorcy-Thélusson* (Neue Pinakothek, Munich)

Figure 21. *M. Sériziat* (National Gallery of Canada, Ottawa)

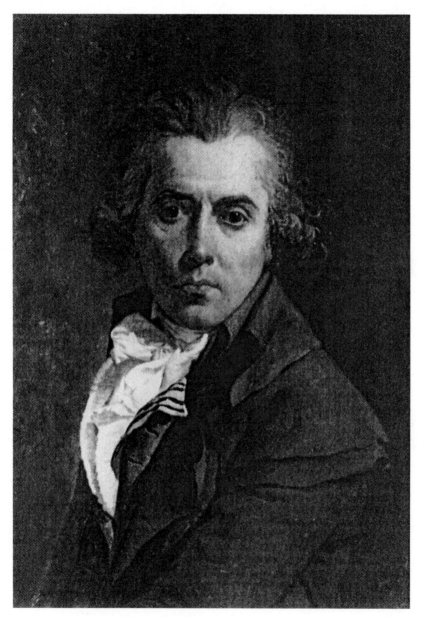

Figure 22. *Self-Portrait*, 1791 (Uffizi Gallery, Florence)

Figure 23. *Mme Pastoret* (Art Institute of Chicago, Chicago, photograph © 1988 The Art Institute of Chicago)

Figure 24. *Mme Trudaine* (Louvre, Paris)

Figure 25.
Study for *Louis XVI Showing the
Constitution to His Son* (Louvre, Paris)

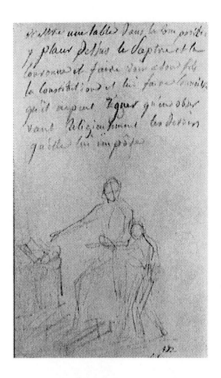

Figure 26.
Study for *Louis XVI Showing the
Constitution to His Son* (Louvre, Paris)

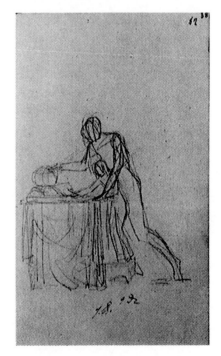

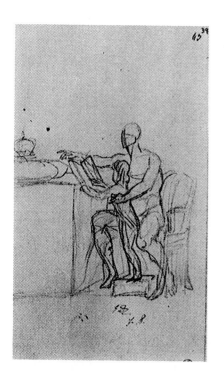

Figure 27.
Study for *Louis XVI Showing the Constitution to His Son* (Louvre, Paris)

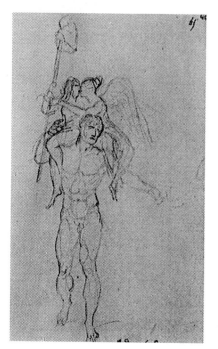

Figure 28.
Study for *Louis XVI Showing the Constitution to His Son* (Louvre, Paris)

Figure 29.
Study for *Louis XVI
Showing the
Constitution to His Son*
(Louvre, Paris)

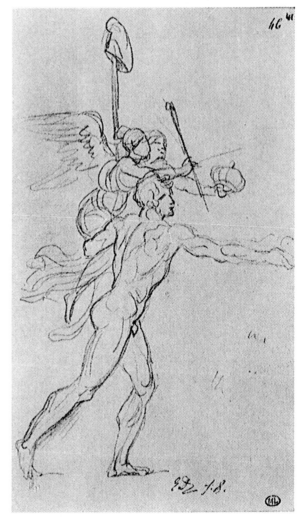

Figure 30.
Study for *Louis XVI
Showing the
Constitution to His Son*
(Louvre, Paris)

Figure 31.
Marat, detail from *Tennis Court Oath*
(Louvre, Paris, on loan to Musée
national du château, Versailles)

Figure 32.
Marie Antoinette (Louvre, Paris)

Figure 33. *The Triumph of the French People,* unfinished (Louvre, Paris)

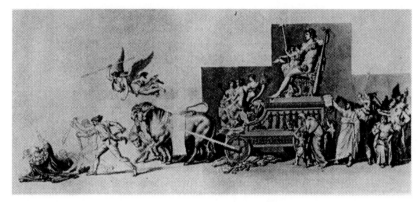

Figure 34. *The Triumph of the French People* (Musée Carnavelet, Paris)

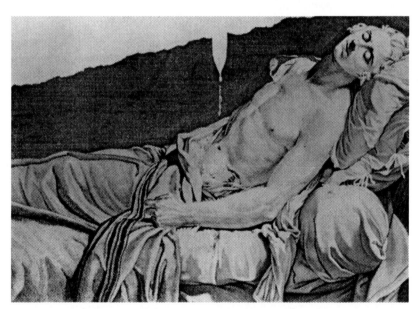

Figure 35. P. A. Tardieu, engraving of *Lepelletier de Saint-Fargeau* (Bibliothèque nationale, Paris)

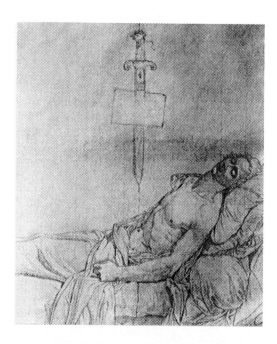

Figure 36.
Anatole Devosges, drawing
of *Lepelletier de Saint-Fargeau*
(Musée des Beaux-Arts,
Dijon)

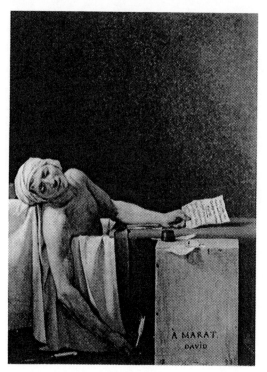

Figure 37.
Marat Assassinated (Musées
royaux des Beaux-Arts,
Brussels)

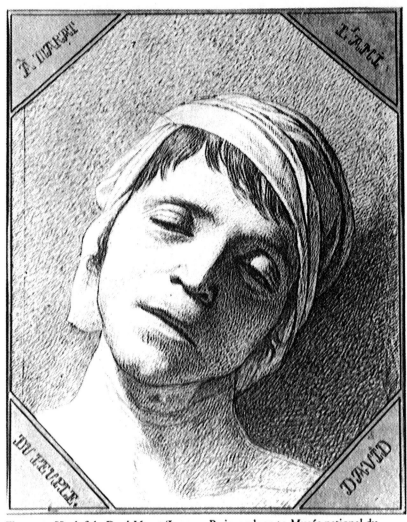

Figure 38. *Head of the Dead Marat* (Louvre, Paris, on loan to Musée national du château, Versailles)

Figure 39. *Joseph Bara* (Musée Calvet, Avignon)

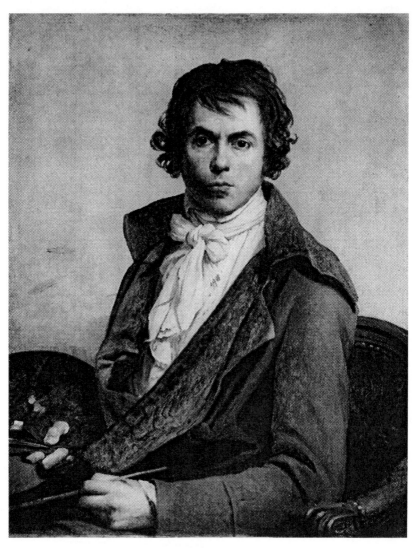

Figure 40. *Self-Portrait,* 1794 (Louvre, Paris)

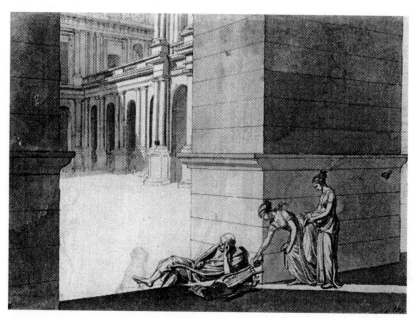

Figure 41. *Homer Sleeping* (Louvre, Paris)

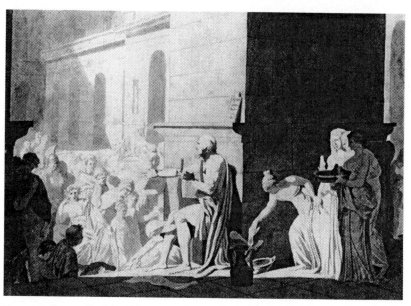

Figure 42. *Homer Reciting His Verse to the Greeks* (Louvre, Paris)

Figure 43. *View from the Luxembourg* (Louvre, Paris)

Figure 44. *Mme Sériziat* (Louvre, Paris)

Figure 45.
Jeanbon Saint-André (Art
Institute of Chicago,
Chicago, photograph © 1988
The Art Institute of
Chicago)

Figure 46.
M. Sériziat (Louvre,
Paris)

Figure 47.
Mlle Tallard (Louvre, Paris)

Figure 48.
Jacobus Blauw (National
Gallery, London,
reproduced courtesy of
the Trustees)

Figure 49. *Casper Meyer* (Louvre, Paris)

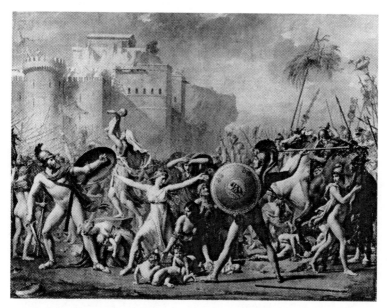

Figure 50. *Intervention of the Sabine Women* (Louvre, Paris)

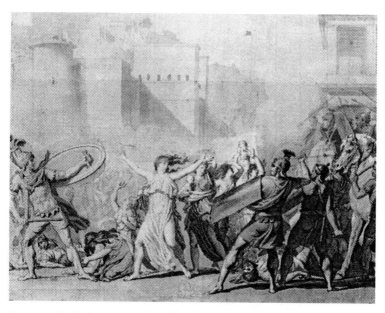

Figure 51. Study for *Intervention of the Sabine Women* (Louvre, Paris)

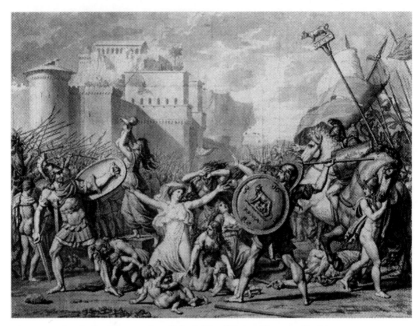

Figure 52. Study for *Intervention of the Sabine Women* (Louvre, Paris)

Figure 53. Study for *Intervention of the Sabine Women* (Louvre, Paris)

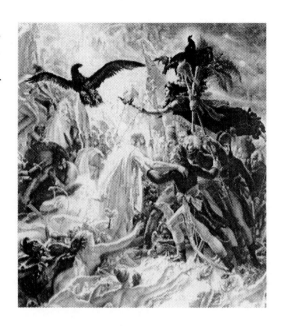

Figure 54.
A. L. Girodet, *Ossian and His Warriors Receiving the Dead Heroes of the French Army* (National Museum of Malmaison, Paris)

Figure 55.
Portrait of Bonaparte (Louvre, Paris)

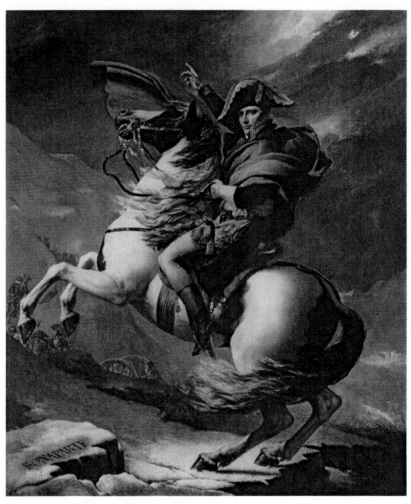

Figure 56. *Napoleon Crossing the Saint-Bernard* (National Museum of the Château, Malmaison)

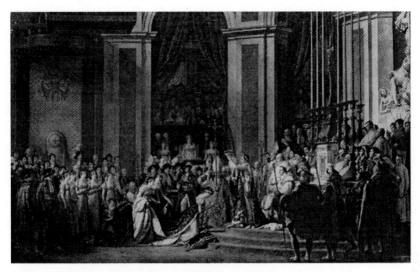

Figure 57. *Coronation of Napoleon and Joséphine* (Louvre, Paris)

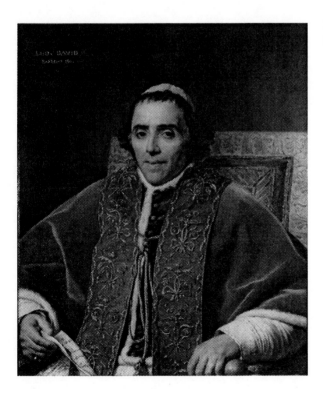

Figure 58. *Pius VII* (Louvre, Paris)

Figure 59.
Study for Pope Pius VII (Harvard
University Art Museums, Fogg
Museum, Cambridge, Mass.,
bequest—Grenville L.
Winthrop)

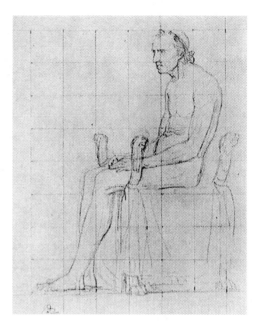

Figure 60.
Study for a portrait of
Napoleon in imperial
dress (Musée des
Beaux-Arts, Lille)

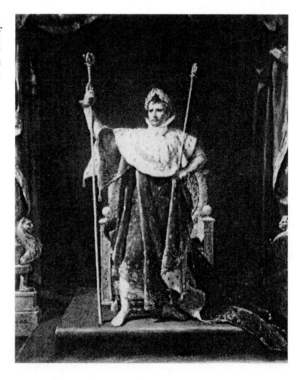

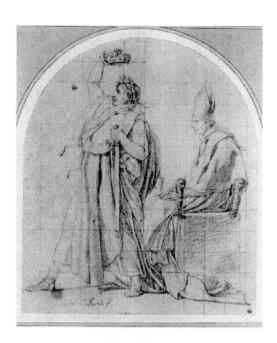

Figure 61. *Napoleon Crowning Himself* (Louvre, Paris)

Figure 62. *Study of Mme de la Rochefoucauld* (Louvre, Paris)

Figure 63. Detail (right-hand side) from *Coronation of Napoleon and Joséphine* (Louvre, Paris)

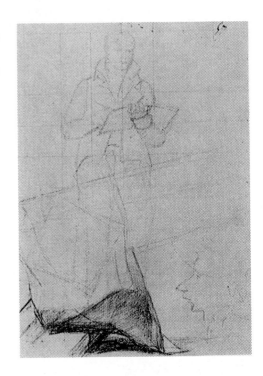

Figure 64.
Study for *Coronation of Napoleon and Joséphine* (Harvard University Art Museums, Fogg Museum, Cambridge, Mass., bequest—Grenville L. Winthrop)

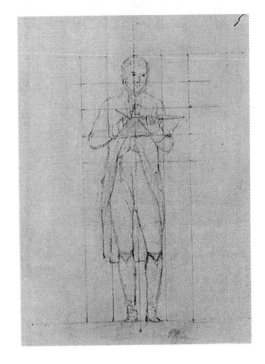

Figure 65.
Study for *Coronation of Napoleon and Joséphine* (Harvard University Art Museums, Fogg Museum, Cambridge, Mass., bequest— Grenville L. Winthrop)

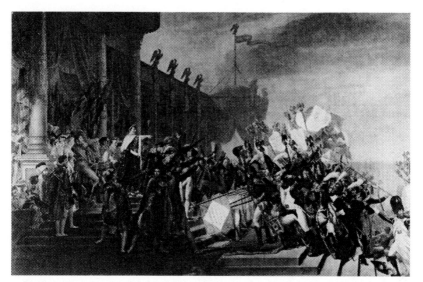

Figure 66. *Distribution of the Eagles* (Musée national du château, Versailles)

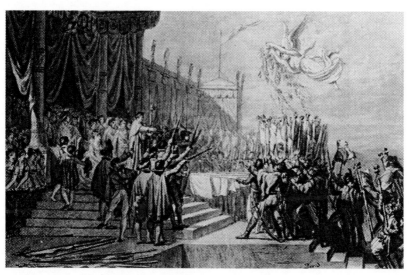

Figure 67. Study for *Distribution of the Eagles* (Louvre, Paris)

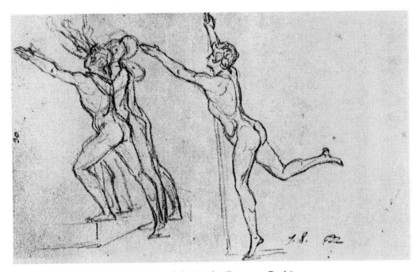

Figure 68. Study for *Distribution of the Eagles* (Louvre, Paris)

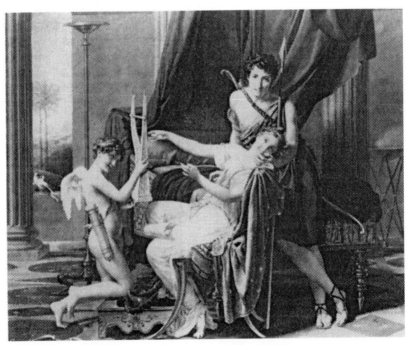

Figure 69. *Sappho, Phaon, and Cupid* (Hermitage, Leningrad)

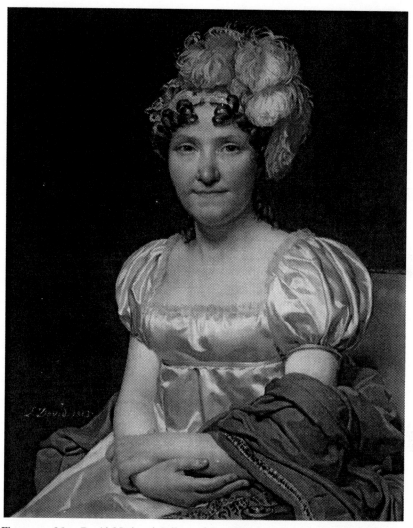

Figure 70. *Mme David* (National Gallery of Art, Washington, D.C., Samuel H. Kress Collection)

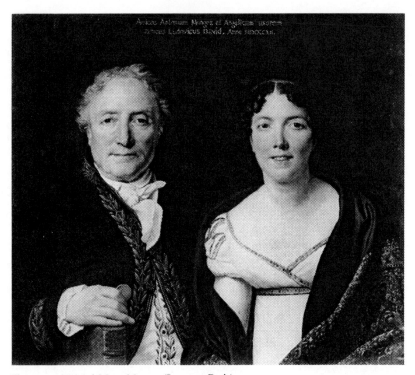

Figure 71. *M. and Mme Mongez* (Louvre, Paris)

Figure 72. *Count Français de Nantes* (Musée Jacquemart-André, Paris)

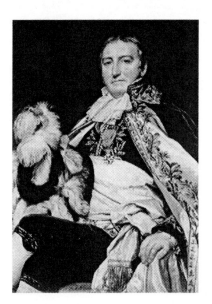

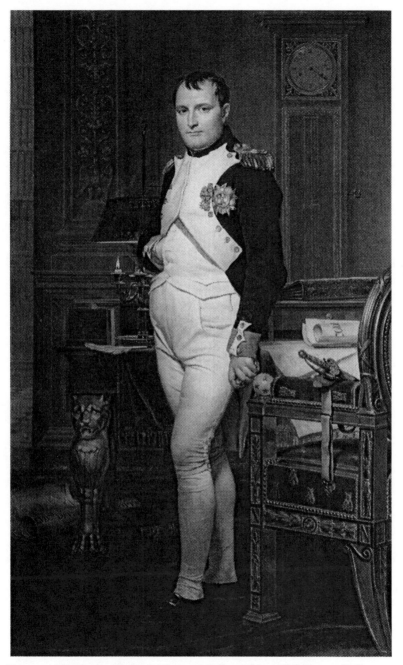

Figure 73. *Napoleon in His Study* (National Gallery of Art, Washington, D.C., Samuel H. Kress Collection)

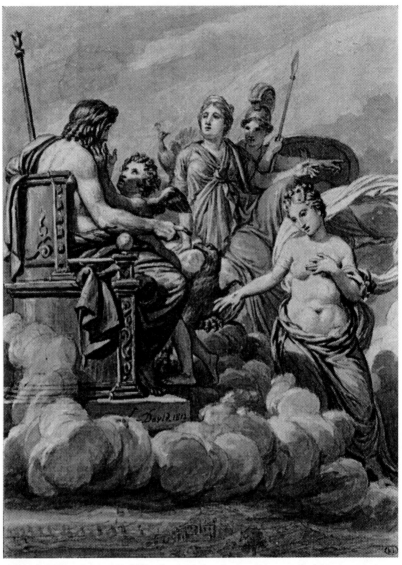

Figure 74. *Venus Injured by Diomedes Appeals to Jupiter* (Louvre, Paris)

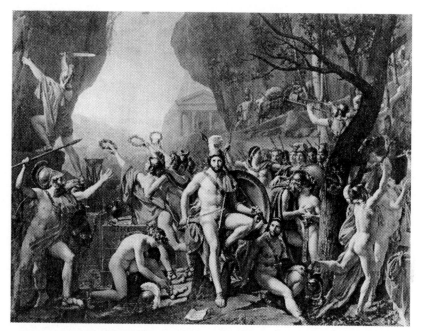

Figure 75. *Leonidas at Thermopylae* (Louvre, Paris)

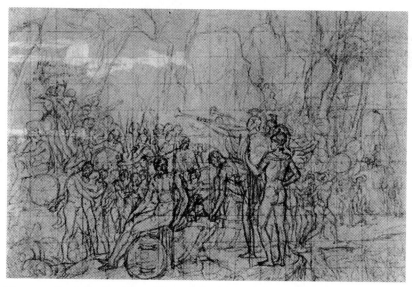

Figure 76. Study for *Leonidas at Thermopylae* (Musée Fabre, Montpellier)

Figure 77. Study for *Leonidas at Thermopylae* (Musée Fabre, Montpellier)

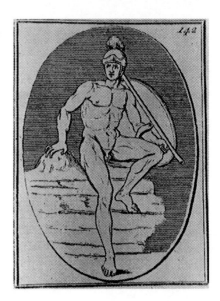

Figure 78. Ajax figure in Winckelmann's *Monumentii antichi inediti*

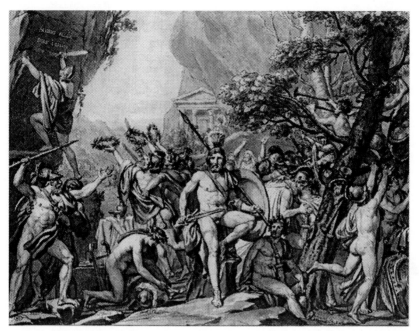

Figure 79. Study for *Leonidas at Thermopylae* (Louvre, Paris)

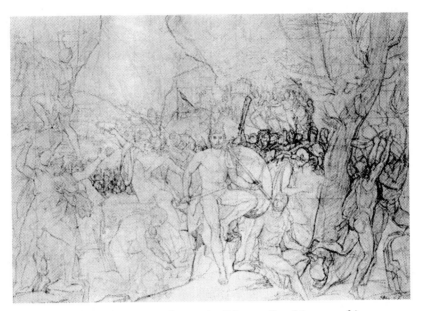

Figure 80. Study for *Leonidas at Thermopylae* (Metropolitan Museum of Art, New York, Rogers Fund, 1963 [63.1])

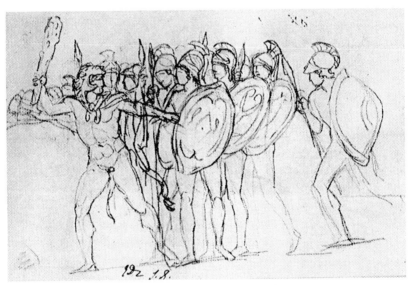

Figure 81. Study for *Leonidas at Thermopylae* (Louvre, Paris)

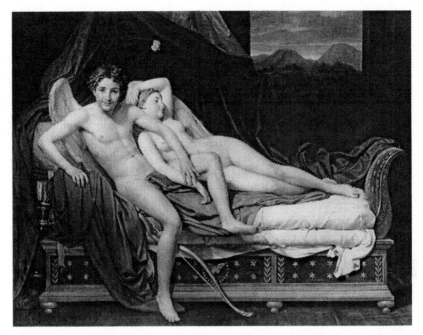

Figure 82. *Cupid and Psyche* (Cleveland Museum of Art, Cleveland, Leonard C. Hanna, Jr., Fund, 62.37)

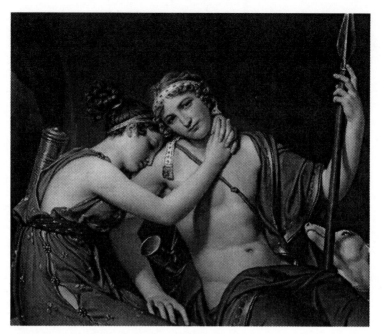

Figure 83. *The Farewell of Telemachus and Eucharis*
(J. Paul Getty Museum, Malibu, Calif.)

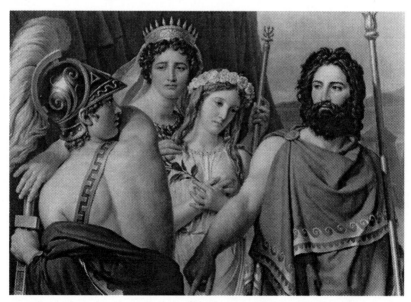

Figure 84. *The Anger of Achilles at the Sacrifice of Iphigenia* (Kimbell Art Museum,
Fort Worth, Tex.)

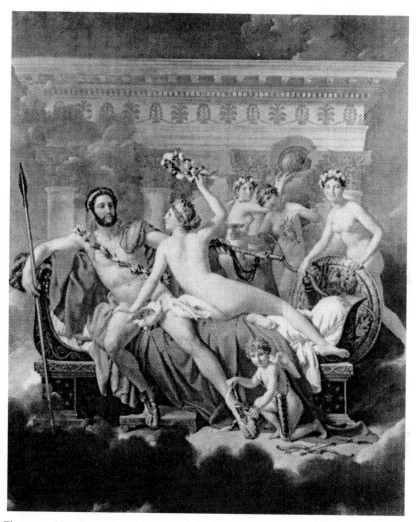

Figure 85. *Mars Disarmed by Venus and the Graces* (Musées royaux des Beaux-Arts, Brussels)

Figure 86. *Apelles Painting Campaspe in front of Alexander* (Musée des Beaux-Arts, Lille)

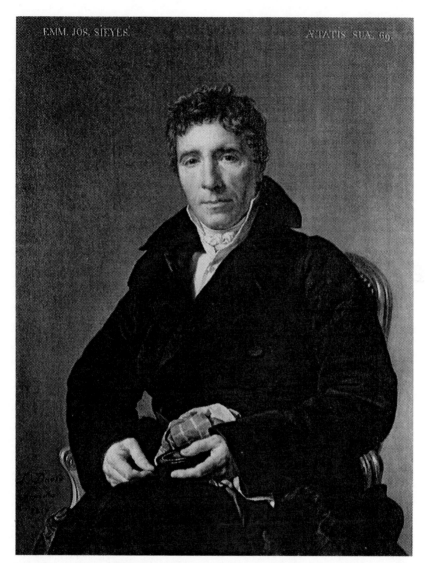

Figure 87. *Emmanuel-Joseph Sieyès* (Harvard University Art Museums, Fogg Museum, Cambridge, Mass., bequest—Grenville L. Winthrop)

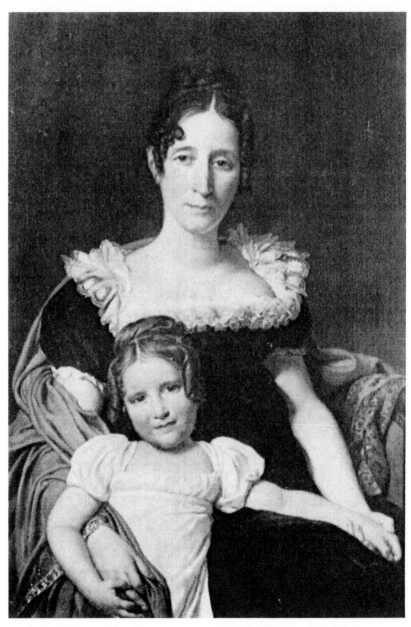

Figure 88. *Vicomtesse Vilain and Her Daughter* (private collection, photograph copyright A. C. L. Bruxelles)

figure of the painting. Changes such as these can be seen in other male figures in the painting. To cite one more example, the soldier next to Romulus in the first sketch is replaced by a nude figure that faces in the opposite direction in the second sketch. The earlier soldier, who prepares to fight, underlines the sense of impending strife whereas the later figure, who turns away from Romulus, and leads a horse away from the battle, suggests the cessation of hostilities. This figure, no longer a Roman soldier but a nude adolescent, anticipates the other nude figures that will appear in the painting and as such it is part of the purifying process.

To put these changes in perspective, it is helpful to trace the sequence from the first studies to the final version of the *Sabine Women,* completed in 1799. When David decided on the Sabine women as the subject of a painting in 1795 he did the preparatory studies in the only style he knew, his own Roman style. He then made study after study, trying to work out his design, just as he did in his previous history paintings. But in this case something else was happening: he not only worked on the design but was developing a new language. As has been noted, the process was like the one David followed in the *Horatii,* only this time it was in reverse. In the heroic painting of 1785, the "epigrammatic edge" was developed as David proceeded through the various studies; the tension increased from one study to the next and the soldiers became more stalwart and resolute. The swords played a central role in the heightening of tension and in charging the work with impending violence. The full breakthrough was achieved in the *Horatii* painting. In the *Sabine Women* the idea is one of peace, of which the painting was to be an allegorical representation. The preparatory studies show women intervening and bringing the battle to a halt. And yet David did not proceed directly from these studies to the finished work, even though he had worked out the essential elements of the design. Rather, he made study after study over months and years. He began and finished other paintings but kept working on the *Sabine Women.* Even though he had for the most part developed the design, he was not satisfied; to finish his allegory of peace he needed a new language, and this is what he finally achieved in the painting of 1799. The result is not increased tension, as in the *Horatii,* but loss of tension; not greater energy but less energy.

Stefan Germer and Hubertus Kohle have written that in the *Sabine Women* David, following Winckelmann, "transforms the historical event into an aesthetic presence and attempts to convey general and permanent validity to the unique by means of stylizing each action."[39] Just as Winckelmann favored the universal over the particular and wanted to free art from the

passions, so too did David. These concepts are at the center of the *Sabine Women*; indeed, they defined David's objectives. "By transposing the active figures into aesthetic calmness he opened these up to the public's emotions, offering an unrestricted projection screen."[40] The aestheticized, purified forms of the *Sabine Women*—in its finished, 1799 form—convey the message that had been at the center of the idea that first came to David when he was still in prison in 1795. But he had not been able to give that idea the artistic form he wanted it to have when he began the preparatory studies. This required five years of effort and the creation of a new style. The *Intervention of the Sabine Women* was the culmination of that effort.

Compositionally, the *Sabine Women* stands apart from David's earlier history paintings. In the *Horatii* and *Brutus,* male and female figures occupy different parts of the pictorial space, but in the *Sabine Women* female figures are in the middle of the painting, dividing the males into separate compartments. The Roman and Sabine soldiers in the foreground are lined up along a horizontal axis, while the armies in the background are an extension of that space, as if they were part of a rectangle that recedes from the front of the painting to the rear. Into this bloc rush the Sabine women, whose figures are organized diagonally so that they cut through the space occupied by the soldiers. The effect of this compositional device is that the women are seen pushing through the space occupied by the men. In pictorial terms it is the women who are dominant; it is they who define the spatial relationships by driving a wedge through and opening up the space between the men. Reading downward from the women to the right of Hersilia, a line is formed by those at the rear which extends forward to those in the foreground, as if that line were the edge of a triangle, at the front of which are the children on the ground. Behind and to the left of Hersilia is the profile of a woman who climbs onto a pedestal that elevates her above the soldiers. She raises a screaming infant over her head with both arms, a gesture that is imitated by soldiers who lift their lances, shields, and helmets upward. It is the woman who makes the gesture of peace and it is the men who respond to the gesture by giving up the fight. But Hersilia is the key figure in bringing the bloody struggle to an end. Stepping dramatically between Tatius and Romulus, she causes one leader to lower his sword and the other to relax his grip on the lance.

The way the women are depicted adds to their impact. Their femaleness is emphasized by exposed breasts and by the way they hold their children and appeal to the men. The woman who clings to the leg of Tatius was once a Sabine woman, but she is now a Roman, by virtue of the infant in her left

arm. As she kneels before one of the soldiers, holding her child, so does another woman behind and to the right of Romulus. In front of her is a dead soldier, sword still gripped in his hand, and above her is a mounted warrior who places his sword in its scabbard. This woman, who is right in the thick of the battle, kneels in order to protect her child. It is in response to her and to the other women that the men give up the fight.

Having men respond to women was an idea that David developed in various ways as he worked his way through preparatory studies. One example will suffice to indicate the possibilities he considered. In the same sketchbook that contains the *Louis XVI* drawings (the Louvre Sketchbook, RF 36942) David did a study (fig. 53) for the three infants on the ground in front of Hersilia. In the drawing the infants are seen from behind, and all three hold their arms upward, toward the bare-breasted woman who shelters them with lowered arms. In the painting two of the three infants of the sketch are now facing us, while the infant on the left still reaches up, as in the drawing, only for a different reason. That child no longer reaches up to be sheltered but because he has been knocked over by the child who has started a fight. While the gender of the two fighting infants is not shown there can be little doubt that they are boys. This is suggested by the fact that, like the men, they are fighting, and it is indicated more literally by the third child in the group, who is shown as a boy. In the drawing the emphasis is on the closeness between the woman and the children, brought out by the infant on the right who reaches up and touches her breast and by the woman who looks down at the other children who also want her attention. In the painting the woman no longer looks down at the infants but turns her head toward Tatius, to whom she now appeals with open hands. Before, her hands had been open to the children but now they convey a message to Tatius; now she is pointing out to him that the boys, like the men, are fighting. Is it not time for such behavior to end?

Thus, the themes of female suffering and male violence, both present in the *Horatii* and *Brutus,* are present again in the *Sabine Women,* but now the relationships are completely different. Before it had been the men who played the dynamic role; they performed the violent actions to which the women reacted with grief. Now the opposite happens: the men have again given themselves over to fighting, but women enter the stage of action and determine the outcome. Symbolically, it is a victory for women and peace over men and violence. The painting's compositional devices give prominence to the females. Moreover, the language David employed has been purified, making it an appropriate vehicle for his subject. In terms of the

argument advanced in previous chapters, the *Sabine Women* represents dominance of the female over the male principle.

One final point about the *Sabine Women*: David's model for Hersilia was one of the Bellegarde sisters, for whom he had signed an arrest warrant during the Revolution. She survived the Terror and he survived the reprisals of the Thermidorean reaction. Her presence in the painting underlines its main theme; she had known the hazards of strife, and now, as Hersilia, she calls for peace. Behind the academic figures of the painting and their studied poses, this personal touch links the work to the world of recent events.

After being released from the Quatre Nations in 1795 David was offered a position in the Institute of France, which he accepted. Among those also elected was his mentor of old, Vien, along with F.-A. Vincent, J.-B. Regnault, August Taunay, and Gérard Van Spaendonck. David attended meetings regularly, and according to Schnapper he enjoyed them.[41] It would seem that he welcomed the opportunity to resume the life of an artist and appreciated recognition that regularized his position. No longer the contentious artist of previous years, David was eager to get on with his work. That he had chosen the *Sabine Women* as the subject that would occupy much of his time and energy until 1799 suggests much about his state of mind when he accepted a position in the Institute.

The newly created Institute was organized along the lines of the old Academy. Although a report of October 17, 1795, said that the Institute would be a "national temple whose doors will always be closed to intrigue and open only to those of well-merited reputation," the new body was not democratic. It was "open only to a small elite," in Schnapper's words.[42] And yet there was one very important difference between the Academy of the ancien régime and the Institute. The new Institute had "nothing to do with teaching."[43] Students studied under their mentors alone, no longer taking the required instruction from the twelve professors of the Academy.

No artist in the years after the creation of the Institute attracted as many students as David. In the five years between 1795 and 1799 his studio became the center of his world. As Delécluze noted, after his imprisonment David eschewed politics and sought peace in the fine arts. He wanted to regain mastery of his brush and he wanted to be with his students, to whom he was devoted. According to Delécluze the language and manners of the *sans-culottes* were banished from David's studio in favor of more polite habits. His studio attracted artists of all types and backgrounds, including emigrés and nobles who returned from the army. Their real or feigned interest in art, Delécluze said, gave these newcomers access to David. It was as if a new

aristocracy had been formed, made up of men of talent and women remarkable for their wit and beauty. Delécluze said it seemed like a return of the old bourgeoisie.[44]

Yet there were tensions in David's studio, explains Delécluze, while David was working on the *Sabine Women*. A group of radical students, the Barbus, or bearded ones, also known as the "Primitifs" or "Penseurs," criticized David for not carrying his new, Grecian style far enough. This was a time, as Walter Friedlaender noted, of a "pan-European archaizing movement," or, as Robert Rosenblum said, of a "search for the most elemental forms," of "complete purification" of art. Those in the vanguard of this stylistic direction would "reduce pictorial art to a minimal vocabulary," stripping away the rhetoric that, from their point of view, had long cluttered art.[45] The search for more simple forms was consistent with the logic of classicism, and it was an approach with which David was in sympathy when he rejected his Roman style in favor of a purified Grecian style. The simplifying and abstracting process that his style underwent while he worked on the *Sabine Women* was congruent with the larger pattern of change, but it stopped short of the goals of David's radical young students.

The leader of the group was Maurice Quay, who died at age twenty-four and none of whose works have survived. All that is known about him comes from the descriptions of other students, such as Delécluze and Charles Nodier. Nodier wrote that

> Maurice Quay . . . was on too high a plane to adapt to commonplace thought or action, to take any interest in the pursuits of the rabble, or to have any faith in its devices. He rejected it when he was twenty; he only lived to twenty-four, and I have often wondered how much further he could have gone as he got older and became caught up in the irresistible momentum of things. . . . Maurice Quay was a splendid-looking man. Nature had decided that his exterior should be as impressive as his genius, and as she does not confer such perfection without atoning for her masterpiece, she allowed us only a glimpse of him. He died before entering manhood.[46]

Like other members of the group, Quay rejected established conventions. Besides growing beards, a sign of nonconformity, they wore exotic clothes, classical tunics, oriental garb, or even rags. They appeared in sheepskin cloaks and white pantaloons or red waistcoats and turbans. The idea was to be different. They wanted to raise eyebrows, to shock. When Quay, the leader of the Barbus, was asked by Napoleon, then the First Consul, about

his strange attire, the following conversation ensued: "Why did you adopt a type of clothing which separates you from the world?" "In order to separate myself from the world."[47] Quay's witty reply reveals an alienation that was at the center of his bizarre behavior and his artistic ideas.

Delécluze describes the time when Quay announced to his friends that he would give up his ordinary clothing in favor of costumes that would set him apart from other people:

> I have decided that in a few days from now, I shall shed these shabby clothes which I am wearing like all the men of our century. Already, as you can see, I have let my hair and my beard grow; a large white tunic is being readied now and I shall wear it under a wide blue cloak, and I shall wear only buskins on my feet. But I can read doubt in your eyes; you think that I, like a faint-hearted man, have had this clothing prepared to adorn myself with it in the obscurity of our small room and only in your presence? Do not be deceived; . . . you will see me dressed in this manner in the Tuileries, strolling among those stupid bourgeois who will be blushing because of the ugliness and the shabbiness of their modern garb.[48]

That Quay was a serious and earnest young man should be evident from this description. Delécluze said he spoke "with the authority and the enthusiasm of a prophet," and this was how he was regarded by fellow students in David's atelier.[49] The Barbus came to regard themselves as something of a sect; they became vegetarians whose strict eating habits were bound up with their religious beliefs. One could not, they came to believe, be Christians and at the same time eat meat.

Small in number as the Barbus were, their ideas reveal some of the deeper changes within French society in the years after the fall of Robespierre. The anti-Christian policy of Robespierre was followed by a Christian revival, as suggested by the writings of François de Chateaubriand, Louis Bonald, and Joseph de Maistre. This revival coincided exactly with the formation of David's radical students into a sect. Besides going back to the Bible the young artists read Homer and Ossian in their search for simple, evident truths. While their bizarre clothing and strange behavior might seem out of keeping with their high-minded goals and idealism it was, in fact, not inconsistent. Both aspects arose from the seriousness of their purpose and reflected a reordering of attitudes and values in the years after the Revolution.

In their exclusivism, cultivation of the strange and exotic, and rejection of

the bourgeois, it would not be incorrect to call the Barbus aristocrats of the spirit. The combination of alienation and protest against the conventional suggests the conditions within France that would result in nineteenth-century Bohemianism.[50] But the Barbus, rather than blending into Bohemian artistic culture, became so absorbed in their philosophic idealism that they rejected art. Charles Nodier describes the stages leading to that rejection:

> Going beyond the reform of painting and of society, [their philosophy] entered the realm of metaphysics; the general emotion which at first took the place of religion for them . . . was a love of art and an obsession with it. By perfecting this and refining it in the furnace of their souls, they attained the pinnacle of nature in all its grandeur and sublimity, and during this second phase art was no more to them than a subject of comparison, an occupational resource. Nature herself finally dwindled in their minds, for the sphere of their ideas had widened. They perceived something wonderful and incomprehensible beyond the last veil of Isis, and they withdrew from the world, for they had gone mad. That's the only word for it, mad like therapeutists and saints, mad like Pythagoras or Plato. They still went to the studios and galleries, but no longer produced anything.[51]

According to the accounts of contemporaries, David inspired his radical young students when he described the purification of style he hoped to achieve in the *Sabine Women*. Delécluze wrote that David was "more than ever attracted to the works of antiquity [and] proposed to use as models only the Greek works which were considered to have been executed in Phidias' time. Among the reliefs, he sought those which had the oldest style; he did the same for medals, and he particularly praised the natural quality and the elegance of line of figures painted on the so-called Etruscan vases."[52] Delécluze explains that David "struck the imagination of the young students and especially of Maurice [Quay], and inspired by [his words] they claimed that David had only foreseen the road to follow, that the principles upon which the arts were practiced had to be radically changed."[53] Because David was not sufficiently thoroughgoing in carrying out his own principles, Quay set himself up as the head of a rival faction. As Delécluze described his tactics, "Maurice encouraged his followers to cease working in David's studio if the model did not seem beautiful to them; he advised them to paint only figures . . . six feet [tall]."[54] The critic Charles-Paul Landon took a dim view of the rebellious students and predicted that their absurd ideas would

come to naught: "Having distorted [David's] words [they] go proudly repeating themselves, not what they have heard said by a famous artist . . . but rather what they think they have heard; they create from it a new, ridiculous doctrine, but they will certainly fail with their proselytes."[55]

David found himself in a difficult position as rebellion took place within the ranks of his own students. Delécluze describes his response as gentle and understanding. Rather than exercising his authority, he tried quietly to maintain harmony. "Without creating a scandal, he found the means of letting it be known to those of his disciples to whom his lessons were not suitable not to disturb the studies of their former comrades."[56] The furthest David seems to have gone was to dismiss Jean-Pierre Franque, his assistant on the *Sabine Women,* who criticized the work for not being sufficiently primitive in style while it was in progress. He never expelled the Barbus from his studio, but by 1800 they drifted away by themselves, occupying an abandoned convent at the foot of the hill of Chaillot, then an out-of-the-way part of Paris. In George Levitine's words, they "faded from the view of the historical spyglass after Nodier's departure for Besançon in the summer of 1802."[57]

Exotic and ephemeral as the group was, they are of real interest to the historian of nineteenth-century French culture. Levitine has shown that within the alienated young artists of the Barbu sect lay the germs of Bohemianism. Anticonventional and antibourgeois, they would withdraw from a world they despised. Their artistic theories were consistent with their contempt for society; just as they scorned the bourgeois order so did they reject all conventional art, indeed all art since the time of Phidias. What they accepted were the abstract forms of Etruscan art or Greek vase paintings. Behind their artistic theories was a radical iconoclasm, and a psychology of rejection that was a function and product of their era. Out of times of intense pressure—such as the French Revolution—come periods of decompression, and escapism. Both the Barbus and the larger Bohemian culture that followed had their sources in these historical conditions.

David's reaction to those conditions was influenced by his age and position. In 1794, the year of his imprisonment, he was forty-six, and when he finished the *Sabine Women* he was fifty-one. He presided over the largest student following of any contemporary artist and was regarded as a person of stature and authority. For someone of his age and position to strike off in a new stylistic direction was not easy. That he set out consciously to do so suggests how uncomfortable he was with his earlier style—and his own later remarks about the *Horatii* can be regarded as proof of his uneasiness. David

wanted to create a new style, and he was open to the larger forces of artistic change. Despite the impatience of his radical students, what is remarkable is that in developing the new style David went as far as he did. The young radicals wanted to break definitively from a tradition with which David chose to remain in contact. Nonetheless, both he and the idealistic students who seceded from his studio looked in the same direction, and both he and they belonged to a pattern of change that reflected contemporary social conditions. David's art underwent devitalization; the Barbus ended up rejecting art altogether.

Referring to the revolutionary decade, 1789–99, Schnapper has said that "David's genius shines like a beacon over the whole of this period."[58] This was also true of the previous decade, the 1780s. Looking at this twenty-year period as a whole, David's light outshines that of any other French artist, but during the last five years he became a different artist. And just as he became a different artist so did the many artists who came under his influence strike off in new directions. Neither he nor they worked in the heroic, grand style, the Roman style as it was now called, which extended from the *Belisarius* through David's great revolutionary paintings. While traces of that style persisted in David's *Homer* studies and *Sabine* studies, it was a style that he strove consciously to reject and did in fact overcome, in favor of the purer Grecian style that he brought to fruition in the finished version of the *Sabine Women*. Not only was the period 1795–99 decisive for David in his rejection of the heroic style made famous by the *Horatii, Socrates,* and *Brutus,* but it was equally decisive for the entire French school of artists. This was a watershed in the history of French art.

Just how profound the change was can be seen by examining the art of David's contemporaries. The relationship between David and his contemporaries reveals the larger pattern of stylistic change to which both he and they belonged. In the second half of the eighteenth century, critics wanted a more forceful art, a virile and heroic art, and they praised artists who captured those ideals on canvas. Out of the antirococo reaction came an art that was not only didactic but also heroic. If the neoclassical productions of Vien and other artists lacked the grand manner that David captured so effectively, others were moving in the same direction as David; if their works lack the stamp of genius that only his have, they speak the same language. For example, Beaufort's *Oath of Brutus* (1771) clearly looks in the direction of David's *Oath of the Horatii*. Both the subject and composition of this work put it in the mainstream of an artistic style that David would carry to its highest stage of development. So too would the works of Peyron, with

which David's paintings were in direct competition: Peyron's *Belisarius* (1779), *Death of Socrates* (two versions, 1787, 1789), *Cimon and Miltiades* (1782), *Death of Alcestis* (1785), and *Curius Dentatus* (1787) all have features in common with David's work. It was also true of works such as Bernet's *Continence of Scipio* (1789), Regnault's *Deluge* (1789), and Girodet's *Death of Camilla* (1785) and *Deposition* (1789). And in the *Prodigal Son* (1782) and *Marius at Minturnae* (1786), by David's favorite student, Drouais, David's influence is obvious. In the *Marius* by Drouais the similarity is not only in the choice of subject but also in the composition. A young soldier has come to put Marius to death, but it is he who flinches at what must be done, not the proud Roman who is ready to receive the fatal stroke of the sword. Such manliness and Stoic resolve were the stuff of David's paintings. Moreover, the receding lines of the floor which define the pictorial space of the foreground and the lines of the curtain which provide the flat backdrop are devices similar to those used by David. The influence of David is again apparent in Armand Caraffe's *Oath of the Horatii* (1791), and to a lesser extent in A.-J. Gros's *Antiochus and Eleager* (1792), a work by another of David's students.

After some twenty-five years of development the Roman style came to an end during the Thermidorean period.[59] Not only did David abandon the style but so did other artists. The years 1795–99 were a period of "contradictory tendencies," according to Rosenblum, a time of "puristic regressions" and "archaizing."[60] It was also a time of proto-baroque, gothic, and romantic tendencies. The era produced not a dominant style but a diversity of styles. In the puristic retreat into the past, some artists looked back to the linear art of the Etruscans and Greek vase painting, whereas others retreated only to the sixteenth century or, in some cases, to the seventeenth century. The stopping-off point for some artists was the School of Fontainebleau, while that of others was the more robust art of Rubens. If Girodet's *Mlle Lange as Danaë* (1799) suggests the "linear sensuousness and elongated proportion" of Primaticcio, Gros's *Napoleon Visiting the Penthouse at Jaffa* (1799) has definite baroque tendencies.[61] To complicate the stylistic picture further, such a work as F. Gérard's *The Dream of Ossian* (1801) is an example of the gothic-romantic current that also issued from this same period—even as its linear forms carry the stamp of the archaizing tendency. Interesting also is Girodet's *Ossian and His Warriors Receiving the Dead Heroes of the French Army* (1802, fig. 54), which mingles the neoclassical and baroque in a scene remarkable for its clutter and diffuseness. Done by one of David's students, it reveals as well as any single painting the definitive break from the disciplined, terse Roman style against which even the master was reacting. If

David's art underwent purification, this work suggests a different type of stylistic change. Out of the heroic style, and out of David's own atelier, came a remarkable welter of styles in the years following the Thermidorean reaction. But there was no renewal of the heroic style. Having come into its own in the last two decades of the ancien régime, that style reached a definitive end in the years after the Revolution. Neither David nor his students would try to recapture the distilled energy of the Roman style. From this time on French art looked in new directions.

There were many disagreements in David's atelier over artistic style and theory—and there were other disputes as well. Delécluze describes a controversy between two students, Alexandre and Etienne, over Gracchus Babeuf, a leader in a radical *sans-culottes* conspiracy that would have returned the Revolution to its former egalitarian principles. As R. R. Palmer has written, with Babeuf and his political allies "we reach the extreme Left of the French Revolution."[62] Babeuf propagated his ideas in a radical paper, the *Tribun du peuple,* and he and others of his persuasion met in the Panthéon Club, which the authorities closed down on February 28, 1796. The person who carried out the orders was a young officer by the name of Bonaparte. Having been subjected to governmental repression, the members of the radical group made plans to seize power, and published broadsides in which they set forth their goals and principles. The authorities learned of the conspiracy and arrested Babeuf on May 10, 1796, a few days before the insurrection was to have taken place. A trial was held, and Babeuf was found guilty and sentenced to death. It was over these matters that two of David's students fell into a violent quarrel. Delécluze met them when they were involved in a heated argument on the rue du Bac, on the Left Bank. With them was another student, F. Dubois, celebrated for his erudition in ancient and modern obscenities, and as Delécluze noted, an ardent revolutionary. Yet another of David's students, F.-J.-B. Topino-Lebrun, was an active Babouvist.

Even as David consciously avoided politics and devoted himself to his students and his art, politics entered his studio. And it was not only David's students who brought politics into his atelier: the master himself invited a rising general to his studio to sit for a portrait. That general, of course, was Napoleon, whom David wished to paint not just because he admired his features but because he had come under Napoleon's spell, just as he had earlier come under the spell of Marat and Robespierre. Napoleon wrote David in 1797 during a successful campaign in Italy, asking him to join him there and paint his battles. One of David's students, Gros, was attached to

Napoleon's staff as an official who appraised paintings that were taken back to France for tribute money. Gros apparently spoke to Napoleon about David and out of the discussion came the offer, which David declined. David was still wary of political involvement, and as Brookner has remarked, his rejection of Napoleon's offer should be linked to his earlier remark that he would "no longer attach himself to men, only to principles."[63]

The popular general returned to Paris on December 6, 1797, and attended several banquets. It was on one of these occasions that David met Napoleon, ironically, at the Luxembourg Palace. Aware of David's potential value—he had been a superb propagandist of the Revolution—Napoleon arranged for the two of them to meet again at a dinner given by Joseph-Jean Lagarde, secretary of the Directory. Delécluze explains that David proposed to make a medallion or engraving of Napoleon and that Napoleon was to come to David's Atelier des Horaces, located above his teaching studio in the Louvre, to pose. When Napoleon did not show up for the sitting because he forgot about it, David wrote him several times and went to see him personally. By now he wanted to do a portrait of Napoleon and suggested that they arrange a sitting. The general explained that he had been busy on the day of the first appointment, apologized for forgetting it, and said he would come to his studio the next day. News of Napoleon's visit spread throughout David's atelier, and when he arrived students lined the corridor. Napoleon removed his hat and he and David exchanged civilities in low voices. Delécluze describes the sense of awe that he and other students felt in the presence of the young general. Delécluze also commented on David's eagerness as he awaited Napoleon's arrival. Everything about his description captures the tension of the moment, heightened by the obvious impatience of Napoleon, who explained that he could not stay long. The sitting lasted three hours. It was the only time Napoleon ever posed for David. The *Portrait of Bonaparte* (fig. 55) was never finished. In the portrait's incomplete state, Napoleon's head is turned to the right, and it is in that direction that his eyes are fixed, a pose that enhances his charisma. The brushwork is fluid and the paint applied with light but sure strokes. David took his unfinished work to Napoleon the next day, and when he returned to his studio his students were eager to hear about the visit. Delécluze notes that David smiled more than usual as he replied: "You are curious to know what has happened? Ah—I believe, or hope at least, that what I have put here on canvas is not inferior to my earlier works. . . . You will see, you will see; but when I will have finished . . . Oh! my friends, what a beautiful head he has. It is pure, it is grand, it is as beautiful as the antique. Finally, here is a man to whom one

would have raised altars in antiquity. Yes, my dear friends! Bonaparte is my hero."[64]

However much David may have admired Napoleon he declined his offer, made in April 1798, to accompany his expedition to Egypt, which sailed from Toulon in the following month. Why did David turn down the offer? Was he trying to preserve his independence? Was he trying to resist political involvement? An earlier incident suggests that David had good reason to be cautious. At the urging of his old friend Quatremère de Quincy, he had reluctantly signed a petition on August 15, 1796, protesting the despoiling of Italy and Holland of their artistic monuments by the armies of France. Paul Barras, one of the directors, was furious: "What is most remarkable," he wrote, "is the signature of David . . . [on the petition] the imbecile . . . is dishonored by his signature."[65] David was more careful two years later, when an immense collection of art booty was paraded through the streets of Paris on its way to the Louvre.[66] This was a public display of some of Italy's finest treasures, including Raphael's *Transfiguration* and *Madonna della Sedia*; Titian's *Burial of Christ* and *Three Ages of Man*; the *Apollo Belvedere*, the *Laocoön*, the *Dying Gaul*; and perhaps most astonishingly, the bronze horses that had been removed from Venice's San Marco. Brookner said of the festivities, "David did not enjoy them."[67] Delécluze wrote that "only one man had a different idea about [the celebration] and the courage to express it: David."[68] Yet David now limited his statements of protest to his students. He was cautious even when addressing that audience, and wisely so, for his comments were repeated publicly and interpreted to David's disadvantage by students who were taking sides against the master. What they had to repeat about David's remarks was distinctly nonpolitical, owing to David's circumspection. "You may be sure," he said, "that the masterpieces brought back from Italy will soon be considered only as rich curiosities. The actual placing of a picture, the distance one has to travel to admire it, contribute to a large extent to its value, and many pictures, notably altar-pieces, will lose a great deal of their charm and their effect once they are no longer in the position for which they were destined."[69] If David had the courage to voice his dissatisfaction over France's plunder of Italy's art treasures he did so on aesthetic, not political grounds. The works of art now in France could not be properly appreciated, because they had been removed from their original locations. It is interesting to note that the public display of the looted art treasures was held on 9 Thermidor, four years since the fall of Robespierre, and David was still cautious.

It so happened that Napoleon cast his spell on David precisely when the

artist was most deeply involved in the *Sabine Women,* a work that was more than ordinarily demanding. As we have seen, not only was this a huge canvas, but also it was more elaborate than his earlier history paintings. And it was a work whose final state was achieved after more than the usual difficulties, for besides working out the design David developed the new, purified Grecian style that he created as he proceeded toward the finished painting of 1799. When David's initial encounters with Napoleon are seen against the background of his work on the *Sabine Women* it is evident that David faced a difficult decision. He was attracted to Napoleon and the world of public affairs and power that he represented, but at the same time he was cautious about political involvement and preferred attachment to principles rather than men. By principles he clearly did not mean those to which he had been devoted as a revolutionary. Undoubtedly he meant the ethical principles that found expression in his art, but he could have also meant the theoretical principles on which his art was based. Since this was the period when he was developing a new style, one that drew from the theories of Winckelmann, David's commitment to principles—not men—had a particular urgency. It was at this time that Napoleon invited David to accompany his expedition to Egypt. David's refusal can be seen within the context of these personal and artistic factors. It was not just that he was wary about attaching himself to Napoleon and becoming involved in politics; he was deeply absorbed in the technical demands and theoretical principles that had to be sorted out and mastered before he could complete the *Sabine Women.* Thus, he remained in his studio, working with his students and laboring on his ambitious painting in the several years before its completion in 1799. He had chosen art over politics and principles over men—over one individual in particular, Napoleon Bonaparte. But the spell had been cast, and David would not continue to resist the attractions of his hero.

4 *David*
AND NAPOLEON

Ah! my friends, what a beautiful head he has. It is pure, it is grand, it is as beautiful as the antique. Finally, here is a man to whom one would have raised altars in antiquity. Yes, my dear friends! Bonaparte is my hero.
—1797, from Delécluze's biography of David[1]

He discovered that his hero had rather too much the temperament of a warrior and that the head of the new dynasty was at least as absolute in his whims as the old . . . "Ah! ah! This is not precisely what one desired."
—1812–13, from Delécluze's biography of David[2]

*B*ETWEEN THESE TWO quotations is a period of some fifteen years, which roughly coincides with the rise and fall of Napoleon as the dominant force in French political life. In the first quotation, David proclaims the twenty-eight-year-old Bonaparte as his hero, after Napoleon's sensational victories in Italy. In the second quotation we hear of David's disillusionment with the leader in whom he had once placed so much of his faith. It is now 1812 or 1813, and David is talking to students about Bonaparte's mistakes. His armies were locked in an all-out struggle for European domination against a coalition of enemy states that would soon bring about his complete defeat. Napoleon, David felt, "had rather too much the temperament of the warrior," and he believed that Napoleon as the head of a new dynasty was "at least as absolute in his whims as the old." Why was David attracted to Bonaparte in 1797, and why did the initial enchantment turn to disenchantment fifteen years later?

To understand David's attraction to Napoleon it is important to keep several points in mind. First, something within David's complex makeup attracted him to leaders, to those who exercised or epitomized power. During the Revolution, he had attached himself to Marat and Robespierre, and in moments of intense agitation he offered to sacrifice his own life for these leaders. Just four years after the death of Marat and three years after the fall of Robespierre he found a new hero in Bonaparte.

The second point to keep in mind concerns the person David chose as his new hero. No other leader has ever exercised such a magnetic hold on the French people.[3] Indeed, in all history few leaders have had such charisma. Mme de Staël, who hated Napoleon, said he captured the imagination of the French people "as much by his character and mind as by his victories."[4] C. M. Talleyrand, who served under and conspired against Napoleon, said later, "His career is the most extraordinary that has occurred for one thousand years. . . . He was certainly a great . . . man, nearly as extraordinary in his qualities as in his career: at least, so upon reflection I, who have seen him near and much, am disposed to consider him. He was clearly the most extraordinary man I ever saw, and I believe the most extraordinary that has lived in our age, or for many ages."[5] Chateaubriand said of the man whose court he had attended and whose despotism he denounced that Napoleon was "the mightiest breath of life which ever animated human clay."[6]

A third point to remember is that the brilliant general appeared to be a republican and dedicated friend of the Revolution. He first made his mark in Toulon in 1793 when, as an untested junior officer, he devised a strategy that

drove the British out of a key French port. This was more than a victory over the British, however: like much of southern France, Toulon had become a center of counterrevolution, and it was for that reason that the British had been invited in. Besides defeating the British, Napoleon struck an important blow for the Revolution. Later, in 1795, the comte d'Artois landed on an island off the French coast and was expected to join counterrevolutionaries in Brittany and the Vendée. This led to royalist demonstrations and pointed toward the 13 Vendémiaire uprising. Paul Barras, the leader of the Constitutionalists, asked Napoleon if he would put down the insurrection, and at the crucial point Napoleon's eight-pounders put the rebels to rout. Barras was able to announce, "The Republic has been saved . . . Citizen Representatives . . . don't forget General Bonaparte . . . Founders of the Republic, will you delay any longer to right the wrongs to which, in your name, many of its defenders have been subjected?"[7] In the thirteen-month campaign in Italy that led up to Campo Formio, Napoleon's armies marched into battle as drums and fifes sounded out revolutionary anthems, "La Marseillaise" and "Les Héros morts pour la liberté." At the important battle of Lodi, Napoleon exhorted his troops to fight bravely as he shouted "Vive la République!" He presented himself to the Italian people not as the head of a foreign army but as the opponent of tyranny. "Peoples of Italy!" one of his proclamations announced, "The French army is come to break your chains . . . we urge war with generous hearts, and turn ourselves only against the tyrants who seek to enslave us."[8] Having freed a town from the Austrians, Napoleon had a liberty tree planted in the town square, a symbol of natural rights and the Revolution. His image as champion of the Revolution accompanied him when he returned to France in December 1797.

Finally, the brilliant general who returned to France after Campo Formio was a peacemaker; he cultivated an appearance of modesty and good breeding. He avoided public appearances and military display, wore civilian dress, and was elected to the Institute. He had carefully nurtured his reputation as a patron of the arts during the Italian campaign and he found it useful to do the same in Paris, knowing full well how great a threat he was to the Directory. The conquering general would not appear as a general, but rather he sought out artists such as David and writers such as Mme de Staël. When he departed for Egypt he was accompanied by more than 150 writers, artists, and scientists who were commissioned to conduct research in the archaeological riches of that ancient land. While David declined Napoleon's offer, the flower of the Institute and the Ecole Polytechnique was present and from their remarkable efforts came the science of Egyptology and an

unlocking of the secrets of the past. Napoleon was no mere soldier on horseback but a scholar, patron of the arts, and friend of science. This, at any rate, was the image he wished to project.

In the history of the world's great leaders it would be difficult to find one more cynical than Napoleon. When it served his interest to say something he did not hesitate to say it. In fact, he made stirring proclamations that were the very opposite of what he actually thought. After the eighteenth of Brumaire he wanted the coup that brought him to power to appear consistent with the principles of the Revolution: "Citizens, the Revolution has been made fast to the principles that started it."[9] He later said, "Look at my virtuous republicans: all I have to do is hang gold braid on their clothes and they are mine."[10] In an 1804 message to the Senate he said, "We have been guided at times by this great truth: that sovereignty resides in the French people in the sense that everything, everything without exception, must be done for its glory."[11] In a conversation during the same year Napoleon said, "The presidents of the cantons and the presidents of the electoral colleges, the army—these are the true people of France—not 20,000 or 30,000 fishmongers and people of that ilk . . . they are only the corrupt and ignorant dregs of society."[12] He wrote in 1810, "My axiom is: France before everything."[13] He said this because it suited his interests at the time. In a moment of greater candor he told the Council of State in 1803, "If I belong to a party, I am for my party; to an army, for my army; to a State, for my State. If I were black, I would be for the blacks; being white, I am for the whites. That's the only truth. The opposite you may tell to children."[14]

The crucial period in Napoleon's rise to power was from November 1799 to December 1800.[15] At the beginning of this period he was a thirty-year-old general who had just returned, without orders, from an unsuccessful campaign in Egypt. When he arrived back in Paris on October 16, 1799, the government was internally weak. New men had entered the Directory, but most were nonentities with little support. There were grave financial problems, the armies could not be paid, brigands plundered large areas of France, and counterrevolutionaries were again active in the Vendée. A motion to declare the "*patrie* in danger" had been narrowly defeated in the Council of Five Hundred on September 14, which implied suspension of the Constitution and dictatorship. A crisis was clearly at hand. Napoleon was approached by members of the Directory who either wanted him out of the way or on their side; he was also approached by Jacobin generals who were prepared to offer him a military dictatorship if he would join them. He chose to ally himself with Sieyès, and Napoleon and Sieyès were the key figures in the coup

of 18 Brumaire (November 9) 1799, which brought the Directory to an end. At first the coup went according to plan, but when news leaked out that the directors had been pressured into resigning or placed under arrest, Jacobin members of both councils organized in protest.[16] Napoleon's threats so antagonized his opponents in the Council of Five Hundred that he had to be rescued by four grenadiers. At this point Napoleon had to appeal to troops for support. When he next entered the hall of the Council of Five Hundred it was after guards had taken the building with lowered bayonets. The parliamentary deadlock was broken, but only by force of arms. Thus were the foundations laid for military dictatorship and for the system of despotism that Napoleon was to build and dominate for the next decade and a half.

Bonaparte's hold on power was not yet secure after the eighteenth of Brumaire, but the following year, 1800, was decisive. He led an army across the Saint-Bernard pass in May and won a major victory at Marengo in June. News of that victory helped solidify his position. Sensing a shift of opinion, Napoleon did everything possible to gain advantage from his success. At his bidding newspapers ground out articles that glorified the Italian campaign and enhanced his own prestige. The very success of these efforts made his enemies desperate, both royalists and Jacobins. They had hoped for his defeat in Italy, but faced with victory and a decisive swing of the pendulum in his favor, extremists of both parties turned to assassination plots. Jacobin plots were uncovered on September 14, October 10, and November 8. The facts of these conspiracies are still in doubt, but there was an attempt on Bonaparte's life on December 24, when a large bomb, the "infernal machine," was detonated in the rue Saint-Nicaise as Napoleon and Joséphine were on their way to the Opera. Twenty-two people were killed and fifty-six were injured, but Napoleon was unharmed.[17]

The arrests of Jacobins in September, October, and November threw suspicion on men of that party, and in January reprisals were swift and severe. Napoleon had exclaimed in the Council of State that "blood must run," and it was Jacobins that he was most bent upon punishing. Besides mass arrests and deportations, those suspected of involvement in Jacobin plots earlier in the year were shot or guillotined on January 13, 20, and 30 of 1801. In fact, the attempt on Napoleon's life was not the work of Jacobins. Rather, it was a royalist plot. There was no evidence tying Jacobins to the events of December 24; the brutal repression that followed resulted from Bonaparte's decision to crush Jacobin opposition once and for all. Reprisals were taken also against royalists. Opposition on both left and right was decimated and the power of Napoleon was stronger than ever. That power

now rested on a foundation of brute force. If Napoleon had appeared as a man of the left the truth was now evident: it was he who crushed the last remnants of Jacobinism.

How did David react to Napoleon's seizure of power and crushing of the Jacobin opposition? Delécluze describes a scene in November 1799 in David's atelier when Etienne brought back news of what had happened at Saint-Cloud, where the 18 Brumaire coup had taken place. David commented, "I have always thought we are not virtuous enough to be republicans. . . . Victrix causa diis placuit sed victa Catoni [The victorious cause pleased the gods, but the defeated one pleased Cato]." Then, puffing on his pipe, David repeated several times, "sed victa Catoni."[18] The Latin phrase was an expression of David's disappointment. He was more directly involved in the events that took place at the end of the following year. Among those executed for suspected implication in the attempted assassination of Napoleon on December 24 was one of David's students, Jean-Baptiste Topino-Lebrun. Like David, Topino-Lebrun had been a political activist during the Revolution.[19] He sat on the Revolutionary Tribunal and was a member of the Committee of Public Security. In the Thermidorean period he became a follower of Babeuf and was a subscriber to the Babouvist periodical, the *Tribun du peuple*. He was far more politically active than David at this time, according to Delécluze. It was Topino-Lebrun's good fortune to have been in Switzerland at the time of Babeuf's attempted coup, for the police, aware of his political ties, later arrested him on May 10, 1796. When proof was given that he was in Switzerland the charges were dropped. Topino-Lebrun was again arrested on October 9, 1800, on charges of conspiring to assassinate Napoleon, after being accused of providing the twelve daggers the conspirators were to have used. The charges were not proven and he was released after being interrogated, which took place on November 13. He was arrested again after the attempted assassination of December 24, along with others suspected of earlier conspiracies against Bonaparte. He was tried on January 7, 1801, found guilty on January 9, and guillotined on January 30. He claimed his innocence to the end.

How close David was to Topino-Lebrun at this time is not altogether clear. He did give testimony on his behalf and Delécluze says he would have liked to have done more to save one of his favorite students. Of all David's students it was Topino-Lebrun who was most political as an artist. The Babouvist content is obvious in his *Death of Caius Gracchus* of 1795–97, which glorified the celebrated Roman who gave up his life for the people. At the time of Topino-Lebrun's arrest in October 1800 he was working on a huge

new painting, the *Siege of Lacedaemon by Pyrrhus*. David, who had begun work on his *Leonidas at Thermopylae*, had seen a sketch of the work and referred to it when he testified on Topino-Lebrun's behalf at the time of his trial. Clearly there had been artistic contact between David and his student, both of whom were working on a similar subject and at the same time. And now, as Napoleon consolidated his hold on power in the aftermath of the attempted assassination, Topino-Lebrun was one of the Jacobins who went to the guillotine. David may or may not have believed in his innocence; it was not yet known that the December 24 conspiracy was a royalist plot. What can be said for certain is that David knew all about the crushing of the last remnants of Jacobin opposition and was personally involved in these events because of his ties to Topino-Lebrun. He could only sit by and observe as his student was guillotined and the last vestiges of Jacobinism were destroyed.

Now we can turn to the relationship between David and Napoleon during the period between Napoleon's return from Egypt and his wiping out of political opposition thirteen months later. When Bonaparte was back in Paris in 1799 he paid David a visit in his studio. He had tried to recruit France's leading artist twice before, and he had posed for a portrait that was never finished. Once again he would try to enlist his services. At the time of his visit, David was readying the recently completed *Sabine Women* for exhibit. According to Jules David, when Napoleon saw the painting he said, " 'I have never seen our soldiers fight as yours do . . . this is how ours fight!' Speaking thus, he imitated a bayonet charge. David replied that he had not wanted to paint French soldiers but the heroes of antiquity." Napoleon was quick to sweep the remark aside. "Believe me, dear David, change it; all the world will be of my opinion." Jules David wrote that David was "painfully affected" by what Napoleon said about the *Sabine Women,* and told his students that "these generals understand nothing of painting." He added that David's pique soon passed and that he strove to give full consideration to Napoleon's observation and said so to his friends and students, all of whom told him he was right. Even with these assurances David was "strongly moved by the brusque criticism," and he remained so for a "long time."[20]

That David took Napoleon's criticisms to heart, painful as they were, suggests how much weight he put on his opinions. How could he have done otherwise? Napoleon had won him over, he was his hero, and he had gone out of his way to support the arts. Surely his artistic judgments had value. Yet David's initial response to Napoleon's criticism was exactly right: "These

generals understand nothing of painting." Napoleon's remarks had nothing to do with the artistic value of his work; his judgment was without aesthetic basis or merit. He did not see the *Sabine Women* as an elevated statement or as the result of an artistic breakthrough by David. Rather, he saw it as a battle that was not fought as it would have been fought by his own soldiers. The crudity of his imitation of a bayonet charge after his disparaging comments reveals only too well Napoleon's absence of taste, his philistine indifference to art.

Felix Markham has written that "Napoleon can hardly be ranked among the great disinterested patrons of art. 'Art for art's sake' was a principle unlikely to find favor with him, and he regarded it as an important part of his propaganda machine."[21] This was also the opinion of Jean-Antoine Chaptal, a contemporary of Napoleon and his minister of the interior. "Napoleon did not care for the arts," Chaptal wrote, "probably because nature had denied him the sensibility to appreciate their merit. Nevertheless, . . . he always appeared to interest himself in the arts. . . . He did this for political reasons in order to demonstrate his broadmindedness. . . . The Emperor gave commissions but was indifferent as to the manner of execution, because he lacked the taste to judge for himself, and being unable to appreciate any particular artist, he was disposed to believe the one he trusted was the best."[22] Chaptal also said that visiting the Louvre with Napoleon was a strange experience because he did not want to stop and look at any exhibit. If someone pointed to a particular work Napoleon would inquire about the artist's name and stare at it impassively.[23] Napoleon's interest in painting was determined by his political agenda and his comments on art, few as they are, come close to expressing contempt. "Ah! Good taste—there is another of those classical phrases for which I have no use. It may be my fault, but there are certain rules for which I lack all feeling. For example, I am insensitive to what is called style, either good or bad."[24] No less telling than this remark is what Napoleon said in a meeting of the Council of State: "Nothing is beautiful unless it is large. Vastness and immensity can make you forget a great many defects."[25]

When Napoleon visited David's studio again, in 1800, he asked him what he was working on. David described *Leonidas at Thermopylae,* his current work.

—I am working on a picture of the Passage of Thermopylae.

—So much the worse: you are wrong, David, you will tire yourself out painting the defeated.

—But, Citizen Consul, these are defeated men who have died for their country, and in spite of their defeat they have repelled the Persians from Greece for more than a hundred years.

—That is not important, only the name Leonidas is known to us while the rest is lost to history.

—All, interrupted David . . . except this noble resistance to an innumerable army. All! . . . except the devotion, to which there should be added, All! . . . except the ways, the austere morals of the Lacedaemonians, . . . it is useful to recall the memory of these soldiers.[26]

Napoleon's criticism of the *Leonidas* reveals again his indifference to art. He was not commenting on a painting that he saw and to which he responded aesthetically, for at the time of the visit David had only done sketches for the *Leonidas* and there is no evidence that Napoleon even saw them. The conversation turned entirely on the subject David had chosen for his painting. As a general Napoleon was uninterested in a work that depicted an army awaiting certain defeat. The nobility and patriotism of the Spartans, to which David attached so much significance, was of no interest to Napoleon. His response to the *Leonidas* was as crude as his earlier response to the *Sabine Women*.

Writing about the period of David's life just after he finished the *Sabine Women* and began work on the *Leonidas,* Delécluze commented on his master's seriousness and dedication. "Only those who have been close to David know to what extent this man loves his art, is preoccupied with it and tries sincerely to perfect it." All his life, he continues, David was trying to find the "true path" of art, and the "direction of his spirit was drawn toward elevated subjects." One aspect of his seriousness was constant study of the art of antiquity and the great masters of modern times. Another sign of his seriousness was that "he remained a complete stranger to irony, so common to his time."[27] Such a person was ill equipped to see what was obvious in Napoleon's banal remarks on his two paintings. It was David's misfortune to have put Napoleon on a pedestal, to have admitted him to the pantheon of his heroes, to have found a place for him in the elevated realm of his imagination. Delécluze's observations help explain David's ingenuousness. As he said, David was a person of good nature (*bonhomie*) and credulity and was almost childlike in his sincerity. "Always trying to purify his art, to perfect some part of his talent, he sacrificed his *amour-propre* with a complete abnegation." He admired his students, praised them, and urged them not to fall into the same errors as himself. There was an "admirable modesty" in

David that made his students strive all the harder to perfect their art.[28] What emerges from these descriptions is the solicitous and protective David—and the fragile David who, in spite of his fame and reputation, was no stranger to indecision and self-doubt.

This was the David who asked his students to help him with the *Leonidas* when he began work on the project. Exactly when this happened is not known for certain, but probably it was some time in 1799. Wildenstein suggests the year 1798, whereas both Schnapper and Brookner say that David did not begin the work until 1800. Almost certainly it was before 1800. On that point Delécluze, at any rate, is absolutely clear: he wrote that David was already working on the *Leonidas* at the time of the 18 Brumaire coup—November 9, 1799.[29]

The story of the 300 Spartan soldiers who met the Persian army at the Thermopylae pass was commonplace in Paris of the 1790s. It had been the subject of a play by Loaisel de Tréogate, *Le Combat des Thermopyles, ou l'école des guerriers,* performed in 1793 and revived in 1798, and of a one-act play by Guilbert, *Léonidas, ou le départ des Spartiates,* given in 1799. It was also the subject of an epic poem by Louis de Fontanes, *La Grèce sauvée,* parts of which the author read at meetings of the Third Class of the Institute, made up of the arts, including literature at this time, of which David was a member. In the second of his readings Fontanes recited the third canto of his poem, which described the moment at the Thermopylae pass when Leonidas and his Spartan compatriots awaited the armies of Xerxes and their own imminent death. This was the very scene David was to portray.

The Leonidas story was particularly relevant to a France that had been at war since 1792 and whose armies constantly faced enemies with larger forces than their own. Parisians could read contemporary meaning into the story of a Spartan army of 300 men who halted the invasion of Greece by a superior Persian army. This meaning is suggested by a dramatic speech delivered by Leonidas to his soldiers in Tréogate's play. When Leonidas addresses his men as "Citizens" and tells them they could make no more worthy sacrifice to their country than to give up their lives it is clear that he is appealing to the French citizenry to dedicate themselves to the *patrie.* As James Henry Rubin has shown, it was those on the left who idealized Sparta in the second half of the 1790s.[30] Glorification of Sparta can be read as a sign of Jacobinism; political moderates and conservatives found their heroes elsewhere.

To identify literary sources that could have suggested the Leonidas story to David is not to explain how he approached it. A conversation he had with his student Etienne, as reported by Delécluze, reveals some of his thoughts

before he began work on the *Leonidas*. When David requested his students to help him on the new work, Etienne showed a sketch to his teacher. After praising the sketch David said, "You have chosen . . . a different moment than the one I intend to depict. Your Leonidas gives the signal to take arms and march to combat, and all your Spartans respond to his appeal. As for myself, I should like to give something more grave to this scene, more reflective, more religious. I wish to paint a general and his soldiers preparing themselves for combat as true Lacedaemonians, knowing well that they will not escape. Some are absolutely calm, others wreathe their flowers to assist *in the banquet they are preparing for Pluto.* I wish neither movement nor impassioned expression, except on the figures who accompany the person writing on the rock: *He who passes, tell Sparta that its children have died for it.* Imagine, my dear Etienne, that in this painting I want to characterize that profound, great, and religious sentiment that inspires love of country."[31]

The David who set such a goal for himself—who wanted to inspire love of country—resembles the David of the Revolution. Patriotism was a theme in all of his political paintings from the *Tennis Court Oath* to the *Bara*. Most revealing in this connection are the three paintings of revolutionary martyrs, *Lepelletier, Marat,* and *Bara,* heroes who gave their lives to the Revolution and to their country. Each work was intended to inspire patriotism not through the depiction of positive deeds but by expressing grief for those whose lives had been sacrificed for the *patrie*. What David set out to do in the *Leonidas* was similar: he would not show soldiers going into combat but rather planned to portray the moment of reflection in which they pondered the death they knew was certain. The artist who would inspire patriotism by showing soldiers preparing for death has obvious ties to the artist who stirred similar feelings in paintings of revolutionary martyrs. David was no longer the Jacobin and activist of the Terror; yet there had been a renewal of his political awareness and as an artist he was again translating that awareness into pictorial form.

David's new painting was to be historical, and it was to be political. The same had been true of the recently completed *Sabine Women,* to which *Leonidas* is connected in many ways. Yet the political content of the new painting had a fundamentally different source than the previous one. The idea for the *Sabine Women* came to David when he was in prison, and as an allegory of peace it was a response to the individual crisis through which he had passed and the larger conflicts that had torn France. David had been in the eye of a severe political storm and in the months of reflection that followed during his incarceration, he conceived a painting that would show

women intervening between rival armies. Reconciliation was the theme of that painting.

The David who painted the *Sabine Women* had forsaken the world of political affairs for the safety of his studio. This, he said, is where he should always have been. When the idea for the *Leonidas* came to David his studio, not the political arena, was still the center of his world. Yet he did not distance himself from politics as he had in the aftermath of 9 Thermidor. He was among the 642 subscribers to Babeuf's journal, the *Tribun du peuple*, an indication that he was not altogether indifferent to politics. There had been a period of withdrawal and necessary distance from active politics, but this is not to say that he was uninvolved in the sense of no longer caring. The very fact that he idolized Napoleon is evidence of a responsiveness to the world of power and events. Combined with Napoleon's personal magnetism was his mastery and power, very much the stuff of politics. David's hero brought to France strength and decisiveness that was urgently needed. David was becoming more open to political issues in the years after his release from prison. His attraction to Napoleon is one indication of the shift. Additional evidence is found in his decision to paint the *Leonidas*, in which he wished to portray feelings that would inspire love of country. He had selected a subject that was favored by those on the left.

When David decided on the Leonidas story as the subject of his next painting there was no conflict between its Jacobin content and his idealized perception of Napoleon. This, as Delécluze said, was before 18 Brumaire. Napoleon had cultivated the image of himself as a friend of the Revolution and those on the left had sought him out as an ally. The 18 Brumaire coup drove home the truth: Bonaparte was an enemy of the Jacobins and would not hesitate to subdue them with force. This was a disappointment to David. According to Delécluze, David thought about the *Leonidas* after the eighteenth of Brumaire, and after he had acknowledged the new head of state. "In the solitude of his atelier, his imagination warmed by the devotion of the three hundred Spartans whose story he had traced his old republican ideas returned. 'I wish at least, he said as he considered his work, to show my *patriotism on the canvas*.'"[32]

David continued working on the *Leonidas* after he was drawn into Napoleonic service. Delécluze writes that as he gave increasing amounts of his time to Napoleonic art commissions he assigned the *Leonidas* to a position of lesser importance and then abandoned the project altogether, until he resumed work on it years later. As we shall see, Delécluze was mistaken about the *Leonidas*: David did continue working on it throughout

his years as a Napoleonic court painter. It would occupy a less important role, however, as David devoted himself increasingly to court projects. After the eighteenth of Brumaire, David had to accept the facts of the new order. David's hero was not the man he had thought him to be, but the French were also less virtuous than he had hoped. One had to live, one had to paint, one had to make accommodations—and David did precisely this. After 18 Brumaire, Napoleon drew heavily upon David's talent, keenly aware of his value. David was France's greatest artist and his works would shed luster on the Napoleonic regime and memorialize it; moreover, David had the reputation of being a Jacobin. It suited Napoleon's purposes to connect former Jacobins to his regime, just as he brought in former royalists. David would serve Napoleon, but only in an artistic capacity. Jules David remarks that when Bonaparte became First Consul after 18 Brumaire he offered David a seat on the Council of State or in the Senate that had been created by the Constitution of the Year VIII. When David declined the offer he explained to Napoleon, "Time and events have taught me that my place is in my atelier. I have always had a great love of my art, and I have devoted myself to it with passion, I wish to give myself up to it entirely. Moreover, positions will pass: I hope my works will endure."[33]

On February 7, 1800, Napoleon signed an order naming David as Government Painter. Apparently he did not consult David first, because on February 27 David announced in the *Journal de Paris* that he decided not to accept the position. Moriez, a student of David, said his master rejected the appointment because the title was insignificant. He would, Moriez said, have been interested only in more prestigious positions such as minister of arts or First Painter. Yet, the decision not to accept the position of Government Painter did not mean that he had distanced himself from Napoleon. In January 1800 the press announced that General Bonaparte had commissioned David to place the Capitoline Brutus in his study in the Tuileries. This was the famous antique sculpture used by David when he painted *Brutus and the Lictors,* of which he had a copy. The original was one of a hundred works of art given to France in 1797 as reparations. This was not the last time Napoleon would show David special attention. And he had ambitious plans, for which David would be useful. In the spring of 1800 Napoleon began to advance a design to embellish Paris. Jules David writes that he came often in the morning from the Tuileries to the Louvre to see David and discuss plans to improve the Invalides. The original idea of providing for injured war veterans in Paris escalated into a more ambitious scheme calling for the construction in every departmental capital of columns

bearing the names of France's soldiers who had died for the *patrie*. Lucien Bonaparte became involved in the project, reports were made, and committees were formed—with David among the members. After a period of considerable involvement David resigned from the project. Jules David says he became bored with it. He wanted to paint, and with commissions from Napoleon he had opportunities to do just that. He was soon at work on *Napoleon Crossing the Saint-Bernard* (fig. 56), begun in 1800 and completed in 1801.

According to Delécluze it was Napoleon himself who ordered the equestrian portrait, but according to Schnapper the few surviving documents indicate that Charles IV of Spain commissioned the painting.[34] Napoleon immediately ordered a copy of the work. David, assisted by pupils, made two additional copies. Having completed the first two versions, David showed them together in September 1801 in the same gallery he had used to exhibit the *Sabine Women*.

The connection between Charles IV and David sheds light on *Napoleon Crossing the Saint-Bernard*. Among the prototypes of the painting are the equestrian portraits of Velázquez.[35] For their part, Velázquez's equestrian portraits have ties to Titian's *Charles V at the Battle of Mühlberg*. Titian's portrait shows Charles V after one of his military victories; he was a ruler who strove to recreate the power and majesty of empire. Charles's advisers, who were trained in Roman law, saw him as the "restorer of the Roman Empire" and the "future ruler of the whole globe," as he was described in inscriptions on triumphal arches built in his honor. With its allusion to the antique *Equestrian Statue of Marcus Aurelius,* Titian's *Charles V at the Battle of Mühlberg* was part of a conscious attempt to connect the sixteenth-century Holy Roman emperor to the greatness of the Roman Empire. Titian's painting projected imperial splendor, and such associations were also present in the equestrian portraits of Velázquez. David intended to benefit from those associations in a painting that portrayed another ruler of imperial stature. Below the triumphant Napoleon are the inscriptions "Bonaparte, Hannibal, and Karolus Magnus Imp." Within four years Bonaparte would, in fact, be emperor.

If David's majestic image of Napoleon benefited from allusions to earlier works, so did his own status as an artist benefit from those same allusions. Few painters have enjoyed greater favor from their patrons than Titian and Velázquez. Serving Charles V, Titian was the new Apelles of the new Alexander.[36] Philip IV conferred various court titles on Velázquez and ultimately awarded him the Order of Santiago. That David aspired to high

position under Napoleon is evident: he did not want political office but if he was to serve Bonaparte in an artistic capacity his role would not be that of just another painter. In the same year that he began *Napoleon Crossing the Saint-Bernard* he declined the position of Government Painter because the title was insignificant. The allusions in his equestrian portrait suggested the type of position he wanted, and which he would use all of his energy and influence in the years ahead to obtain.

According to Delécluze, after David accepted the commission for *Napoleon Crossing the Saint-Bernard* he told Bonaparte that he would begin immediately and asked him when he would like to pose. "Pose?" asked Bonaparte, who had already made it clear to David that he did not like to pose. He explained to the artist that it served no purpose and that the great men of antiquity had not posed.

—But I paint you for your century, for men who have seen you, who know you; they will want to recognize your likeness.

—Likeness? It is not the exactness of traits, a wart on the nose, that makes a likeness. It is the character of the countenance, what animates a person that it is necessary to portray.

—One does not preclude the other.

—Certainly Alexander never posed for Apelles. No one knows if portraits of great men are likenesses. It suffices that their genius lives.

—You understand the art of painting. . . .

—You are satisfied; right?

—Yes, but I had not seen painting before in that light. You are right, Citizen First Consul. Oh well! You will not pose. Let me begin, I will paint without it.[37]

David's idea was to show Bonaparte sword in hand but Napoleon said he wanted to be seen "calm on a spirited horse." This created considerable technical problems. It was hard enough to paint a portrait when the subject refused to pose but even more demanding to do an equestrian portrait under such circumstances. In fact Napoleon had crossed the Alps on a mule, but he insisted that he be shown on his favorite steed. While David presumably looked at Napoleon's horse, his real model seems to have been Falconnet's equestrian statue of Peter the Great. And these improvisations were not enough: David had his eldest son dress up like Napoleon, and had his student Gérard sit on top of a ladder so he could get the angles of his subject

right. He borrowed the hat and coat Napoleon wore on the expedition so he was able to achieve accuracy for those trappings.

The circumstances under which David worked took a toll. The clothing is shown in remarkable detail, as if David were reproducing exactly the only items he could examine. By contrast, the face of Napoleon is stylized and generalized. It lacks the immediacy and presence, the sense of a living person that is so striking in the unfinished 1797 portrait. The equestrian portrait shows a Napoleon who is grand and heroic, very much the conquering general, but it is an aloof and distant Napoleon. Perhaps Napoleon's remoteness in the 1800 portrait is a function of the heroic idea that was central to David's conception and was part and parcel of the work's allegorical content. Another explanation, and the two are not mutually exclusive, is that because Napoleon refused to pose there was no chemistry between him and the artist. As a portraitist that rapport was crucial for David throughout his career. In this work, rapport is lacking. It is technically brilliant and the attention to detail, even for David, is stunning. Moreover, it does exactly what Napoleon said he wanted: his greatness, his "genius," comes through in the painting more than his real physiognomy. And it does so at the expense of the soldiers who are seen behind Napoleon, tiny figures climbing the narrow mountain pass, weary from their long trek. The sheer amount of the pictorial space the mounted Napoleon occupies is remarkable.

To appreciate David's difficulties with the *Napoleon Crossing the Saint-Bernard* we must look beyond Bonaparte's refusal to pose and the various devices that were necessary simply to get the work painted. When David accepted the commission he was working on the *Leonidas,* the second of his two ambitious postrevolutionary history paintings, for which he had developed a new style, the purified Winckelmannian style that was a rejection of his earlier Roman style. Now he was asked to do a portrait of Napoleon for which a heroic style would have been more appropriate than his purified style. He had developed his Grecian style so he could paint an allegory of peace, and then he chose another subject that was elevated, reflective, and religious, one that would also be an appropriate topic for this style. At this point he was wrenched in a different direction. He had to turn away from antiquity and the historical genre to portray contemporary history. He had done this before, during the Revolution, but then his heroic Roman style was suitable for either type of subject. This was not the case in 1800. The Grecian style that David had just brought to fruition was less fitting for *Napoleon Crossing the Saint-Bernard.* Here is a work that for all of its technical

brilliance seems studied and calculated. Style and content have not been ideally fused.

That Napoleon was pleased with the 1800 equestrian portrait is indicated by the copies he immediately ordered. Students did much of the work on this and the three other copies that were subsequently commissioned, but David did have to invest something of himself in the paintings. Delécluze wrote that David reworked them often and with great care. These were the first of many copies that David would do for Napoleon. That an artist who simmered with discontent under the ancien régime's system of patronage and was committed to artistic liberty accepted his position as a court painter under Napoleon is puzzling. One wonders what happened to the artist who defied the stipulations of a royal commission when working on the *Oath of the Horatii* and painted the work larger than the rules allowed. That artist said he had abandoned the picture he was doing for the king in order to paint one for himself and boldly proclaimed he was only concerned with his own artistic development. Now, a decade later, David attached himself to a court that placed greater demands on him than he had ever experienced during the ancien régime.

Both Delécluze and Jules David say that David was won over by Napoleon. Delécluze says his conversion was complete and sincere, at least in the beginning. He added that David became a man of the times in his polite demeanor and that he dressed the part in silk clothes, buckles, and sword.[38] Jules David writes that David saw Napoleon as a genius who towered over his contemporaries and that he entered his service more from a citizen's duty than in the office of courtier.[39]

Outwardly, at least, David's position under Napoleon was successful as he lent—or sold—his brush to the regime and received various titles and distinctions. In 1803 Lucien Bonaparte told David he should paint only for Napoleon and in the same year he was named Chevalier of the Legion of Honor. In 1804 he was appointed First Painter of the Emperor. Unlike the earlier title of Government Painter, this was one that he accepted. David took pride in the honors he received from Napoleon. Delécluze writes that he wore his Legion of Honor medal the rest of his life. In 1808 he requested letters of patent for his title of Chevalier of the Legion of Honor, and a few weeks later Mme David paid 60 francs for the letters. They were subsequently registered and entitled David to armorial bearings, a description of which was included in an official document that Napoleon himself signed.

Parallel to David's success as artist and courtier under Napoleon, there is a discordant counterpoint of financial bickering over payment for commissioned paintings. Before describing the many financial disputes between

David and Napoleon's officials, some observations about David and mone-
tary matters will be useful.[40] Both Delécluze and Jules David maintain that
he lived simply. He was capable of real magnanimity and translated his
solicitude for students into economic terms—up to a point. His fee as
teacher was 12 francs per month but he admitted poor students free. Impor-
tant to an understanding of how he regarded money was his artistic pride.
There can be no doubt that he wanted his position as France's greatest
painter to be recognized in economic terms. Moreover, it was art itself that
he believed was at issue. With an unerring ability to see a direct correlation
between his belief in the monetary value of his own art and the value of art as
art, he had no trouble arguing his case for payment from his usual position of
high principle. This should be kept in mind because although the disputes
over money took place between David and Napoleon's officials, it was
Napoleon who often commissioned the paintings, and he often was the
ultimate authority when it came to payment. But this is not to suggest that
David's opinion of—perhaps it would be better to say feeling toward—
Napoleon was determined strictly and narrowly by Napoleon's willingness
or unwillingness to pay him what he thought his paintings were worth. The
extended disagreements over money were not just over francs. They had to
do with David's image of himself as an artist and his image of Napoleon.

On May 3, 1803, David requested 24,000 francs for payment on his two
copies of *Napoleon Crossing the Saint-Bernard.* He explained to M. Estève,
controller of accounts, that he had received payment for 24,000 francs from
Charles IV, king of Spain, for one version, and that he had settled on the
lesser amount of 20,000 francs each for the two copies, for which he had
already received payment of 26,000 francs. To justify the amount of the
request David wrote that the two copies he "executed by order of the First
Consul have been no less carefully done" than the other version. He says he
would be under Estève's "special obligation" if he would share his observa-
tions on the requested amount with the First Consul.[41] David seems to have
thought he was in the right and apparently assumed that Napoleon would
see the matter in the same light as himself. He was reluctant to make the
request, as he reminded Estève at the beginning of the letter that his wife had
already spoken to him about the payment. At this point David hesitated
even to bring up the question of payment, but when he did so he thought
Napoleon would give his approval. On May 5 Estève asked Napoleon if he
wanted to authorize payment. Apparently Napoleon wanted another opin-
ion, for on May 13, Dominique Vivant Denon, director general of museums,
informed him that the requested sum was excessive.

On March 22, 1805, David submitted a request for 94,000 francs, payment

for the *Sabine Women* (72,000 francs), which he mistakenly thought Napoleon wished to purchase; the *Portrait of Pius VII* (10,000 francs); and two copies of *Pius VII* (12,000 francs). On the very next day, March 23, Jean-Baptiste Nompere, comte de Champagny, minister of interior, informed David that he would have to pay 4,000 francs annually for the lodgings and studio he and his students were allowed to use. Then, two days later, on March 25, David requested payment of 25,000 francs for the work he had already begun on the *Coronation of Napoleon and Joséphine*. This sniping back and forth between David and Napoleon's officials about payments soon turned into a crescendo of discord. On April 11 David requested the intendant general to speak to Napoleon to make certain that he would be paid 100,000 francs for the *Coronation*. "I have learned from your office that the imperial decree that authorizes payment to me of 100,000 francs for a grand painting of 30 feet does not exist."[42] He explained that he needed assurance that he would be paid the agreed amount. Then, four days later, on April 25, David requested a 25,000 francs advance on the *Coronation*, which he explained that Napoleon himself had agreed upon. On May 9 David's request for 25,000 francs advance payment on the *Coronation* was forwarded to Napoleon, who was in Italy. He approved payment on May 19. Yet, the matter of how much David was to be paid for the *Coronation* had not been resolved. The intendant general of buildings asked David on April 16 to inform him of the price he expected for the painting. On June 19 David wrote Pierre Antoine Noël, comte de Daru, that he expected payment of 100,000 francs for the *Coronation*, the amount he had already indicated and presumably the amount he thought had been agreed upon from the beginning. This time David went further. When he was commissioned to do the *Coronation* it was to be but one of a series of four paintings depicting not only the coronation itself but also Napoleon's *Enthronement*, the *Distribution of the Eagles*, and the *Reception at the Hôtel de Ville*. He was now suspicious about monetary arrangements with Napoleon's officials and wanted them to know what he expected to be paid for his work. At the end of his letter, which describes each of the four works in detail, he says, "I would be satisfied with the sum of 100,000 francs for each."[43] Of the other three paintings only one, the *Distribution of the Eagles*, would be completed. David's monetary claims were deemed excessive and the project was never brought to completion. Before the decision was finally made to cancel the other two paintings frequent exchanges arose between David and Napoleon's officials over payment on the *Coronation* and *Distribution*, and there were disagreements over money for other paintings Napoleon commissioned from David.

David's difficulties with Napoleon's officials—and Napoleon—were not limited to monetary arrangements. On June 30, 1805, David petitioned Napoleon to grant him the same prerogatives enjoyed by Charles Lebrun under Louis XIV. As First Painter he wanted to reinvest his office with the powers it had once had. For an artist who had experienced difficulty being paid for works he had been commissioned to do, the request seems ambitious, to say the least. David was reaching, even grasping, for an enlargement of his powers that he never received. The language in which he framed the request is inflated and excessive. Addressing Napoleon, he says:

> All the great things that have given luster to your accession to the Throne, this astonishing reunion of all the virtues that you possess, of which a single one is sufficient to form a hero, all would be lost in the obscurity of time if the arts were not employed to pay the tribute of recognition that you are owed. You have given all of this the power of your thought and deeds; it is to history, poetry, painting, sculpture, and architecture that the honorable mission belongs of transmitting this to posterity. I dare to hope that His Majesty will throw a glance of his eye on an object as important in its ties to industry and commerce and is vital to all that it has done for the glory and happiness of the Empire. It is reserved to the Century of Napoleon to eclipse those famous centuries, so vaunted, before our own. The circumstances that your genius has prepared are favorable; you will be, Sire, for the glory of the arts what you have done, in the eyes of the universe, for the glory of arms.[44]

David's request was part of a prolonged struggle for power that pitted him against Vivant Denon, Napoleon's director general of museums. The old constitution of the Louvre had been abolished in 1802 and the post of director general created, which gave one official control of the Louvre, Versailles, and other art institutions. It was Denon, an artist of slight importance—he specialized in self-portraits, in which he often showed himself in the guise of Rembrandt—who held the post of director general from the time of its creation to the end of Napoleon's rule. An exact contemporary of David, he was a skilled courtier who won favor with Louis XV, Louis XVI, Napoleon, and Pius VII.[45] Between him and David the tables were exactly reversed: one was as great an artist as the other was feeble and one was as skilled a courtier as the other was inept. In the struggle for power it was always Denon who emerged the victor.

In July 1803 the Louvre was renamed the Musée Napoléon, the first time Napoleon's name was used royally. In centralizing control over artistic life

Bonaparte was following the example of the Bourbons, whose support of the arts he surpassed. While the policy of ransacking Europe of its art treasures began with the Revolution, it was Bonaparte who carried it out most rigorously and systematically, and it was in the museum that bore his name that the immense booty was put on display. Denon not only headed the Musée Napoléon but played a key role in selecting the art treasures that France plundered from defeated countries. He made sweeping changes that enabled the Musée Napoléon to accommodate the plundered riches of Europe. Among the changes was the eviction of artists who had been given studios and lodgings in the Louvre. By 1805, when David began work on the *Coronation,* he had to set up his studio elsewhere.

In the five-year period between Napoleon's enlistment of David as his leading artist and David's eviction from the Louvre many changes had taken place. By stages Bonaparte had restored the monarchy as he became First Consul, then Consul for Life, then Emperor. His coronation in 1804 saw a return to court life as gaudy and opulent as under the Bourbons. The Napoleon who made these changes had turned against people he had once courted. Initially he sought out the philosophers of the Institute, but when he saw that ideas could work against him—and his power—he changed.[46] He came to loathe the philosophers of the Institute, the "Ideologues," as he called them. He derided them as sanctimonious dreamers and said they were incapable of action. As late as 18 Brumaire he still needed and solicited their support, but thereafter he turned against them openly. In doing so he rejected the intellectual traditions of the Enlightenment held dear by the Ideologues. Under the Constitution of the Year VIII, the Declaration of the Rights of Man disappeared. Two years after that Napoleon took upon himself the power to appoint senators and grant pardons and name presidents of Assemblées de canton. Two years after that he was Emperor. Dissent had become intolerable to Napoleon, who pursued a systematic policy of crushing it in any form. Opposition newspapers were shut down and the Second Class of the Institute, which was devoted to the study of moral and political sciences, was dissolved in 1803. As recently as 1801 that class had published a glowing account of Napoleon, but now, in the aftermath of the Concordat, any chances of harmony were over. The rationalist members of the Second Class disapproved Napoleon's coming to terms with the papacy in 1801, and they also opposed a foreign policy that led to the resumption of war in 1803. Having warned the Ideologues in the Institute not to discuss politics—he said he would break them like a "bad club"—he wiped them out. Besides their opposition to his policies what Napoleon could not bear

was their intellectual independence. His ordering Mme de Staël into exile is one example of his refusal to tolerate those who would not conform.[47] Other examples are his purging Benjamin Constant and Marie-Joseph Chénier from the Tribunate. As Napoleon himself said, on March 25, 1802, "There must not be any opposition. What is government? Nothing, if it does not have public opinion on its side. How can it hope to counterbalance the influence of a tribune if it is always open to attack?"[48] In this pronouncement one can hear the voice of a man who would make himself Consul for Life in the following month and Emperor two years later.

What did David think when Napoleon crushed the intellectual elite that had been formed in the Paris of Louis XVI and continued to flourish in the 1790s, in the Institute, and in salons? David had been active in the Institute and had ties to the world of Paris salons. Among those who felt the brunt of Napoleon's repression were some of his old friends, including Marie-Joseph Chénier, who was retired from the Senate along with the other Ideologues in 1802. What did his dismissal mean to David? And what did Napoleon's prohibition of all gatherings of the Theophilanthropists, a philosophical society of which he was a member, mean to him? Or Napoleon's removal of abbé Grégoire from his bishopric, one of the prominent figures in David's *Tennis Court Oath* and a hero of the Revolution? What did David think of the Concordat, Napoleon's coming to terms with the papacy, and government support of a church for which David had once, as a Jacobin, had no use? What was David's opinion of Napoleon's court?

At no point did David speak out openly against Napoleon or his regime, to which he remained outwardly loyal to the end. But loyalty is not an absolute commodity, in which one must invest everything or nothing. There are degrees of loyalty, just as protest can take many forms. There are those who are unequivocally loyal and there are those who are unswerving in their opposition. In between are many shades and degrees both of loyalty and protest. Among the possibilities to be considered with regard to David is that while he remained outwardly loyal to Napoleon he did not remain inwardly loyal, at least not completely. If David did come to feel that all was not well within the world Napoleon dominated, how did that awareness come through? With this question in mind we can turn to Napoleon's court, the grand and glittering arena in which David was quite out of his element. Then we can consider his depiction of that court in the *Coronation of Napoleon and Joséphine*.

Napoleon's court became more monarchical as it moved from Malmaison to the Tuileries. Titles were admired, not scorned; etiquette became elabo-

rate, as of old; costumes became splendid; and there was no want of festivities and ceremonies. Republican austerity had no place in this world. Once again the populace was dazzled by the spectacle of lavish carriages that carted courtiers and officials to the theater and opera. A new saint's day, the Festival of Saint Napoleon, was introduced in 1802, and in 1803 ceremonial mourning was reinstated at the court and coins were struck with Napoleon's likeness. The Legion of Honor that was created in 1804 was not unlike the old orders of chivalry, and those who wore its badge had at least some trappings of a new nobility. All of these changes point toward Napoleon's imperial coronation in Notre Dame on December 2, 1804. To legitimize his crown Napoleon persuaded Pope Pius VII to travel from Rome to Paris and to consecrate the event with his holy presence. As during the time of Pepin the Short, divine right was written into the catechism.

The painter J.-B. Isabey and the architects Charles Percier and Pierre Fontaine decorated Notre Dame and were in charge of the costumes. For the end bays of the cathedral, where the coronation took place, arches were constructed to conceal the gothic columns, giving a mock classical effect. This addition was studded with figures representing the cohorts of the Legion of Honor and with Napoleon's armorial bearings. Stands were erected in the aisles along both sides, and in the triforium velvet and tapestries were hung everywhere. A special throne was built and a long platform placed at the west end of the nave. Over the throne there rose a triumphal arch bedecked with eagles, which Napoleon had chosen as his emblem. To determine the order of precedence for the ceremony a decree had been issued in July, and presiding over the event was Louis-Philippe de Ségur, master of ceremonies and member of an ancient aristocratic family. He and David actually came to blows over the seat to which the artist had been assigned. Just before the ceremony began David was told that he was not to have his original seat but a place in the galleries, from which he could have seen neither the procession nor the crowning. Only after the volatile David exploded and fisticuffs ensued was he allowed to keep the original seat.

David did not begin painting the enormous (610 by 930 centimeters) *Coronation of Napoleon and Joséphine* (fig. 57) until December 21, 1805. Between the ceremony and the point at which he and his students went to work on the canvas, he had done the necessary preparatory studies—there were many for so ambitious a work—and he had done a portrait of *Pius VII* and much of the work for a full-length portrait of *Napoleon*, commissioned by Charles-François Lebrun, the grand treasurer. Because David worked on

these two paintings before he and his students began the actual painting of the *Coronation* it is helpful to examine them first. Such an approach makes sense not only for chronological reasons but also because the two portraits provide an important backdrop against which the *Coronation* should be seen. We will also examine several of the preparatory studies for the *Coronation*.

When Pius VII learned that David was to paint his portrait (fig. 58)—he and the artist met at the end of December 1804—the pope was uneasy about the prospect. He said he should be concerned about being alone with a man "who had killed his King and who would make short work of a poor *papier-maché* pope."[49] The flash of humor in this remark was characteristic. Liberal, forgiving, and gentle, Pius VII was also a man of principle and fortitude. Willing to make concessions to Napoleon when he signed the Concordat in 1801 and again in 1804 when he agreed to attend the coronation, he stuck to his position when he had to.[50] He would subsequently resist Napoleon's demands and be imprisoned. The stand he took in 1809 contributed to Napoleon's downfall.

When David met the pope he was deeply touched by the prelate's warmth and simplicity. "This good old man, what a venerable figure! How simple he is . . . and what a beautiful head he has! . . . He is truly a pope; he is a true priest. . . . He is as poor as Saint Peter . . . but that only makes him more respectable. . . . Finally, he is evangelic to the letter; this brave man has given me his benediction. That has not happened to me since I left Rome . . . Oh! how he is in the great tradition, the way he holds his hand so well with its ring. . . . He was beautiful to see."[51] The pope as revealed in David's comments is a person of complexity, a "good old man," "venerable," "simple," "respectable," and "brave." David's obvious enthusiasm bespeaks the warmth of his response, and he was moved by the benediction he received at the pontiff's hand. It made him recall his days as a student in Rome. Thinking of Pius VII and Rome brought to mind the great papal patrons of the Renaissance and the artists who had served them, Raphael and Michelangelo. Unlike the ambitious and secular Renaissance popes, Pius VII was "poor, humble . . . only a priest." And it will have been his good fortune, David concluded, to have painted him; he will have painted both a pope and an emperor.

Of the two the pope came off better, infinitely better, in the portraits David did of the two men at essentially the same time—the 1805 *Pius VII* and the 1805–6 *Napoleon in Imperial Dress*. In the case of the *Pius VII* the chemistry between the subject and the artist brought forth a work of remarkable freshness, one that perfectly captures the ambiguous qualities evident in

David's written description of the pope. Here is a pope who is at once modest, serious, and alert. And just as David described the Italian pope's head as "beautiful" so did he present it in the portrait. In only one respect does the painting differ from the written description: the Pius VII of David's portrait is anything but the "old man" of his description. The pope was sixty-three at the time, a more advanced age than one would suspect from David's painting.

The Pius VII of the 1805 portrait can be compared to a drawing of the pope done for a different purpose. The *Study for Pope Pius VII* (fig. 59, in the Fogg Museum) was a preliminary sketch for the *Coronation*. It shows the pope resigned and dejected. The shoulders of the nude figure are slumped forward, the eyes look uneasily upward and the mouth turns grimly downward. Why the contrast between the pope of David's two renderings, the painting and the drawing? To answer this question it must be realized that the portrait was done after sittings had taken place, during which David was able to respond to his subject. This is a commissioned portrait and the pope is shown in an official capacity with his red cassock, but it is also a very private painting, private because of what David has put into it, private because it bears the stamp of his own response. The pope of the drawing was done for a different purpose. Here the pope was witness to a historic event that he did not regard with complete equanimity.

The day before the coronation, Pius had learned that Napoleon and Joséphine had only had a civil marriage. He was disturbed over the news and insisted that Napoleon and Joséphine be married in the eyes of the Church. Cardinal Fesch presided over a private ceremony that night with no witnesses. Further problems had surfaced concerning the liturgy, which was changed considerably from the traditional liturgy used at Rheims for royal coronations. When the kings of France were crowned they repeatedly prostrated themselves before the officiating cleric, a ceremony that Napoleon understandably wanted to change. The number of anointings was reduced from seven to three. Another problem was that Napoleon refused to take Communion. Yet another difficulty was the coronation itself. The original plan seems to have been for Pius to crown Napoleon, and that is how the event was described in the first printed program, but Napoleon changed his mind and told the pope that he was going to crown himself. Pius resigned himself to this scenario, and it is his resignation that comes through in David's drawing. It could well be that there was nothing unusual in the fact that the figure of the pope is nude in that drawing; this was a procedure that David followed often in preparatory studies. It was not usual, however, in

the sketchbook at the Fogg Museum, in which this drawing is contained. The Pius VII of this drawing is not only resigned but vulnerable, which his nudity makes all the more pronounced.

Napoleon saw several of David's studies of the pope with his hands on his lap, just as they are seen in the Fogg drawing. His comment to David revealed him at his most cynical: "I didn't have him come all that way to do nothing."[52] What makes Napoleon's comment all the more cynical—he *had* lured the pope to Paris simply because he needed him to add legitimacy to his coronation—was that once Pius arrived, Napoleon denied him the function in the coronation that he was supposed to have performed. And then, as if that were not enough, he mocked him later by implying that David should show the pope participating actively in the coronation. To David, who felt admiration and affection for the pope, such a remark must have seemed crude and cruel.

David painted the *Pius VII* portrait at the beginning of 1805. Shortly afterward he began work on the portrait of *Napoleon in Imperial Dress* intended for the Appeals Court in Genoa. Napoleon disliked the painting and gave orders that it was not to be sent to Genoa. "The portrait is so bad, so filled with defects that I do not accept it and do not wish to send it to any town, especially in Italy where it would give a very bad idea of our [art] school."[53] Since the original painting has been lost no judgments can be made on the work itself, which is known only by an oil study (fig. 60). According to Jules David, a student named Georges Devilliers did most of the work on the Genoa painting, but the oil study is signed L. David and dated 1805. While only a study, it is in oil and at 58 by 49 centimeters it was a guide to his student for the full-length painting. The study is weak to the point of feebleness, and as such it must share a large measure of the responsibility for the failure of the finished portrait. While David might have entrusted a student with work on the Genoa *Napoleon* because he was occupied with the *Coronation* and pushed for time, the inferior quality of his own study suggests that he was not that interested in the work. It is significant that he also finished the *Pius VII* while he was working on the *Coronation,* and this is one of his very finest portraits. The very qualities of freshness and complexity that come through so vibrantly in the *Pius VII* portrait are precisely what are lacking in the *Study for a Portrait of Napoleon in Imperial Dress.*

One explanation for the differences between the two works—it is remarkable that they are not only by the same artist but done in the same year—is that the pope posed for David whereas Napoleon, as always, did not. There

was rapport in one case between the artist and subject but not in the other. Another explanation can be found in a preparatory sketch for the *Coronation* which shows both Napoleon and Pius VII. *Napoleon Crowning Himself* (fig. 61) has Napoleon holding a crown with one hand and a sword in the other. Seated directly behind him with both hands in his lap is the pope. Not only is Pius sitting behind Napoleon but also he is on a slightly different axis that puts him on a more backward plane. Because Napoleon stands to the front and to the left of the pope he is given greater prominence than the pope. What underlines the difference is that Napoleon is shown grandiosely holding a crown in one hand and a sword in the other while the empty-handed pope looks dejectedly downward. And while Napoleon's shoulders are thrown proudly backward those of the Pope slump forward. The flowing curves that trace the figure of Pius VII undulate downward while the lines that define Napoleon are vertical and angular. The sword reinforces the geometric regularity of the standing figure.

The dejected pope captures something of David's response to the coronation ceremony; David saw him as a victim of the proud Napoleon who prepares to place the crown on his own head. The Napoleon who victimized the Pius VII of this drawing is the same Napoleon that David depicted in the Genoa portrait. He stands in the same position, holds his hand upward and wears the same imperial robe. In adapting the figure from the coronation study to the painting for the Genoa Court of Appeals David merely rotated the figure 90 degrees and made a few appropriate adjustments. His heart does not seem to have been in the work.

In the *Coronation of Napoleon and Joséphine* Napoleon is shown preparing to place a crown on the head of Joséphine. Gérard is said to have told David after he saw the work in progress, "I must admit that I found the stance of the Emperor crowning himself and holding his left hand defensively on his sword not very felicitous. There is something histrionic about it which I don't think Napoleon would like very much. What about the Emperor putting the crown he has just received from the Pope's hands and taken from his brow on the Empress's head? . . . that would perhaps be calmer and more graceful, with more of that elegant simplicity you like."[54] Another reason for this change was interest on the part of Napoleon and his officials in previous coronations. There had been a long discussion about Pope Leo III's coronation of Charlemagne, and about Constantine's self-coronation. For artistic reasons and because of historic precedents the decision was made to show Napoleon crowning Joséphine. As a result, David transformed Na-

poleon from the proud figure of *Napoleon Crowning Himself* to the dignified person whose attention is on Joséphine.

In the study Napoleon's weight is on his left leg and his head is tilted slightly back, but in the painting his weight is shifted forward and the eyes look downward at his wife who is about to become Empress. This is a less histrionic Napoleon, as Gérard suggested; Napoleon's facial features are as delicate as the hands that hold the imperial crown. This delicacy is consistent with and would seem to have been conditioned by that of Joséphine. The signs of age that had appeared on the face and chin of Joséphine have been courteously overlooked in favor of the perfect features that David has shown.[55] Just as she has been idealized, so has Napoleon. Both faces have lighter complexions than the faces of the prelates and members of the court who observe the ceremony. The other faces are realistic, those of Napoleon and Joséphine are free of wrinkles or other blemishes. David painted Napoleon and Joséphine politely, as could be expected of an artist who wanted to please and knew how to do so.

In deciding to show Napoleon preparing to crown Joséphine instead of himself, David relocated and altered the sword that he had painted in Napoleon's left hand. The conspicuous sword of the drawing becomes the thin, barely visible sword that hangs from Napoleon's side in the painting. As David worked through the late studies he sketched a different sword for the finished painting. This sword appears, somewhat improbably, in the *Study of Mme de la Rochefoucauld* (fig. 62), one of the few surviving oil studies for the *Coronation*. That the lady who holds Joséphine's gown is shown much as she is in the painting suggests a late date for the study; it was done as David approached the finished form of the painting. At that time an idea came to him. Napoleon would not hold a sword conspicuously, but a sword in the painting would achieve importance. Why did this idea occur to David while he was working on this oil sketch, where it seems so out of place?

Showing a sword alongside female figures in a preparatory sketch was something David had done before, in a late drawing for the *Horatii* (fig. 5), as that painting's form crystallized. The swords were to be the spiritual heart of that painting; both compositionally and ethically they were central to the heroic content of the work. Now, in the *Study of Mme de la Rochefoucauld* a sword has again appeared in a sketch. This time, however, the sword is no longer the instrument of violence that it had been, nor is it used to separate two realms, the male and female. The hand that rests on the sword in the *Study of Mme de la Rochefoucauld* is relaxed, the pictorial rhythms are gentle

and flowing. In fact, the edge of the hand follows the same trajectory as the bust of Joséphine's lady-in-waiting. The sword beneath this hand is hardly menacing.

In the *Coronation of Napoleon and Joséphine* the sword appears on the far right of the painting, where it is in the hand of Joséphine's son, Eugène Beauharnais. Two choirboys standing behind Eugène stare at the sword in fascination (fig. 63). All other eyes are on the coronation, on Napoleon and Joséphine. The figures directly in front of the choirboys watch Napoleon as he prepares to place the crown on the head of Joséphine, as do the clergymen, some of whom peer through the candelabra, intent on seeing the great event that unfolds below them. By contrast, the boys look elsewhere—at a sword. The boy on the right not only looks at but touches Eugène's sword—with a hand that holds the chain of a censer directly below the sword. The incense would waft up from the censer to the sword, enveloping it in perfume. The sword itself is ornamental, with a handle that turns on a hinge, one end of which Eugène flips upward with his finger. The large, curved sword is attached to Eugène by long straps, which enable him to hold it so far from his body—and make it so conspicuous. The second choirboy looks over the shoulder of the first, so he can see his companion touching, playing with, the ornamental sword. In this elaborately worked out detail David has commented quietly and privately—and ironically—on the event he has portrayed. It was an event of pomp and pageantry but it was not a heroic event. Nor was Napoleon the heroic figure for David that he had once been.

This reading of the *Coronation* suggests that as narrative and descriptive as the painting is, it also contains something of David's own responses to the event. He attended the ceremony on December 2, 1804, and he began painting the canvas in December of the following year. By that time he had done many preparatory studies and more were to follow before completion of the painting. The task of arranging sittings with the dignitaries who were to be included in the painting was a difficult task in itself. David's work on these studies brought him into close contact with the Napoleonic court and with the members of Napoleon's family. With great effort he arranged appointments and when they appeared they were often so rushed that he had to do quick sketches. He borrowed clothing from some of his sitters and was obliged to pay special attention to others. Where an individual was to be placed and how prominent that person would be in the painting led to complications that from David's point of view were far from pleasant. For instance, only a portion of M. de Charette's head was shown, but David assured him, "There'll be enough for you to imagine the rest."[56] As Jules

David said, painting the *Coronation* was one of the most "delicate tasks" the artist ever undertook because of the vanity of courtiers and the small points of etiquette he had to take into account, matters as "difficult as they were futile to resolve." This irritated David. "Often while working on the *Coronation* the painter exhaled his bad humor against courtiers who wanted only the first place and would have willingly asked that the Pope and Emperor be sacrificed to their vanity, without so much as considering their negligence in coming to the atelier for their posing sessions."[57]

There were particular complications with the members of Napoleon's family. On September 16, 1807, David wrote Claude Thienon, a painter in the service of Louis Bonaparte, asking him to explain the difficulties he would have making changes in the painting that his patron wanted. Progress on the work was at an advanced stage and to rework figures would not be easy, particularly, David said diplomatically, one "as essential" as His Majesty. He continued, "As you know, everything is calculated in a painting, and changing a figure slightly can lead to an incalculable number of adjustments that will completely disorganize an entire part of the painting and often the entire work."[58] Of course, nothing was more important to David, he said, than to please Louis, and if "His Majesty desires a change I will have to obey him." As it turned out David's plea was to no avail; Louis had been shown standing behind Joseph, which he objected to, so David reworked his figure to make Louis fully visible. This meant changing other figures and led to further dissatisfactions and demands for even more changes.

David was not the only person to have difficulties with the prideful members of the Bonaparte family. In fact, the members of that family greatly complicated Napoleon's plans for the coronation. Napoleon had no heir at the time, so he had to consider various possibilities. Joseph was the logical choice, but he had only two daughters, which made Lucien the apparent candidate. The problem here was that Napoleon had steadfastly opposed the marriage of his brother to Mme Jouberthon. Napoleon and Lucien quarreled and Lucien left for Italy before the coronation, where he joined his mother. For her part, Mme Mère disliked Joséphine and her entire family, and in the quarrel between Napoleon and his brothers she took the brothers' side. She announced that she would not attend the coronation ceremony. In fact, she relented, but not in time to be there. She was on her way to Paris on December 2. Compounding Napoleon's problems was a scene with Louis over his being passed over as heir. Moreover, the sisters were also difficult over matters of precedence. When Napoleon granted the titles of "Highness" to the wives of Joseph and Louis, his own sisters Caroline and Elisa

claimed they should have the same title. After his sisters' protestations Napoleon yielded and gave them the titles they wanted. They then raised objections to carrying Joséphine's train, which they regarded as demeaning.

The inclusion of Mme Mère in the *Coronation* can be seen against the background of these family complications. Seated in a gallery she is directly behind Joséphine, the woman she despised. She does not deign to look at Joséphine. Her head is erect, as if she is avoiding looking at the event taking place below her, but her eyes do turn toward her standing son, whom she could see without turning her head in his direction. She sits stiffly and her face is masklike, without emotion. Yet by turning her eyes toward her son she belies her interest in the role he is playing. David's decision to portray her thus reveals his awareness of the tense family relationships that complicated life for Napoleon on the occasion of his coronation. And of course even to include her in the painting was a necessary invention, an act of artistic legerdemain that projected the type of official image that Napoleon obviously wanted. And so Mme Mère is seen in the gallery looking at her son and at the far left of the painting are Joseph, Louis, Caroline, Pauline, and Elisa, polite observers of the coronation ceremony, the other members of Napoleon's family.

In the gallery behind Mme Mère are members of David's family, his wife and two daughters, and standing behind them is David himself, with an artist's pad in his hand, drawing the event he was commissioned to paint. To show the David family directly behind Mme Mère was another artistic sleight of hand. While it is not known exactly where David sat it could not have been behind Mme Mère, who after all was not even there. Why did David show himself and other members of his family directly behind Napoleon's mother, the matriarchal head of the Bonaparte family?

Napoleon's ideas on marriage and the family were conservative, reflecting his Corsican background. During discussions of the Civil Code in 1802-3 he said, "The official performing a civil marriage requires a formula containing the promise of obedience and fidelity on the part of the wife. She must be made to realize that on leaving the tutelage of her family she passes under that of her husband."[59] Anxious to strengthen the family in the Civil Code, which was published on October 30, 1804, Napoleon emphasized the husband as the dominant power. Napoleon was very much the patriarchal head of the Bonaparte family. Yet, even as he translated his own views on marriage and the family into laws that would outlive his own reign and have an enormous impact on the future position of French men and women—husbands and wives—Napoleon did not have an easy time with the members

of his own family. His relationship with Joséphine had been stormy and the marriage would end in divorce, which his own Civil Code made more difficult to obtain. Moreover, as head of the Bonaparte family Napoleon encountered one problem after another with his mother, brothers, and sisters, and particularly on the occasion of his own coronation. Thus, a month after Napoleon published the Civil Code, which expressed his patriarchal views, his own coronation became something of a comic opera, thanks to the bickering and jealousy of the Bonaparte family.

What is the meaning, then, if any, of David's portrayal of himself and his own family behind Mme Mère? David had a stormy marriage himself, and had been divorced. Clearly, and this was consistent with his liberal, progressive thinking, he believed in divorce. Yet, he had remarried, and settled into a marriage that became close and in which ties with the four children were important. David did everything he could to further the careers of his sons and the happiness of his daughters. Thus, in the *Coronation*, a husband, David himself, who had divorced but remarried his wife, is seen standing behind her and his two daughters, an ironic counterpart to the scene below, which shows a mother in the gallery who in fact was not there.

It has been suggested that David did not paint his own portrait in the *Coronation*. In a superb piece of detection, Agnes Mongan has compared two drawings of David in one of his sketchbooks in the Fogg Museum. One drawing (fig. 64) is at the beginning of the book; the other (fig. 65) is toward the end. The second of these drawings, Mongan suggests, is not by David but by a student, perhaps Isabey. "The touch," she writes, "is unlike David's, and the proportions of the figure differ from David's [drawing of himself in the same album]. The legs are larger and more slender, and the eyes and mouth have different accents."[60] She speculates that Isabey drew David before painting him in the *Coronation*. For David to have Isabey paint him in the *Coronation* would have been an unusual procedure. The figure is not prominent, so the reason could not have been to relieve himself of work. He would have done so because he did not want to portray himself. What makes this all the more puzzling is that the figure of David in the painting shows the artist who had been commissioned to do the work, and with his drawing pad in his hand that is how he is seen. Thus, even as David included himself in the painting as the artist who painted the scene, he took himself out of the painting by having a student do his portrait.

According to this construction, by having Isabey paint his portrait David was saying something about his own role in painting the *Coronation*. From beginning to end that role had been fraught with difficulty. He had to fight,

literally, so he could see the event he had been commissioned to paint. He had painted a portrait of a pope who had been manipulated and who had been the object of Napoleon's mocking remarks. He had experienced great difficulties in the years of preparatory studies for the painting, difficulties that filled him with bad humor. He not only had to repaint the figure of Louis Bonaparte but had to make additional adjustments as a result of that change. And finally, he painted Mme Mère, who was not actually there, in the gallery below himself and the members of his own family. David included her and, in the way that Mongan has suggested, he excluded himself. In this gesture, one could argue, David commented ironically on the scene he painted, on the actors and actresses on the historical stage that he portrayed, and on his own role as artist. That role was one that David found inadequate. Throughout the time that he was painting the *Coronation* he quarreled with Napoleon's officials about payment for the work. Moreover, during this same period he tried to enlarge his authority as First Painter. He was dissatisfied with his position. It was this dissatisfied artist, then, according to the argument advanced here, that Isabey painted in the *Coronation*.

Napoleon saw the *Coronation* for the first time on January 4, 1808, when he and members of his retinue appeared in their carriages at the church of Cluny, where David had set up shop. After walking back and forth for what struck David as a great length of time, Napoleon said he felt as if he were again present at the ceremony, as an observer. "It is good, Monsieur David, I am very pleased."[61] Still, he did order changes. Opinions of the work vary today. Schnapper admires both the design and technique and considers it "a masterpiece, brilliantly arranged and painted."[62] For Anita Brookner, "the picture, with its exotic ardours, is in fact a key work of the Romantic movement," and one that "epitomizes the triumph of David and his school."[63] Kenneth Clark is of rather a different opinion. For "all its colossal accomplishment [the *Coronation*] is slightly commonplace"; it is a lesser work than David's "great pictures of the eighties" and falls not into "the history of classicism, but into that of official painting. . . . The heads of the ladies are very accomplished . . . but they are not art."[64]

Both Schnapper and Brookner are right in their positive evaluations: the *Coronation* is "brilliantly arranged and painted" and it is a "key work of the Romantic movement." At the same time, Clark is not unfair in his estimate of the work's lesser artistic value. He is willing to concede its technical achievement, but depreciates it as an official painting. When he says it does not belong to the history of classicism he separates it from the idea paintings on which David had built his reputation. Onto those paintings David had

placed the stamp of his own genius. As carefully composed and cerebral as the earlier masterpieces were, they were also charged with tension and energy, and they were heavy with ideological and political content. None of this is found in the *Coronation*. It is a fine collection of portraits, and the design is masterly. Yet Clark is right when he says the heads of the women—the same is true of the men—are not art. The many portraits in the painting are not art in the same sense that David's great portraits are art. One example will suffice to make the point. The Pius VII of the *Coronation* is superbly done but it is still a figure in an official portrait; it does not have the special, ambiguous qualities of the *Pius VII* portrait, a work that manifests David's own response to the pope. Throughout the *Coronation* the technique is superb, an impressive achievement for a painting of such size and wealth of detail. Yet, the whole is less than the sum of the parts. In this respect it is light-years removed from the *Oath of the Horatii*.

Nor does the *Coronation of Napoleon and Joséphine* demonstrate the same type of greatness as the *Tennis Court Oath*. It is difficult to compare the two works, because one is known only through a final study whereas the other is the result of nearly four years of work and is a finished painting that fully displays David's technical mastery. Still, the contrast between the two works is revealed by their designs. The *Tennis Court Oath*, a painting of contemporary history, is an idea painting and a statement. The oath that creates a nation radiates tensions that pass through the assembled crowd and draws down a flash of lightning from the heavens above. The soldiers are menacing, the delegates pulled together in a spirit of unity, the crowds in the galleries swept up in the enthusiasm. It is a work that bristles with interest and tension and whose greatness transcends the sum of its parts.

By contrast, the *Coronation of Napoleon and Joséphine* is without these qualities. It is the record of a political event of no less interest for David's contemporaries than the Tennis Court Oath, and it is one that was enacted with lavish pageantry. Moreover, unlike the earlier event it was one that David witnessed. Yet he has not made an emotional investment in the work as he had in the *Tennis Court Oath* or in the other masterpieces of earlier years, although the *artistic* investment is complete, in the technical sense of the word. As a technical achievement it is one of David's great paintings, but it is without—or almost without—ideas. David painted a polite and courtly work that pleased his patron, but at the same time he left his own signature on it, not only in the name David at the bottom of the work but also in the choirboys directly above who look at the sword. He "signed" the work in the way he included himself in—or excluded himself from—the painting.

These insidious and ironic touches reveal David's responses to the event he portrayed, to the actors in the event, and to his own role as artist.

Delécluze writes that David was filled with enthusiasm when Napoleon commissioned him to do the series of four grand paintings that were to commemorate the imperial coronation. He adds that within a week he had already committed his first ideas to paper. David was not to retain this enthusiasm throughout his work on the coronation series. Delécluze explains that after working on the *Coronation of Napoleon and Joséphine* for almost four years he was exhausted. David's grandson, Jules David, was of the same opinion when he wrote that David became tired from his work on the huge canvas. The sheer size of the painting made it a heavy burden, one that would have worn out a younger man. And David was getting older: the artist was sixty when he brought the *Coronation* to completion.

David had decided on the scene he would portray in the *Distribution of the Eagles* (fig. 66) on June 19, 1806, when he sent a description of all four paintings in the coronation series to one of Napoleon's officials. His description of the *Distribution* is as follows:

> The third of the Coronation festival is consecrated to valor and fidelity. This is the distribution of the eagles to the Army and the national guard of the Empire. The place of the scene is in the Champ de Mars covered with deputations representing France and the Army. The eagles carried by the presidents of the electoral colleges for the departments and by colonels for the Army are arrayed by the degrees of the throne. At a given signal all columns are set in motion, pressing against each other as they approach the throne. Then, rising up, the Emperor pronounces: "Soldiers, there are your standards, these eagles help you to rally. They will always be where your emperor will judge them essential for the defense of his throne and his people; you will swear to sacrifice your lives to defend them and contribute to maintain them by your courage and the road to victory. You swear it, we swear it." Never was an oath better observed: what different attitudes, what varied expressions! Never was a scene more beautiful; what opportunities it offers to the genius of painting. It is the precursor of the immortal battles that signaled the coronation anniversary of His Majesty. Thus will an astonished posterity cry when it observes this picture: "What men and what an Emperor!"[65]

David's written account is made up of two parts: the first part is a description of the event itself with all of its pageantry, while the second part is more

personal and subjective, suggesting the beauty of the scene and the opportunities it offered David to immortalize it for posterity. Just how personally David was touched by the scene he was to paint is indicated by his words "Never was an oath better observed."

An 1808 sketch of the *Distribution* (fig. 67) reveals David's artistic skill as he gave pictorial form to the written description. The two most prominent figures are Napoleon at the top of the row of stairs and the colonel on the landing below who swears the oath with extended arm. The colonel is obviously derived from David's two earlier oath paintings, the *Horatii* and the *Tennis Court Oath*. The sketch, then, is highly personal in the sense that David linked it to two of his greatest earlier works and in the sense that it illustrates his enthusiastic written account of the oath-taking event. Like the *Oath of the Horatii* and the *Tennis Court Oath* the *Distribution of the Eagles*—in this 1808 study—has a heroic stamp. Or perhaps it would be best to say that within the work's pageantry, David found a place for figures who invest the scene with a heroic quality that enhances the weight and stature of the work. Such was David's thinking and artistic scheme for the *Distribution of the Eagles* in the year 1808.

In compositional terms there are several differences between the 1808 study and the 1810 *Distribution*. Most significant is the elimination from the painting of the Winged Victory that showers laurel wreathes on the oath-taking deputies in the earlier study. Napoleon did not like the allegorical figure and told David to remove it. Another change is the disappearance from the painting of Joséphine, who is seen sitting behind Napoleon in the preliminary drawing. Napoleon repudiated Joséphine in 1808, the very year in which David made his study, and he had no choice but to paint her out of the 1810 *Distribution*.

In eliminating the Winged Victory and Joséphine from the *Distribution* David made other significant changes. In the 1808 study the oath-taking deputies hold a cluster of upright standards on which the allegorical figure above scatters laurel wreathes. While eliminating the Winged Victory, David also reworked the deputies below. Before, the deputies were a coherent group, well defined and easily read, and their standards were gathered together symmetrically. In the 1810 painting the deputies gesture in different directions, their clothing is more elaborate, and their standards are unfurled and bear inscriptions. Hats now have plumes, uniforms are embellished with buckles, braids, and medals, and the standards are capped by gold eagles. The opulence and bustle of the 1810 deputies is in striking contrast to the directness and coherence of their 1808 counterparts. The differences

between the two versions are less striking at the other side of the composition, where David eliminated the figure of Joséphine. In the 1808 study Joséphine is seated behind Napoleon and behind her stands her son Eugène. Directly below Eugène are two boys. In removing Joséphine from the 1810 painting David also dispensed with the boys. Eugène has become more prominent not only because he is seen in full profile but because he throws his right leg forward in a theatrical gesture. Rather than merely observing the distribution of the eagles he now participates in the rhetorical gesturing that has become so pronounced in the 1810 painting.

There is rhetoric and there is gesturing in the 1808 sketch, to be sure, but both elements are inflated dramatically in the 1810 painting. A new group of figures has been added to the painting between Napoleon and the soldiers below him. The figures in the new group raise their arms in a counterpoint of oath taking in a way that contributes to the theatricality. This change is consistent with the reworking of the soldiers on the steps, who are now shown in all of their pageantry. Their gestures introduce an element of theatrical excitement into what had been a more solemn scene.

By reworking the figures who swear the oath David not only inflated the work's rhetoric but altered the character of the event he has depicted. In the 1808 study there is a bond between Napoleon and the soldiers. He looks at them and holds his arm in their direction. For their part, the soldiers are arrayed in three distinct groups, progressing by stages toward Napoleon. This ordered movement is less obvious in the 1810 painting. Also, in the circle of figures that has been placed between Napoleon and the soldiers, the men face away from Napoleon. Compositionally they form a group, a semicircle, which cuts Napoleon off from the soldiers. Further separating Napoleon from the soldiers are the lowered standards that block off the steps which were open in the 1808 study, as if to emphasize the Emperor's accessibility. The 1810 Napoleon is a more distant and hieratic figure who looks out over his soldiers and whose hand does not receive the oath as before; now his hand is held majestically forward.

Consistent with this change is the reworking of the colonel on the platform. In the 1808 sketch he seems to have wandered in from the *Oath of the Horatii* or the *Tennis Court Oath*. He has been replaced by a figure who balances on the toes of his left foot, a figure of lightness that bears no resemblance to the stalwart figure of the colonel in the drawing. This figure is derived from a number of preparatory studies (for one example, see fig. 68) based on the mannerist bronze sculpture *Mercury* by Giovanni Bologna. The academic, almost frozen figure of this painting turns his head not

toward Napoleon but toward the deputies to his right who raise their hands upward in salute. Through this figure the entire character of the oath-taking ceremony has been altered and it has lost its associations with the *Horatii* and *Tennis Court Oath*.

As we have seen, the 1808 study was an artistic working out of David's 1806 written description of the event he was commissioned to paint. Of the four written sections in his report only this includes two parts, one descriptive and one suggesting his own responses to the event. What seems to have prompted those responses was the subject he was to portray, an oath-taking event that triggered memories of former works. By including figures in his 1808 study that he associated with those works he was putting something of himself into the work. But David took himself out of the 1810 painting by removing the oath-taking colonel with whom David felt personal associations. By removing this figure from the painting he weakened the heroic content of the work. The heroism of earlier works sent sparks and embers into the 1808 study, charging the scene with energy. But in the 1810 painting those sparks and embers have been extinguished. The rhetoric has been inflated and at the same time the entire work is marked by a frigidity that flows from the outstretched arm of Napoleon across the balletic—and classicistic—figures of the deputies below.

David was involved in financial disagreements with Napoleon's officials throughout the entire period that he worked on the *Coronation* and *Distribution*. We have seen that besides submitting bills for payment for various other works he also tried to pin down the price for the *Coronation*, which was 100,000 francs. As early as April 11, 1805, David tried to win approval of that sum, and he repeatedly tried to gain acceptance of the amount. He continued to try to resolve the question of payment after finishing the *Coronation* and after Napoleon saw it and expressed his approval. After the visit to David's atelier on January 4, 1808, Napoleon still considered 100,000 francs excessive. On February 24, 1808, David wrote to Napoleon that he wanted to consecrate his brush entirely to him—and he requested payment for the *Coronation*. On October 3, 1808, he wrote to Daru that he had received 65,000 francs payment and explained that he would now like to receive the balance of 35,000 francs. Still no payment. Then, on December 15, 1809, David wrote the comte de Rémusat, first chamberlain of the emperor, that he would "redouble his efforts to create a work worthy of [his] immortal Sovereign," and on the same day he submitted a bill for amounts he still hoped to receive.[66] This time he included a list of his expenses not only for the *Coronation* but also for two other works in the series. Acknowledging

receipt of 65,000 for the *Coronation*, he claimed that the government still owed him 110,000 francs. On January 12, 1810, Denon wrote to Daru about the amount David should be paid for each of the works in the coronation series. He suggested payment of 40,000 francs each, plus a "gift" from Napoleon "proportionate to the satisfaction he will have expressed for each production."[67] Daru wrote back on January 31 that he preferred precise figures. On February 6 Denon provided the figures: 65,000 for the *Coronation*, and tentatively 52,000 for the *Distribution of the Eagles*. A week later, February 13, Napoleon announced that he had decided to cancel the third of the coronation paintings, the *Reception at the Hôtel de Ville*. Then, two days later, he personally signed a document stating that payment for the *Coronation* was to be 65,000 francs, the amount already handed over to the artist, and that payment for the *Eagles* would be 52,000 francs if the painting pleased him. David would also receive 2,400 francs for his expenses on the *Hôtel de Ville* picture. Thus was the question of payment for the *Coronation* finally settled. It had been five years since David indicated that he expected to receive 100,000 francs, and more than two years since the painting had been finished. In the meantime, he was close to completion of the *Distribution of the Eagles*, for which he would receive 52,000 francs, if Napoleon liked it. This was barely over half the amount David originally requested. The *Hôtel de Ville* project was scrapped at this time. The fourth work, the *Enthronement*, had been jettisoned in 1805. The project for four grand state paintings that had stirred David's enthusiasm when he received the commission ended with bickering over payment, canceled commissions, and hurt feelings.

Throughout the long and unpleasant episode David tried to retain favor where it counted. Above all, this meant paying court to Napoleon, which he did assiduously. He describes a conversation about a gallery that Napoleon intended to create in the Luxembourg to exhibit the paintings in the coronation series. Napoleon asked the artist what it should be named.

The Gallery of the Coronation, I told him.

No, the Gallery of David replied the Emperor. There is the Gallery of Rubens, and this one will be called the Gallery of David.

The difference here is great, for while Rubens was a greater painter than Marie [de Médicis] was queen, Napoleon is a greater Emperor than David is painter.[68]

There were others besides Napoleon whose favor David sought. During the

final negotiations for payment on the paintings in the coronation series Daru became the crucial figure between David and Napoleon. Unbeknownst to Daru, David painted a portrait of his wife, for which he made apologies upon presenting it as a gift. "It was only when the work neared completion that I recognized that I unwittingly committed an indiscretion, not thinking that what was a pure pleasure for me could compromise the delicacy of your wife."[69]

David tried to win favor, but his efforts were clumsy. Two weeks after apologizing to Daru for painting the portrait of his wife, he asked Daru to assist him in securing the full rights that he believed should be attached to the position of First Painter. It had been five years since he first requested the same powers Lebrun had enjoyed under Louis XIV and now, when his position was much weaker, he repeated the request. He asked Daru to present his case to Napoleon, who by this time was surely weary of David's many solicitations.

As clumsy as David's efforts may have been when trying to win the favor of Napoleon and his officials it can be said to his credit that he was consistent in the position he had chosen to take and in fairness to him it may not have been unreasonable. The 100,000 francs that he requested for the paintings in the coronation series, all of which were to be 610 by 930 centimeters, can be compared to the 72,000 francs he earned from the considerably smaller *Sabine Women*. His claim was that his own expenses for the *Coronation* came to 30,000 francs. But the issue for David, as we have seen, was not just economic. What was also at stake, and what may have motivated him above all else in his efforts to receive the payments he felt he deserved, was his pride. The curious thing is that the more strongly motivated he was—the harder he pushed for payment, the greater his courtly solicitations—the more inept he became. He and his pride were the losers.

For years David worked almost entirely on paintings commissioned by Napoleon, his officials, and the members of his family—along with studies he continued to do for the *Leonidas*. That was the case until 1809, when he accepted a commission from a Russian aristocrat, Count Youssoupoff, who lived in Paris from 1808 to 1811, when France and Russia were at peace. As a collector and lover of French art, he wanted a work by David, and commissioned *Sappho, Phaon, and Cupid* (fig. 69). The story is taken from a French translation of Anacreon, one of the sources of David's earlier *Paris and Helen*. With David's 1809 painting there was a return to the erotic art that had been favored by eighteenth-century connoisseurs.

Sappho and Phaon was not well received and is still regarded as one of

David's less successful works.[70] In the earlier *Paris and Helen* (fig. 12), also an erotic subject, he designed a work that met the highest criteria of his art at that stage of his career. Even as he invested this painting with erotic meaning he did so with a seriousness that was at the center of his art. That is precisely what is missing from *Sappho and Phaon,* a work that has no real precedents in David's earlier work. In *Paris and Helen* there is a characteristic Davidian contrast between the male and female figures and the composition as a whole is rigorously ordered. The rigor and simplicity of *Paris and Helen* has been replaced by the confusion and decorative clutter of *Sappho and Phaon,* and the athletic Paris has given way to an effeminate Phaon. Phaon and Sappho appear to be posing and both are artificial in contrast to the more meditative Paris and Helen. Everything about the Sappho painting seems contrived, as if the signs of love were tacked on as an afterthought, rather than emerging from interior feelings. The two turtledoves and the double trees in the background reinforce the painting's artificiality, as does the manneristic Cupid with the heavy, drooping wings.

David was working on the *Distribution of the Eagles* in 1809 when he accepted the commission for *Sappho and Phaon.* He did the painting hurriedly, and later, in 1814, he requested a sketch of it from Youssoupoff, since he did not have as much as a trace of it in his studio. It may have been that David attached no particular significance to the commission and did not invest a great deal in the work. Yet, that he accepted a commission so far removed from the mainstream of his recent work suggests that he was beginning to look in new directions. In the light of what was to follow it is clear that the painting very much fits into the line of development his work would take in following years.

The year 1809 began one of those periods of reconstruction that punctuated David's career. He had had two major breakthroughs, that of the Roman style and that of the Grecian style. Both were achieved only after enormous effort and at great cost, and in the case of the latter after much thought and discussion. As insignificant as *Sappho and Phaon* is, it anticipates the work of David's last period. It is in a style that is associated with his exile, but it is one whose beginnings go back to the year 1809 and to this painting.

Both of David's earlier breakthroughs took place within the framework of history painting. In *Sappho and Phaon* David turns to mythology, which would much occupy him in coming years. Unlike the breakthrough paintings of earlier years, this work was not the culmination of a long period of growth and change but was done in passing, on the spur of the moment, so to speak. And he probably attached little significance to the work, unlike the

earlier breakthrough works in which he had made such a large investment. Still this painting did draw deeply from David's interior life, as had the other, more important works. It did so in ways that were unknown even to himself. He had been in Napoleonic service for nine years and in that capacity he came to feel many burdens. This was certainly so in 1809 and it helps explain *Sappho and Phaon,* a work that is diversionary not only in subject but was diversionary for David. Without being conscious of it he was striking off in a new direction and this painting is a record of that fact.

After the *Distribution of the Eagles* in 1810, David's Napoleonic commissions came to an end. In the next several years he turned to portraiture. He painted Mme Daru in 1810, the wife of Napoleon's quartermaster general; he did a portrait of Count Français de Nantes, a Napoleonic official, in 1811. In 1812 he painted a close friend and his wife, M. and Mme Mongez, and in the same year he did the *Napoleon in his Study,* commissioned by a Scottish nobleman, Alexander Douglas, who admired Bonaparte. In 1813 he painted the only portrait of his wife, *Mme David.* David also began unfinished portraits of his daughters and sons-in-law and he painted a self-portrait in 1813.

The quality of these portraits varies. Those of his daughters and sons-in-law are so weak it is little wonder that he never bothered to complete them. Nor is the self-portrait of 1813, in which he wears his Legion of Honor medal, very probing. Compared to the 1791 and 1794 self-portraits this one lacks conviction. Its blandness contrasts with the intensity of the 1791 self-portrait and the sense of rectitude projected by that of 1794. The portrait of *Mme David* (fig. 70) is a different matter. In this work David sees through the plainness of his wife, which he makes no attempt to conceal, and into her character, which he has come to value. The fancy feathered hat does not flatter the woman who wears it but draws attention to her ordinary features, as if to assert the truth of the painting. The same direct quality of the *Mme David* portrait comes through also in *M. and Mme Mongez* (fig. 71). M. and Mme Mongez look straight ahead and are portrayed without embellishment. Antoine Mongez was an antiquarian and numismatist and he is seen holding a coin and resting his hand on a book. His much younger wife, a former student of David, is shown in a cape and brocaded gown whose simple lines do not conceal a thick figure and heavy arms.

Count Français de Nantes (fig. 72) had been a Jacobin and deputy to the Legislative Assembly during the Revolution, in which capacity he railed against religion. During the Directory he was a member of the Council of Five Hundred. He opposed the 18 Brumaire coup, but came to terms with

Bonaparte afterward, for which he received handsome rewards. He was a prefect and councillor of state, a count of the Empire, and in June 1811 he became a grand officer of the Legion of Honor. In David's portrait he is shown wearing the medal that went with this distinction. He wears an official blue velvet uniform with an ornamental cape and holds a hat in his lap that is both ringed and topped by feathers, a hat of such ambitious construction that it would certainly have been conspicuous when worn. Like the broad sash with the gold braid on the end and the lace tucked into the neck of the uniform, the hat suggests excess. In all of his finery Count Français de Nantes is the opposite of M. and Mme Mongez and Mme David. If they are characterized by directness and portrayed without flattery, he is seen in all of his self-importance, pompous, inflated, puffed up. They look directly ahead; he is shown from a lower angle and leans back in his chair, projecting a sense of the grandness that his rich trappings express. Yet, those trappings do not flatter him; precisely because they are trappings they emphasize that which is merely external. The truth here is as compelling as that of the *M. and Mme Mongez* and *Mme David* portraits, but it is a different type of truth. Here the reality is the display, the ostentation, the gaudiness, and it is a reality underlined by the self-satisfied expression of the ruddy-faced Napoleonic count.

The 1812 portrait of *Napoleon in His Study* (fig. 73) met with Bonaparte's approval, unlike the disastrous Genoa portrait of 1805–6. "You have understood me, my dear David; in the night I am occupied with the happiness of my subjects and during the day I work for their glory." In a nice piece of flattery, David showed Napoleon in his study, where he is working in the early hours of the morning. The clock behind him gives the time as 4:13, and the candle on the desk makes it clear that it is night. Papers have fallen over the side of the table, and are next to a chair that holds a sword, whose strap hangs from the handle. Directly above the sword, on top of the table, is a roll of papers with the word "Code" inscribed on the top sheet. Napoleon was quick to see David's point. The scattered papers and the copy of the Napoleonic Code indicate the work he does for his subjects at night and the sword represents the glory he brings them in the daytime. Reinforcing this point are the military uniform and medals worn by Napoleon, an appropriate foil to the quill that sits on the edge of the desk, an instrument of the public official. A very nice piece of flattery indeed. This portrait is flattering also in the depiction of Napoleon, whose physical decline David chose not to show. Delécluze's verdict was that it was a "poor likeness" and that it suffered from being "too ideal."[71] Apart from the figure of Napoleon the

painting shows a collection of objects that David rendered with characteristic attention to detail: chair, table, lamp, rug, and clock. Not only did he have to do the work without sittings, but he had to solicit information about the decor and furnishings from acquaintances. To that information David added what he was able to draw from his own memory. It is a very successful portrait. Still, when compared to the other portraits done about the same time, *Count Français de Nantes, M. and Mme Mongez,* and *Mme David,* it is evident that something is missing. In their different ways all of the other portraits have a psychological dimension and all reveal an active chemistry between David and his subjects. By contrast, the *Napoleon* portrait is an outstandingly professional work, and it proved that David still knew how to flatter. More than this it could hardly have been, given the circumstances in which it was painted.

While David had done no commissioned works for Napoleon for two years, he had not yet abandoned all thought of doing so. Perhaps the success of *Napoleon in His Study* gave him encouragement. In 1811 he had tried to revive the Genoa portrait project, but Napoleon rejected the offer. Also in 1811 he submitted designs for furniture for Napoleon's Grand Cabinet in the Tuileries. That too came to nothing. Now, in 1812, he had done a portrait which Napoleon liked, and he was making a copy of the work. This was in July. In September he inquired about plans to decorate the Louvre, for which he wished to submit two designs, both of historical subjects. Hoping to secure a commission, he did two finished studies, *Venus Injured by Diomedes Appeals to Jupiter* (fig. 74) and *The Departure of Hector.*[72] David did not get the commission and from this time on he made no further efforts to secure others. *Venus Injured* and *Departure of Hector* might have materialized as successful and perfectly good paintings, but they would not have been characteristically or even recognizably Davidian, not at this stage of his career. Both works are regressive and suggest the rhetorical, baroque style of David's student years. This can undoubtedly be explained by the purpose for which they were done. As studies for a princely apartment in the Louvre they were appropriately decorative, but however careful David may have been in the choice of subject and style, his efforts did not result in a commission. There was now a definitive break between him and the official world to which he had once belonged. Napoleon no longer sought him out and he no longer tried to secure court commissions. His days as a court painter were over.

David now devoted himself to *Leonidas at Thermopylae* (fig. 75), the ambitious history painting that he began, according to Delécluze, before

the eighteenth of Brumaire and which Delécluze says he abandoned when the demands of Napoleonic service made continued work impossible. Delécluze's explanation was that David gave up the *Leonidas* project when he became mired in his duties as a court painter and returned to it when he gave up those duties. David's sketchbooks reveal a different story. They indicate continued work on the project from the time of the first studies to the moment of completion. The story of David's work on the *Leonidas*, as told by the sketchbooks, is as fascinating as it is complicated, but it is a story whose narrative line, unfortunately, cannot be followed page by page and chapter by chapter. It cannot be followed page by page, because of David's working methods. His procedure was to do sketches in bound books, albums such as those already discussed in connection with the *Tennis Court Oath* and *Louis XVI* project. He normally did one drawing after another in sequential order, but sometimes he set aside an album after a series of drawings for a particular work and when he picked it up again he might not do new drawings for the same painting as before. In some cases it was years later when he picked up an album that still had blank pages, and when that was the case he might thumb through it until he found unused sheets of paper for studies.[73]

For most of David's works it is possible to establish an approximate order for preparatory drawings, or at least to follow the general drift of his progress, but the task of reconstructing his work on the *Leonidas* is so fraught with difficulty as to be almost impossible. One reason for the difficulty is the sheer number of drawings. The task of following David's progress on the *Leonidas* is so thorny because of his working procedures, his going back and forth from one album to another, rather than working straight through a particular album. Thus, the *Leonidas* drawings appear in different albums—alongside studies for other works.

Given the impossibility of following David's progress step by step as he worked on the *Leonidas* it will be necessary to follow a different procedure for tracing the painting's development. We can compare David's approach to the *Leonidas* when the project was in its early stages to his final thoughts as indicated by the painting itself. In the Montpellier drawing of about 1800 (fig. 76), Spartan soldiers are in the middle of the Thermopylae pass, one side of which can be seen in the background. For the 1814 painting David turned the geography 90 degrees so that Leonidas and his soldiers are at the head of the pass which recedes into the background. Leonidas is at the center of the composition, as if to symbolize the centrality of his role in the heroic episode that was about to begin. He now holds a sword in one hand and a shield and lance in the other, whereas in the Montpellier drawing he only holds a spear.

The Leonidas of the Montpellier sketch has a brooding quality that suggests David's earlier figure of Brutus, which is even more evident in another *Leonidas* study (fig. 77), also at Montpellier. The very different hero of the painting has been adapted from a figure of Ajax in Winckelmann's *Monumentii antichi inediti* (fig. 78). In adapting the Ajax figure David has made two changes: he looks directly ahead (although his eyes are turned upward) rather than to his right and his hand holds a sword rather than resting on a rock. The other figures in the painting have also been reworked, almost completely. Carried over from the Montpellier sketch is a soldier on the far left who carves an inscription with his sword on the side of a cliff, the soldiers to the left of Leonidas who fraternally embrace each other, the figure to Leonidas's right who fastens his sandal, and the soldiers who sound their trumpets. In carrying these figures over from the Montpellier drawing David gave them different places in the painting, so much so that they are hardly recognizable.

In the 1800 study a powerful rhythm extends from the standing figures on the right of Leonidas toward the soldier on the far left who carves the inscription on the rock. The soldiers who sound their trumpets with outstretched arms suggest the earlier *Horatii* figures. This is not another of David's oath scenes, but it is one that has an ethical point. That point is defined by the trumpets that are aimed directly at the sword that carves the inscription on the rock, "Passer-by, tell Sparta that her sons died for her." Below the inscription are the men who will fight to the death for their country.

The key figures compositionally are the soldiers with the trumpets. With their clarion call they urge their fellow Spartans toward the soldier who carves the inscription, giving momentum to the rhythm sweeping forward and upward. Seen within this sweep, in counterpoint, Leonidas stares straight ahead, the only figure who does so. At the same time that he is set apart from the other figures he is seen within a larger compositional unit. His shield and those of other soldiers behind him help to integrate him into that unit. Piled shields are seen also in the far left of the drawing and others are held by the soldiers on the right who perform their exercises. The circular shields help pull together the different groups of figures and contribute to the unity of the whole. The combination of powerful rhythms and what might be called a skillful use of counterpoint was heavy with promise. As tentative as much of the drawing is in this study, David's grasp of the essential forms he wished to develop augured well for the future of the work.

In the 1814 painting the figure of Leonidas is no longer set against a

rhythmic progression from right to left. The standing soldiers who began that progression at one end have been eliminated and the soldier at the other end who carves the inscription has been cut off from the companions who had moved toward and were pressed against him. In the painting he has become a lone figure standing on a ledge, physically removed from the soldiers below him. Now only three soldiers acknowledge his deed—the three figures to the left of Leonidas who spring in unison on their toes and hold garlands in their outstretched hands. Their rhetorical gesturing toward the soldier who carves the inscription is in striking contrast to the patriotic involvement of the figures in the Montpellier drawing. What had been a compositional and ethical focal point has become a separate episode. The rhetorical gestures of the springing soldiers strip their part of the work of its former power; what had been unified and forceful has become theatrical and artificial. These are not Spartan soldiers, as in the earlier drawing, but stylized figures who carry the fragrance of the studio.

Throughout the painting are episodes that bring attention to themselves and detract from the unity that had been present in the Montpellier drawing. A blind Spartan has been introduced on the left who will fight to the death along with his companions. The two soldiers who embrace one another fraternally have been moved to the right of Leonidas, and in their new position they are no longer integrated through parallel rhythms into a larger group. Even the way they embrace each other seems more literal, as if David were making a direct copy of two models. The figures at the feet of Leonidas also seem to have been done from models and both are compositionally autonomous rather than part of a unit; the same is true of the springing figure on the far right and the figure behind him, and the two soldiers behind the tree who sound their trumpets. Earlier these soldiers had been part of an assembled group; now they are cut off from that group. Below the soldiers who sound their trumpets is yet another group of figures who move from right to left, as had the main body of soldiers in the Montpellier drawing. The difference is that in the earlier drawing the soldiers pressed toward the companion who carved the inscription on the rock, whereas these soldiers have no connection with that event. They too are a self-contained unit and as such they contribute to the larger fragmentation that has taken place.

Delécluze felt that when David began work on the *Leonidas* he brought to bear the qualities of a poet but that when he finished he was a prose artist. This is a perceptive observation. In fragmenting the unified group of the Montpellier drawing into segments David turned the *Leonidas* into a collec-

tion of narrative episodes. The blind man moves toward Leonidas, the soldier ties his sandal, the warriors embrace each other before the battle, the soldier carves the inscription on the rock, and so on. What adds to the work's narrative character is the row of men and horses climbing the mountain path in the rear. Beyond the path is a temple with a figure looking down at the Spartan army below and in the far background the Persian army can be seen. By rotating the geography David provided himself with narrative opportunities that he did not hesitate to work into the painting.

Related to the narrative conception that replaced the earlier poetic conception is the way feelings have been portrayed. One example illustrates the change. In the Montpellier drawing David shows a Leonidas who rests his right hand on his knee and stares solemnly ahead as he contemplates the certain death that awaits him and all of his men. The Leonidas of the painting holds in his right hand the sword that he will use in the battle, drawing attention to that event through this gesture. Knowing the outcome of the battle, he turns his eyes upward. No detail illustrates better than this what Delécluze meant when he said the *Leonidas* began as poetry and ended up as prose. David's objective was to portray a scene that was grave, reflective, and religious. In the Montpellier drawing he seemed capable of achieving that objective through a recognizably Davidian Leonidas, somber, inward, and Brutus-like in his determination and resignation. The Leonidas of the 1814 painting is an altogether different type of figure. That the grave, reflective, and religious character of the work should be conveyed by the hero's upturned eyes suggests that this is a new type of hero. The truth is that David was a different artist.

What transformed the artist who, after investing so much in the *Leonidas*, painted a work that for all of its fine details did not achieve the potential suggested by the Montpellier drawing? Despite his mistakes about the *Leonidas*, Delécluze is a useful guide to understanding the decline that he believed had taken place and that he saw reflected in the work itself. That he believed that David gave up work on the project is significant. David may well have gone out of his way not to let others know of his work on the *Leonidas*, or at least he did not publicize the fact. As a student who was unusually close to David and remained so when others were leaving the master's atelier, Delécluze should have known, if anyone did, of David's continued work on the *Leonidas*.

While David was in the midst of large Napoleonic commissions he would scarcely have had time for systematic work on the *Leonidas*. This was particularly true in 1805-10, when he was deeply involved in the paintings for the

coronation series. The sketchbooks show that David did drawings for the *Leonidas* during this period, but they were not preparatory studies for a work about to be painted. Rather, David continued to think about and do drawings for the *Leonidas* while he was pouring most of his time and energy into works commissioned by Napoleon. Sometimes, while doing studies for a Napoleonic painting, he thought of the *Leonidas* and would do a drawing for that work as a result.[74] Even as he poured time and energy into his ambitious Napoleonic paintings his thoughts continued to turn, at times, toward the *Leonidas*. It may well be that the difficulties he had with those paintings and with Napoleon's officials concerning financial payments encouraged him to think about a project he had begun before entering Napoleonic service.

Delécluze wrote that David resumed work on the *Leonidas* after completing the *Distribution*. This would have been in the wake of the frustrations and disappointments David had experienced as a court painter. Giving particular attention to the year in which David completed the *Distribution*, Delécluze discusses the 1810 decennial competition at great length, as does Jules David. That competition was ordered by Napoleon, who announced that prizes were to be given for works that furthered the glory of the Empire. Juries examined entries in the various categories and submitted reports. In the history category first prize went to Girodet's *Scene of Deluge*, while David's *Sabine Women* received only honorable mention. The jury said of Girodet's work that "the poetic thought and picturesque composition . . . are entirely the invention of the painter." Moreover, "the energy and sensibility that M. Girodet has shown in his composition merit the greatest praise." The jury also remarked on the work's striking effects, "so touching and so terrible," which inspired fear and created an effect of extreme danger. It was maintained that Girodet's work, always refined, was also brilliant and vital. By contrast, the jury found David's *Sabine Women* derivative, lacking in originality, and it questioned the propriety of the nude figures. The composition was considered poor, the tone "weak and monotonous" and generally lacking "vigor and harmony."[75] Napoleon, unhappy with the jury reports, decided to invoke public opinion by ordering the competition pieces to be shown in the Louvre. When debate within the Institute spilled into the public arena the public was divided into two camps, for and against the juries. Attention was particularly focused on the honorable mention given the *Sabine Women*, which the *Journal de l'Empire* called a "great scandal in the Republic of Arts."[76] The jury noted that of all the history paintings in the competition the *Sabine Women* was painted first. The suggestion was that

David was from an older generation and that he had been eclipsed by younger artists, including his own students. As Delécluze said, one result of the 1810 decennial competition was a rivalry between David and Girodet. That the jury should favor the former student over the master was not easy for David to swallow, and what made it all the more bitter was criticism of a work he considered the masterpiece of his Grecian style.

Napoleon's efforts to shed glory on the French school in the 1810 competition had the effect of fragmenting that school. As controversy spread from the Institute into the public, partisans took sides and in arguing their cases they focused on the shifting currents of artistic change. It seemed that art was in a period of disarray. Long acknowledged as the leader of the French school, David now resolved to reestablish his position. As Delécluze says, he was the most serious artist of the time but also he had been the most changeable. He had been drawn to all governments and all leaders because of his "puerile enthusiasm," but he would now put his art back on course and reassert his position. He had received honors from other governments and was pleased to get them.[77] And he sought more honors, an indication of how much recognition meant to him.[78] It must have fed the demands of his pride to sense that his position in the French school was slipping. He had not been sympathetic to fashionable trends of art and after looking at one of Girodet's works he said he seemed no longer to understand anything about painting. The currents of romanticism that were wending their way through French art were disturbing to David. When he saw medieval subjects invade the Salon in 1808 he commented sadly that "in ten years study of the antique will be abandoned . . . all these gods and heroes will be replaced by knights and troubadours singing under the windows of their ladies [in] an old dungeon. The direction that I have given to the fine arts is too severe to last for long in France."[79]

David was not yet prepared to relinquish the field. After the disappointments of recent years he was ready to reassume his position as France's leading artist. For the last decade he had staked out his place within the Napoleonic regime and its system of patronage. He now retreated to his studio and was seldom seen in the larger, official world that had been the scene of so many frustrations. He even sold his house at this time, as if to make a new start. If his return to portraiture represents one response to his altered circumstances when he left Napoleonic service, his work on the *Leonidas* suggests a different response. This was to be the work that would reestablish his leadership. It was no longer a painting that he thought about in passing, while painting huge Napoleonic canvases, but was one that

would reclaim a position that had shown signs of slippage. Once again he would put forth a huge effort and make a heavy personal investment in a painting that would carry the stamp of his dedication.

The David who worked on the *Leonidas* after completing the *Distribution* was marked by his experience as a court painter. We have already seen how he replaced the *Horatii*-like figure in the *Distribution* with the figure based on Giovanni Bologna's bronze *Mercury* (fig. 68). The loss of energy that resulted from this change was part of a larger transformation that affected the entire painting. The hieratic figure of Napoleon stares over the soldiers who are all but engulfed by their standards and whose leader is the balletic figure that was based on a mannerist sculpture. That figure is far removed from the steadfast figure in the 1808 study. The balletic, devitalized figure of the painting is an indication not only of stylistic change but changes within David—changes pointing toward a loss of conviction in his art.[80] What makes this devitalized *Distribution* figure so important to understanding the stages by which the *Leonidas* evolved into the finished painting is that the figure is repeated in that work. It is repeated in the row of figures to the left of Leonidas who hold garlands and spring up on their toes and it is repeated in the helmeted figure on the far right who seems to be dancing out of the painting. These stylized figures seem to have wandered into the painting from the *Distribution of the Eagles*. They may be regarded as emblems of David's devitalized late style.

Done over many years, the *Leonidas* was fed by different ideas, objectives, and styles, the welter of which created problems David was unable to solve. That he was older may have made the task he faced more difficult. In retrospect it can be said that his former powers of regeneration were diminished. Perhaps the long period of service under Napoleon sapped something of David's vitality. It was in this very work that he hoped once again to establish his leadership, but he was not up to the task. To understand why this was so it is necessary to go beyond stylistic conflict and beyond the impact on David of his many years as a court painter. So too is it necessary to find other explanations than the effect of age. If there was an artistic weakening, it was not because David's brush faltered. He was unable to resolve the problems posed by the subject of his painting. The *Leonidas* had begun as a patriotic painting, and the theme of patriotism continued as he brought the work to completion, but just as France had changed, so too did the content of David's painting.

Delécluze writes that David was uneasy when he was working on the *Leonidas,* and that he often directed conversation toward politics. "Although

habitually very reserved in these matters, he spoke freely when the occasion presented itself and when he was able to express himself in strict confidence." He spoke of Napoleon on these occasions. As we have seen in the quotation at the head of this chapter, he had discovered that "his hero had rather too much the temperament of a warrior, and that the head of the new dynasty was at least as absolute in his whims as those of old." Sometimes when he thought of all that had happened he would sigh, "Ah! ah! This is not precisely what one desired." He spoke also of the "perilous enterprises in which the chief of state had been engaged."[81]

When David withdrew definitively from official service in 1812, Napoleon's position in Europe seemed supreme. The armies of Prussia and Austria had been defeated repeatedly and Russia had accepted an alliance with France. Only in Spain was there still open resistance, and that seemed peripheral. Yet in that very year, 1812, the Napoleonic system was to receive blows from which it would never recover. For years Napoleon had to commit troops to Spain, thereby weakening his position elsewhere; patriotic, anti-French feeling developed in Prussia and indeed in other parts of Germany and Europe as well; Austria resented the alliance with the Corsican upstart; and most important, Russia withdrew from Napoleon's Continental System and resumed commercial relations with England. Napoleon resolved to crush Alexander and amassed his *Grande Armée,* the largest military force ever assembled up to that time. He had made France the dominant force in Europe by the sword and it was with the sword that he would respond to the latest challenge. The very logic by which he had established French hegemony in Europe drove him now to march with 700,000 men into the vast, barren, frozen expanses of Russia. The *Grande Armée* was destroyed and while Napoleon assembled new forces and fought as brilliantly as ever he was unable to defeat armies larger than his and led by generals who used his own methods and strategies.

Jules David writes that David followed the news of battles anxiously during the period of military reversal. Members of his family were directly involved in the warfare. David's oldest son, Jules, the father of David's biographer Jules David, had been an outstanding student who became expert in Greek. He was a government official under Napoleon. One of the daughters, Emilie, was temperamentally like Jules, calm and sanguine. The other two children, Eugène and Pauline, were just the opposite, impetuous and difficult. David had become cross with young Eugène, as when the boy took in stray dogs from the courtyard of the Louvre and turned his sister's bedroom into a pound for them. There were tense, emotional scenes

between the father and son. Finally, after taking him into his studio to study art David lost patience and told Eugène he could go to Rome to study with Antonio Canova or enter the army. Eugène decided on the latter, in 1804. He began as an enlisted man but thanks to his father's influence became an officer. He fought bravely, even recklessly, and received a chest wound that would have been mortal had it not been for excellent medical treatment. At the Battle of Austerlitz he was so distressed by the battlefield carnage that he asked his father to come and see it. David declined to do so. Afterward, Eugène gave himself completely to military life.

This is the son David was concerned about during the period of military reversals in 1813, when he was working on the *Leonidas*. He was saddened by the news of Eugène's death at the Battle of Leipzig, as were his students who had known him when he spent a brief period in David's atelier. In memory of the former fellow student, plans were made to raise a funeral monument on his behalf. But then, remarkably, Eugène appeared at David's home in Paris, still alive—but barely. He had been struck with five blows of the sword at Leipzig and left for dead on the battlefield. He was found by Russians who revived him and took him prisoner. Critically wounded, he escaped from the Russians and got through enemy lines. At Weimar he met a former student of his father's who gave him money that he hid in his bandages. Marching by night through woods he came to Worms, where he was seen by both French and enemy soldiers. A French lieutenant rescued him at the risk of his own life and presently Eugène arrived back in Paris, to the astonishment of his family. David and his wife did not recognize him at first, and when they did they were overcome by happiness. Before recovering fully Eugène returned to active service.

Eugène was not David's only connection with the wartime reversals while he was working on the *Leonidas*. Both of his daughters were married to officers in Napoleon's army. Emilie married a Colonel Meunier of the Ninth Light Infantry Regiment who had a distinguished military career since 1792. He urged a fellow officer, Colonel Jeanin, to marry his sister-in-law, Pauline. Pauline agreed, in spite of the disfiguring facial wounds Jeanin had received in combat. Both of these sons-in-law fought with Napoleon to the very end.

Jules David writes that his grandfather escaped from distress over his son and sons-in-law by working with even greater ardor on the *Leonidas*. At times the patriotic sparks flew, as can be seen in various sketches of Hercules in David's albums.[82] That David should have thought of Hercules while painting the *Leonidas* was only natural, for the Spartan leader was said by Herodotus to have descended from the Greek god.[83] David added the inscription HERAKLEOS on the altar-blocks behind the soldier who ties his sandal. In his

studies the figure of Hercules is shown over and over, wielding his menacing club and in some cases leading fellow soldiers into battle. For David the club-wielding figure of Hercules was not exactly a stranger. This Greek warrior-god had epitomized the awesome virtue that he associated with the Revolution and with the Terror. Hercules had personified the patriotism of the People for David and was a figure that played a prominent role in the revolutionary festival that David had organized on August 10, 1793. One of the most ambitious of the revolutionary festivals, it was a day for all of Paris to give itself over to patriotism. And for David the figure of Hercules was an emblem of his own patriotism.

This fierce patriotism was far removed from the grave, reflective, religious feelings that David associated with patriotism when he began work on the *Leonidas* in 1799. As he worked on the painting in 1812 and 1813 the martial patriotism of earlier years resurfaced, in connection with Leonidas who was a descendant of Hercules and in David's reaction to contemporary events. This was when the sparks flew. A wash drawing of 1813 (fig. 79) is compositionally close to the painting that David completed in the following year, and it suggests a different response on David's part to contemporary events—and to the role of his son in Napoleon's military campaigns. In this study the Hercules figure does not appear. In the area of the painting where David considered placing Hercules, behind the shield of Leonidas, an old man throws his arms upward in alarm. A year later, in the Metropolitan Museum drawing (fig. 80), dated 1814, the figure of Hercules has appeared where the old man had been in the 1813 drawing.[84] This Hercules is a club-wielding warrior who seems to have been taken directly from an earlier study, fol. 57 v. in Louvre album RF 6071 (fig. 81). After shifting back and forth, David finally transformed Hercules into the neoclassical figure of the painting who carries a bow rather than a club and wears a wreath rather than a helmet. This purified figure leads a group of men who stand serenely at his side, meditating upon that which is to happen. In the drawing fol. 57 v. in album RF 6071, these same soldiers rushed toward their leader, Hercules, as if to make ready for battle.

That David classicized his Hercules figure and drained energy from his followers is consistent with his objectives for the work as a whole, or at least with one set of objectives. The meditative, religious element had been there from the beginning, and a militant Hercules group could have seemed too powerful, too strident. As the painting took shape under his brush David could well have decided on strictly artistic grounds to leave out the Hercules group.

The problem was that his brush was pulled in different directions. On the

one hand there was a surge of patriotic feeling, perhaps kindled by the military roles played by David's son and sons-in-law. The bravery of Eugène must have made a particular impression, triggering responses tied to David's own experience. Not only would his son's heroism have struck a chord in David the artist, but his impetuousness, his violence, was at one with David's own volatile character. It is as if the son were reenacting the father's life—on a different stage. David had channeled his ardor, passion, and propensity for violence into politics during the Revolution, and Eugène acted out similar tendencies as a soldier in Napoleon's army. Yet David's comments to Delécluze indicate that he regretted the destructive war and the fact that his hero Napoleon had "rather too much the temperament of the warrior." And he despaired over his son, who was nearly killed in the battle that sealed Napoleon's fate. Thus, David vacillated between including and not including the symbolically patriotic figure of Hercules in the *Leonidas*. The final result was a compromise, not the actual figure of Hercules but a classicized figure that took his place. Only the name Hercules remained, on the altar-block.

There were other compromises. The appearance of the sword in Leonidas's right hand was in keeping with one line of David's artistic thought, that which expressed engagement. A comparison of the Leonidas of the Montpellier drawing and the figure of the 1814 painting is particularly revealing in this respect.[85] The later figure is stouter, more massive, and he grips the sword resolutely. At the same time, Leonidas turns his eyes upward, in an expression of the reflective and religious feeling that David also wished to convey. The two impulses, the martial and the meditative, are clearly at odds with each other and are not successfully resolved. This Leonidas is also more prominent than the 1800 Montpellier figure and more central to the work as a whole. His prominence makes the failure of unresolved impulses all the more glaring. This defect is central to the work's larger shortcomings.

Thus David strove on the one hand to invest the *Leonidas* with heroic patriotism but on the other hand he wanted to achieve a more reflective and religious patriotism. He was unable to fuse the two impulses successfully, and as the work progressed it was the latter than tended to become more pronounced. As David painted the *Leonidas* the armies of France suffered crushing defeats, and when it was finished Napoleon had abdicated. Begun as a patriotic painting, it ended up as an allegory of defeat. Never again would David undertake a work of such ambition and never again would he paint a political subject.

Napoleon was defeated and had abdicated when David finished the *Leonidas*. He did not exhibit the new work in the 1814 Salon, but showed it privately in his own studio, along with the *Sabine Women*. It was a considerable success. Once again David's art appeared to be prophetic: if the *Brutus* had anticipated the Revolution of 1789, the *Leonidas* was emblematic of Napoleon's defeat in 1814. This time history took a bizarre twist. In 1815, during the Hundred Days, Napoleon was back in Paris. Several days after his arrival he visited David in his atelier (this was after David had first gone to see Napoleon). Once again, as at the beginning of his fantastic career, Napoleon needed the support of artists and intellectuals, and once again he courted favor with David. He saw the *Leonidas,* the work that he had dismissed years before, but now he rendered a different verdict. Like others, he was quick to see its contemporary meaning. "Very good, Monsieur David, continue to illustrate France. I hope that copies of this painting will be placed in our military schools without delay. They will recall for our young students the particular virtues of their state."[86] On that same day Napoleon named David Commander of the Imperial Legion of Honor. He had already restored the title of First Painter, which David had accepted, and he showered titles and positions on the members of David's family.

Did David recognize the self-serving motives behind Napoleon's generosity? If not he had only himself to blame. Like others he would take his chances; he too was acting out of self-interest. And he did not like the Bourbons. While the restored dynasty had taken a tolerant line toward former revolutionaries, David was not sorry to see them again put to rout. With the Restoration came a return of the lily, symbol of the old dynasty, revered by its adherents and execrated by its opponents. A woman who was an ardent royalist gave David a bouquet of lilies, eager to see what he would do. He thanked her and then asked his wife to remove them because of the smell. Turning to his student Etienne, he said that the woman had given him the flowers with the same candor as the old woman who had carried faggots used to burn John Huss.

David avoided the Bourbons and avoided going out in public during the Restoration. He was not happy with a restoration of the old dynasty. As Delécluze writes, he was completely disgusted with public affairs in 1815, at the time of Napoleon's miraculous return. It was not just self-interest that made him receptive to Napoleon's generous offers. If one had to choose, he would choose Bonaparte over the Bourbons. And there was something about Napoleon that touched David when he paid him the visit in his studio. He could not avoid comparing that visit to the pomp of an earlier

visit, when Napoleon and his entourage had descended on his atelier to see the *Coronation*. The man of 1815 was not the same man who had wanted to see David's grant painting of his coronation. Napoleon now presented himself as a humble visitor. But Bonaparte was still able to cast the magic of his spell and, as before, David succumbed. And so he signed the *acte additionnel*, commiting himself to a regime whose future hinged on the outcome of a single battle.

The day after the Battle of Waterloo David submitted a request for services rendered as First Painter for the last ten days of March and the month of April. A week later he received payment for those services. Not exactly a dignified way for David to end his long relationship with Napoleon, but perhaps it was not unfitting.

David

IN EXILE

*We arrived in Brussels on Sunday, in perfect health. We would have taken less time,
but I did not want my wife to travel at night. Nothing hurried us and we are as
fresh as when we left Paris. We live in a very hospitable town, in which, as I see it, I
will find all the pleasures of society. But I will avoid them as much as possible. I
love, as you know, the meditative life and wish to pursue it here more than ever.*
—January 29, 1816, letter from David in Brussels to M. and Mme Buron[1]

*I am well appreciated in the country I live in; I have refused the offers of a great
king who asked me to organize a ministry of arts in the states of Prussia.
Here I have repose, the years pass by, I am tranquil with my conscience,
as is necessary for me.*
—January 1, 1819, letter from David in Brussels to his son Eugène[2]

*We will never understand each other, my good friend, as long as you persuade
yourself that one can only be happy in France. I am convinced of the contrary. Since
my return from Rome in 1781 I have never ceased to be persecuted, tormented in my
work by all of the most odious means, and if heaven had not favored me with a
certain resolution I would have succumbed.*
—November 2, 1819, letter from David in Brussels to Gros[3]

I have an aversion to all that pertains to the arts in France.
—September 12, 1820, letter from David in Brussels to his student[4]

David, faciebat in vinculis, 1822.
—David's signature on copy of *Distribution of the Eagles*[5]

A FTER THE BATTLE OF WATERLOO David obtained passports for England and Switzerland and sent an unfinished copy of the *Distribution of the Eagles,* which he cut into three pieces, to the west of France for safekeeping. Watched by the police, he traveled east for Switzerland, whose border he reached on July 23, 1815. Traveling without his wife, he went from place to place in the weeks that followed, staying in Neufchâtel, Saint-Aubin, Yverdon, Lausanne, Vevay, Rolle, Geneva, Bonneville, Servoy, Chamonix, Gex, Saint-Laurent, and Salins. Deciding to return to France, he arrived in Besançon on August 10, where the authorities prevented him from continuing toward Paris. Asking to see the minister of police, he explained, "I see with much regret that more importance is attached to my name than it merits, especially concerning politics, in which, as you well know, Monsieur, I have not occupied myself."[6] After writing Prince Schwartzenberg, an Austrian general, he received papers that authorized him to return to Paris. On August 27 he wrote his wife from Besançon that he finally had his passport and that he would be leaving for the capital at three in the morning. When he arrived in Paris, his recent ordeal had taken a heavy physical and emotional toll. Walter Scott, who saw him at a dinner, said his appearance was "the most hideous" he had ever seen.[7]

If David hoped to resume his life as an artist in Paris, this was not to happen. The returning Bourbons had been conciliatory at the time of the first Restoration, and granted a general amnesty in Article 11 of the Charter. The mood was uglier after the Hundred Days, not only because the king and those of his party resented the ease with which Napoleon had returned to power, but because the allies who had been called in to defeat the usurper were bent upon punishing the nation that had welcomed him. As vindictive as the royalists were in their own right, they were driven to greater excesses to prove to the allied armies that occupied France that they were in control. When debate began on measures to be taken against those guilty of involvement in the Hundred Days, the Count of La Bourdonnaye said, "To stop their criminal conspiracies we must use irons, executioners, and torture." "Death and only death, can frighten their accomplices and put an end to their plots."[8] After heated debate in the Chamber of Deputies the Amnesty Law was finally adopted on January 12, 1816. Article 7 of that law identified those who were to be punished: "Those regicides who, in spite of almost unlimited mercy, have sworn the *acte additionnel* or accepted the employment of the duties of the Usurper, and who are thus declared irreconcilable enemies of France and the legitimate government, are exiled in perpetuity

from the kingdom which they must leave within one month."[9] The law could not have applied more exactly to David.

He considered going to Rome, but even with the pope's support he was barred from doing so; he chose Brussels instead. Delécluze describes his last days in Paris. "He saw that he would not finish his life in his country. The final time that the artist spent in France was full of sadness, and although the austerity of his manners never permitted him to complain, even in the company of friends, those who knew him could tell easily from certain things he recalled and by the delicate attention that he showed to those who surrounded him, more often than was his custom, that his soul was constantly and profoundly moved."[10] Finally it was time to go, and David spent his final night in Paris with his students. Except for his wife the members of his family were not there. As Delécluze describes the scene, "He was seated at the middle of a table with his wife on his right and a student on his left. Throughout dinner he served himself, spoke of small things, as was his custom, and did not allow a single word to be said about his departure from France or the future that awaited him or the men who drove him into exile."[11]

In the first of the quotations that begin this chapter David has just arrived in Brussels after taking leave of Paris. He has written his aunt and uncle, M. and Mme Buron, to assure them that the trip went well. It was January 29, 1816, and already David was thinking about the life he would leave in the city he had chosen for his exile. Brussels, he said, was a "very hospitable town," but he intended to live quietly, pursuing the "meditative life." After the experiences of the last six months it is hardly surprising that he felt this way. Delécluze wrote that David's "celebrity was not only intact when he left France but his misfortune made it even greater in the foreign country than it had ever been."[12] That France's greatest artist was banished from his own country at age sixty-seven seemed remarkable to contemporaries. Soon after arriving in Brussels he was sought out by the king of Prussia, whose armies had only recently joined in the defeat of Napoleon at Waterloo. Through his ambassador, Count von Goltz, Frederick William III offered David the position of director of fine arts in Berlin. The letter in which the offer was made was dated March 12, 1816; it was delivered personally by the distinguished Alexander von Humboldt, who had written a letter of his own to David. "You will find in my country an enlightened king who protects the arts and knows full well the merit of your great works; a government that religiously honors all agreements it enters into; a sphere of activity that will be that much the greater because of all that has to be done; and I dare add,

for my compatriots, an élan for the arts, a noble enthusiasm for the arts which, if properly directed, should restore the school to its former brilliance."[13] David explained to Humboldt that, flattered as he was by the offer, he was concerned about his wife's health and needed time to think it over. Prince Hatzfeld, Prussian ambassador to the Low Countries, became involved in the negotiations and told David that he would be made minister of fine arts and would receive a salary greater than the 12,000 francs he had received from Napoleon. This was a tempting offer, and David wanted the advice of others. Among the exiles who had joined him in Brussels were Cambacérès and Sieyès; he solicited their opinions. J.-J., duc de Cambacérès, urged him to accept, but Sieyès felt differently. "Free, independent, honored, and in easy circumstances, why should you give up these advantages?"[14] David accepted this advice, but when he told Hatzfeld of his decision the Prussian minister again tried to persuade him, this time with the support of his three daughters. When the minister and his daughters went to see David they discovered that a countess, a close friend of the king of Prussia, was already there, and for the same reason. Even after David declined the entreaties of these visitors, new efforts were made to win him over. In the final scene of an act that had taken a comic turn, but was no less gratifying to David, the king's brother, Prince Mansfeld, visited David in his studio. He offered personally to convey the artist and his wife to Berlin in his own carriage. As Jules David remarked, "In spite of these flattering efforts David persisted in his resolution not to yield to the entreaties of the prince."[15]

After giving his definitive reply to the king of Prussia, David informed comte Mercy d'Argenteau, governor of Brussels, of his decision to remain where he was and to serve the king of the Low Countries, William I. "The infinite price that I attach to my tranquility, the need I have for moral repose so I can dedicate myself for the rest of my life to my art, perhaps with some success, has made me decide on a country that because of the excellent spirit of its sovereign has a constitution perfectly in keeping with the ideas of a century in which the traces of revolution have been erased by the sentiment for the public good that this king inspires, and in which the wisdom and moderation of the head of state have prevented the reactions that desolate other countries."[16] If David's purpose was to inform William I that he had declined a most flattering offer by the king of Prussia to go to Berlin, he also wanted him to know that he appreciated the political benefits of his new country.

David was well received in Belgium. He was invited to Ghent in July 1816,

where a brilliant reception was given in his honor by the Royal Society of Fine Arts. He presided over the distribution of prizes, visited the studio of a local artist, and signed his name on a register in the library along with the signatures of twenty other famed artists. When he returned to Brussels he received a verse from the artists of that city to assure him of their support, which they felt he might welcome, given his circumstances as a political exile:

Viens, ne regrette plus la France
Et sois heureux dans nos climats;
L'amitié, la reconnaissance
Sèmeront des fleurs sur tes pas.
Le climat n'est rien; le génie
Rassemble d'un noeud fraternel
Paris, la Flandre, l'Ausonie,
David, Rubens, et Raphaël.[17]

Surrounded by students, David settled into a routine that allowed him much of the repose he wanted. He was working again, and in 1817 exhibited his recently completed *Cupid and Psyche* in the Royal Museum of Brussels, where, according to *Le Constitutionnel,* William I saw the "charming painting." This was on August 19. Four days later, on August 23, 1817, David wrote that while the government had drawn up a list of thirty-eight people who would have to leave the Low Countries, his name was not on the list. "I have nothing with which to reproach myself, I have done good all my life, I have been useful in all countries I have lived in; leaving people alone they have not bothered me; I have lived only to know them."[18] In the following year, 1818, his name disappeared from the police list of those in the Low Countries who were under surveillance. In May of that year he was elected to the Academy of Fine Arts in Antwerp, and in June the Society of Fine Arts and Literature in Ghent struck a gold medal in his honor. He had just exhibited his latest work, *Telemachus and Eucharis,* which was well received. It would seem that David was acclimated to life in Belgium and appreciated the success, honors, and recognition.

This was what he said in a letter to his son Eugène, written on January 1, 1819. The second quotation at the head of this chapter is taken from that letter. After explaining to his son that he was well appreciated in his new country and that he had declined the offer of the king of Prussia to organize the Ministry of Arts, he said, "Here I have repose, the years pass by, I am tranquil with my conscience, as is necessary for me." He wrote in the same

letter that "all my colleagues have returned to France, and I would certainly be in their number if I were weak enough to request my return in writing. Knowing your father and his pride of character, could he do what they have done?"[19] From the beginning there were indications that David could have avoided the legal consequences of Article 7, and that after leaving France he could have returned. According to Jules David, the prefect of police, Elie Decazes, tried to reject David's request for a passport after the passage of Article 7. David refused to accept any favors. "I do not wish to be exempted by a particular favor, and if your interest for the arts extends as far as refusing my passport I will ask the magistrates to make known my right to go into the exile to which I am condemned."[20] David shows himself as a person of rectitude in this pronouncement, but he also reveals his bitterness. He would take his talent, his principles, and his anger to Brussels. What is interesting about the conversation with Decazes is that if Decazes had intended to intercede on David's behalf there is little doubt that he would have been successful, given the extraordinary favors he was able to extract from Louis XVIII.[21]

As soon as David arrived in Brussels students and friends sent a petition to Decazes requesting his return to France. Among the fifty-six names on the list were three of David's most distinguished students, Gros, Gérard, and Girodet, along with rising younger artists such as Pierre-Paul Prud'hon. During David's absence the faithful Gros tried to keep his school intact. Jules David writes that David's students "considered his departure a momentary satisfaction of the law of amnesty, and no one doubted that his absence would be of short duration."[22] In April 1816 Gros told David through a student how much he was needed in Paris. "Assure M. David that we are pervaded with his memory and that it is his cause that sustains us. Tell him that our cries for his near return will be ceaseless, and that without this hope we would already have thrown away our palettes and brushes. For myself, tell him how I am pained by his absence, how his memory is dear to me, and that one of the happiest days of my life will be when I can see again a man of such sublime talent."[23] After hearing of Gros's efforts on his behalf David wrote him on July 16, 1816, thanking him for the many witnesses of his friendship. The most sensible thing Gros could do was to help his students. "Defend the dear young people [when they are ready to compete for the Prix de Rome] from the injustice of their judges, who have not ceased to follow their master. Preserve them, be their guide; there is no better example for them than virtue and talent."[24]

Here is the David of old—virtuous, righteous, solicitous of students, and

keenly aware of past and present injustices. He had no intention of returning to France. He would send his students to Gros, and he was quite interested in responses to exhibits he continued to have in Paris, but he would not compromise himself by requesting a pardon. Gros wrote him on February 17, 1817, to explain that Count de Forbin, one of David's former students and now director of museums, wanted to buy the *Sabines* and the *Leonidas* for the government. These paintings, Gros said, should be placed where they belonged, in France, and besides achieving that objective their sale would prepare the way for David's return.

Writing to Gros on May 13, 1817, David did not even mention the efforts made on his behalf to bring about his repatriation. Jules David remarked that this letter filled Gros with chagrin. Gros was convinced that the government would grant David clemency and said so to F.-J. Navez, a Belgian student. Navez told Gros that students working under the master in Brussels used their influence to keep him there. Writing David again on June 20, 1817, Gros urged him not to heed the counsel of those who surrounded him with "sterile admiration." With a small effort on David's part he could return to France. First he could sell the *Sabines* to the government and then the *Leonidas*. "These paintings, having become public ornaments in France, will open the doors to the illustrious master."[25] David did sell both the *Sabines* and *Leonidas* to the government, but only after hiring a lawyer to represent him. During lengthy and difficult negotiations a dispute broke out over the reproduction rights to the *Sabines* and *Leonidas,* and when the government finally agreed to David's terms, the sale was completed on January 27, 1820, which brought David the sum of 100,000 francs.

In the meantime, Gros continued his efforts to bring David back to France. He wrote in January 1818 that "the first painter of Europe invariably has his position assigned by his century and by posterity. His return, so salutary to the French school, will be desired one day as much by the government as artists, who are ill protected without the presence of the father of the school."[26] In the following year, 1819, he advised David that if he would only write a respectful note to the king it would almost certainly result in royal clemency. Less illustrious men than he had already been pardoned. "Why wait? . . . The years pass, my dear master, your children, your students, and you mark the days. Anyone who would dissuade you from this counsel is your enemy and that of the French school, of which you are the father."[27] Gros repeated his appeal in December 1819: "In spite of the *éclat* that you have given the French school I perceive the malady by which it

is threatened." Only when the "father and veritable savior" of the school returned would it be safe.[28]

To Gros's appeals for his return David replied over and over that he was happy in Brussels and had no wish to be repatriated. He had students, he had repose, and he had his art. In a letter of May 13, 1817, he wrote that he worked as if he were only thirty years old and loved his art as if he were sixteen. "I forget all the world, except for my brush."[29] In November 1819 he told Gros that he was mistaken in thinking one could only be happy in France. It is from this letter that the third quotation was taken at the beginning of this chapter. "We will never understand each other, my good friend, as long as you persuade yourself that one can only be happy in France. I am convinced of the contrary." It was not just because he enjoyed the tranquillity of Brussels that he chose to remain there but because of the memories he had of Paris, where "I have never ceased to be persecuted, tormented in my work by all of the most odious means, and if heaven had not favored me with a certain resolution I would have succumbed." If David's earlier comments hinted at feelings of victimization this one drives that fact home decisively. He had taken a large cup of bitterness with him when he left Paris, but in Brussels he tried to, and for the most part did drink from other vessels. He now partook freely of the gall. Curiously, the ever-loyal Gros helped bring David's hostility to the surface.

As long as David was the unquestioned master, the father of the school in absentia, and Gros was the loyal, devoted, and fawning student there were no problems in the relationship. These roles were disturbed in 1817, when David showed his latest painting, *Cupid and Psyche* (fig. 82), in Paris and asked his former student for comments. When Gros wrote to David about the new work he began with the usual praise of the master and gave himself again to hopes for repatriation. Then, rather abruptly, he said, "Let us speak of art." As he had always maintained, and as had just been confirmed, each of David's works revealed something new in execution and feeling. The finish and precision were impressive, everything was justly placed, and with such grace and polish it was as if he alone understood Greek painting. So far so good. But as for himself, he found the head of Cupid a little "faunesque," the hands a little brown, and they were not done with particular care. Also, Psyche's toe was a bit conspicuous and the foot of Cupid, so agreeably wrapped in drapery, was rather long.[30] Gros's criticisms were certainly slight. The student was not really sitting in judgment of the master, but telling David what he thought of his latest painting and by and large his

comments were favorable. Still, one senses uneasiness on Gros's part when he discusses *Cupid and Psyche*. He did not really like David's latest work.

Gros was one of the leading artists of his time and had received important commissions for the last twenty years. He had earned an imposing position within the Napoleonic system of patronage and did so again with the Bourbons. His career was more steady than David's and in some respects more successful. While not an artist of the same stature as David, his brilliant use of color, which he developed after careful study of Rubens, influenced David and contributed to the more sumptuous style of the *Coronation* and *Distribution*. Throughout the Brussels period David wrote often of his interest in the Flemish masters, but it was Gros, years earlier, who had helped turn David's art in this direction.

Given Gros's immense success under both Napoleon and the Bourbons, and given the influence he had exerted on his teacher, one is puzzled by his correspondence. Jules David felt that something was awry, and of this there can be little doubt.[31] Without trying to question Gros's motives, what can be said is that his abject pleading with David to return to France so he could resume his proper role of leadership was at variance with his own success and fame. Living in exile in Brussels, David received a steady flow of self-denying letters from Gros but at the same time he learned of his student's many honors. He learned from Gros himself, in a letter of December 15, 1819, that his student had received the Order of Saint-Michel from the king. Gros conveyed the news apologetically, and went out of his way to praise David, to whom he gave credit for his success. David wrote back to Gros on December 27, 1819, to congratulate him on his newly received honor. He had feared that Gros's critics would discourage him, but the king had avenged him. After this begrudging compliment David told Gros to consider him, a master who had known and loved Gros since his youth, as a second father. It was in the paternalistic role of mentor that he had just assumed that he gave Gros some advice: he should do a history painting. The very fact that he had received so many honors should put him on his guard, for such success could make him complacent. David himself had experienced life's vicissitudes; of fame, success, and banishment, the latter was best for art. He had done more in the four years he had spent in Brussels than he would have done in Paris. Gros, living in ease in Paris, should think about posterity, for which honors and riches were of no account. And living in France was an impediment because that country was so frivolous.

In urging Gros to do a history painting because this was what posterity would remember, David was implying that the work on which Gros had

built his reputation was less important. Gros had specialized in battle scenes while working for Napoleon and now he was doing portraits. When David told him what he should be painting, his advice carried a hard edge of aggressiveness, fed by his inability to accept comfortably the success of a former student and a growing sense of his own isolation. While he said he enjoyed the repose of Brussels, the truth is that he was uneasy there; as often as he claimed to enjoy life in Brussels, he never forgot his banishment from France. Gros's successes made him even more aware of that fact.

David wrote in June 1820 that his so-called Paris friends would praise him in one breath and cry "Vive le roi!" in the next. As for himself, the public took its vengeance on him too much in Paris, so Gros should abandon any hope of his return. "I am content here, I am content, and do not have to see those who would trouble my eyes." In this same letter David again advised Gros to do a history painting. "You love your art too much to limit yourself to futile subjects and 'tableaux de circonstance.'" Posterity would not remember the works that had brought him fame and honors, for it demanded something severe. "Seize your brushes, do something grand that will assure you your just place."[32] The message running through David's advice to Gros was that his work lacked seriousness. An authoritarian tone had entered the correspondence, and in a letter of April 1, 1821, there is open hostility. "I am glad that you have given up uniforms, boots, etc., etc. You have made your reputation in these paintings, in which you have no equal. Give yourself now to real history painting."[33] In the years that followed Gros continued to urge David to return to Paris, but relations seem to have cooled. He did visit David in Brussels in November 1821, and again in 1823. They corresponded less frequently, however, and when David did write he complained increasingly of illness. He was ill and he was bitter.

One expression of David's bitterness was a comment he made to a student, Claude Gautherot, in September 1820, quoted at the head of this chapter: "I have an aversion to all that pertains to the arts in France." Even more telling is the final quotation at the beginning of this chapter: "David, faciebat in vinculis, 1822." This was how David signed the copy of the *Distribution* that he had cut into three pieces after the Battle of Waterloo and had taken with him to Brussels. By the time he finished it six years after arriving in Brussels, he was bitter and felt victimized. The inscription he put on his grand Napoleonic painting had appeared in earlier works, when he had been in prison. And this was how he had come to see himself, as a banished artist living and painting in exile.

As a resident of Brussels David belonged to a group of political exiles that

included other former revolutionaries—Sieyès, Cambacérès, Bertrand Barère, Baron Alquier, D. V. Ramel de Nogaret, Joseph Cambon, A.-L. Levasseur, P.-A. Merlin, Prieur de la Marne, Antoine Thibadeau, Silvain Lejeune, and Pierre Paganel. David had painted two of them in his *Tennis Court Oath*, Sieyès and Prieur de la Marne, and he did portraits of Sieyès, Alquier, and Ramel-Nogaret while working in Brussels. He also painted a portrait of General Gérard, who had joined Napoleon during the Hundred Days and went to Brussels after having been relieved of his duties by Louis XVIII. Another of David's portraits was of the comte de Turenne, who had fought under Napoleon at Waterloo and was banished with the second return of the Bourbons. Living among and painting men who like himself paid the price for their former political involvements helped define David's experience in Brussels. So too did the police surveillance during the first several years of his residence. Although his name disappeared from the surveillance list in 1818, the police did, at least on occasion, continue to follow his movements.[34] Others were interested in David's political past for different reasons. An Englishman sought him out at the theater and wanted to shake his hand, not because it was that of a great artist but because it belonged to a man who had been the friend of Robespierre.[35] In 1819 he received political verse that praised the patriot artist who, like his Leonidas, would live in history.[36] David took a certain pride in his position as a political exile. After the Duke of Wellington had tried to have him expelled from Brussels, he asked the artist to do his portrait. David's refusal made Wellington furious. David's comment about the portrait he had been asked to paint was, "I would rather stab myself with a sword than paint an Englishman."[37]

Thus, there were two Davids living in Brussels, the banished artist who sought repose and pursued the meditative life, and the former Jacobin who kept the company of those who shared his political past, refused to bend his knee to the Bourbons, and flashed out in anger at enemies. This is but one of several polarities. Also, there was the David who basked in the appreciation he received in his new country and there was the embittered exile who felt increasingly isolated and cut off from Paris; there was the David who once again haggled with government officials over payment for his paintings and over reproduction rights for prints and there was the benevolent artist who showed his recently completed works for the benefit of the poor in the Hospice of Saint Gertrude and the Ursulines and felt that one's fellow citizens should not have to pay to see works of art;[38] and there was the David who was devoted to and at the same time resented the success of his students. In these divisions the David of old can certainly be seen, a man

who was touchy and resolute, generous and jealous, high-minded and tough-minded, contented and bitter, withdrawn and engaged, kind and angry. These divisions are not unfamiliar, but they have been cast in a new mold, that of his life as an exile. Try as he did to accept his position in Brussels, he was unable to. A fellow exile, Barère, says that David commented often on how much cleaner the streets of Brussels were than those of Paris. David wanted to appreciate the advantages of a city that had been generous to him and honored him. Barère told him how fortunate he was to have received so many honors and so much attention. He sensed his friend's low spirits and tried to help him realize how favored he was. "His melancholy and withdrawn air made me unhappy, I tried to distract him by speaking of his fame as an artist. 'Are you not surrounded in Brussels by the admiration of the ordinary people, the men of letters, and the painters, nearly all of whom are your pupils? . . . Do you not enjoy the consideration and the kindness of a liberal monarch? . . . Are not the works of your genius collected, exhibited in the gallery of the Luxembourg in Paris, and do not foreigners and Frenchmen alike vie with each other in singing the praises of the great European painter? Do you not possess the inestimable satisfaction of being the founder of the French school of painting? Well, what more do you want? Why so wretched?' David broke his silence with these words: '*Amor patriae*!' "[39]

These words were like those David had used earlier, much earlier, when he described the "profound sentiment" that he wished to inspire in an ambitious painting he had decided to do. Love of country was at the center of his purpose when he began work on the *Leonidas,* and that sentiment occupied him throughout the many years he spent on the project. David's patriotism was a central part of his moral and emotional life, and now that he was living in Brussels as an exile he was removed from the country to which he had been so devoted. He railed about the state of the arts in France, he denounced Paris for its frivolity, he despised the Bourbon order, and he was desolate because he was cut off from the *patrie.* As he lay on his deathbed in December 1825 he was looking at corrections for a print of *Leonidas at Thermopylae.* "Too dark . . . too light . . . the gradation of light is not right . . . this place is blurred . . . yet, there is the head of Leonidas."[40] These were David's last words. Imperfect as the print was, he was moved by the hero who was an expression of his own *amor patriae.*

As an artist David was active, very active, during the ten years he spent in Brussels. In terms of output, the Brussels period is one of his most productive. His works fall into two categories, mythological paintings and por-

traits. As before, it was when he returned to antiquity that he was at his most ambitious. It was through works of this type that he intended to maintain his reputation, add to his fame, and continue moving forward in new directions. Altogether, David did four mythological paintings in Brussels: *Cupid and Psyche* (1817; fig. 82), *The Farewell of Telemachus and Eucharis* (1818; fig. 83), *The Anger of Achilles at the Sacrifice of Iphigenia* (1819; fig. 84), and *Mars Disarmed by Venus and the Graces* (1824; fig. 85).

Brookner writes that when David moved to Brussels his style underwent an "almost instantaneous change." Her explanation for the sudden change is that "the removal from Paris to Brussels . . . meant removal not only from a physically stimulating environment but evasion from a prime moral dilemma." She adds, "The supreme irony is that with the relaxing of all restraints and the ability to choose, more or less, his own subject matter, David reverts to a somewhat fatuous courtly style. He concentrates on mythological scenes of love and blandishment."[41] Brookner's negative eval- uation of David's Brussels painting is shared by other critics, such as Friedlaender.[42] Schnapper also agrees with this assessment, which was already articulated by Delécluze in 1855.[43] Indeed, if there has been consen- sus on any period of David's art it is on the Brussels period: agreement has been general that the flame of David's genius waned during the period of his exile.

Dorothy Johnson has recently argued against this opinion. In an article on *Cupid and Psyche* she not only enters a plea on behalf of that painting but calls for a reevaluation of the entire Brussels period. "*L'Amour quittant Psyché* not only belongs in a different category from [David's] earlier paint- ings but announces a number of extraordinary developments in [his] art: it is a bold and innovative work, harbinger of fascinating directions to come, instead of the first step of a precipitous senescent decline. A closer study of the painting will reveal that, far from reverting to rococo frivolities, in his first history painting produced in exile David was revisiting a classical myth. . . . To convey more forcefully his innovatory interpretation of the subject, David employed daring experimental pictorial and technical devices which perplexed the critics of his time."[44] It is certainly true that contempo- rary critics failed to understand *Cupid and Psyche*. It is also true that it was a "bold and innovative" work done by an artist filled with new ideas that he itched to get on canvas. David's own correspondence suggests how keen he was to paint after arriving in Brussels and how eager he was to prove that he had something new to say. "I feel that my imagination is as live and fresh as in the first days of my youth."[45] There can be no doubt that *Cupid and Psyche*

is the work of an artist who was striking off in a new direction, and a bold one at that.

When Gros saw *Cupid and Psyche* he was quick to recognize that it stood apart from the master's earlier oeuvre. "It confirms what I have always said: that each of your works is characterized by a new type of execution and feeling."[46] As we have seen, Gros was critical of Cupid's head, hands, and foot. The head that he called a bit "faunesque" is that of a leering, unpleasant youth, whose hands, as Gros said, were brown and roughly painted and whose foot was too long. Gros clearly found David's Cupid distasteful. What he appears not to have realized is that this was the appropriate response.

In Greek myth Psyche's beauty was so great that Venus became jealous and decided to have her destroyed by a monster. Cupid saw her, became infatuated, and took her to a palace where he kept her in secret, and where he visited her at night. He promised her eternal happiness, but on the condition that she not try to see his face. Having no idea what her lover looked like, and anxious to satisfy her curiosity, she lit a lamp while Cupid was asleep, but a drop of oil from the lamp fell on him. Cupid awoke and left, the palace disappeared, and Psyche had to endure further tribulations until she eventually secured forgiveness from Venus and was once again reunited with her lover.

In David's painting Cupid and Psyche are seen before Psyche was overcome by curiosity. She and her lover have made love, she is asleep, and he is on the side of the bed, as if preparing to leave. The problem is that if he were to do so he would knock Psyche to the floor with the thick wing that she rests against. Cupid's wings, covered with heavy feathers, are part of the work's realism. What adds to that aspect of the painting is the grinning face of Cupid, the dark color not only of his hands but his entire body, and the big toe that points upward from a foot that is too long. The contrast between the singularly unattractive, dark Cupid and the glowingly beautiful Psyche is certainly striking. His shoulders are slumped and his stomach is thrown forward as he sits awkwardly on the side of the sofa, his foot stuck in the drapery. While his limbs are those of a gangling youth, those of Psyche flow in beautiful rhythms. His arm rests heavily on her breast while hers is wrapped sinuously around her own head, giving her a sense of composure and containment. She is serene, he is restless; she is an idealized female, he is a nasty boy. Other details in the painting reinforce the strange effect produced by the contrast between Cupid and Psyche. An emblematic butterfly representing the soul of Psyche is seen on the velvet base of the sofa, while a

large grey moth flies over her head; the drapery that provides a brilliant red backdrop for Psyche changes color, becoming a more common orange as it passes beneath the body of Cupid and covers the male part of his anatomy; under the drapery are sheets that have been placed on the hurriedly and ill-made sofa; and behind the sofa there is a landscape, which could just as easily be a painting that hangs from the wall as an actual landscape seen through a window.

None of these details are the result of chance. David wanted to do a painting that would be striking, even shocking. He wanted to demonstrate to contemporaries that he had not stood still, that even as an artist in his seventieth year he had something new to say. His way of achieving these objectives, as in all of his statement paintings, was by entering into dialogue with the past: he would innovate through tradition.[47] Tradition meant the classical tradition, but also included modern commentaries on the past, the works of artists from the Renaissance to his own day. David drew from antiquity and from the works of other artists, the great masters and his own contemporaries. It was a procedure that had produced all of the history paintings on which he had built his reputation and once again, in a new work, *Cupid and Psyche,* it was to show him breaking new ground, still alive and creative as an artist.

Among the sources for the *Oath of the Horatii* were Poussin and contemporary artists who painted patriotic oath scenes. David drew from these influences and in doing so created a work of such forcefulness that it stood apart from the outwardly similar paintings of his rivals. For the *Sabine Women,* to mention another work in which David innovated through tradition, he drew from the theories of Winckelmann and was influenced by contemporary artists who, like himself, were in search of a simpler and more pure style. The idealized, classicized forms of this work were appropriate to his objectives. While David again entered into dialogue with the past in *Cupid and Psyche,* he did so with utterly different results than before. His intention was not to heroize or idealize, but to deflate, to parody.

In his earlier historical paintings he had made elevated statements, whereas in *Cupid and Psyche* he does just the opposite. A lewd, gangling boy is seen alongside an idealized nude. David's Psyche is not just any idealized nude. She is derived from a nude figure by his former pupil, Ingres, which first appeared in sketches in 1810 and reappeared in the two *Odalisque with a Slave* paintings of 1839 and 1842. Ingres may also have used the same nude figure in *Sleeper of Naples,* which Joachim Murat had owned and was destroyed in 1815, at the time of his defeat by the Austrian army. After Ingres

left David's studio, relations between him and his former mentor soured, and in 1814 he made it known that he would have no more contact with David. By that time Ingres was recognized as a major force in French art.[48] He had entered David's studio in 1797, and as his assistant helped the master paint the *Mme de Récamier* portrait. Soon Ingres was designing nudes that came out of his work with David. Of course, Ingres struck off on his own, creating figures that represented his approach and were rooted in his sensibility. That sensibility was strikingly different from David's and imbued his nudes with originality. If their pedigree goes back to Ingres's apprenticeship with David, they evolved in ways dictated by Ingres's particular genius.

David did not imitate Ingres as a token of esteem but to reappropriate that which his student had taken.[49] To put an idealized nude next to an unpleasant-looking boy is to deflate, to belittle. But it was not just through juxtaposing the naked Cupid and the statuesque Psyche that David settled accounts with his former student. Ingres's nudes were the result of an abstracting process that made them pure form, achieved at the expense of psychological realism. Their faces are inexpressive; they seem to be without desire and indeed without soul.[50] Their bodies are their reality, and it is hardly surprising that they appear as odalisques, and in harems. Seeing into this dimension of Ingres's art, David turned it to his advantage in *Cupid and Psyche,* through parody. Thus the moth that flies over Psyche is a comment on the butterfly that traditionally represented her soul. This Psyche has no soul; her only reality is her body and as such she is but the object of male desire. This is what makes the contrast between the perfection of her body and the coarseness of the boy so striking. The Psyche who lies so serenely, so contentedly, has just been had, so to speak, by the grinning youth who is about to leave the bed and knock her to the floor. David has ingeniously parodied the Cupid and Psyche myth and—at the same time—parodied the nudes of Ingres, his former student.

In his criticism of *Cupid and Psyche* Schnapper says, "Cupid and Psyche are simply a nude couple sitting on the edge of a sofa; the composition is powerful, but myths can be recreated only by superstition and fantasy, for realism is alien to them."[51] He has fallen into the same trap as the Paris critics of 1817, who also failed to appreciate what the work was about. Of course realism is alien to the subject, as Johnson has convincingly argued. David was trying to parody the myth, not recreate it, and realism helped him achieve that objective. And Johnson may also be right when she maintains that, contrary to Brookner's claim, *Cupid and Psyche* was not a reversion to rococo frivolities. David might not have reverted to "a somewhat fatuous

courtly style," as Brookner puts it, but the fact is that all of David's mytho-
logical paintings from the Brussels period treat themes that are amorous.
And this is a very important fact.

While David had done such works before, he had done so only occasion-
ally; works of this type were an undercurrent that passed beneath the main
flow of his art. Throughout his career most of his major works had patrio-
tism as their theme: the *Horatii, Socrates, Brutus, Tennis Court Oath,* all three
revolutionary martyr paintings, and the *Leonidas.* In Brussels he did no such
paintings, just scenes of "love and blandishment." The *amor patriae* that had
flowed so powerfully into his art before no longer did so, and could not do
so. David lived in Brussels, banished from his native land, and he despised
the restored Bourbon regime. What could he paint? Portraits, of course,
which he did. Also, because he wanted to strike off in a new direction, he
could do works that belonged to the great tradition, that of antiquity. These
were to be his statement paintings.

As convincing as Johnson is in her interpretation of *Cupid and Psyche* it
remains to be seen whether her view of the other three Brussels mythological
paintings is equally persuasive. Is *Cupid and Psyche* a "harbinger of fascinat-
ing directions to come"? Does the *Farewell of Telemachus and Eucharis* (fig.
83), completed by David in the following year, 1818, once again reveal him as
"bold and innovative"? Clearly, as Johnson has argued, *Telemachus and
Eucharis* is linked to *Cupid and Psyche.* Both works have the parting of mythic
lovers as their subject, but whereas the earlier work was limited to physical
love the new one portrayed a higher, spiritual love. Here is a contemporary
description of the work: "Eucharis and Telemachus have tricked both Men-
tor and Calypso . . . in order to indulge a mutual passion that is as yet chaste
and pure. The time has come to part. Telemachus has already clasped
Eucharis in his arms and bidden her the farewell that is to end their moment
of happiness. He is about to rise and leave the cave when his beautiful and
noble friend, unable to bear the terrible separation, throws her arms around
her lover's neck and, probably for the first time, yields to the delightful
feelings he arouses in her."[52] As in *Cupid and Psyche* the parting lovers are in
love physically, but now the love is chaste and innocent; as in the previous
work the lovers belong to each other, but now the parting is sorrowful rather
than cynical. Eucharis rests her head on the shoulder of Telemachus and
holds her arms around his neck, as if unable to accept that which must
happen. Telemachus leans his head tenderly against Eucharis, but he knows
that the separation must take place. This is suggested by one hand which

even as it rests on his lover's leg establishes distance between him and her, and by the other hand which holds a spear.

The figure of Eucharis is a series of curves, formed by her back, neck, and arms, while Telemachus is essentially rectilinear. In other words, the compositional devices long employed by David in the depiction of female and male figures have survived, much attenuated, in this painting. This is not to suggest that *Telemachus and Eucharis* can be linked in any positive way to David's earlier works. In earlier works he developed compositional methods for portraying male and female figures which defined moral differences between the two sexes. In *Telemachus and Eucharis* he has done just the opposite. What is most striking in this work is a unity of sentiment between the two figures, a pervasive sentimentalism new in David's art. To achieve that unity the usual line separating the male from the female has been blurred, so much so that at first glance the painting appears to portray two women. Not only has the face of Telemachus been feminized but his torso is soft and without definition.

As a pendant to *Cupid and Psyche*, *Telemachus and Eucharis* achieves new effects. This was intentional. If realism and cynicism are at the core of the earlier work, idealism and sentiment pervade the other. Once again, David was pushing ahead, exploring, breaking new ground. What would seem to have given him direction was *Cupid and Psyche,* to which this work, in dialectical terms, was a response. To see *Telemachus and Eucharis* as part of a dialectic is a useful way to view the work. It came out of a logic dictated by his previous painting. Having shown a cynical parting of mythic lovers, he would now do just the opposite. The interest in *Cupid and Psyche* derives from the motives that passed into the work and made it distasteful. David did put something of himself in the painting. This is no longer so in *Telemachus and Eucharis.* The idea was to show a parting of perfect lovers who are sorrowful over parting. The result is a painting—for David—of embarrassing sentimentality, a painting whose realm of feeling the mournful dog on the side helps define. The feeling is dictated by the logic that determined David's choice of subject and defined his objectives. None of David's own emotions have found their way into the painting; those that have appeared are completely external in the sense of having been tacked on because that was what the work required. Art has been separated from life. *Telemachus and Eucharis* reveals David's inability to regenerate from within. Outwardly, it is innovative; it does something David had not done before, but this is achieved without conviction and without emotional involvement.

If *Telemachus and Eucharis* revealed David's bankruptcy so too did *The Anger of Achilles at the Sacrifice of Iphigenia* (fig. 84), done in the following year, 1819. This work is as lacking in conviction as the one that preceded it.[53] David seems to have realized that he was adrift, that he was painting without purpose and without commitment. His two most recent works were cut off from the mainstream of his art and from a past that was becoming increasingly remote. He began to dwell on the past. He knew that he would not return to Paris and would not live in France again. He was visited by an English journalist in 1822, a member of Parliament, who had seen Paganel, Lejeune, and Barère, all regicides. David explained that he and they regretted nothing, and he felt certain that posterity would do justice to all of them. He also recalled to the British visitor the revolutionary festivals he had organized, "marvelous processions" and "brilliant ceremonies" with beautiful girls in tunics throwing flowers accompanied by hymns of L.-S. Lebrun, E.-N. Méhul, and Claude Rouget de Lille.[54] It was not just in conversations that David recalled the past. It was at this time that he drew up a list of his paintings, those done in Rome, Paris, and during his exile. He did not say his most recent works were done in Brussels, but "dans mon exil."[55]

David was now working on his last painting, *Mars Disarmed by Venus and the Graces* (fig. 85). In a letter to Gros, dated October 21, 1823, he said, "I believe, God willing, that I will be able to finish the painting *Mars and Venus* before the final term. It is my last farewell to painting, and I do not fear to tell you that it is different from what you have seen."[56] He complained of chronic illness and that his hand was failing, but in the painting that would be his final effort he would still do something new. And it is that; it turns sharply away from both of his previous works, *Telemachus and Eucharis* and *The Anger of Achilles*, but in doing so it goes full circle and returns to his first Brussels painting of mythological lovers, *Cupid and Psyche*.

In *Mars and Venus*, as in *Cupid and Psyche*, David parodies his former student, Ingres, whose *Reclining Odalisque* of 1814 is the source of the Venus. David's parody is broader in his last work than before, and includes himself. Indeed, self-parody is at the heart of this work, which is by far the largest of the Brussels paintings. Its sheer size connects *Mars and Venus* to the masterpieces of earlier years, but through parody rather than restatement or recreation. Mars is a parody of several of David's own male figures. His position suggests the earlier figure of Tatius in the *Sabine Women*, while his bearded face resembles Leonidas. This is not a patriotic Leonidas who in a moment of reflection turns his eyes upward as he contemplates battle, but a heavy-lidded Mars who has abandoned the battlefield. The warrior-god of

David's *Mars and Venus* hands his sword to the three Graces, one of whom has already taken his helmet. Mars is about to receive a token of favor, a flowered garland, from Venus, and a pretty cupid removes his sandals. One of the Graces offers him a goblet and the other, who will take his sword, already has custody of his bow and shield. The god's eyes droop and his right hand barely holds the lance, for which he no longer has any use.

If David's previous Brussels paintings were unheroic, this one is unheroic in a quite different sense of the word. It is consciously and deliberately antiheroic, and as such it is an ironic commentary on his own pervious works that exalted the brave, the stoic, the manly, and dedication of the individual to the *patrie*. If any single touch drives this point home best it is Mars handing his sword to the Graces. Throughout his career the sword had been the emblem of male courage that was put in service of the state. Now, at the very end, the absolute end of his career, and in his last painting, David makes his final statement. All that he had believed in was over; he was cut off from the nation; there was no outlet for engaged patriotic art; and the age itself, that of the Bourbon Restoration, was incapable of eliciting heroic responses from the serious artist. One could innovate, one could break new ground, but one could not do what one had once done best.

Conclusion

DAVID, HISTORY,

AND HISTORY PAINTING

WHEN DAVID was admitted to the Academy it was as a history painter. Years of study had prepared him for works of this type, and after 1781 he submitted a new history painting for every Salon until 1789. During the Revolution he became a painter of contemporary history, but after the fall of Robespierre he returned to traditional history subjects. After completing the *Sabine Women* he began work on the *Leonidas,* which he finally completed in 1814 after devoting much of his time and energy during the previous fifteen years to official commissions for Napoleon, scenes once again from contemporary history. These paintings are the core of David's oeuvre. It was as a history painter that he competed most actively with rivals, built his reputation, presided over the largest and most prestigious school of French artists, and put his artistic theories into practice.

Also, it was as a history painter that David's decline was most pronounced. In a career that lasted over a half-century, his greatest work as a history painter is confined to a decade, from 1784 to 1794. Before this decade there was a long period of study and struggle, out of which came the heroic Roman style and works that carry the stamp of genius. Never again would David's history paintings have the conviction of these works. When he returned to history painting after the Revolution he was a different person and a different artist. Both the *Sabine Women* and *Leonidas* command respect but they are not of the same order of greatness as the earlier masterpieces, nor are the scenes of contemporary history, the state paintings, that David did for Napoleon. Technically, these works are among David's finest, but fine painting does not make for greatness. David worked longer on the *Sabine Women,* the *Leonidas,* the *Coronation,* and the *Distribution* than any other works. Even with all of the effort he put into them he was unable to reach the same heights as in the earlier history paintings.

The work, not yet discussed, that reveals the full extent of David's decline as a history painter is *Apelles Painting Campaspe in front of Alexander* (fig. 86), begun in 1813 but never completed. David took the canvas to Brussels in 1816 and continued work on it but abandoned it for the mythological paintings that, along with his portraits, occupied him exclusively in his remaining years. Compositionally it can be linked to the masterpieces of earlier years, to the heroic, Roman works of the 1780s. Once again, as in the *Horatii* and *Brutus,* there is a separation of male and female figures, and these figures, all on the same plane, are seen against panels that define the background space, much as columns did in the earlier paintings. The doric orders in the *Horatii* and *Brutus* are part of an ordered geometry and severity that was at one with

David's artistic and ethical purposes. Against a rectilinear background David's males are seen in all of their resolution and sternness and the females in all of their sorrow and grief. In the later painting Apelles is seated in front of a canvas that he has begun to paint and he and Alexander stare at Campaspe, who is seated on a bed. The artist has fallen in love with Alexander's mistress and is so smitten that he was unable to paint, as indicated by the tentative, scratched lines on the canvas, a record of his confusion.

In the 1785 painting the Horatii reach for the swords that will bring victory to Rome, and in the later work Alexander points at his embarrassed mistress, whom he will relinquish to his artist. One work portrays three brothers who swear an oath to fight to the death for the *patrie*, the other shows one of history's greatest generals and conquerors in rather different circumstances. If one work is heroic, the other is the opposite; if one bristles with energy, the other completely lacks that quality; if one separates male heroism from female suffering, the other breaks down the ethical division between the two sexes. The relaxation that is evident in the standing Alexander, whose hand points limply at his mistress, is even more pronounced in the seated Apelles, whose shoulders slump forward and whose arm hangs helplessly at his side. The Campaspe who elicits these responses sits modestly, even bashfully, on the side of her bed, turning away from the men who stare at her undressed body. In the heroic paintings of the 1780s, deeds of violence create a gulf between the two sexes; in the painting that David began in 1813 the love of two men for the same woman forms a bond between those same sexes.

As similar compositionally as the *Apelles* is to the heroic masterpieces of the 1780s, it completely lacks the tension of those works. Does this mean that the similarity is fortuitous, the result of chance, or might it be there by conscious design, and for a reason? To answer that question it is useful to look at the year in which the *Apelles* was begun. In 1813 David was immersed in the *Leonidas*, for which he did a wash drawing (fig. 79) that shows an old man lifting his arms in distress. It was at this time that David confided to his students that Napoleon had "rather too much the temperament of a warrior." He also spoke of the "perilous enterprises in which the chief of state had been engaged," for which he had every reason to be concerned given the active military role in those enterprises of his son Eugène and his two sons-in-law. Why, then, did David begin work on *Apelles* at this time? Might his disillusionment with Napoleon have been a factor? Could he have decided to do a painting of Alexander the Great, antiquity's greatest general, while

considering the burdens of war that France and all of Europe felt under Napoleon, the greatest general of the modern era?

Predictably, Napoleon admired Alexander; he said that "his warfare was methodical and deserves the highest praise. . . . Alexander deserves the reputation he has enjoyed in every century and every nation."[1] Moreover, he liked to see himself as a modern-day Alexander the Great: "If I had remained in the East, I probably would have founded an empire like Alexander."[2] Despite his brilliance as a general, Napoleon was unable to hold his empire together: when David began work on the *Apelles* that empire was coming apart. This timing suggests the possibility of Napoleonic associations in David's portrayal of Alexander the Great. The presence in the painting of Apelles is significant, too. When Napoleon explained years earlier to David that he did not want to pose for a painting of himself crossing the Saint-Bernard, he remarked that Alexander had not posed for Apelles. And when the comte de Sommariva, president of the committee of the government, requested a painting of Napoleon creating the Cisalpine Republic he said it was to be like a work done for Alexander by Apelles. David had high ambitions when he entered Napoleon's service, as if he wanted to be a modern Apelles at the court of the modern Alexander. This did not happen. By putting Apelles in front of Alexander, who will give him his mistress, he shows, ironically, how generous a patron of old had been to his favorite artist. Such generosity David had not received. After years of frustration he left Napoleon's service, which, according to the argument just advanced, David looked at retrospectively in his *Apelles*. David did not limit his backward glance to his years in Napoleonic service. He retreated further, to the more distant world of the 1780s, and the heroic Roman paintings that had catapulted him to a position of leadership within the French school of art. Even as there are Napoleonic associations in the *Apelles,* so does the work employ some of the compositional features of his earlier masterpieces. The result is parody of the earlier style that is part and parcel of the larger purpose of deflation.

Passing judgment on the *Apelles* is complicated by the fact that it was never finished. Nevertheless, earlier unfinished works, *Joseph Bara* and *Mme Récamier,* can legitimately be included among David's masterpieces. No such claim can be advanced for the *Apelles,* a work that belongs more to the world of nineteenth-century kitsch than to the severe, heroic world of David's earlier history paintings. How is this collapse to be explained? Clearly the answer does not lie in a loss of artistic skill in the technical sense. The quality

of painting in the *Leonidas,* completed after David began the *Apelles,* is still impressive. Moreover, David retained a high level of technical mastery during the years of exile in Brussels. Signs of decline were certainly present in those years, but most conspicuously in the mythological paintings in which, paradoxically, he made the largest investment. While a full assessment of David's Brussels portraits cannot be made, since some are in private collections and virtually unknown, it is clear that when the chemistry was right between David the people he painted, the old magic was still there. *Emmanuel-Joseph Sieyès* (fig. 87), signed in 1817, can be counted among David's finest portraits. So too can the *Vicomtesse Vilain and Her Daughter* (fig. 88), signed in 1816. In one work David has painted a fellow exile, who had written a famous pamphlet after Louis XVI summoned the Estates-General, had occupied a prominent place in David's *Tennis Court Oath,* and had been the principal instigator of the coup of 18 Brumaire. In this work David has portrayed someone who, like himself, had been caught up in the Revolution and its ideals. Sieyès was now sixty-nine years old, as David showed on the canvas, but he has retained his vitality and energy. He is now a private person, dressed in a simple black coat, seated on an upholstered chair, and holding a snuff box, but he is someone who had walked the corridors of power and his face retains a sense of purpose. In the *Vicomtesse de Vilain and Her Daughter* David has responded to female elegance and to a charming girl whose cocked head expresses childish innocence. Once again there is a rapport between David and his female sitter, as had been the case so often in the past.

Why the decline, then, in David's work as a history painter, a decline that is so marked in the *Apelles* and, in the main, continues through the Brussels mythological paintings? The later paintings, done in exile, are in fact a clue to the earlier work. Love was the subject of all four of the mythological paintings; love was also the subject of the *Apelles.* Cut off from France as a political exile in Brussels, David was unable to pour his own patriotic feeling into history paintings. Throughout his long career this was precisely what he had done, from the heroic works of the 1780s to his revolutionary paintings to those done during the Directory and under Napoleon. It was something he could no longer do after departing from France. Indeed, the *Apelles,* out of all of David's history paintings, is the only one that has love as its subject. Thus, in his final, unfinished history painting, his farewell to a genre that was the foundation of his greatness, he looks toward the amorous mythological works that were to occupy him after he was separated from the *patrie.* And just as living as an exile in Brussels prevented David from choosing

patriotic history subjects, so did conditions in France in 1813 contribute to the selection of Apelles and Alexander as the subject of his painting: "Ah! Ah! This is not precisely what one desired." France was coming apart, and in its particular way this painting is a record of that fact. History was responsible for the artistic collapse so evident in David's last history painting.

Of all the major artists whose creative lives coincided with the revolutionary era, not just in France but throughout Europe, David was most directly involved in the conflicts and struggles of the age. Not only was he in the eye of the revolutionary storm, but also, to use a different image, he was an actor on the political stage. No artist or writer was insulated from the profound changes that issued from France and swept across all of Europe. The one figure who is most often regarded as the exception to this rule, Jane Austen, was in fact deeply influenced by the revolutionary experience. Indeed, her novels can be regarded as a record of that experience. Interesting in this regard is *Mansfield Park*, which Austen began in 1811 and completed in 1813— the very year in which David did his first sketch for the *Apelles*. One of the characters in this novel, Mary Crawford, is based on Austen's cousin, Eliza de Feuillide, whose husband, a French aristocrat, went to the guillotine during the Terror. She often stayed with the Austen family at Steventon while her husband's life was in danger and at the time of his execution. Austen would have known directly about revolutionary violence through this episode. Another character in *Mansfield Park*, William Price, is based on Austen's brother Francis, an officer in the Royal Navy who played an active role in the naval struggle against Napoleon. William Price "had been in the Mediterranean—in the West Indies—in the Mediterranean again . . . and in the course of seven years had known every variety of danger, which sea and war together could offer."[3] So too had Francis Austen. *Mansfield Park* draws directly from Austen's experience and its Burkean images and metaphors reflect Austen's response to revolutionary ideology. Her earlier novels looked backward, to the world of eighteenth-century cultivation and sensibility; this one is firmly rooted in the new world of the nineteenth century. Its depth, range, and complexity are inextricably bound up with the historical experience to which it was tied. It can be regarded as evidence of Austen's capacity to respond creatively to the burdens of the revolutionary era.

In 1813 Goya was doing etching after etching in his *Disasters of War*, and in the following year he would paint one of his very greatest works, *May 3*. Napoleon said that Spain was an ulcer that killed him, and through Goya we have a vivid record of the destructiveness—and the savagery. This was the

first guerrilla war of modern times, and it was fought with a barbarity that Goya captured grimly in his etchings and paintings. Like David, Goya was a painter of contemporary history, but how extraordinarily different the works of the Spanish master are from those of his French contemporary. These two are incomparably the greatest artists of their generation. From their bitter hostility to academies in the 1780s and early 1790s to their shared fate as political exiles at the end of their lives, the parallels between the two artists are remarkable. Equally remarkable are the differences. Every element of Goya's art continued to grow and develop, even to acquire new depth, virtually to the end of his career. If David continued to paint superb portraits after Napoleon's defeat, Goya executed some of his most astonishing works after the return to power of the despised Ferdinand VII. The *May 3* was one of those works. So too are the portraits of the restored king that express Goya's loathing of that monarch. But perhaps most important are the Quinta del Sordo paintings that Goya painted for the interior of his own house, scenes of witches, an all-devouring Saturn, men who beat each other senseless as they sink into quicksand, and a forlorn dog who stares out at a world he cannot comprehend. All of these paintings came from deep within Goya; they are a record, at once, of his state of mind and the historical conditions that helped form that state of mind. What happened in Spain, politically, ideologically, and militarily, had a direct bearing on Goya the person and Goya the artist. As an artist he translated his responses to the history of his age into works that are compelling precisely because they are so harrowing.

In 1813 Beethoven was in the midst of a fallow period that lasted from a virtual nervous collapse in 1812 to a return of his creative urge between 1815 and 1818. From that point on he turned out the masterpieces of his late period, works of towering greatness. As a young man Beethoven reacted enthusiastically to the changes that originated in France and swept across Europe. The heroic music of his middle period, from 1803 to 1812, drew inspiration from the ideas and ideals that were so profoundly important to this composer. His dedication of the Third Symphony to Napoleon, scratched out when Beethoven's hero was crowned emperor, is evidence of his involvement with the world of men and events. So too is the bust of Brutus that he kept in his room. Also revealing is the subject Beethoven chose for his only opera, *Fidelio,* in which the forces of virtue and freedom triumph over those of despotism and tyranny. The libretto of *Fidelio* was derived from Jean Nicolas Bouilly's *Léonore ou l'amour conjugal,* which was based on Bouilly's own experience as a provincial administrator during the

Revolution. If the ideals of freedom and liberty were central to Bouilly's *Léonore*, so did they occupy a similar position in Beethoven's *Fidelio*. This is not to say that Beethoven was an uncritical admirer of France and the Revolution. The fact is that his opinions were alternately favorable and unfavorable. What remained constant was his dedication to the revolutionary ideals of freedom and liberty. When Beethoven recovered from depression after 1815, Austria was dominated by a repressive, reactionary political regime. Through his conversation books it is clear how involved he and his friends were in contemporary political issues. "We [Austrians are] Patriot killers," one of his friends said to Beethoven, and "Constitutions make men free," said another.[4] Ideas such as these did not find their way into Beethoven's music, but they do shed light on the late masterpieces. Central to Beethoven's achievement in those works was his separation from the world he lived in, a passing into the world of spirit. Why this happened is one of those mysteries that cannot be explained. What can be said is that when Beethoven entered that world he bitterly resented contemporary political conditions and he drew from his past experience and from the ideals that had stirred him earlier, in the heroic music of his middle period. This, surely, is one reason for his decision to set Schiller's *Ode to Joy* to music in the Ninth Symphony. And just as the idealism of youth passed into his last symphony, so did the strife and conflict that had shaken all of Europe when Napoleon's armies marched across Europe find their way into the martial sounds of the Missa Solemnis.[5] Even as Beethoven was forlorn, weary of body and soul, fatigued by and disgusted with the world, his idealism continued to enter into his compositions.

David is alone among these creative figures in his failure to continue to respond positively to the tensions and conflicts, the burdens and the strife, of the revolutionary era. The reason, paradoxically, was his dedication to the ideals of the Revolution. It was when his patriotism could no longer pass into his art that one part of his art atrophied. The creative wellspring did not dry up completely, and the hand was still capable of producing assured, even splendid paintings, but those works, at the end of his life, belonged to the private part of his experience. It was the depleted public part of that experience that was responsible for the artistic collapse. The irony is that it was history, the history of the age, that took such a heavy toll on David as a history painter.

Notes

INTRODUCTION

1. Palmer, *The Age of the Democratic Revolution.*

CHAPTER ONE

1. Locquin, *La Peinture,* 217. The translations are a combination of my own and the English language sources I have used. In most cases if a French passage was available in translation I quoted it in that form.

2. David, *Le Peintre,* 56–57.

3. David discusses this incident in an unfinished autobiography written years later. See Wildenstein, *Documents,* cat. no. 1361, 155–58.

4. David said in the autobiographical sketch, ibid., "I learned [from this incident] to know the injustice of men."

5. Miette de Villars, *Mémoires,* 69.

6. Brookner, *David,* 53.

7. Wildenstein, *Documents,* cat. no. 58, 9.

8. I have benefited from discussions with David Wisner about the relationship between Vien and David and the exchange of ideas about David between Vien and d'Angiviller.

9. David, *Le Peintre,* 19–20.

10. Pevsner, *Academies,* 191.

11. Ibid., 192.

12. *French Painting 1774–1830,* 101–17; the discussion is by Antoine Schnapper.

13. For an excellent discussion of this episode see Leymarie and Argan, *David e Roma,* 226–28.

14. The Patroclus works best reveal his fluctuations of style. See Howard, *A Classical Frieze,* and Rosenblum, "David's Funeral."

15. Brookner, *David,* 66.

16. Ibid., 75; see David, *Le Peintre,* 157, for David's discussion of Drouais in his unfinished biographical sketch.

17. David, *Le Peintre*, 34.

18. Ibid., 28.

19. Holt, *The Triumph of Art*, 16.

20. David, *Le Peintre*, 33.

21. Rosenblum, *Transformations*, 69. See also Starobinski, *1789*, 99–124.

22. Rosenblum, "A Source," 269–73.

23. See Locquin, *La Peinture*, and Leith, *Art as Propaganda*, and "Nationalism."

24. Ettlinger, "Jacques-Louis David," 105–23.

25. Honour, *Neo-classicism*, 69–80; Herbert, *David*, 15–64; Schnapper, *David*, 97; Brookner, *David*, 66–80.

26. Crow, "The Oath," 424–71.

27. Brookner, "Jacques-Louis David," 155–71. Brookner's review of Crow, "State-of-the-Art Crowd," is favorable, but Crow's much longer review of her book on David is less generous, to say the least; see "Gross David." Crow included Brookner's book on Greuze in his bibliography but her *David* is conspicuous for its absence. Very conspicuous.

28. For a discussion of this and other historical concepts of the period see Vovelle, *The Fall*, 73, and for the prerevolutionary period see Egret, *La Prérévolution*, and Margerison, "History, Representative Institutions."

29. This part of Crow's argument makes use of Darnton, "The High Enlightenment." See also Darnton, *Mesmerism*.

30. Crow, "The Oath," 429.

31. Crow, *Painters*, 240.

32. Brookner, *David*, 69; and Honour, *Neo-classicism*, 34.

33. Crow, *Painters*, 273.

34. Honour, *Neo-classicism*, 36.

35. Bryson, *Word*, 224–38.

36. This is a point that Brookner has developed superbly: the *Horatii* "may have frightened the spectator, but what is more to the point, it gave a much more profound and lasting emotional thrill to the painter himself. To the small, inarticulate, violent, and vulnerable David came this fantasy of strength, calm [and] power" (*David*, 74), and "looking back again at the picture one can see that an enormous passion has been invested in it, and that is the feeling that has gone into it rather than the feeling that comes out of it that makes it memorable" (*David*, 76–77). I have also benefited greatly in my thinking about the *Horatii* from Norman Bryson, *Word*, ch. 4, and *Tradition*, 63–84.

37. Brookner, *David*, 75.

38. Ibid.

39. Corneille, *Théâtre choisi*, 106, 107.

40. Delécluze, *Louis David*, 108.

41. Brookner, *David*, 40.

42. Ibid., 43.

43. This interpretation, important to Brookner's analysis of David, also appears in

Clark, *Romantic Rebellion*, 28. It is an interpretation that Bryson does not find convincing; see *Word*, 226. What made me even more convinced of the correctness of Brookner's position was examination of sequences of male and female figures in David's Louvre albums, his personal sketchbooks. In these bound books one can follow David's working procedures and also see how ideas occurred to him. Groups of male and then female figures occur repeatedly. Arlette Sérullaz, *conservateur* of the Cabinet des dessins in the Louvre, will publish a complete catalogue with illustrations of all of David's drawings, in conjunction with a special exhibit to celebrate the bicentennial of the Revolution. This publication will be of incomparable value to David scholarship.

44. For a study of these drawings, which contains reproductions, see Sérullaz, "Unpublished Sources," 37–41.

45. The phrase is Friedlaender's, *David*, 17. For an intelligent discussion of David's progress on the *Horatii* see Hazlehurst, "The Artistic Evolution," 59–63.

46. Brookner, *David*, 79. It was in the drawing in Lille (fig. 4) that David copied the figure from Poussin's *Rape of the Sabines*. The Ecole des Beaux-Arts drawing in Paris (fig. 2) has a Camilla that is very similar to the right-hand figure in Poussin's *Testament of Eudamidas*, but it does not have the old woman standing behind her. That woman appears as the nurse in the Louvre drawing (fig. 5).

47. On the larger subject of the relationship between the Enlightenment and the Revolution see Peyre, "The Influence of Eighteenth-Century Ideas," and Cobban, "The Enlightenment and the French Revolution." For all of its erudition, Daniel Mornet's *Les Origines intellectuelles* is not entirely convincing. On the one hand, Mornet does show how ideas took hold within ever larger circles of French readers during the eighteenth century, but his conclusions about the impact of ideas on French society are surprisingly cautious. Had Mornet been able to read later historians such as François Furet one wonders whether his conclusions would have been so cautious. One strength of Mornet's work is that he shows that Rousseau's influence resulted from his novels more than the *Social Contract*. This leads him to the conclusion that Rousseau's influence was more literary than political. A valuable corrective is Joan McDonald, *Rousseau and the French Revolution*, and Carol Blum's superb *Rousseau and the Republic of Virtue*.

48. This is a topic I discuss in *Morality and Social Class*. Among the sources I found particularly useful were Grimsley, "The Human Problem," Hall, "The Concept of Virtue," Green, *Jean-Jacques Rousseau*, Starobinski, *Jean-Jacques Rousseau*, and Guéhenno, *Jean-Jacques Rousseau*.

49. I discuss Diderot in *Morality and Social Class*, esp. 68–76. See also Blum's excellent *Diderot*.

50. Diderot, *Salons*, 4:377.

51. As Jean Seznec writes, "Diderot and Historical Painting," 135, "David is the very type of painter whom Diderot has in mind [in 1771, when Beaufort showed his *Oath of Brutus* in the Salon], the type of painter he is forever calling out for."

52. Diderot, *Salons*, 4:146.

53. For Diderot's commentary, ibid., 203–4.

54. Carol Blum's *Rousseau and the Republic of Virtue* discusses Rousseau's identification with his characters in his novels. Rousseau himself was the voice of both Saint-Preux and Julie in *La Nouvelle Héloise,* and he was Emile also. Much of the appeal, and the power, of both works is rooted in the author's identification with his own characters. By the same token, Diderot was both Rameau and *lui* in *Le Neveu de Rameau,* his masterpiece. Both Rousseau's and Diderot's works are useful to an understanding of David because the authors' conflicts appear in voices that issue from divisions within their own internal lives. Moreover, those divisions, personal as they were, were also tied to the tensions and conflicts within French society. In both *La Nouvelle Héloise* and *Le Neveu de Rameau* the authors protest against the cultivated world of Paris. Both Rousseau and Diderot had been attracted to and lived within that world. The burdens of rejection were not easy. In the case of Rousseau the tensions were all the greater because of sexual ambiguity. As much as he idealized his heroine, Julie, he felt threatened by women. (Jean Starobinski analyzes this brilliantly in "The Illness of Rousseau.") Eventually Rousseau ended conjugal relations with Thèrese, the mother of the five children he gave up for adoption. Like David, Rousseau's idealization of heroic virtue and Spartan manliness can be seen within the framework of his own experience.

55. Peyron wrote of the *Horatii* that David "did every bit of the picture with that kind of conscientious, diligent facility . . . it only comes to those who have had to overcome great obstacles in the practical execution." Quoted in Schnapper, *David,* 74.

56. David, *Le Peintre,* 38.

57. David, *Le Peintre,* 33.

58. For a discussion of David's social ties in the years before the Revolution see Bordes, *Le Serment,* 17–26.

59. For the impact of America and England on French liberals during this period see Palmer, *The Age,* 1:143–282.

60. Extracts of the correspondence between Mazzei and Stanislas-Augustus are in Bordes, *Le Serment,* Appendix 8, 137–47. The correspondence began on July 13, 1788, and continued to December 1791.

61. See Herbert, *David,* 53–54; and Starobinski, *1789,* 111–15.

62. For the following discussion of David's friendship with Chénier I am indebted to Wisner, "David and André Chénier." I also draw from Scarfe, *André Chénier,* and Dimoff, *La Vie.*

63. "Qu'il ne peut y avoir que les talents oisifs et inutiles dans la Tyrannie, encore moins dans l'aristocratie, et que tous les talents sont de l'essence de la démocratie, vraie république." Chénier, "Essai sur les causes," in *Oeuvres complètes,* 630.

64. Chénier develops these ideas in the second chapter of his "Essai sur les causes": "Quelle morgue, quelle arrogance ces sociétés littéraires inspirent à ceux qu'elles admettent parmi leurs membres! . . . Assis au coin du feu, il pense être sur un fauteuil académique. Tous ceux qui entrent, il les regarde comme des récipien-

daires. Mais sans m'étendre sur les inconvénients que ces associations littéraires peuvent avoir dans la vie privée, je me borne à examiner combien elles nuisent aux arts" (635).

65. Chénier did argue that men of talent could gain recognition in tyrannies, if the tyrant was wise and enlightened. The real problem was aristocracy, where men of privilege will resent and block the way of men of humble birth. Ibid., 630.

66. See "La République," ibid., 483.

67. "Que s'ils n'egalent point ces hommes excellent Qui font métier de l'art, professeurs des talents. . . . Qui font métier de l'art! Oui, le genie en France est un poste, une charge, un bureau de finance." Ibid., 474.

68. Ibid., 472.

69. Chénier did recognize that men of talent could rise in both tyranny and democracy, but according to different mechanisms, and he also recognized that the people could exercise a type of despotism in democracy, an idea that seems both prescient and ironic given Chénier's fear of the people during the Revolution. For his discussion of these points see "Des Lettres," Part 3, ch. 2, "des lois," in *Oeuvres*.

70. Brookner, *David*, 85.

71. That Chénier and the other members of the Trudaine circle were interested in the Socrates story reflects their upper-class liberal views. Socrates took the hemlock because his rational views offended the people; he was a victim of intolerance and popular fear and repressiveness. Whether or not this was actually so is discussed by I. F. Stone, "Witch Hunt in Ancient Athens?" For fear of the people in Rousseau see Crocker, "Rousseau and the Common People," and for the larger questions of how the Enlightenment viewed the people see Payne, *The Philosophes*.

72. Chénier's disgust with conditions in France is expressed in his "Hymn to Justice": "O sainte égalité! dissipe nos ténèbres. Renverse les verrous, les bastilles funèbres." *Oeuvres*, 163.

73. See "Essai sur les causes," "The influence of courts." One brief example will suffice: "Les cours . . . où la seule presence excite le ressentiment et la vengeance, parce qu'elle semble un reproche et une insulte à la conscience du maître, ou il n'y a d'autre talent ni d'autre vertu que de plaire au maître." *Oeuvres*, 638.

74. An excellent study of French finance is Bosher, *French Finances*. The older view of the fiscal crisis of 1787 (see Lefebvre, *The Coming*, 15) has been challenged by Gruder, "No Taxation." For an intelligent discussion of the Assembly of Notables see Harris, "The French Pre-Revolution."

75. Shafer examines the pamphlet literature, "Bourgeois Nationalism," as does Greenlaw, "Pamphlet Literature."

76. Herbert, *David*, 53.

77. Quoted in ibid., 17.

78. Wilson, *Diderot*, 701.

79. Ibid., 702.

80. Crow, *Painters*, 253.

81. David said upon hearing of the death of Drouais, "I have lost my emulation." He carefully assembled Drouais's letters and had a small monument built in his memory alongside his lodging in the Louvre. For this episode see David, *Le Peintre,* 53–56.

82. David's depiction of Brutus elicited a hostile response from his long-time antagonist, First Painter J. B. M. Pierre, who criticized the work according to proper academic standards of composition: "Well, Monsieur. In the *Horatii* you managed to get three figures on the same plane, something never before achieved in painting. Now you put your principal character in shadow; better and better. You are doubtless right because the public finds it admirable. But who said you could design a picture without using a pyramidal line?" That an artist of Pierre's stature was so outspoken in his criticism of the *Brutus,* and delivered his negative verdict in polite language that fairly dripped with mockery, was more than David could take. His anger burst forth when he was alone with his students, before whom he compared the Academy to a wigmaker's shop and whose program of study he said was based on poses and conventional movements that really were so many tricks and mannerisms. David said the professors of the Academy manipulated the model's torso as if it were "a carcass of chicken," and he "scorned their *métier* as he did filth." The conversation with Pierre is quoted in Brookner, *David,* 91, and the conversation between David and his students is in David, *Le Peintre,* 57.

83. David, *Le Peintre,* 57.

84. Wisner, "David and Chénier," 533, has drawn attention to how "sad" the Trudaine circle was in Chénier's absence. See also Bordes, *Serment,* 132–33, which contains David's letter to Maria Cosway describing the sadness.

85. Crow, *Painters,* 254.

86. Translated as *Interpreting the French Revolution* in 1981. The French edition appeared in 1978. For an excellent review see Baker, "Enlightenment."

87. Cochin, *Les Sociétés.*

CHAPTER TWO

1. Wildenstein, *Documents,* cat. no. 221, p. 30.

2. Ibid., cat. no. 381, p. 44.

3. Ibid., cat. no. 428, p. 50.

4. Ibid., cat. no. 1096, p. 109.

5. Ibid., cat. no. 181, pp. 23–24.

6. Ibid., cat. no. 575, p. 64. For this incident see Dowd, "Jacques-Louis David," 879.

7. Wildenstein, *Documents,* cat. no. 1096, p. 109.

8. Ibid., p. 108.

9. Ibid., p. 209.

10. Levey, "Reason and Passion," 209.

11. Brookner, *David*, 87.

12. Kemp, "Some Reflections," 268–70.

13. Crow, *Painters*, 245–47.

14. Leymarie and Argan, *David e Roma*, 151.

15. Robert Schumann has discussed this aspect of David's art superbly in "Virility and Grace."

16. I have found Furet, *Interpreting*, particularly insightful in understanding the dynamics of change between the revolutions of 1789 and 1792. This polemical work is one of the broadest attacks yet on Marxist interpretations of the Revolution. Another recent book, Sutherland's *France*, indicates in a very different way how much the historiography of the Revolution has changed since Alfred Cobban and others challenged the Marxist interpretation in the 1960s. I find Sutherland's book very useful, just as I do other works in English, such as Sydenham, *French Revolution*, Hampson, *A Social History*, and Thompson, *French Revolution*. In reading the works of these historians alongside Mathiez, Lefebvre, and Soboul I am struck by the differences, which go beyond interpretation of details. I am also struck by the wealth of information in the works of the French historians. I sometimes found the clearest account of an event or episode in Mathiez, *The French Revolution*, for instance. I benefited from recent and earlier studies and from works on both sides of the ideological divide. Sutherland's bibliography was a useful guide as was that of Wright, *Revolution and Terror*, and McManners, "The Historiography of the French Revolution," in Goodwin, *The American and French Revolutions 1763–93, New Cambridge Modern History*, vol. 8.

17. Lefebvre, *The Coming*, 143.

18. Ibid., Appendix.

19. Blum, *Rousseau*, 188. What follows immediately as well as elsewhere in this chapter is heavily in the debt of this fine book.

20. Ibid., 173.

21. Ibid., 175.

22. Ibid., 178.

23. Ibid., 200.

24. This passage is quoted in Rosenblum, *Transformations*, 52–53; and Herbert, *Brutus*, 86–88.

25. See Abray, "Feminism," and Levy, Applewhite, and Johnson, *Women*. A different perspective of women and revolutionary France is in Hufton, "Women in Revolution"; see also Kelly, *Women*.

26. Blum, *Rousseau*, 190; see 190–92 for a discussion of Saint-Just's ideal state.

27. Ibid., 213.

28. Abray, "Feminism," 59.

29. Bordes, *Le Serment*, 29. I should like here to express my indebtedness to this superb book.

30. They are reproduced in Bordes, *Le Serment,* figs. 86–88. See also Cosneau, "Un grand projet," and Bordes, "Un portrait."

31. These translations are taken from and translated in Schnapper, *David,* 112–13. All of David's comments in the Versailles Sketchbook are reproduced in Lee, "Jacques-Louis David." Complete facsimiles of the Versailles Sketchbook and the Louvre Sketchbook that followed it are reproduced in Bordes, *Le Serment,* figs. 85–151 and 152–225.

32. Schnapper, *David,* 124.

33. Rudé, *Crowd,* 9.

34. Ozouf, *Festivals,* 32–33.

35. Brookner, *David,* 105.

36. Bordes, *Le Serment,* reproduces eight articles in various journals on the *Louis XVI* painting, 166–73.

37. Scarfe, *Chénier,* 218–67, is an excellent guide for Chénier's political involvement after returning to Paris. For a discussion of the Society of 1789 see Challamel, *Les Clubs contre-révolutionnaires.* Wisner's, "David and Chénier" was helpful for this discussion.

38. Scarfe, *Chénier,* 220.

39. Ibid.

40. Chénier, *Oeuvres,* 199.

41. Ibid., 172.

42. Ibid.

43. Ibid., 175.

44. Ibid., 167.

45. This is shown by Wisner in "A Literary Source."

46. Dowd, *Pageant-master,* 56.

47. Scarfe, *Chénier,* 272.

48. Ibid., 305.

49. A still useful study of Marat is Gottschalk, *Jean Paul Marat.* The discussion of Furet and Richet on Marat is particularly probing in *La Révolution française,* 109–11, 176–79, 214–16, 283–87.

50. On May 27, 1791, he wrote that "eleven months ago five hundred heads would have sufficed; today fifty thousand would be necessary; perhaps five thousand will fall before the end of the year. France will have been flooded with blood; but it will be more free because of it." See Gottschalk, *Jean Paul Marat,* 121.

51. Chénier wrote his *Ode à Marie-Anne Charlotte Corday* shortly after Marat's execution. "In the first stanza he referred to an 'impudent reptile' who had written an 'infamous hymn' in honor of Marat. This was probably a reference to a poem published by the Jacobin Audouin on the 21st of July." Scarfe, *André Chénier,* 301.

52. Gottschalk, *Jean Paul Marat,* 101.

53. Ibid., 166.

54. Ibid., 106.

55. Hautecoeur, *Louis David,* 113.

56. Brookner, *David*, 125.

57. I have followed Bordes here, *Le Serment*, who corrected Dowd, *Pageant-master*. Dowd saw David as a political Jacobin when he joined the Jacobin Club. See also Michel, in Leymarie and Argan, *David e Roma*, 137.

58. Furet, *Interpreting*, 53–79.

59. Mellon, "Jacques-Louis David," 364–80. The Dowd quote is in Mellon, 370.

60. Agulhon, *Marianne*, 15. Leith has also studied revolutionary imagery in "Reflections on Allegory," and "The Birth of a Goddess." He discusses not only the figure of "Liberty," but also that of "Equality," another female goddess.

61. Agulhon, *Marianne*, 16.

62. Ibid.

63. Ibid., 18.

64. Hunt, *Politics*, 94.

65. This description is from Wildenstein, *Documents*, in which David's report to the Convention on the Fête de la Réunion of August 10, 1793, given on July 11 of that year, is reproduced in full, cat. no. 459, pp. 53–54. Hunt's discussion of the festival, *Politics*, 96–98, is probing and insightful, as is her discussion of revolutionary imagery throughout her book. There is also an excellent discussion of the festival of August 10 in Schnapper, *David*, 137–40.

66. Hunt, *Politics*, 96. Leith, "Birth of a Goddess," has emphasized the persistence of female images after the appearance of Hercules in August 1793. However potent a figure Hercules may have been, the earlier female images continued to be used. How they were used is discussed by Sheriff, "Comments on Revolutionary Allegory."

67. Wildenstein, *Documents*, cat. no. 666, p. 70.

68. Eisler, *Neoclassicism*, 141. The French text is in Wildenstein, *Documents*, cat. no. 666, p. 70.

69. Eisler, *Neoclassicism*, 141. Dowd, "Jacobinism," 204, explains that David did not join in the destruction of art during the Revolution but rather helped save even religious art. The quoted passage here suggests that he shared in the iconoclastic furor that swept France and resulted in destruction of the royal statues on Notre Dame and the decapitation of figures in churches and cathedrals throughout France.

70. For revolutionary festivals see Ozouf, *Festivals*. Dowd's *Pageant-master* is the standard work on David's role in these festivals.

71. See Dowd, "Jacobinism," "Jacques-Louis David," and *Pageant-master*.

72. Palmer, *Twelve Who Ruled*, 319–20.

73. Dowd, "Jacques-Louis David," 878.

74. With other women Mme David appeared at the Hôtel de Ville in October 1789 and participated in the march on Versailles. For a discussion of David's family life see Dowd, "Jacobinism," 198.

75. Dowd, "Jacques-Louis David," 890.

76. In a short autobiography written in 1793, reproduced in Wildenstein, *Documents*, cat. no. 1368, pp. 155–58, and Bordes, *Le Serment*, 174–75, David describes

his intention to give 15,000 livres awarded to him by the Convention to widows and orphans whose husbands and fathers died for the *patrie*. He also describes the gift of 7,000 livres in prize money to artists who had not received awards and were more needy than himself. This document is a remarkable testimony of David's vanity, pride, self-righteousness, and also his genuine idealism.

77. Brookner, *David*, 110, describes David as "a party man, but a party man 'en délire,' with the energy of the hypermanic at his command." Crow takes strong exception to this view in "Gross David."

78. Brookner, *David*, 117.

79. Nanteuil, *David*, 32, says of it that "there is not the slightest trace of emotion in its execution."

80. Thompson, *The French Revolution*, 473, describes the Marie Antoinette sketch as "cruel"; it shows her "defying death and a hostile mob, with Habsburg disdain." Interestingly, Marie Antoinette went to the guillotine on the same day, October 16, 1793, that David first showed his *Marat* to the public in a ceremony that included "funeral hymns" and "repeated oaths to die for the nation." See Herbert, *Brutus*, 101. This ceremony took place a few hours after Marie Antoinette was executed. David would have seen the former queen conveyed to the scaffold as he was awaiting a ceremony later in the day that commemorated two revolutionary martyrs, Lepelletier and Marat.

81. Thompson, *The French Revolution*, 472.

82. Schnapper, *David*, 146.

83. Brookner, *David*, 117, writes that the "ineffectiveness of the composition conveys the strength of the forces pulling David away from a balanced and professional use of stylistic motifs and the immoderate temper that overcame him when trying to return to professional symbols."

84. Dowd, *Pageant-Master*, 100.

85. Schnapper, *David*, 151.

86. Ibid.

87. It is clear that while David had worked out part of the design he did depart from the description in some respects, for based on P. A. Tardini's engraving and Anatole Devosges's drawing of the painting there was no crown on Lepelletier.

88. Brookner, *David*, 111. David's drawing of Lepelletier actually emphasized his ugliness. It is reproduced in Cantelli, *Jacques-Louis David*.

89. This and the following quotations are from Loomis, *Paris*, 70–83.

90. Mme Roland said of atrocities committed in the September Massacres: "Women brutally violated before being torn to pieces by these tigers . . . you know my enthusiasm for the Revolution; well, now I am ashamed of it; it has been dishonored by this scum and it has become hideous to me." The quotation, translated, is in Loomis, *Paris*, 83.

91. Thompson, *French Revolution*, 402.

92. Ibid.

93. David, *Le Peintre,* 141.

94. Ibid., 142–43.

95. Schnapper, *David,* 155.

96. Ibid., 156.

97. Ibid., 160.

98. See Starobinski, *1789,* 118.

99. David, *Le Peintre,* 146.

100. Leith, "Youth Heroes," 127.

101. Sloane, "David," 145.

102. Ibid., 149.

103. Ibid., 146.

104. See Sloane, "David," and Leith, "Youth Heroes." Germani, "Robespierre's Heroes," describes Robespierre's involvement in the heroization of Bara. David's fabrication of a revolutionary hero was bound up with his struggle against political rivals, the Hébertists on the left and Dantonist moderates on the right. Both favored Marat as a revolutionary hero, the radicals sincerely and the moderates cynically. Robespierre was trying to establish stability, which meant suppressing the *sans-culottes.* Marat stood for continued popular agitation and was a potent political symbol for that reason. This was exactly what Robespierre wanted to diminish. As a result he tried to restrain the Marat cult, although he was obviously unable to repudiate Marat. What he could do was fabricate new heroes who would be completely free of controversy. Bara was one of those heroes.

105. A careful examination of the work in the Musée Calvet, Avignon, has convinced me of this. Even such details as Bara's right nipple are shown, proof to me that David intended the figure to remain nude.

106. Wildenstein, *Documents,* cat. no. 1096, p. 110.

107. Ibid., 109.

108. General Desmarres, who wrote to the Convention about Bara and told David how he thought the youthful martyr should be depicted, went to the guillotine shortly afterward, a victim of revolutionary factionalism. See Sloane, "David," 149–51 and the chronology in n. 21, p. 154. David himself, according to Michelet, said in April 1793, "I believe there will not be twenty of us members of the mountain left." See Blum, *Rousseau,* 224.

109. See Wildenstein, *Documents,* cat. no. 872, p. 90.

110. David can be said to have allowed his anger to have passed fully into his art, but not into the paintings that represented his major artistic investment. Indeed, the ephemeral works, such productions as *The Triumph of the People* and most obviously his political cartoons, were the repositories of his obstreperous and violent tendencies. For a reproduction of one of those drawings, *The English Government,* see Schnapper, *David,* fig. 86, p. 147. Clearly a different creative process was at work in the martyr paintings. For a discussion of the political cartoons see Alfred Boime,

"Jacques-Louis David." Boime sees continuity between the cartoons and David's paintings.

CHAPTER THREE

1. David, *Le Peintre*, 217.
2. Wildenstein, *Documents*, cat. no. 1142, p. 115.
3. Ibid., cat. no. 1143, pp. 115–16.
4. Ibid., cat. no. 1198, p. 124.
5. Robespierre's speech is printed in Bienvenu, *The Ninth of Thermidor*, 143–74. The debate that followed is on pp. 175–84. An account of the meeting that night in the Jacobin Club is on pp. 181–84. See also Loomis, *Paris*, 376–403; Lefebvre, *French Revolution, 1793–1799*, 131–36; Palmer, *Twelve Who Ruled*, 361–87; Mathiez, *French Revolution*, 487–510; Thompson, *French Revolution*, 547–63.
6. Wildenstein, *Documents*, cat. no. 1138, p. 114.
7. Ibid., cat. no. 1145, p. 116.
8. Ibid., cat. no. 1146, p. 117.
9. Ibid., cat. no. 1145, p. 116.
10. Ibid., cat. no. 1142, p. 115.
11. Ibid., cat. no. 1146, p. 117.
12. The following quotations are taken from David's statement which is reproduced in entirety in ibid., cat. no. 1198, pp. 123–32. See also Brookner, *David*, 128.
13. Brookner, *David*, 122.
14. Wildenstein, *Documents*, cat. no. 1145, p. 116.
15. Ibid., cat. no. 1143, p. 116.
16. Ibid., cat. no. 1142, p. 115.
17. Fried, *Absorption*, 176.
18. Wildenstein, *Documents*, cat. no. 1142, p. 115. While David does not mention the *Homer* studies by name this was the project he meant when he wrote, "I have undertaken a painting of a composition of great scope and full of difficulties."
19. Ibid., cat. no. 1143, p. 116.
20. Nanteuil, *David*, 122.
21. Brinton, *A Decade of Revolution*, 195. See also Lefebvre, *The Thermidoreans*, Woronoff, *The Thermidorean Regime*, and Lyons, *France*.
22. Brinton, *A Decade of Revolution*, 199.
23. Ibid., 197.
24. Ibid.
25. Schnapper, *David*, 173–74.
26. I have not seen the *Blauw* portrait, which was installed in the National Gallery in London after its purchase in 1984. Waldemar Janusczak discusses it in the *Manchester Guardian Weekly*, October 11, 1987, "Dirty Art of Politics." Comparing it to the portrait of *Casper Meyer*, he finds the latter "heroic" in conception, in contrast

to "quieter, more intimate, less political" image of the *Blauw* portrait. Based on a reproduction of the *Blauw* portrait I do not agree with Janusczak.

27. Palmer, *Age*, 2:178. For the Batavian Republic see also Schama, *Patriots*, chs. 4–8.

28. Blauw expressed his admiration for David the artist and the citizen in a letter of November 29, 1795. See David, *Le Peintre*, 324–25.

29. Both Lyons, *France*, 129–32, and Woronoff, *The Thermidorean Regime*, 139–40, comment on the theme of peace in the art of this period. See also Rosenblum, *Transformations*, 89–94.

30. Delécluze, *David*, 120.

31. Schnapper, *David*, 186.

32. Ibid., 187.

33. Holt, *A Documentary History*, 349.

34. Ibid., 350.

35. Ibid., 350–51.

36. Ibid., 349.

37. Ibid., 340.

38. Rosenblum, *Transformations*, 176–83.

39. Germer and Kohle, "From the Theatrical," 180.

40. Ibid., 181.

41. Schnapper, *David*, 182.

42. Ibid.

43. Ibid., 180.

44. Delécluze, *David*, 191.

45. Friedlaender, *David*, 31. Rosenblum, *Transformations*, 147, 151, 158.

46. Schnapper, *David*, 187–88. Nodier's "Les Barbus," is in an appendix in Delécluze, *David*, 438–47; this passage is on p. 444.

47. Levitine, *The Dawn*, 2.

48. Ibid., 64. The passage is on p. 90 of Delécluze, *David*.

49. Levitine, *The Dawn*, 60; Delécluze, *David*, 428.

50. Besides Levitine, *The Dawn*, see Pelles, *Art, Artists*, 84–89. For Bohemianism in nineteenth-century France see Graña, *Modernity*, and Seigel, *Bohemian Paris*.

51. Schnapper, *David*, 189; Delécluze, *David*, 442.

52. Levitine, *The Dawn*, 61; Delécluze, *David*, 71.

53. Levitine, *The Dawn*, 61; Delécluze, *David*, 72.

54. Levitine, *The Dawn*, 62; Delécluze, *David*, 72.

55. Levitine, *The Dawn*, 62.

56. Ibid., 69; Delécluze, *David*, 122.

57. Levitine, *The Dawn*, 84.

58. Schnapper, in *French Painting*, 112.

59. The competition of the Year II offers an interesting view of how art and politics were fused at the height of the Revolution. See Olander, "French Painting."

60. Rosenblum, *Transformations*, 146, 158, 160.

61. Friedlaender, *David*, 44.

62. Palmer, *Age*, 2:233. See also Thomson, *The Babeuf Plot*, and Rose, *Gracchus Babeuf*.

63. David refused to sign a petition for a student, Topino-Lebrun, involved in the Babeuf conspiracy; see Wildenstein, *Documents*, cat. no. 1233, p. 136. Brookner, *David*, 142.

64. Delécluze, *David*, 203–4.

65. Hautecoeur, *David*, 171.

66. For France's looting of art treasures see Gould, *Trophy*, Quynn, "The Art Confiscation," and Saunier, "Les Conquêtes artistiques."

67. Brookner, *David*, 143.

68. Delécluze, *David*, 208.

69. Brookner, *David*, 143.

CHAPTER FOUR

1. Delécluze, *David*, 203–4.

2. Ibid., 340–41.

3. For a useful study of opinions on Napoleon see Geyl, *Napoleon*.

4. Staël, *On Politics*, 88.

5. Markham, *Napoleon*, 265.

6. Ibid.

7. Cronin, *Napoleon*, 86.

8. Ibid., 117–18.

9. Herold, *Mind*, 72.

10. Ibid., 6.

11. Ibid., 72.

12. Lefebvre, *Napoleon from 18 Brumaire*, 184–85.

13. Herold, *Mind*, 178.

14. Ibid., 5.

15. Lefebvre, *Directory*, Wolock, *Jacobin Legacy*, and Olivier, *Dix-huit brumaire*.

16. Markham, *Napoleon*, 75–77.

17. For a discussion of the incident see Sydenham, "The Crime."

18. Delécluze, *David*, 230.

19. See Bordes, "Les Arts," Rubin, "Painting and Politics," Levin, "La Définition," and "The Wedding of Art," and Rawson, *The Spartan Tradition*.

20. Delécluze, *David*, 363.

21. Markham, "Napoleon and His Painters," 187.

22. Brookner, *David*, 183. Chaptal wrote this after he had turned against Napoleon.

23. See Gould, *Trophy*, 42–43.

24. Herold, *Mind*, 144.

25. Ibid.

26. Delécluze, *David*, 231.

27. Ibid., 219.

28. Ibid., 222–23.

29. Ibid., 230.

30. Rubin, "Painting and Politics," 552–53. Also see Rawson, *Spartan Tradition*, 230–91.

31. Delécluze, *David*, 225.

32. Ibid., 230.

33. David, *Le Peintre*, 367.

34. Schnapper, *David*, 205–6.

35. Velázquez is Spain's greatest painter along with Goya, whose reputation outside Spain was limited in 1800. Interestingly, Charles IV had commissioned Goya to do the splendid *Family of Charles IV* in 1798. Probably completed in 1800, this work reveals the fatuity of a king whose position was already precarious and who was to be driven from his throne and end up as one of Bonaparte's pawns. The allusions to imperial splendor in David's painting commissioned by this monarch can be seen, ironically, against this political background. For a valuable discussion of Goya's *Family of Charles IV* see Licht, *Goya*, 67–82.

36. Tietze, *Titian*, 38.

37. Delécluze, *David*, 232.

38. Ibid., 234–35.

39. David, *Le Peintre*.

40. For a discussion of David and Napoleon that includes monetary matters see Lanzac de Laborie, "Napoléon."

41. Wildenstein, *Documents*, cat. no. 1400, p. 162.

42. Ibid., cat. no. 1439, p. 166.

43. Ibid., cat. no. 1474, p. 171.

44. Ibid., cat. no. 1446, p. 167.

45. Gould, *Trophy*, 86–102; and see *Regency to Empire*, 324–25.

46. See Lefebvre, *Napoleon from 18 Brumaire*, 122–59; Boas, *French Philosophes*, 1–69; Levin, "La Définition," 48–51; "David," 5–12; and Godechot, *Les Institutions*, 732–60.

47. Herold, *Mistress*, 213–23, 250–55; Andrews, *Germaine*, 88–105; Winegarten, *Mme de Staël*, 54–73.

48. Lefebvre, *Napoleon from 18 Brumaire*, 141–42.

49. Nanteuil, *David*, 136.

50. Lefebvre, *Napoleon from 18 Brumaire*, 135–40; and *Napoleon from Tilsit*, 72, 183–85.

51. Delécluze, *David*, 165.

52. Schnapper, *David*, 222. In the painting David followed Napoleon's directions by having the pope raise his right hand.

53. Wildenstein, *Documents*, cat. no. 1484, p. 173.

54. Schnapper, *David*, 222.

55. A more accurate and less flattering depiction of Joséphine as Empress is the drawing by Jean-Baptiste Isabey, reproduced in Brookner, *David*, pl. 80. One of David's preparatory studies in the Versailles Museum, illustrated in Verbraeken, *Jacques-Louis David*, fig. 77, shows a somewhat less idealized Joséphine, with something of a double chin.

56. Schnapper, *David*, 232.

57. David, *Le Peintre*, 410.

58. Wildenstein, *Documents*, cat. no. 1507, p. 175.

59. Herold, *Mind*, 20.

60. From Agnes Mongan's notes in a forthcoming catalogue of David's drawings in the Fogg Museum, Cambridge, Massachusetts. I am in the debt of both Agnes Mongan and Miriam Stewart who allowed me to see the David drawings in the Fogg Museum.

61. Wildenstein, *Documents*, cat. no. 1517, p. 176.

62. Schnapper, *David*, 246.

63. Brookner, *David*, 154.

64. Clark, *Romantic Rebellion*, 36.

65. Wildenstein, *Documents*, cat. no. 1474, p. 171.

66. Ibid., cat. no. 1560, p. 182.

67. Ibid., cat. no. 1565, p. 182.

68. Ibid., cat. no. 1547, p. 180.

69. Ibid., cat. no. 1574, p. 183.

70. For critical opinions of the work see *French Painting*, p. 372.

71. Delécluze, *David*, 347.

72. Both studies are in the Louvre, inventory numbers 1918 and 1919. For a discussion of the two works see *Neo-classicisme dessins*, entry no. 58.

73. I saw the albums containing *Leonidas* studies in the Louvre and in the Musée des Beaux-Arts in Lille. The latter drawings have been reproduced in *Autour de David*, which contains Sérullaz's excellent introductory article, 17–21. As noted earlier, Sérullaz is preparing a complete catalogue of David's drawings.

74. One example of this procedure is in RF 23007, which is filled for the most part with sketches for paintings in the coronation series. There are studies for the colonel on top of the platform who prepares to give the oath to Napoleon, after which there is a drawing of the Hercules figure for the *Leonidas*. It would seem that while thinking about the patriotic oath in the *Distribution* David conceived of a figure that he considered including in the *Leonidas*, the figure of Hercules, who also had patriotic connotations.

75. David, *Le Peintre*, 462–63.

76. Ibid., 467.

77. See Wildenstein, *Documents*, cat. no. 1559, p. 182 (named honorary member of the Royal Academy of Munich, November 1809); cat. no. 1600, p. 186 (accepts

nomination to the Academy of Fine Arts in Florence, February 1811); cat. no. 1633, p. 189 (named to Academy of Saint Luc in Rome, November 1811); cat. no. 1649, p. 191 (receives diploma as honorary member of Imperial and Royal Academy of Fine Arts in Vienna, March 1812); cat. no. 1691, p. 195 (named honorary member of the Society of Fine Arts in Ghent, August 1814).

78. On April 20, 1808, David offered to make a copy of the *Coronation* for Louis Bonaparte at a reduced price if he would "deign to give me a mark of his esteem for my talent by honoring me with the decoration of his order." See Wildenstein, cat. no. 1531, p. 178. David said that Napoleon was to pay him 100,000 francs for the original version, which was not true. One is reminded of Beethoven's misrepresentations in his financial dealings with publishers at much the same time. Beethoven was as high-minded as David in matters of principle and as inconsistent when it came to pursuit of his own economic advantage.

79. David, *Le Peintre*, 504. See Pupil, *Le Style troubadour*.

80. For David's studies that include rather literal copies of Bologna's *Mercury* and then lead into the figure that eventually appeared in the *Distribution*, see Louvre album RF 1870, fols. 19–28.

81. Delécluze, *David*, 340–41.

82. There is a sequence of Hercules drawings in RF 6071, fol. 51–58. The drawing reproduced here, fig. 80, is 57 v. in that sequence.

83. Kemp, "J.-L. David," 179.

84. See Bothmer, "A propos du 'Leonidas.'"

85. The sketchbooks reveal how much thought David put into the Leonidas figure. See, for example, RF 6071, fols. 3, 5, 7, 16; and RF 9137, fol. 51 v.

86. David, *Le Peintre*, 516.

CHAPTER FIVE

1. David, *Le Peintre*, 526.

2. Wildenstein, *Documents*, cat. no. 1841, p. 213.

3. Ibid., cat. no. 1855, p. 215.

4. Ibid., cat. no. 1881, p. 220.

5. David, *Le Peintre*, 582.

6. Wildenstein, *Documents*, cat. no. 1741, p. 199.

7. Ibid., cat. no. 1753, p. 200.

8. Bertier de Sauvigny, *Bourbon Restoration*, 132.

9. Brookner, *David*, 176.

10. Delécluze, *David*, 358.

11. Ibid., 360.

12. Ibid., 363–64.

13. David, *Le Peintre*, 528.

14. Delécluze, *David*, 366.

15. David, *Le Peintre*, 531.

16. Wildenstein, *Documents*, cat. no. 1797, p. 205.

17. David, *Le Peintre*, 532.

18. Wildenstein, *Documents*, cat. no. 1806, p. 207.

19. Ibid., cat. no. 1841, p. 213.

20. David, *Le Peintre*, 524.

21. For a discussion of Decazes and his relationship with Louis XVIII, see Bertier de Sauvigny, *Bourbon Restoration*, 126–28.

22. David, *Le Peintre*, 532.

23. Ibid., 534.

24. Ibid.

25. Ibid., 539.

26. Ibid., 545.

27. Ibid., 558.

28. Ibid., 562.

29. Ibid., 538.

30. The letter appears in ibid., 545–46.

31. Ibid., 574. There is a good discussion of Gros in Friedlaender, *David*, 60–66. The fact that Gros committed suicide in 1835 should be kept in mind when considering his relationship with David and its strange tendencies.

32. David, *Le Peintre*, 571–72.

33. Ibid., 577.

34. Wildenstein, *Documents*, cat. no. 1926, p. 224.

35. Ibid., cat. no. 1889, p. 221.

36. Ibid., cat. no. 1860, p. 216.

37. Ibid., cat. no. 1786, p. 204.

38. David, *Le Peintre*, 552.

39. Brookner, *David*, 180.

40. Wildenstein, *Documents*, cat. no. 2008, p. 233.

41. Brookner, *David*, 183.

42. Friedlaender, *David*, 32–35.

43. Schnapper, *David*, 294–302, is less critical than Brookner and Friedlaender, and renders favorable judgment on *The Farewell of Telemachus and Eucharis*. He says, p. 297, of *The Anger of Achilles at the Sacrifice of Iphigenia*, "David once again employs that uncertain mixture of realism and idealism that prevents us from considering his late mythological paintings as wholly successful."

44. Johnson, "Desire Demythologized."

45. Delécluze, *David*, 367.

46. Ibid., 546.

47. Bryson, *Tradition*, develops this idea splendidly. For his discussion of David's Brussels paintings see pp. 115, 139–40.

48. Ingres had showed himself as a formidable competitor of David. His 1806 *Napoleon I on the Imperial Throne* is vastly superior to David's Genoa portrait of Napoleon done in the previous year. Not only is Ingres's *Napoleon I* superior to David's *Napoleon*, but clearly Ingres used David's work as his point of departure. Ingres's Napoleon is seated and David's is standing, but they are dressed in the same imperial uniform and hold the same staffs of authority. The Napoleon of Ingres's painting is seated on rather than standing before his throne—and it is the same throne that is seen in David's painting, as if the student were putting himself in direct competition with the master.

49. This is what Bryson, *Tradition*, 139, sees David doing in *Mars and Venus*. It is a procedure that I see taking place also in *Cupid and Psyche*.

50. Picon, *Ingres*, 56–63.

51. Schnapper, *David*, 294–95.

52. Ibid., 296.

53. For a different view of this work, see Johnson, " 'Some Work.' "

54. Wildenstein, *Documents*, cat. no. 1936, p. 226.

55. Ibid., cat. no. 1836, pp. 226–27.

56. David, *Le Peintre*, 588.

CONCLUSION

1. Herold, *Mind*, 224.

2. Ibid., 50.

3. That Austen was affected by the revolutionary experience is the thesis of my *Jane Austen*.

4. Knight, *Beethoven*, 143. Beethoven was completely deaf at this time, so his friends communicated with him in writing. The conversation books that have been preserved are a record of what Beethoven's friends said to him during the period of his deafness. They indicate how political Beethoven's circle was.

5. In the last movement in particular, the Agnus Dei. For a superb discussion of the military interruptions in the Agnus Dei see Cooper, *Beethoven*, 266–75.

Bibliography

Abray, Jane. "Feminism in the French Revolution." *American Historical Review* 8 (February 1979): 43–62.

Agulhon, Maurice. *Marianne into Battle: Republican Imagery and Symbolism in France, 1789–1880.* Cambridge, England, 1981.

Andrews, Wayne. *Germaine: A Portrait of Mme de Staël.* New York, 1963.

Antal, Frank. *Classicism and Romanticism, with Other Studies in Art History.* New York, 1966.

Auerbach, Erich. "La Cour et la Ville." In *Scenes from the Drama of European Literature.* New York, 1959.

Autour de David: Dessins néo-classiques du Musée des Beaux-Arts de Lille. Lille, 1983.

Baker, Keith. "Enlightenment and Revolution in France: Old Problems, Renewed Approaches." *Journal of Modern History* 53 (June 1981): 281–303.

Bertier de Sauvigny, Guillaume de. *The Bourbon Restoration.* Philadelphia, 1966.

Bienvenu, Richard, ed. *The Ninth of Thermidor: The Fall of Robespierre.* London, 1968.

Blum, Carol. *Diderot: The Virtue of a Philosopher.* New York, 1974.

———. *Rousseau and the Republic of Virtue: The Language of Politics in the French Revolution.* Ithaca, N.Y., 1986.

Boas, George. *French Philosophes of the Romantic Period.* New York, 1964.

Boime, Albert. *The Academy and French Painting in the Nineteenth Century.* London, 1971.

———. "Jacques-Louis David, Scatological Discourse in the French Revolution, and the Art of Caricature." *Arts Magazine* 62, 6 (1988): 72–81.

Bordes, Philippe. "Les Arts après la Terreur: Topino Lebrun, Hennequin et la peinture politique sous la Directoire." *Revue du Louvre* 29, 3 (1979): 199–211.

———. "J.-L. David's 'Serment du Jeu de Paume': Propaganda without a Cause?" *Oxford Art Journal* 3 (October 1980): 19–25.

———. "Un portrait de David identifié: L'insurgé américain Filippo Mazzei." *Revue du Louvre* 31, 3 (1981): 159–62.

———. *Le Serment du Jeu de Paume de Jacques-Louis David.* Paris, 1983.

Bosher, John. *French Finances 1770–1795: From Business to Bureaucracy.* Cambridge, England, 1970.

Bothmer, Dietrich von. "A propos du 'Leonidas aux Thermopiles' de David—un dessin inédit au Metropolitan Museum." *Revue du Louvre* 14, 6 (1964): 327–33.

Brinton, Crane. *A Decade of Revolution 1789–1799.* New York, 1934.

Brookner, Anita. "Aspects of Neo-Classicism in French Painting." *Apollo* 68 (September 1958): 67–73.

————. *Greuze: The Rise and Fall of an Eighteenth Century Phenomenon.* London, 1972.

————. "Jacques-Louis David: A Personal Interpretation." *Proceedings of the British Academy* 60 (1974): 155–71.

————. *Jacques-Louis David.* New York, 1980.

————. "The State-of-the-Art Crowd." *Times Literary Supplement.* Nov. 29, 1985, 1348–49.

Bryson, Norman. *Word and Image: French Painting of the Ancien Regime.* Cambridge, England, 1981.

————. *Tradition and Desire: From David to Delacroix.* Cambridge, England, 1984.

Cantelli, R. *Jacques-Louis David: 1748–1825.* Paris, 1930.

Challamel, A. *Les Clubs contre-révolutionnaires, cercles, comités, sociétés, salons, réunions, cafés, restaurants, et libraires.* Paris, 1895.

Chénier, André. *Oeuvres complètes.* Edited by Gérard Walter. Paris, 1958.

Clark, Kenneth. *The Romantic Rebellion: Romantic versus Classic Art.* New York, 1973.

Cobban, Alfred. *A History of Modern France: Old Regime and Revolution 1715–1799.* Harmondsworth, 1957.

————. *The Social Interpretation of the French Revolution.* Cambridge, England, 1964.

————. "The Enlightenment and the French Revolution." In *Aspects of the French Revolution.* New York, 1968.

Cochin, Augustine. *Les Sociétés de pensée et la démocratie: Etudes d'histoire révolutionnaire.* Paris, 1912.

Cooper, Martin. *Beethoven: The Last Decade 1817–1827.* London, 1970.

Corneille, Pierre. *Théâtre choisi.* Edited by Maurice Rat. Paris, 1961.

Cosneau, Claude. "Un grand projet de J.-L. David (1789–1790)." *Revue du Louvre* 38, 4 (1983): 255–63.

Crocker, Lester. "Rousseau and the Common People." In *Studies in the Eighteenth Century,* edited by R. F. Brissenden and J. C. Eude, pp. 73–93. Toronto, 1976.

Cronin, Vincent. *Napoleon Bonaparte: An Intimate Biography.* New York, 1972.

Crow, Thomas. "The Oath of the Horatii in 1785: Painting and Pre-Revolutionary Radicalism in France." *Art History* 1 (December 1978): 424–71.

————. "Gross David with the Swoln Cheek." *Art History* 5 (March 1982): 109–17.

————. *Painters and Public Life.* New Haven, Conn., 1985.

Darnton, Robert. *Mesmerism and the End of the Enlightenment in France.* New York, 1970.

————. "The High Enlightenment and the Low-Life of Literature in Pre-Revolutionary France." *Past and Present* 51 (May 1971): 81–115.

————. *The Literary Underground of the Old Regime*. Cambridge, Mass., 1982.

David, Jules. *Le Peintre Louis David 1748–1825*. Paris, 1880.

Delécluze, E. J. *Louis David, son école et son temps*. Paris, 1855.

Diderot, Denis. *Salons*. 4 vols. Edited by Jean Seznec and Jean Adhémar. Oxford, 1957–67.

Dimoff, Paul. *La Vie et l'oeuvre d'André Chénier: Jusqu' à la Révolution française*. 2 vols. Paris, 1936.

Dowd, David. *Pageant-master of the Republic, Jacques-Louis David and the French Revolution*. Lincoln, Nebr., 1948.

————. "Jacques-Louis David, Artist Member of the Committee of General Security." *American Historical Review* 57 (July 1952): 871–92.

————. " 'Jacobinism' and the Fine Arts: The Revolutionary Careers of Bouquier, Sergent and David." *Art Quarterly* 16 (Autumn 1953): 195–214.

————. "Art and the Theater during the French Revolution: The Role of Louis David." *Art Quarterly* 23 (Spring 1960): 3–21.

Egret, Jean. *La Pre-Révolution Française 1787–1788*. Paris, 1962.

Eisler, Lorenz. *Neoclassicism and Romanticism, 1750–1850, Enlightenment/Revolution*. Englewood Cliffs, N.J., 1970.

Ettlinger, L. D. "Jacques-Louis David and Roman Virtue." *Journal of the Royal Society of Arts* 115 (January 1967): 105–23.

French Painting 1774–1830: The Age of Revolution. Detroit, 1975.

Fried, Michael. *Absorption and Theatricality: Painting and Beholder in the Age of Diderot*. Berkeley, Calif., 1980.

Friedlaender, Walter. *David to Delacroix*. Cambridge, Mass., 1952.

Furet, François. *Interpreting the French Revolution*. Cambridge, England, 1981.

Furet, François, and Denis Richet. *La Révolution*. Paris, 1965.

Germani, Ian. "Anti-Jacobin Images of Jean Paul Marat." *Consortium on Revolutionary Europe Proceedings*, pp. 138–48. Athens, 1986.

————. "Robespierre's Heroes: The Politics of Heroization during the Year Two." *Consortium on Revolutionary Europe Proceedings*, forthcoming.

Germer, Stefan, and Hubertus Kohle. "From the Theatrical to the Aesthetic Hero: On the Privatization of the Idea of Virtue in David's *Brutus* and *Sabines*." *Art History* 9 (June 1980): 168–84.

Geyl, Pieter. *Napoleon: For and Against*. New Haven, Conn., 1949.

Godechot, Jacques. *Les Institutions de la France sous la Révolution et l'Empire*. Paris, 1968.

————. *The Counter Revolution: Doctrine and Action 1789–1804*. London, 1972.

Gottschalk, Louis. *Jean Paul Marat: A Study in Radicalism*. New York, 1966.

Gould, Cecil. *Trophy of Victory*. London, 1965.

Graña, César. *Modernity and Its Discontents.* New York, 1967.

Green, F. C. *Jean-Jacques Rousseau: A Study of His Life and Writings.* London, 1955.

Greenlaw, Ralph. "Pamphlet Literature in France during the Period of the Aristocratic Revolt." *Journal of Modern History* 29 (December 1957): 349–54.

Grimsley, Ronald. "The Human Problem in *La Nouvelle Héloise.*" *Modern Language Review* 53 (April 1958): 171–84.

Gruder, Vivian R. "'No Taxation Without Representation': The Assembly of Notables and Political Ideology in France." *Legislative Assembly Quarterly* 7 (1982): 267–79.

Guéhenno, Jean. *Jean-Jacques Rousseau.* 2 vols. New York, 1967.

Hall, G. Gaston. "The Concept of Virtue in *La Nouvelle Héloise.*" *Yale French Studies* 28 (1962): 20–33.

Hampson, Norman. *A Social History of the French Revolution.* London, 1963.

———. *The Enlightenment.* Harmondsworth, 1968.

Harris, Robert D. "The French Pre-Revolution: Aristocratic or Bourgeois." *Consortium on Revolutionary Europe Proceedings,* pp. 349–61. Athens, 1987.

Hautecoeur, Louis. *Louis David.* Paris, 1954.

Hazlehurst, F. Hamilton. "The Artistic Evolution of David's *Oath.*" *Art Bulletin* 42 (March 1960): 59–63.

Herbert, Robert. *David, Voltaire, Brutus and the French Revolution: An Essay in Art and Politics.* New York, 1967.

Herold, Christopher. *The Mind of Napoleon: A Selection from His Written and Spoken Words.* New York, 1955.

———. *Mistress to an Age: A Life of Madame de Staël.* Indianapolis, 1958.

Holt, Elizabeth. *A Documentary History of Art,* vol. 2: *Michelangelo and the Mannerists: The Baroque and the Eighteenth Century.* Garden City, N.Y., 1958.

———. *The Triumph of Art for the Public.* Garden City, N.Y., 1979.

Honour, Hugh. *Neo-classicism.* Harmondsworth, 1968.

Howard, Seymour. *A Classical Frieze by Jacques-Louis David.* Sacramento, Calif., 1975.

Hufton, Olwen. "Women in Revolution 1789–1796." *Past and Present* 53 (November 1971): 90–108.

Hunt, Lynn. *Politics, Culture and Class in the French Revolution.* Berkeley, Calif., 1984.

Johnson, Dorothy. "'Some Work of Noble Note': David's La Colère d'Achille Revisited." *Gazette des Beaux Arts* 104, 6 (December 1984): 223–30.

———. "Desire Demythologized: David's *L'Amour Quittant Psyche.*" *Art History* 9 (December 1986): 450–70.

Kelly, Linda. *Women of the French Revolution.* London, 1987.

Kemp, Martin. "Some Reflections on Watery Metaphor in Winckelmann, David and Ingres." *Burlington* 110 (May 1968): 268–70.

———. "J.-L. David and the Prelude to a Moral Victory for Sparta." *Art Bulletin* 51 (June 1969): 178–83.

Knight, Frida. *Beethoven and the Age of Revolution*. New York, 1974.

Lanzac de Laborie, L. de. "Napoléon et le peintre David." *Revue des études Napoléoniennes* 3 (January 1913): 21–37.

Lee, Virginia. "Jacques-Louis David: The Versailles Sketchbook." *Burlington* 111 (April, June 1969): 197–208, 360–69.

Lefebvre, Georges. *The Coming of the French Revolution*. New York, 1947.

————. *The French Revolution from Its Origins to 1793*. London, New York, 1962.

————. *The French Revolution from 1793 to 1799*. London, 1964.

————. *The Thermidorians*. New York, 1966.

————. *The Directory*. New York, 1967.

————. *Napoleon from 18 Brumaire to Tilsit 1799–1807*. London, 1969.

————. *Napoleon from Tilsit to Waterloo 1807–1815*. New York, 1969.

Leith, James. *Art as Propaganda in France, 1750–1799: A Study in the History of Ideas*. Toronto, 1965.

————. "Nationalism and the Fine Arts in France, 1750–1789." *Studies on Voltaire and the Eighteenth Century* 89 (1972): 919–37.

————. "Youth Heroes of the French Revolution." *Consortium on Revolutionary Europe Proceedings*, pp. 127–37. Athens, 1986.

————. "Reflections on Allegory in the French Revolution." *Consortium on Revolutionary Europe Proceedings*, pp. 631–45. Athens, 1987.

————. "The Birth of a Goddess: The Advent of *l'Egalité* in the French Revolution." *Consortium on Revolutionary Europe Proceedings*, forthcoming.

Levey, Michael. "Reason and Passion in Jacques-Louis David." *Apollo* 20 (September 1964): 206–11.

————. *Rococo to Revolution: Major Trends in Eighteenth-Century Painting*. New York, 1966.

Levey, Michael, and W. Graf Kalnein. *Art and Architecture of the Eighteenth Century in France*. Harmondsworth, 1972.

Levin, Miriam. "David, de Staël and Fontanes: *The Leonidas at Thermopylae* and some Intellectual Controversies of the Napoleonic Era." *Gazette des Beaux Arts* 95 (January 1960): 5–12.

————. "La Définition du caractère républicanisme dans l'art française après la Révolution: *Le Leonidas aux Thermopyles de David*." *Revue de l'Institut Napoléon* 137 (1981): 40–67.

————. "The Wedding of Art and Science in Late Eighteenth-Century France: A Means of Building Social Solidarity." *Journal of Eighteenth-Century Life* 7 (May 1982): 54–73.

Levitine, George. *The Dawn of Bohemianism: The BARBU Rebellion and Primitivism in Neoclassical France*. University Park, Md., 1978.

Levy, Darlene Gay, Harriet Branson Applewhite, and Mary Durham Johnson. *Women in Revolutionary Paris 1789–1795*. Urbana, Ill., 1979.

Leymarie, Jean, and Carlo Argan, eds. *David e Roma*. Rome, 1981.

Licht, Fred. *Goya: The Origins of the Modern Temper in Art*. New York, 1979.

Locquin, Jean. *La Peinture d'histoire en France de 1747 à 1785: Etude sur l'évolution des idées artistiques dans la seconde moitié du XVIIIe siècle*. Paris, 1912.

Loomis, Stanley. *Paris in the Terror: June 1793–July 1794*. Philadelphia, 1964.

Lucas, Colin. "Nobles, Bourgeois and the Origins of the French Revolution." *Past and Present* 60 (August 1973): 84–126.

Lyons, Martyn. *France Under the Directory*. Cambridge, England, 1975.

McDonald, Joan. *Rousseau and the French Revolution, 1762–1791*. London, 1965.

McManners, John. "The Historiography of the French Revolution." In *New Cambridge Modern History*, vol. 8: *The American and French Revolutions 1763–93*, edited by A. Goodwin. Cambridge, England, 1965.

Margerison, Kenneth. "History, Representative Institutions, and Political Rights in the French Pre-Revolution (1787–1789)." *French Historical Studies* 15 (Spring 1987): 99–120.

Markham, Felix. *Napoleon*. New York, 1963.

———. "Napoleon and His Painters." *Apollo* 80 (May 1964): 187–91.

Mathiez, Albert. *The French Revolution*. New York, 1964.

Mellon, Stanley. "Jacques-Louis David, Revolutionary: The Case Reopened." *Consortium on Revolutionary Europe Proceedings*, pp. 364–80. Gainesville, Fla., 1983.

Miette de Villars. *Mémoires de David, peintre et député à la Convention*. Paris, 1850.

Mornet, Daniel. *Les Origines intellectuelles de la Révolution française 1715–1787*. Paris, 1954.

Nanteuil, Luc de. *David*. New York, 1985.

Neo-classicisme dessins français de 1750–1825. Catalogue of Louvre exhibit June 14–October 2, 1972. Paris, 1972.

Novotny, Fritz. *Painting and Sculpture in Europe 1760–1880*. Harmondsworth, 1960.

Olander, William. "French Painting and Politics in 1794: The Great Concours de l'an II." *Consortium on Revolutionary Europe Proceedings*, pp. 19–27. Athens, 1980.

Olivier, Albert. *Le Dix-huit brumaire*. Lyons, 1959.

Ozouf, Mona. *Festivals and the French Revolution*. Cambridge, Mass., 1988.

Palmer, R. R. "The National Idea in France before the Revolution." *Journal of the History of Ideas* 1 (1940): 95–111.

———. *Twelve Who Ruled: The Year of the Terror in the French Revolution*. Princeton, N.J., 1941.

———. *The Age of the Democratic Revolution: A Political History of Europe and America*. 2 vols. Vol. 1, *The Struggle*. Vol. 2, *The Challenge*. Princeton, N.J., 1959, 1964.

Parker, Harold. *The Cult of Antiquity and the French Revolutionaries*. Chicago, 1937.

Paulson, Ronald. *Representations of Revolution, 1789–1820*. New Haven, Conn., 1983.

Payne, Harry C. *The Philosophes and the People*. New Haven, Conn., 1976.

Pelles, Geraldine. *Art, Artists and Society: Origins of a Modern Dilemma*. Englewood Cliffs, N.J., 1963.

Pevsner, Nikolaus. *Academies of Art: Past and Present*. Cambridge, England, 1940.

Peyre, Henri. "The Influence of Eighteenth-Century Ideas on the French Revolution." *Journal of the History of Ideas* 10 (1949): 63–87.

Picon, Gaëtan. *Ingres.* Geneva, 1967.

Pupil, François. *Le Style troubadour ou la nostalgie du bon vieux temps.* Nancy, 1985.

Quynn, Dorothy Mackay. "The Art Confiscation of the Napoleonic Wars." *American Historical Review* 50 (April 1945): 437–60.

Rawson, Elizabeth. *The Spartan Tradition in European Thought.* Oxford, 1969.

Regency to Empire: French Printmaking 1715–1814. Baltimore, 1985.

Roberts, Warren. *Morality and Social Class in Eighteenth-Century French Literature and Painting.* Toronto, 1974.

———. *Jane Austen and the French Revolution.* London, 1979.

———. "David's *Horatii* and *Brutus* Revisited." *Consortium on Revolutionary Europe Proceedings,* pp. 510–18. Athens, 1986.

Rose, R. B. *Gracchus Babeuf: The First Revolutionary Communist.* Stanford, Calif., 1978.

Rosenblum, Robert. *Transformations in Late Eighteenth Century Art.* Princeton, N.J., 1967.

———. "A Source for David's 'Horatii.'" *Burlington* 112 (May 1970): 269–73.

———. "David's 'Funeral of Patroclus.'" *Burlington* 115 (September 1973): 567–76.

Rubin, James Henry. "Painting and Politics, II: J.-L. David's Patriotism, or the Conspiracy of Gracchus Babeuf and the Legacy of Topino-Lebrun." *Art Bulletin* 58 (December 1976): 547–68.

Rudé, George. *The Crowd in the French Revolution.* Oxford, 1959.

Saunier, Charles. "Les Conquêtes artistiques de la Révolution." *Gazette des Beaux Arts* 20 (January, February, April 1899): 74–80, 158–60, 340–46; 22 (July, August, November 1900): 82–88, 157–63, 433–40; 25 (March 1901): 244–59.

Scarfe, Francis. *André Chénier: His Life and Work.* Oxford, 1965.

Schama, Simon. *Patriots and Liberators: Revolution in the Netherlands 1760–1813.* New York, 1977.

Schnapper, Antoine. *David.* New York, 1982.

Schumann, Robert. "Virility and Grace: Neoclassicism, Jacques-Louis David and the Culture of Pre-Revolutionary France." *Consortium on Revolutionary Europe Proceedings,* pp. 519–28. Athens, 1986.

———. "Penser *la mort de Marat.*" *Consortium on Revolutionary Europe Proceedings,* forthcoming.

Seigel, Jerrold. *Bohemian Paris: Culture, Politics and the Boundaries of Bourgeois Life.* New York, 1986.

Sells, Christopher. "Some Recent Research on J.-L. David." *Burlington* 117 (December 1975): 811–14.

Sérullaz, Arlette Calvet. "Unpublished Sources for 'the Oath of the Horatii.'" *Master Drawings* 6 (1968): 37–41.

———. "Quelques dessins néo-classiques conservés à la Bibliothèque Thiers." *Revue du Louvre* 24, 6 (1974): 417–20.

————. "Dessins inédits de Fragonard, David et Drouais." *Revue du Louvre* 2, 1 (1976): 77–81.

Seznec, Jean. "Diderot and Historical Painting." In *Aspects of the Eighteenth Century,* edited by Earl R. Wasserman, pp. 129–42. Baltimore, 1965.

Shafer, Boyd. "Bourgeois Nationalism in the Pamphlets on the Eve of the French Revolution." *Journal of Modern History* 10 (March 1938): 31–50.

Sheriff, Mary D. "Comments on Revolutionary Allegory." *Consortium on Revolutionary Europe Proceedings,* pp. 681–88. Athens, 1987.

Sloane, Joseph. "David, Robespierre and 'the Death of Bara.' " *Gazette des Beaux Arts* 74 (September 1969): 143–60.

Soboul, Albert. *The Parisian Sans-Culottes and the French Revolution.* Oxford, 1964.

Staël, Madame de. *On Politics, Literature and National Character.* Garden City, N.J., 1965.

Starobinski, Jean. *Jean-Jacques Rousseau: La transparence et l'obstacle.* Paris, 1957.

————. "The Illness of Rousseau." *Yale French Studies* 28 (1962): 64–74.

————. *1789: The Emblems of Reason.* Charlottesville, Va., 1982.

Stone, I. F. "Witch Hunt in Ancient Athens?" *New York Review of Books* 34 (January 21, 1988): 37–41.

Sutherland, D. M. G. *France 1789–1815: Revolution and Counterrevolution.* London, 1885.

Sydenham, M. J. *The Girondins.* London, 1961.

————. *The French Revolution.* New York, 1966.

————. "The Crime of 3 Nivose (24 December 1800)." In J. F. Bosher, ed., *French Society and Government 1500–1850.* London, 1973.

Thomson, David. *The Babeuf Plot: The Making of a Republican Legend.* London, 1947.

Thompson, J. M. *Robespierre.* 2 vols. New York, 1936.

————. *The French Revolution.* London, 1943.

————. *Leaders of the French Revolution.* New York, 1965.

Tietze, Hans. *Titian.* London, 1950.

Verbraeken, René. *Jacques-Louis David jugé par ses contemporains et par la posterité.* Paris, 1973.

Vovelle, Michel. *The Fall of the French Monarchy, 1787–1792.* Cambridge, England, 1984.

Wick, Daniel. "The Court Nobility and the French Revolution: The Example of the Society of Thirty." *Eighteenth-Century Studies* 13 (Spring 1980): 203–84.

Wildenstein, Georges. *Documents complémentaires au catalogue de l'oeuvre de J.-Louis David.* Paris, 1973.

Wilson, Arthur M. *Diderot.* New York, 1972.

Winegarten, Renee. *Mme de Staël.* New York, 1985.

Wisner, David. "Jacques-Louis David and André Chénier, the Death of Socrates, the

Tennis Court Oath, and the Quest for Artistic Liberty (1787–1792)." *Consortium on Revolutionary Europe Proceedings,* pp. 529–44. Athens, 1986.

―――. "A Literary Source for David's *Tennis Court Oath*: André Chénier and the Allegory of the Legislator." *Consortium on Revolutionary Europe Proceedings,* forthcoming.

Wolock, Isser. *Jacobin Legacy: The Democratic Movement under the Directory.* Princeton, N.J., 1976.

Woronoff, Denis. *The Thermidorean Regime and the Directory.* Cambridge, England, 1984.

Wright, D. G. *Revolution and Terror in France 1789–1795.* London, 1974.

Index

Academy, French, 4, 5, 14–15, 18, 28–29, 49–50

Academy of Saint Luke, 12

Acte additionnel, 6, 186, 189, 190

Age of Democratic Revolution, 3, 5

Alexander the Great, 143, 212–13

Alexandre (student of David), 125

Alfieri, Vittorio, 30

Alquier, baron de, 198

Amar, J. B. André, 48

American Revolution, 4

Angiviller, Charles-Claude de Flahaut, comte de la Billarderie d', 4, 5, 12, 13, 14, 16, 28, 29, 33, 41, 49

Antirococo reaction, 26, 27, 123

Artois, Charles Philippe, comte de, 44, 132

Austen, Jane, 215

Babeuf, François-Emile, 125, 135

Bailly, J.-S., 52, 56, 58, 64, 65

Bara, Joseph, 84, 85, 86, 87

Barbus, the, 119–23

Bardon, André, 21

Barère de Vieuzac, Bertrand, 198, 199

Barnave, Antoine Pierre Joseph Marie, 51, 58

Barras, Paul François Nicolas, comte de, 127, 132

Barry, Jeanne-Béru, comtesse du, 88

Beaufort, Jacques-Antoine: *Oath of Brutus,* 18, 27, 123, 221 (n. 51)

Beauharnais, Alexandre de, 88

Beauharnais, Eugène de, 158, 166

Beethoven, Ludwig van, 216–17, 235 (n. 78), 237 (nn. 4, 5)

Bellegarde sisters, 88, 118

Bernard of Saintes, 106

Bièvre, François-Georges Mareschal, marquis de, 16, 29

Blauw, Jacobus, 109–11

Bologna, Giovanni, 166, 180

Bonald, Louis de, 120

Bonaparte, Caroline, 159, 160

Bonaparte, Elisa, 159, 160

Bonaparte, Joseph, 159, 160

Bonaparte, Letizia (Mme Mère), 159, 160, 161, 162

Bonaparte, Louis, 159, 160

Bonaparte, Lucien, 146, 159

Bonaparte, Napoleon, 97, 119, 125–28, 130, 131–38, 150–54, 156, 158–60, 181, 184–86, 213; before 18 Brumaire, 125–28; cynicism of, 132–33; rise to power, 1799–1800, 133–35; plots against, 135–36; views on art, 136–38; crushes opposition after 1800, 150–52; court of, 151–52; coronation of, 152–54, 156, 158, 159, 160; invasion of Russia by and defeat of, 181, 184–85; and the Hundred Days, 185–86; and Alexander the Great, 213

Boucher, François, 10, 11, 12

Bouillé, General F.-C., 61

Bouilly, Jean-Nicolas, 216–17
Bouquier, Gabriel, 75
Boze, Joseph, 98
Buron, Jacques, 188, 189
Buron, Mme, 188, 189

Calonne, C. A., 32
Cambacérès, J. J., 191, 198
Cambon, Pierre Joseph, 95, 198
Camus, Albert, 45
Caraffe, Armand: *Oath of the Horatii*,
 124
Carra, Jean-Louis, 20
Chalgrin, Mme, 69
Champagny, Jean-Baptiste, comte de,
 148
Charles IV (king of Spain), 143, 147
Chateaubriand, François René, vicomte
 de, 120, 131
Châteauvieux Festival, 61, 63, 73, 77
Chénier, André, 30–33, 35, 37, 38, 57, 59,
 60–63, 64, 65, 66, 67, 73, 88, 102, 222
 (nn. 62–64), 223 (nn. 64–69, 71–73),
 224 (n. 84), 226 (n. 51)
Chénier, Marie-Joseph, 63, 71, 76, 151
Cochin, Augustin, 38
Cochin, Nicolas, 17, 29
Commune of the Arts, 50
Condorcet, M.-A., marquis de, 60
Constant, Benjamin, 151
Corday, Charlotte, 78–82
Corneille, Pierre, 22, 23, 26, 27
Crussol, marquise de, 88
Cuviller, Charles-Etienne-Gabriel, 49

Dagorne (inspector of the national
 domain), 106
Danton, Georges Jacques, 68, 69, 75, 88
Daru, Pierre-Antoine, comte de, 167,
 168, 169
Dauch, Martin, 52
Dauphin, the. *See* Louis XVII

David, Emilie, 181
David, Eugène, 181–82, 184, 188, 192
David, Jacques-Louis: studies on, ix–x;
 early life of, 3–4; and Academy, 4, 11,
 12, 13, 14, 15, 29, 31, 37, 38, 49, 50, 211;
 patriotism of, 5, 6, 44, 90, 96, 140,
 141, 180–84, 198, 199, 204, 206, 207,
 214–15; and Salons, 5, 11, 13, 15–29, 38,
 44, 48; in Italy, 5, 12–17, 29, 31; and
 Napoleon, 5, 125–28, 130, 131–38,
 141–73, 180–86; and the Bourbon
 Restoration, 5, 187–88, 190, 199; and
 the French Revolution, 11, 37, 38, 42,
 43–89 passim; as student of Vien,
 11–12; and the radical critics, 19–22, 28,
 37–38; and liberal circles, 29–30; and
 André Chénier, 30–35, 60–67, 102; and
 the Revolution of 1789, 44, 45, 46,
 48, 49, 50–52; and the Revolution of
 1792, 45, 46, 47, 48, 58–67; Grecian
 style of, 45, 112–16, 121–25; and the
 Jacobin Club, 66, 67, 74, 78, 81;
 imprisonment of, 95–99, 104, 105, 107;
 and Gros, 193–97; as history painter,
 211–12, 214–15, 217
—works by: *Andromache Mourning Hec-
 tor*, 13, 25, 78; *Anger of Achilles at the
 Sacrifice of Iphigenia*, 206, 236 (n. 43);
 *Apelles Painting Campaspe in front of
 Alexander*, 211–12, 213, 214, 215; *Joseph
 Bara*, 84–91, 100, 107–8, 140; *Beli-
 sarius*, 13, 15, 21, 27; *Jacobus Blauw*, 100,
 109, 110, 111, 230–31 (n. 26); *Bonaparte*,
 126; *Brutus and the Lictors*, 5, 11, 30,
 33–38, 43, 44, 48, 49, 66, 89, 90, 113,
 116, 117, 211, 224 (n. 82); *Mme Buron*,
 23; *Combat of Mars and Minerva*, 11,
 12; *Coronation of Napoleon and José-
 phine*, 5, 148, 150, 152–64 passim,
 167–69, 196, 211; *Cupid and Psyche*, 192,
 195–96, 200–205, 237 (n. 49); *Mme
 David*, 171, 172, 173; *Death of Socrates*,

19, 32; *Distribution of the Eagles*, 5, 148, 164–68, 171, 188, 189, 196, 197, 211, 234 (n. 74); *Farewell of Telemachus and Eucharis*, 200, 204, 205, 236 (n. 43); *Homer Reciting His Verse to the Greeks*, 101–3; *Homer Sleeping*, 101; *Intervention of the Sabine Women*, 100, 101, 111–28 passim, 137, 138, 140, 141, 145, 178, 179, 194, 206, 211; *M. and Mme Lavoisier*, 43, 44, 45; *Leonidas at Thermopylae*, 5, 137, 138, 139–42, 173, 182–83, 194, 211, 212, 214, 234 (n. 74); *Louis XVI Showing the Constitution to His Son*, studies for, 58, 59, 60; *Marat Assassinated*, 78–84, 85, 86, 87, 88, 89, 90, 140; *Marie Antoinette*, 75; *Mars Disarmed by Venus and the Graces*, 6, 200, 206–7, 237 (n. 49); *Casper Meyer*, 100, 109, 110, 111; *M. and Mme Mongez*, 171, 172, 173; *Count Français de Nantes*, 171, 172, 173; *Napoleon Crossing the Saint-Bernard*, 143–46, 147; *Napoleon in His Study*, 171, 173; *Oath of the Horatii*, 5, 13, 15, 16, 17, 18, 19–28, 30, 31, 33, 34, 35, 36, 43, 55, 66, 89, 90, 100, 101, 102, 103, 104, 113, 115, 116, 117, 122, 123, 157, 163, 165, 166, 211, 212; *Mme d'Orvilliers*, 53, 54, 57; *Paris and Helen*, 43, 44, 45, 112, 169–70; *Mme Pastoret*, 56, 57; *Pius VII*, 148, 152–55, 163; *Count Potocki*, 13; *Mme Récamier*, 213; *Jeanbon Saint-André*, 100, 105–6, 107; *Saint Jerome*, 13; *Saint Roch Interceding with the Virgin for the Plague Victims*, 13; *Sappho, Phaon, and Cupid*, 169–70; *Self-Portrait* (1791), 55, 56, 99, 100; *Self-Portrait* (1794), 99–100, 101; *M. Sériziat* (1790), 53, 54, 107; *M. Sériziat* (1795), 100, 104, 107, 108, 109, 110; *Mme Sériziat*, 100, 104, 105, 107, 108, 109, 110; *Joseph Sieyès*, 214; *Mme de Sorcy-Thélusson*, 53, 54, 57; *Mlle Tallard*, 100, 109, 110; *Tennis*

Court Oath, 51–64 passim, 64, 81, 101, 113, 163, 165, 166; *Triumph of the French People*, 75, 76; *Mme Trudaine*, 56–57; *Venus Injured by Diomedes Appeals to Jupiter*, 173; *Vicomtesse Vilain and Her Daughter*, 214; *View from the Luxembourg*, 103–4

David, Jules (son of the artist), 181
David, Jules (grandson and biographer of the artist), 136, 146, 147, 155, 181, 182, 191, 192
David, Mme, 15, 74, 160
David, Pauline, 181
Decazes, Elie, 193
Decennial Competition of 1810, 178–79
Delafontaine, Pierre, 199
Delécluze, Etienne, 23, 111, 118, 119–30 passim, 135, 138, 139, 141, 143, 144, 146, 147, 148, 149, 164, 173, 177, 178, 179, 184, 185, 190
Denon, Vivant-Dominique, baron de, 168
Desmarres, J.-B., 85, 229 (n. 108)
Desmoulins, Camille, 46, 60, 69, 75
Devilliers, Georges, 155
Devosges, Anatole: drawing of *Lepelletier de Saint-Fargeau*, 78
Diderot, Denis, 11, 14, 26, 27, 32, 34, 221 (n. 51), 222 (n. 54)
Drouais, François-Hubert, 15, 16, 29, 34, 37, 49, 124, 224 (n. 81)

Elisabeth, Mme (younger sister of Louis XVI), 69
Esteve (Napoleon's controller of accounts), 147
Etienne (student of David), 125, 185

Ferdinand VII (king of Spain), 216
Fesch, Cardinal, 154
Flaxman, John, 114
Fleury, marquis de, 87

Flouest: *Tennis Court Oath,* 52
Fragonard, Jean-Honoré, 41
Franque, Jean-Pierre, 122
Frederick William III (king of Prussia), 190
French Revolution, 3, 5, 18, 19, 20, 32,
 33, 38, 45, 46–48, 55, 56, 58, 67–73,
 84–85, 97, 98, 106, 108–9, 131, 141, 142;
 and Age of Democratic Revolution,
 3–5; Assembly of Notables, 32; Estates
 General, 32, 33, 38; Revolution of
 1792, 45, 46, 47, 55, 56, 58, 67; Revolu-
 tion of 1789, 45–46, 58, 67; Tennis
 Court Oath, 46, 51, 52; and women,
 46–48, 74, 80; Jacobin Club, 47, 48,
 68, 70, 81, 95; Châteauvieux Festival,
 59, 60, 61, 63, 66, 77; the Terror,
 67–69; revolutionary imagery, 70–73;
 counterrevolution, 84–85; uprising of
 1 Prairial, 97, 98, 106; Thermidorean
 period, 106, 108–9; coup of 18 Bru-
 maire, 134, 141–42
Fuseli, Henry, 8

Gautherot, Claude, 197
Gérard, General Etienne Maurice, 198
Gérard, François, 144, 155–57, 193
Girodet, Anne-Louis, 124, 178, 179, 193
Goltz, Count von, 190
Gossec, François Joseph, 63, 77
Gouges, Olympe de, 47
Goya y Lucientes, Francisco José de,
 215–16, 233 (n. 35)
Grégoire, abbé Henri, 52, 151
Grimm, Melchior, baron, 124, 125–26,
 188, 193, 194, 195, 196, 197, 201
Guilbert (author of *Léonidas, ou le départ
 des Spartiates*), 139
Guiraud (spokesman for Social Contract
 section), 78, 80

Hamilton, Gavin, 18
Hatzfeld, Prince, 191

Hébert, Jacques, 60, 68
Huin, Mme, 40, 41
Humboldt, Alexander von, 190, 191

Ingres, Jean-Auguste-Dominique, 202,
 203, 206, 237 (n. 48)
Isabey, Jean-Baptiste, 152, 161

Jeanin, Colonel (David's son-in-law), 182
Jefferson, Thomas, 5, 30
Joséphine, Marie-Joseph Tascher de la
 Pagerie (empress of France), 154, 159,
 160, 161, 165
Jouberthon, Mme, 159
Journal of the Society of 1789, 60
Julliard, Mme, 41

Kervegan, C. C. Danyel de, 51
Kornmann circle, 20

La Bourdonnaye, Count François
 Augustin, 189
Lacoste, Elie, 106
Lafayette, Marie-Joseph, marquis de,
 61, 64, 65
Lagarde, Joseph-Jean, 126
Lagrenée, Jean-Louis-François, 16
Landon, Charles-Paul, 121–22
Lavicomterie, L.-T., 106
Lavoisier, Antoine Laurent de, 88
Lebrun, Charles, 149
Lebrun, Charles-François, 152
Lepelletier de Saint-Fargeau, Louis
 Michel, 47, 50, 76–79
Levasseur, A.-L., 198
Lindet, Robert, 106
Loménie de Brienne, E. C., 32
Louis XV, 11
Louis XVI, 3, 4, 45, 46, 88
Louis XVII (the dauphin), 41, 58, 59, 60
Louis XVIII, 193, 198

Mainbourg, de (student of David), 94, 101, 103

Maistre, Joseph de, 120

Mansfeld, Prince, 191

Marat, Jean-Paul, 42, 60, 61, 63–66, 67, 78–83, 95, 131, 226 (n. 50), 229 (n. 104)

Marie Antoinette, 5, 46, 88

Marie Thérèse Charlotte (daughter of Louis XVI), 41

Maurepas, Jean Frédéric Phélypeaux, comte de, 34

Mazzei, Filippo, 30, 222 (n. 60)

Ménageot, François, 29

Mercy d'Argenteau, François, comte de, 191

Meunier, Colonel (David's son-in-law), 182

Meyer, Casper, 110

Miette de Villars (biographer of David), 10, 11

Mirabeau, Honoré Gabriel de Riqueti, comte de, 51, 58, 64, 65

Moline, P. L., 75

Montesquieu, Charles de Secondat, baron de, 4, 31

Moriez (student of David), 142

Murat, Joachim, 202

Nantes, Français de, Count, 171–72

Nantes, 51, 53, 54, 55

Nodier, Charles, 119, 120, 121, 122

Paganel, Pierre, 198

Parlements, 3, 32

Pastoret, C. E., 57–58

Pastoret, Mme, 57–58

Pécoul, Charles-Pierre, 15

Péron, Alexandre, 22, 23

Peyron, Jean-François-Pierre, 17, 29, 123, 124, 222 (n. 55)

Philip IV (king of Spain), 143

Pierre, Jean-Baptiste-Marie, 12, 14, 15, 16, 49, 224 (n. 82)

Pius VII (pope), 152–55

Plutarch, 33

Pompadour, Jeanne-Antoinette Lenormand d'Etiolles, marquise de, 11

Pourrat, Mme, 30

Poussin, Nicolas, 26

Prieur of Côte d'Or, 106

Quatremère de Quincy, Antoine, 12, 75, 88, 127

Quay, Maurice, 119, 120, 121, 122

Quinault, Philippe, 44

Rabaut Saint-Etienne, J.-P., 52

Regnault, Jean-Baptiste, 118, 124

Rémusat, comte de, 167

Restoration, Bourbon, 185

Reubell, J.-F., 52

Robert, Hubert, 98

Robespierre, Maximilien Marie Isidore, 5, 6, 18, 46, 58, 66, 67–69, 70, 85, 90, 91, 95–97, 120, 131

Roland de la Platière, Jean Marie, 40, 41

Rousseau, Jean-Jacques, 26, 31, 221 (n. 47), 222 (n. 54)

Roux, Jacques, 68

Saint-André, Jeanbon de, 105, 106

Saint-Just, Louis Antoine, 45, 46, 47, 69

Schiller, Friedrich, 217

Sedaine, Michel-Jean, 4, 22, 23, 28

Ségur, Louis Philippe de, 152

Sériziat, Emilie, 105–6, 107

Sériziat, Pierre, 54, 104–7

Seven Years' War, 4

Sieyès, Emmanuel-Joseph, 51, 58, 64, 133, 191, 198

Society of 1789, 60

Sommariva, comte de, 213

Spaendonck, Gérard Van, 118

Staël, Germaine, Mme de, 131, 132, 151
Stanislaus Augustus (king of Poland),
 30, 222 (n. 60)
Suvée, Joseph-Benoît, 98
Suzanne, F. M., 12

Talleyrand, Charles Maurice de, 131
Tardini, P. A.: engraving of *Lepelletier de
 Saint-Fargeau,* 78
Taunay, Nicolas-August, 118
Terray, Antoine-Jean, 87–88
Theophilanthropism, 151
Thibault, Anne-Alexandre-Marie, 52
Thienon, Claude, 159
Tischbein, Johann-Heinrich-Wilhelm,
 16
Titian, 143
Topino-Lebrun, François-Jean-Bap-
 tiste, 125, 135, 136
Trudaine, Charles-Louis de Montigny,
 30, 57–58, 88
Trudaine, Charles-Louis de Sablière, 30,
 88
Trudaine, Mme, 56–57, 88
Trudaine circle, 30–34, 38, 57, 60, 66, 224
 (n. 84)
Trumbull, John, 30

Turenne, Henri-Amadée-Mercure,
 comte de, 198
Turgot, A.-R.-J., 3, 4, 28, 30

Velázquez, Diego Rodríguez de Silva y,
 143, 233 (n. 35)
Vernet, Carl, 69
Viala, Agricol, 84
Vien, Joseph-Marie, 4, 5, 12–14, 49, 112,
 118, 123
Vigée-Lebrun, Elisabeth, 41
Villeroy, duc de, 87
Vincent, François-André, 118
Voeu des Artistes, 49
Voltaire, François-Marie Arouet, 13
Voullard, Henri, 106

Wellington, Duke of, 198
West, Benjamin, 18
Wicar, Jean-Baptiste, 10, 36
William I (king of the Netherlands), 191,
 192
Winckelmann, Johann Joachim, 112–16,
 128, 175
Wollstonecraft, Mary, 47

Youssoupoff, Nicolas, Count, 169